RICHARD DIEBENKORN

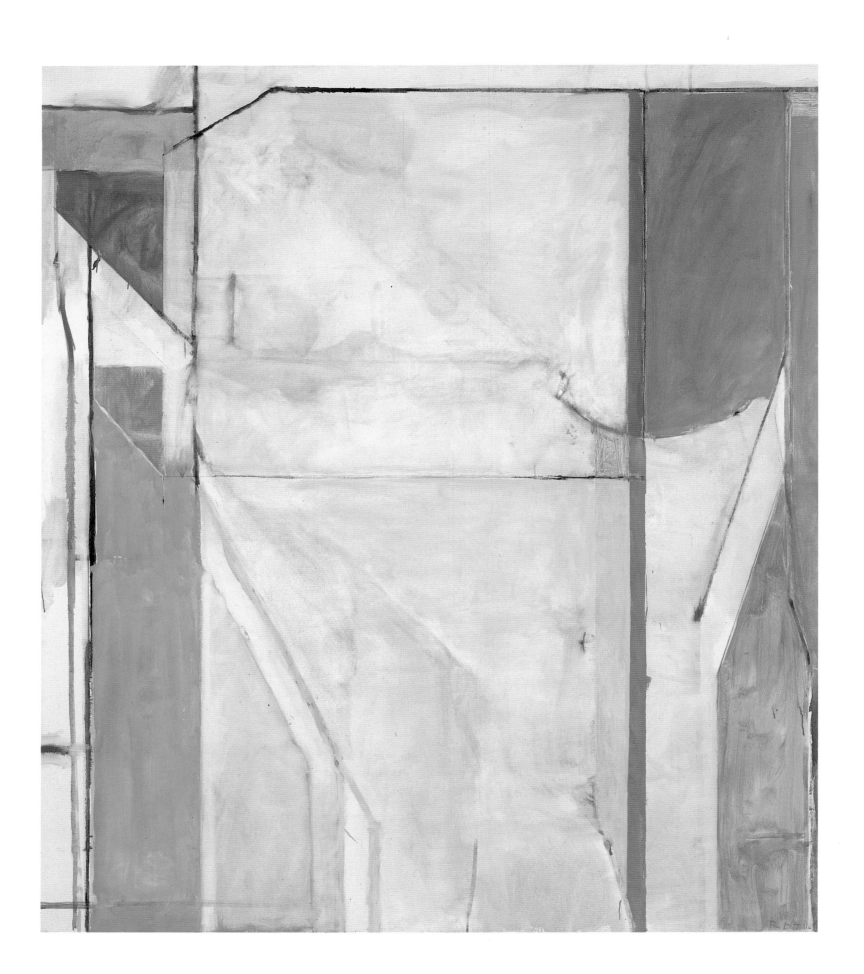

RICHARD DIEBENKORN

REVISED AND EXPANDED

Gerald Nordland

Edited by Ashley Benning
Copyedited by Jasmine Moorhead

Designed by Kathleen Oginski

First published in the United States
of America in 1987 by
Rizzoli International Publications, Inc.
300 Park Avenue South
New York, NY 10010
www.rizzoliusa.com
Copyright © 1987, 2001 Gerald Nordland

Printed and bound in Japan

Library of Congress Cataloging-in-Publication
Data is available upon request.

ISBN: 0-8478-2348-2
ISBN-13:978-0847823482

Frontispiece:
Ocean Park No. 43, 1971. Oil on canvas.
93 x 81 in. Mr. And Mrs. John Berggruen collection,
San Francisco

Right:
Portrait of the artist, 1986

CONTENTS

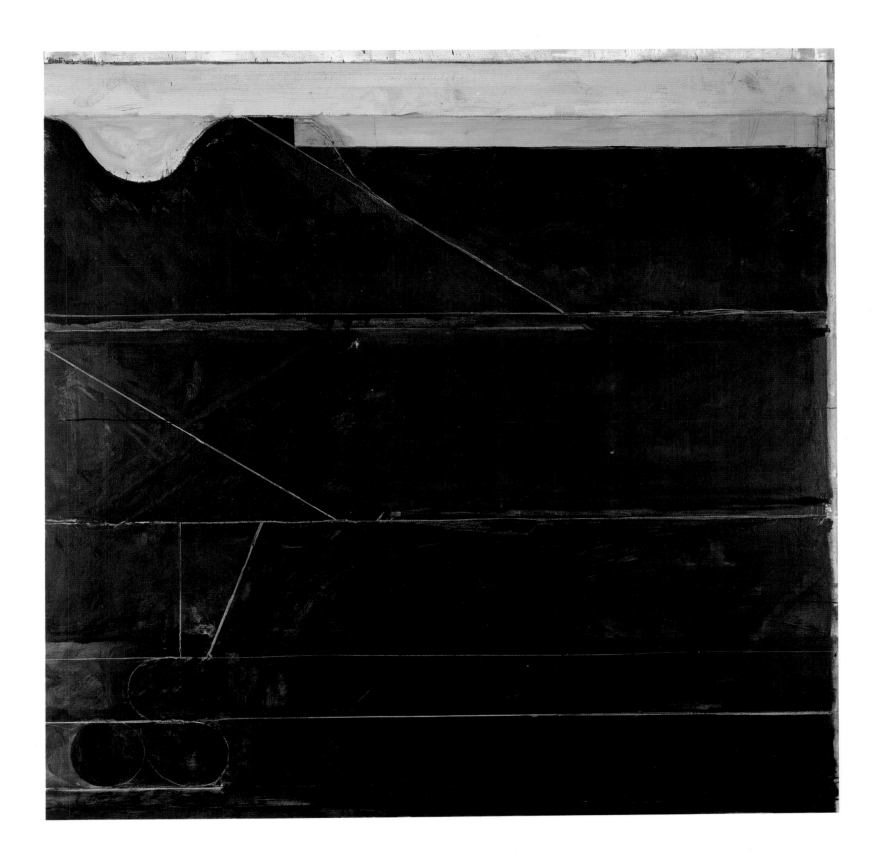

R

ichard Diebenkorn, painter, draughtsman, and printmaker, should be seen as the leading individualist in twentieth-century American art. He is perhaps best known to followers of the art world as the creator of a series of large abstract paintings referred to as the Ocean Park series: he is known to more seasoned observers through his powerful and precocious abstract expressionist period (1948–55) or by his eleven-year period as figure painter (1955–67). He held tenaciously to his self-direction in each period, as independent of commercial-gallery or critical influence as he had been of sentimentality or the ubiquitous seasonal trends and fashions of the art of his lifetime. Throughout, he maintained a remarkable consistency of quality in all of his major modes, producing memorable and enduring works in each.

Born in 1922, he was younger than any of the first generation of abstract expressionists, and yet he can be more properly associated with the values and sense of history of the generation of Rothko, Still, Baziotes, and Motherwell than he can with artists who came later to maturity. He was drawn to the practice of art against parental advice, and for him success was not to be measured by property, physical comfort, or financial security, but by the freedom to spend his days in the studio, working to find transcendence within a tradition that he was attempting to understand, validate, and reinvigorate.

Diebenkorn studied in the San Francisco Bay area before and during World War II and underwent military training in Virginia and the Carolinas. During that training he was able to visit a number of key collections of early modern art in Washington, Philadelphia, and New York, and those experiences helped him to build upon his West Coast education and to make his first abstract paintings. He had been profoundly stirred by such diverse influences as Hopper, Cézanne, Matisse, Miró, Baziotes, and Motherwell. Following his Marine service, he returned to the Bay area to

Ocean Park No. 133, 1985. Oil on canvas. 81 x 81 in.
Phil Schrager collection, Omaha, Nebraska

enroll at the California School of Fine Arts in early 1946, where he was quickly recognized as an artist of unusual promise. Awarded the school's highest grant, which permitted him to make art full-time in the Northeast during the 1946–47 academic year, he spent long days and evenings, in his description, teaching himself to paint. Returning to school to teach in 1947, he became acquainted with an expanded faculty, including the abstract painters Clyfford Still, Elmer Bischoff, Hassel Smith, and Edward Corbett.

The young painter could not help but feel somewhat equivocal about his direction. On the one hand he was devoted to French modernism, particularly that of Matisse, who was little understood at the school. At the same time he was committed to abstract painting as the challenge of his generation. He recognized that both Picasso and Matisse had come to the point of abstraction and turned back. He found himself striving to expand his ideas and techniques through the experience of Miró and Gorky, whose work he had seen both in San Francisco and on the East Coast, to the major influence of Matisse and the relentless logic of Mondrian's reductive analysis. The accessibility of advanced art in the 1940s was not what it is today, yet Diebenkorn was familiar with the critical journals and sought out reproductions in books and magazines. He visited the San Francisco Museum of Art's developing American collection, which included the Picasso-style Arshile Gorky, the psychoanalytic Jackson Pollock, the astonishing Mark Rothko, and the enigmatic Still. By 1948–49 Diebenkorn had digested his influences, worked through others, and synthesized them with early experiences to produce a powerful and convincing abstract painting idiom of his own.

He resigned his faculty position at the close of 1949 to enroll in the Master of Fine Arts program at the University of New Mexico. Over the next five years his paintings grew in size and experienced a number of color shifts as the artist worked in Albuquerque, then Urbana, Illinois, and finally in Berkeley, in his first mature period. He shook off the words and examples of teachers and peers from San Francisco and found himself exploring a landscape impulse, reflecting the coloristic influences of regional light and incorporating a new and more autographic drawing technique, owing something to de Kooning's example. Viewing a Matisse retrospective in 1953 revitalized that master's color influence on the younger artist, which blossomed during Diebenkorn's nine-month stint in Urbana. All of these energies rose to a full synthesis in the Berkeley paintings of 1953–55. At that time Diebenkorn became identified as an abstract expressionist painter of unusual creativity, perhaps the most significant western exemplar. Shows in Los Angeles and Chicago received serious attention and were followed by his first New York solo show, of Berkeley paintings, from which a later exhibition in Boston was selected.

Rather abruptly in the latter part of 1955, Diebenkorn began to paint representationally from landscape and still-life subjects. He continued his familiar expressionist paint handling while developing a new body of clearly figurative work. His close friends Elmer Bischoff and David Park had preceded him in the conversion to figuration, and he had been drawing with them and discussing their work for more than a year when the

change came about. Although the "mainstream" of modernist art seemed to be in non-figurative work, Diebenkorn sensed it was necessary to investigate what he felt was incompletely explored, and he did so heedless of its effect on his career or reputation.

The three painter-instructors were soon grouped with their students in what became publicized as the Bay Area Figurative school. Diebenkorn resisted being labeled a member of a school, but that description remained attached to his work for a number of years. He was deeply challenged by the possibilities of figurative painting and systematically explored still-life, landscape, and figure composition. National recognition came to him quite against the current of contemporary art. Diebenkorn's independence in choosing to live and work in California was thought by some to be an obstacle to acceptance, and even an indication of lack of seriousness. Nevertheless Diebenkorn's work continued to receive acclaim through inclusion in important exhibitions.

In 1967 Diebenkorn accepted a professorship in painting at the University of California at Los Angeles, and he moved to the beachside community of Santa Monica. Within a year he found himself making abstract paintings again. His new work was not cast in the emotional abstract expressionist model of his 1947–55 period but was developed in a serene and contemplative mode, in a larger format, with most of the same coloristic and painterly processes that he had evolved early on and continued to use in his figurative work. In these works, occult balances of geometry and brushwork, thinly and thickly painted areas, erased and overpainted sections interact with color and proportions of glorious certainty. In detail, the ghosts of underpaint leak through at edges and seams, revealing subtle underlays of color that enrich perfectly at a normal viewing distance. These works, Diebenkorn's Ocean Park canvases, have become for many the most engaging and rewarding painting experiences of modern art.

Richard Diebenkorn moved repeatedly, with apparent sureness, at cross purposes to the bandwagon movements of his time, seeking his own unique vision of modernism. Meanwhile, he remained steadfast to the great and primary art influences of his early life. Diebenkorn's work is no longer specifically identifiable with a region, school, or generation of painting. He pursued an often intricate course, and his achievements mark him as one of the small handful of major American artists of the late twentieth century.

Diebenkorn was born in Portland, Oregon, in 1922, to a family of middle-class circumstances. Two years after his birth, his father, a sales executive in the field of hotel supplies, was transferred to the company's headquarters in San Francisco. Raised in a residential area west of Twin Peaks, Richard drew and painted as a child and grew up thinking he would become an artist of some kind. He received early encouragement from his grandmother, Florence Stephens, an amateur painter, book reviewer, and something of an unusual lady.[1] It was she who accompanied him to an exhibition of paintings by Vincent van Gogh at the California Palace of the Legion of Honor in the early 1930s, when the boy was no more than ten or twelve years old. One of Diebenkorn's vivid early memories was of visitors laughing at and ridiculing the paintings, with a gallery

guide joining in. Only his grandmother—no particular exponent of postimpressionism—understood van Gogh to be an adventurous and brilliant artist who was exploring the communication of fresh subject matter.

Among his youthful experiences with art was Diebenkorn's enjoyment of the illustrated books of Howard Pyle and of N. C. Wyeth, who coupled their romantic writings with detailed, skillfully executed drawings. Memorable also were the vigorous painting of Frederic Remington and, to a lesser extent, the work of Charles Russell and Will James, with their strong resonances of cowboy culture. Before long Diebenkorn's own drawings focused on imaginative depictions of violent adventure stories, from the medieval to the modern—demonstrating his enthusiasm for swords and armor, the swashbuckling chronicles of Alexandre Dumas and Rafael Sabattini, the life of the Old West, and weapons of all kinds. Many of those images would later appear in his mature works. He spent summers in Woodside, California, at his grandmother's small house, where he "carved swords and made shields, and emblazoned them with insignia."[2] The quatrefoil of cross or clover, and the spade or club form would recur in his drawings for years.

Grandmother Stephens conducted a book review program for a San Francisco radio station, and she guided his reading with unobtrusive skill. She seemed to know "absolutely which books at which time to give him—Arthurian legends one year, English history the next, thus feeding the boy's imagination for many summers while he was in grade and high school."[3]

That imagination took root in Diebenkorn's grade school painting and drawing, presaging the ways in which he would approach his work later on. "In the classroom . . . I used strong color, painted loosely, took subjects that the other fellows were interested in . . . at home my work was quite different. It was a sort of elaborate note-taking with references to my private world. The pictures were tight, rather small, the color used to identify things . . . the picture being a means of my being transported and brought into real contact with things of importance to me,"[4] the artist noted in a 1957 interview. He continued, "what I do now combines both these approaches." Perhaps he would not have accepted that statement for his late works: the note-taking aspect had fallen away for more than twenty years, while the use of color and paint freedom continued to grow and evolve to the last.

During his high school years Diebenkorn encountered new influences that introduced him to the contemporary art scene. He was given an annually renewed subscription to *Esquire* magazine, which had the distinction of having a lively editorial policy, wide-ranging articles, occasionally first-rate fiction, and a broad variety of informed critical writing on theater, film, literature, and music. Eight or ten articles a year were published on individual artists then working in New York, among them important leaders of the Ash Can school—Robert Henri and William Glackens—as well as distinguished artists in mid-career such as Bernard Karfiol, Yasuo Kuniyoshi, William Gropper, Henry Varnum Poor, Abraham Rattner, Raphael Soyer, and others less well known. However, no difficult modern

artists, and no Dove or O'Keeffe, Schamberg, Morgan Russell, or Gorky were, ever presented.

Certainly exposure to these artists led him to think about art in a professional sense and what that meant. "Art, for me, was always something I did privately."[5] "[In] high school . . . for one thing I was probably a little intimidated. I can remember standing in the doorway of the art studio at Lowell High School looking in, and seeing these people busily working . . . professionally . . . [but] what they were doing was not at *all* like the sort of cramped illustrative thing that I did at home."[6] "It wasn't art that I was interested in; it was drawing and painting. . . . I had no real understanding of drawing and painting as art."[7]

In September 1940 Diebenkorn entered Stanford University. His parents expected him to prepare for a career in one of the professions or to go into business, despite his early interest in art. His desire to study art was suspended as he was plunged into lower-division requirements—literature, history, and music—subjects that nevertheless fostered enduring passionate interests. "My father didn't think being an artist was a respectable or worthy goal for a man. He hoped I would see my way to more serious work and would find myself turning toward medicine, law, or business."[8] To the contrary, as he proceeded through his first two years, Diebenkorn found himself less and less inclined toward preparing for a professional vocation. With the U.S. entry into World War II, it became obvious that the young man would be serving in the military. During his second year at the university, he signed a contract with the Navy V12 program to become a member of the Marine Corps with the assurance that he could remain at Stanford until graduation and then go into active service. In his third year he took advantage of his military status to enroll in some art courses and neglect courses such as political science and economics. At this point Diebenkorn's father became permissive, ". . . and so I took further advantage . . . [with] additional art courses, until that was about all I was taking."[9]

The art department at Stanford—headed by Daniel Mendelowitz (1905–1980), a watercolorist, landscape painter, and art historian— was small, and few students aspired to become professional artists. But Mendelowitz sensed a special self-directedness in Diebenkorn and permitted the young man to paint landscapes away from the studio and to bring his work in for regular criticism. Mendelowitz had studied with Reginald Marsh and had a strong interest in the work of Edward Hopper, with which Diebenkorn had become acquainted through a book given to him in high school. The teacher gave slide lectures and surely shared his own enthusiasms with his students, which along with reproductions displayed in the studios and public spaces, may have underlined Hopper's importance for Diebenkorn. "Hopper's use of light and shade and the atmosphere . . . drenched and saturated with mood, and its austerity, was the kind of work that seemed made for me."[10] According to the young artist, his response to Hopper's imagery "fitted in with the writings of Sherwood Anderson, Hemingway, and Faulkner, whom I had been reading."[11]

While he was studying with Mendelowitz, Diebenkorn became impatient with the transparent quality of watercolor, which necessitated

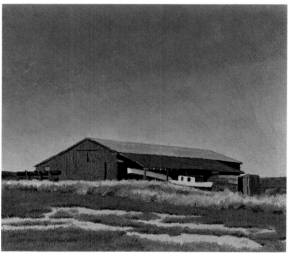

Mushroom House, 1942. Oil on canvas. 17½ x 13½ . Mr. and Mrs. Richard Diebenkorn collection, Santa Monica, California

Boat House, 1942. Oil on canvas. 14¼ x 16¼ in. Mr. and Mrs. Richard Diebenkorn collection, Santa Monica, California

anything short of a perfect stroke being begun anew. He tried reworking his watercolors, revising them in opaque watercolor or gouache. Mendelowitz advised him to discard these efforts, but Diebenkorn persisted and often felt he had succeeded. Later, when with the Marines in Hawaii, he was revising a watercolor and resolved that he "was going to get it even if he had to make the black white and the white black."[12] This manner of working left the artist with a rich paint surface to deal with, an approach that he incorporated into his working techniques throughout his career, in watercolor as well as in oil.

Mendelowitz offered one unique service to Diebenkorn that was never extended to any other Stanford undergraduate: he arranged for Richard and himself to have tea with Mrs. Michael (Sarah) Stein (1870–1953), whose home and famed art collection were located in Palo Alto. The artist remembered the visit: "It was not a big house, but it was ample. It had a large living room with paintings hung in at least three tiers. In addition, there was a dining room or a study, which was similarly hung." He remembered seeing *Woman with the Hat (Femme au chapeau)*, 1905, *La Baie de Nice*, Easter 1918, both by Matisse, as well as works by Picasso and Cézanne, and great prints and illustrated books. It was an exciting experience for an impressionable young man. The visitors stayed about an hour and a half, studied the paintings, and enjoyed anecdotes about Matisse and the years of the Fauve and cubist revolutions when many of these key works had been made. *Woman with the Hat* was the most controversial if not the most important painting of the Fauve movement, and *La Baie de Nice* is a haunting example of Matisse's leanest Nice-ean manner, much appreciated by Diebenkorn for over forty years but only recently reevaluated by contemporary curators.

Diebenkorn studied oil painting at Stanford with Victor Arnautoff (1906–1979), a Russian-born artist, who taught the classical fundamentals of form delineations with an emphasis on precision, discipline, and accurate rendering. Diebenkorn was vaguely aware that Arnautoff was a highly principled man, a hard-working and serious artist with many distinctions. He knew that Arnautoff was a thoughtful supporter of unpopular causes, and he was admiring of his intellectual independence. Consequently Diebenkorn had a high regard for Arnautoff, although his friendship with Mendelowitz was more spontaneous. He "recognized that the European modernists were a thorn in Dan's side."[13] Nevertheless, from these experiences he realized that he could simultaneously utilize different influences—Hopper, Mendelowitz, Arnautoff—while struggling with a new discovery, gained through studying black-and-white reproductions, Paul Cézanne.

At this time Diebenkorn customarily painted from nature on the Stanford campus or in and around nearby Palo Alto. Often a specific building would strike a chord of familiarity or would project a mood to which he responded, and it would be recorded in a naturalistic manner. Both painting instructors were tolerant of his independent endeavors and left him on his own, critiquing his finished work. One of the earliest surviving works of the artist's formative years is *Palo Alto Circle*, 1943 (p. 14), painted

during the artist's last six months at Stanford. It is an image of a hotel building with railroad tracks, a chain-link fence, and a passenger platform standing between the observer and the hotel. Sunlight slants across the hotel's two-story facade with its curtained and blinded windows and strong shadow patterns, while "Cafe" and "Coca-Cola" signs can be read at the first level. One might presume that the artist had angled about to find this quintessentially "American" view, with its strong Hopperesque light, its frontal imagery, the framing device of rails in the foreground, and the vertical lamp standard along the right margin. To the contrary, he "had recognized the potentialities of the scene one morning and began painting it that afternoon."

The influence of Hopper on this painting is very clear, in subject matter, understatement, and the projection of mood. However, there is a consistency of concept and execution present that is rare in student work. Diebenkorn's instructors' confidence in permitting him to select his own problems was validated by his impressive solution.

Not every hour of the young artist's day was devoted to painting, music, and literature. He was a fraternity member and he enjoyed social functions on the campus. He met Phyllis Gilman, a fellow student, and in spring 1943, shortly before Diebenkorn was called up for active duty by the Marines and transferred to the University of California at Berkeley, the two were married.

The artist reported to Berkeley, in uniform, to a thirty-five-man unit for Officer Candidate training. Many of his fellow candidates were reassigned from one educational major to another on the judgment of Marine personnel. When Richard announced his major as art to the assignment officer, the administrator could find no equivalent placement in his books. Stumped, the officer made the decision "to keep you in art." Diebenkorn became the only military student in the well-recognized art department of the university.

Diebenkorn had little formal experience in the wider world of art and art education and did not realize that Berkeley's art department was a stronghold of the teachings of Hans Hofmann, which had permeated the curriculum through the discipleship of many of the department's instructors, including Erle Loran (1905–1999), Diebenkorn's painting instructor. Because of the attention focused on Loran's book on the composition of Paul Cézanne, Diebenkorn presumed that his teachings were drawn from that study and the accumulated insights of a painter's career. Loran felt, on the other hand, that Diebenkorn had not been properly prepared at Stanford so his teaching techniques were more tailored, geared toward correcting this. "Diebenkorn struggled with the assigned problems," Loran said. "He didn't handle the overlapping planes assignment successfully, and he didn't accept criticism easily. One could see that he was talented, and I felt he was destined for important work." Loran did not ordinarily permit a student to work outside of class, but he agreed to do so with Diebenkorn, saying recently, "I felt it was something to indulge him in. One has to be flexible. He didn't disappoint me."[14] Loran recalled that Diebenkorn resisted his teaching, feeling he was too rigid. Diebenkorn admitted that there was

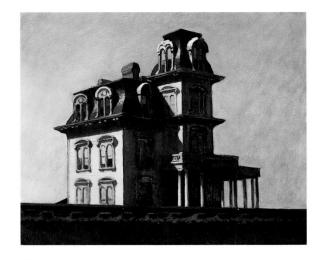

Edward Hopper, *House by the Railroad*, 1925. Oil on canvas. 24 x 29 in. Collection, The Museum of Modern Art, New York, Given anonymously

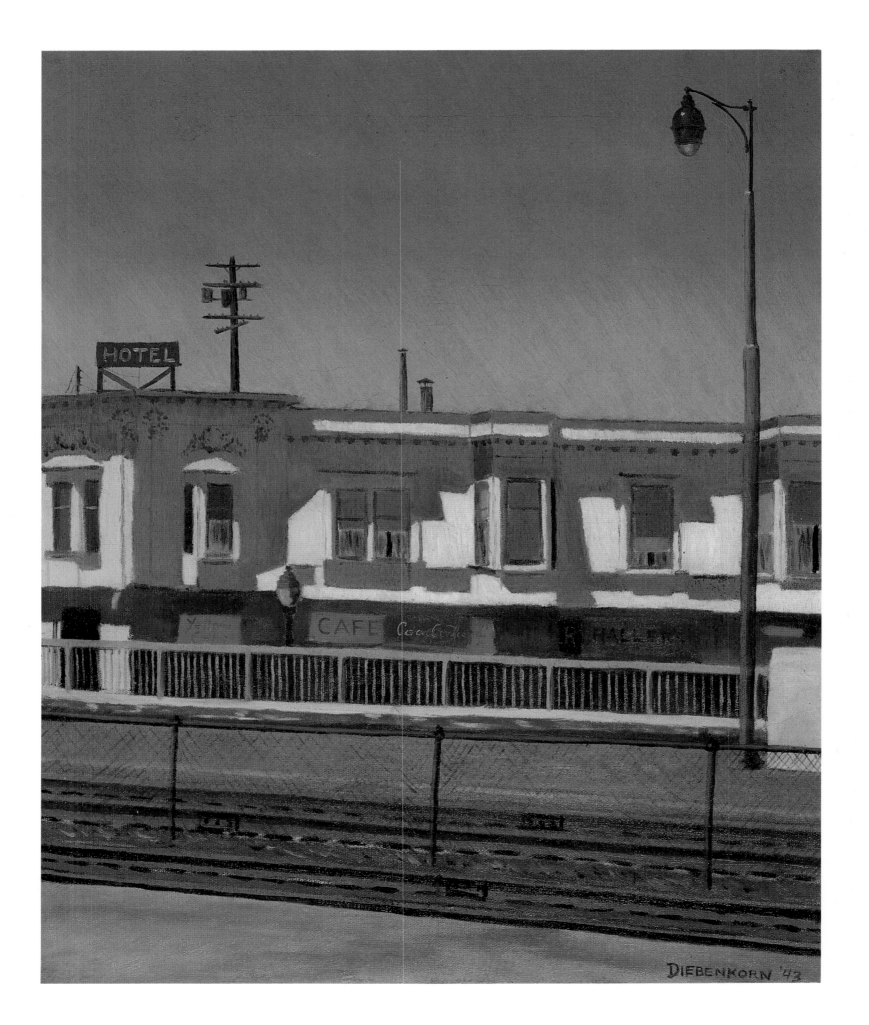

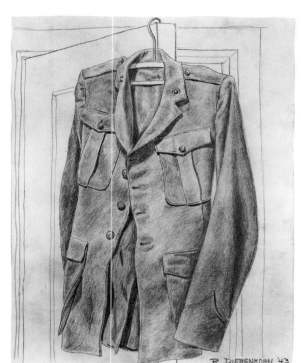

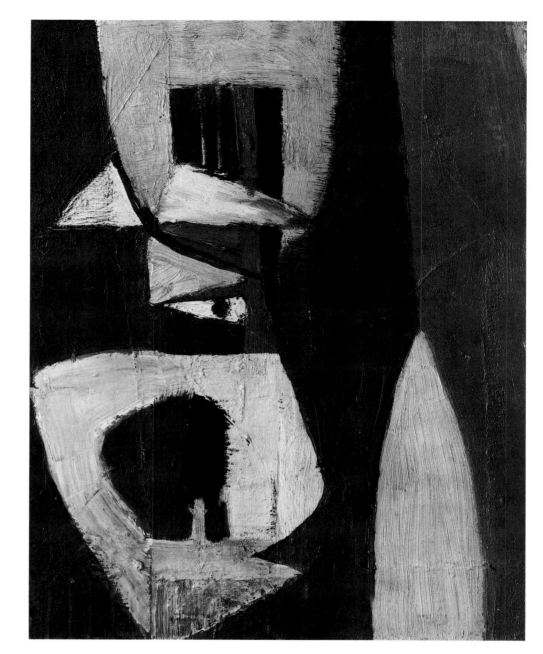

some truth to that accusation but expressed his gratitude to his instructor for his flexible encouragement. It was a brief but influential interlude in the experience and education of the artist. Of the results Loran commented, "Hofmann rarely achieved the effect of shifting planes without overlapping, in his own work. Mondrian was able to do it most often. The remarkable achievement of Diebenkorn today has been to achieve such spatial effects without having the conscious element of shifting, which is routine in Mondrian and Hofmann."[15]

Diebenkorn's single semester at the University of California was an important one. He attended contemporary art history classes given by Eugene Neuhaus and was there introduced to an approach to visual analysis that was new to him. He studied drawing with Worth Ryder (1884–1960), another Hofmann disciple. Art training at Berkeley was much more structured and professionally oriented than he had previously experienced: for example, whereas at Stanford he had begun looking at

Opposite:
Palo Alto Circle, 1943. Oil on canvas. 19 ¾ x 16 in. Private collection

Marine Jacket, 1943. Graphite on paper. 11 x 8 ½ in. Mr. and Mrs. Richard Diebenkorn collection, Santa Monica, California

Untitled, 1946. Oil on canvas. 12 x 9 ½ in. Mr. and Mrs. Richard Diebenkorn collection, Santa Monica, California

Cézanne's work as a patchwork of brushstrokes—a baffling juxtaposition of foreground, background, and lopsided objects—at Berkeley he came to see order and clarity in the uninterrupted strokes. Understanding followed and continued to develop as he saw that Cézanne was separating the optical elements of experience from the conceptual and elaborating on what he saw and how he saw it. Instead of painting the subject matter, Cézanne painted the components of it—the way light fell here, the color of the shadows there—breaking up the subject matter. There was a simplification going on, an elimination of detail and of everything that was nonvisual. Cézanne's emphasis was on using color to turn the whole work into a harmony of color and light, reducing reality to a two-dimensional surface, and then reducing it further within the canvas to a system of colored spots or patches. It was at around this time that Diebenkorn encountered Maurice Denis's famed dictum, and he found that he understood it directly:

> It is well to remember that a picture before being a battle horse, a nude woman, or some anecdote—is essentially a plane covered with colors assembled in a certain order.[16]

Diebenkorn recognized that Cézanne's paintings were both depictions of that artist's "little sensations" of still life, portraiture, or landscape and synthetic compositions prophetic of cubism and abstraction as these styles would develop. That the arrangement of colors in sticky paint on a scrap of canvas was as real an art as the subject matter depicted was a revelation, and how those two realities coexisted and supported one another would become the subject of a lifetime of study.

A book on Cézanne and a few *Dyn* magazines that he picked up at the San Francisco Museum of Art were precious additions to the artist's seabag when he left for active duty with the Marines following the Berkeley assignment. After basic training at Parris Island, North Carolina, which was "mercifully short," and a stint at Camp Lejeune, North Carolina, Diebenkorn reported for Officer Candidate School training at Quantico, Virginia. He was soon dropped from the OCS roster after having argued with a sergeant who reprimanded him for not having taken a "Japanese fortification" with Marinelike force.

Although he was not able to paint in his barracks in Quantico, he did a number of portrait drawings of noncommissioned officers and a few officers. The drawings were quite disciplined, lifelike portraits. One of the sergeants recommended to the Commanding Officer that Diebenkorn's talent deserved special consideration in relation to his next assignment, and he was reassigned to the Photographic Section at Quantico.

In the Photographic Section he worked with a cadre of Walt Disney-trained, animated map makers, making vast colored washes to distinguish geographical areas. Lacking polished production skills, he was assigned fewer and fewer projects until he mostly had time and artist's materials on his hands. He began to paint again in water media, drawing upon his most recent experiences in Berkeley with landscape painting and upon his responses to the Cézanne book and the *Dyn* magazines he had brought

with him from San Francisco. *Dyn* was published by Wolfgang Paalen (1907–1959), in Mexico during 1942–44, and the Number 6 issue—which included reproductions of works by such artists as Braque, Hayter, Matta, Pollock, and David Smith—particularly intrigued Diebenkorn because of its inclusion of paintings by Robert Motherwell and William Baziotes. "I didn't know who these people were, but they grabbed me. There was a flavor, something I hadn't seen in French modernism . . . or in American . . . something very fresh and compelling. . . ."[17] This was, of course, an early warning of the movement later to be called "abstract expressionism."

Excited by these new stirrings in the art world, Diebenkorn did his first abstract paintings in Quantico. None of these works—improvisations with still-life or cityscape underpinnings—have survived. The surrealist impulse, a reflection of Baziotes and Motherwell and intuitively absorbed by Diebenkorn from the black-and-white reproductions he had seen of these artists' works, could also be discerned.

As he became more settled in Virginia, he found it possible to leave the camp on weekends to travel to Washington, D.C., about thirty miles away, where he would visit the National Gallery, the Corcoran Gallery of Art, and the Phillips Collection. On repeated visits the painter came to know certain works well, discovering unexpected new depths and subtleties with each viewing. These trips were inexpressibly important and exciting for both of the Diebenkorns. Visiting museums was all they could afford to do, but it was also the only thing they wanted to do.

The Phillips Collection, in particular, afforded them a warmth, comfort, and stimulus that was unmatched. The collection was housed then, as it is now, in the original (1897) family mansion. It contained works at the time ranging from El Greco, Hogarth, Goya, and Chardin through the great masters of the nineteenth century to the postimpressionists, Cézanne and Gauguin, and on to Matisse, Picasso, Bonnard, Klee, and Miró. There was also a strong representation of American art, including the early moderns. The Phillips was the first museum of modern art in the United States when it opened in 1921, and it was there that the Diebenkorns encountered many of the great figures of earlier and modern history for the first time, experiences that profoundly shaped their visual educations. The comfortable environment, homelike furniture, and freedom to relax, smoke, and speak conversationally about the works they found satisfying or difficult, created an atmosphere that was never duplicated in their museum-going life.

The Studio, Quai Saint-Michel, 1916, by Henri Matisse was the single painting that Diebenkorn found most influential during his wartime visits to the Phillips. A nude model reclines on a bed at the far side of the workroom. The ceiling, floor, and right windowed wall converge abruptly on the subject. Open corrections can be recognized in the paint handling of the upper margin of the rear wall, in the placement and adjustments of the three pictures on that wall, and in the treatment of the panes of glass in the windows overlooking the Seine. The vertical elements—part of the window, curtains, shutters, inner and outer walls of the building—echo and parallel the right framing edge of the canvas, underlining the essentially

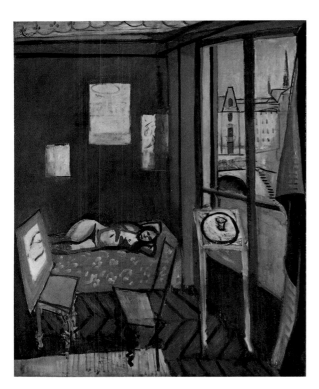

Henri Matisse, *The Studio, Quai Saint-Michel*, 1916.
Oil on canvas. 58¼ x 46 in. The Phillips Collection,
Washington, D.C.

abstract nature of pictorial composition. It became clear to Diebenkorn that Matisse was dealing with a real space—his own studio—but that he was also engaged in a controlled abstract exercise in pictorial invention and formal manipulation. Interior space, a model, and exterior space with river, bridge, and buildings were locked together into a brilliant unity that reverberated through Diebenkorn's art and thought for many years. The young man's vision could hardly have been better influenced than by this masterful document of figurative modernism.

Composed in a much more shallow, light-filled space, *The Open Window*, 1921, by Pierre Bonnard, was also an influential painting in the Phillips holdings. It is a powerful and mysterious canvas that coalesces in a single image; Diebenkorn was moved not by the color or light, but by how every element in the painting joined together perfectly to create a magnificent unity.

When time permitted, Diebenkorn planned visits beyond Washington to Philadelphia and once to New York City, to familiarize himself with the museums in these cities. The artist visited the A. E. Gallatin Collection at the Philadelphia Museum of Art at least twice, retained the catalogue, and recollected the experience. He responded readily to works by Cézanne and Matisse there, and to other artists with whose work he was familiar. Matisse's *Interior—Nice*, 1918, impressed Diebenkorn especially, as he associated it with the Phillips painting he admired, the later work as colorful and lightfilled as the earlier one is somber and controlled. He also responded to artists who were less familiar or unknown to him, including Schwitters, Arp, Klee, and the then little-known Spanish sculptor Julio González. His visit to the Museum of Modern Art, in New York, was equally stimulating in its rich fare of masterpieces. These visual art experiences were without parallel for the western artist, provoking a deepened understanding of both the chronological development of modern art and its internal processes. That knowledge emerged not as a revelation but as a gradual sorting out through accumulated exposure.

Diebenkorn came to understand some notable works of modern art by his own reading of them. He had encountered a number of great works, and many lesser ones, and had begun to sift through them for himself. He knew enough of the literature to realize that modern artists had chosen a path outside of accepted patterns of academies and traditions, building upon the ideas of their predecessors and a few contemporaries they came to recognize and admire. The pattern of commitment and struggle was taken in order to express values that had often been at odds with those of society. At that time, in 1944, modern art in the United States was more determinedly opposed by the weight of public opinion than impressionism had been in France in 1875. The painter might hope to establish himself in a coterie of young artists for mutual support, but the pursuit of goals obscure to the bulk of society, in a tradition that each artist defined for himself, was a pattern that Diebenkorn recognized and accepted as his own. He was committed to becoming an artist and to working with nonobjective imagery. Seeing more of modern art sensitized him to new experiences and inspired him to want to add his link to the chain. He thereby

created his own tradition, his own verifiable map of modernism, which included all of those meaningful antecedents and others he added as he went along, expanding his concept of art and his abilities at the same time. This climate of struggle and search, of willing renunciation of bourgeois values in the pursuit of a new art, regardless of cost, came to an end in the 1950s. Perhaps Diebenkorn's generation was the last to which this struggle can be honestly ascribed or by whom it can be fully understood.

Diebenkorn's map of modernism circa 1944 would not be identical with his map at the close of his life. The importance of Picasso was under-played in that early map; Cézanne and Matisse had enormous positions of authority; and the place for Baziotes and Motherwell could not then be calculated. He struggled to find how these complementary but vaguely antagonistic elements could be brought into a personal balance. He was drawn to abstraction as an unavoidable issue of his time, and he responded intuitively, with both certitude and excitement.

Orders were issued in Virginia in early 1945 for Diebenkorn to report to Camp Pendleton, California, where he would take his place in the Photographic Section until transferred to the Hawaiian Islands for final preparation of the combat assignment. Phyllis gave birth to the couple's first child, Gretchen, in Los Angeles, just a few days before Richard took ship for Hawaii. Diebenkorn was to serve in a three-member reconnais-sance unit—composed of a photographer, a writer, and a graphic artist—that were intended to gather information on the enemy ahead of invasion forces. The explosion of the atomic bombs on Japan in August 1945 made the units unnecessary, and Diebenkorn was returned to California and eventually discharged.

Back in the San Francisco Bay area, at his parent's home in Atherton, the artist and his wife and newborn daughter were reunited. Certain by now that he could best finish his art education at a professional school, rather than return to Stanford University, Diebenkorn decided to attend the California School of Fine Arts (CSFA). This was no surprise to his wife, but it was a blow to his parents, who had hoped that in the face of mature responsibilities as a husband and father he would choose a tradi-tional path, as they had urged. He enrolled at the school in January 1946 on the G. I. Bill. In the first week he met David Park, a faculty member in painting who was to become his most influential teacher and friend. During this period he also became friends with Douglas MacAgy, director of the school, Clay Spohn, a painter and draftsman, and John Grillo, a fellow student.

Park (1911–1960) was painting human heads in a flattened, Picasso-related fashion, when Diebenkorn began studying with him. "They were small paintings and divided by perhaps a profile, very simple profile and a mouth, an eye, and usually in ocher, heavily painted. Not broadly and not yet any abstract expressionist look but strongly set, surface-oriented— really quite beautiful paintings . . . and I guess he was interested in my work and that of one other painter. We were the only ones then doing abstract painting in his class."[18]

Diebenkorn and Park had a many-layered relationship. Diebenkorn

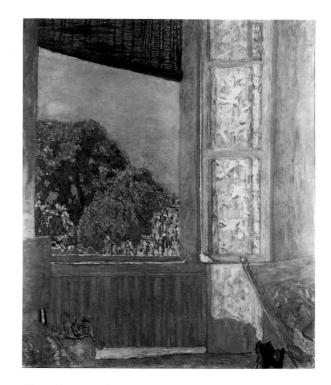

Pierre Bonnard, *The Open Window*, 1921. Oil on canvas. 46½ x 37¾ in. The Phillips Collection, Washington, D.C.

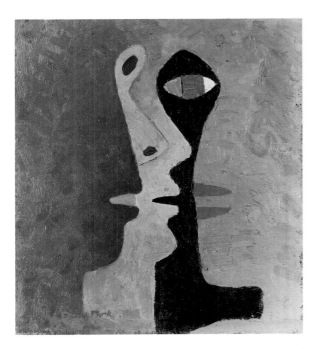

David Park, *Three Profiles*, c. 1944. Oil on canvas. 8¾ x 7⅜ in. University Art Museum, University of California, Berkeley, Lent by the Schorer Family

described him as, "a complex, educated man He knew music, played Bach on the piano, at Berkeley he knew Roger Sessions, Mark Shorer, Stephen Pepper from the UC faculty. He was paternal towards me . . . and while he was also a colleague, he sometimes reverted to the paternal role. It was a rewarding relationship. I felt the distance between his generation and my own." He continued, "Park encouraged heavy pigment as a proper use of oil paint. He was devoted to impasto and identified it with the morality of the artist. He didn't like thin paint, saying it 'reminded him of piss,' meaning it was trivial and showed a lack of commitment. He had an overdose of New England morality."[19]

Diebenkorn met Elmer Bischoff (1916–1991) in 1947. Bischoff had received his master's degree in painting from Berkeley before the war. After war service in Great Britain, Bischoff was hired by MacAgy at the California School of Fine Arts in the fall of 1946, but he and Diebenkorn did not meet until nearly a year later. They became fast friends, and with Park shared studio visits and drawing models. Bischoff recalled:

Park acted parentally [toward Diebenkorn]. When they met in each other's studios [every three weeks] to respond to the new work, Park was more severe and outspoken with Diebenkorn than with me. Park and Diebenkorn were quite different in their sensibilities, which created tension. Park painted thickly and Diebenkorn, leanly. Park had a strongly moral tone. Diebenkorn [was] a moral person also but seldom led into judgmental attitudes. Park had a prejudice against lean painting. Working hard gave Park a sense of wellbeing. Diebenkorn had a quick eye and a fluent sense of how to organize and pull together a composition. Park may have felt a self-indulgence in Diebenkorn.[20]

Diebenkorn later said, "Park tried to get me out of red-yellow-blue usage and simple dark-light relationships. He said there are other kinds of color. In a way red, yellow, and blue are abstractions, an intellectual way of seeing color, and therefore, like black-and-white. Color for Park involved other hue relationships, and of late, I have understood him. I love to do it, still—use the three primaries—yet it is a sort of subjective thing."[21] Diebenkorn's implication is that the whole palette need not be forced to explore color fully, while to Park's way of thinking, the secondary colors establish harmonies of interaction that are more surprising and sensuous. Park and Diebenkorn admitted to one another that they each had a light and color in their paintings that related to where they were raised—Boston versus San Francisco. When Diebenkorn asked directly, "What painter in your mind has the best color?" Park responded unequivocally: "Miró." Diebenkorn knew Miró's work from paintings in Philadelphia and New York, and he would later explore that artist's form for its whimsy and his color "for its weight and opacity and somberness."[22]

By mid-semester, Diebenkorn was recognized by many of the school leaders and faculty as being especially gifted. MacAgy (1913–1973), his wife Jermayne (1914–1964), who was the Assistant Director and Curator

Untitled, 1946. Oil on canvas. 25 ¾ x 19 in.
Mr. and Mrs. Richard Diebenkorn collection,
Santa Monica, California

at the California Palace of the Legion of Honor, and Adaline Kent (1900–1957), a leading sculptor and wife of sculptor Bob Howard (1896–1983) of the California School of Fine Arts faculty, were all enthusiastic about Diebenkorn's talents. Diebenkorn applied for and won the Albert Bender Award, a $1,500 grant, for 1946–47. The grant was intended to provide for a year's independent travel and work, and the Diebenkorns hoped to use it to live in New York City for most of the year.

 After a few days in New York, it became clear to Diebenkorn that Manhattan was jammed with young people like himself seeking affordable apartments, few of which were available. He expressed his frustration while attending an artist's party one evening. Someone asked him, "Why not go up to Woodstock? Numbers of artists leave there in the winter and there are lots of places to rent, if you don't mind being snowbound." Richard

Untitled (Magician's Table), 1947. Oil on canvas.
14 ½ x 15 in. Mr. and Mrs. Richard Diebenkorn
collection, Santa Monica, California

scouted Woodstock within the week and found an acceptable house with
room for a studio. He sent for Phyllis and Gretchen and they settled into a
new rhythm, snowbound much of the time, as had been promised.

The Woodstock stay was a very intense and concentrated period in the
artist's life. In Woodstock, and for the next decade, following abstract paint-
ing was a conviction. Representation was against that conviction. Looking
back from the 1980s he recalled it as a period of "teaching myself to paint."
Free from the guidance of Mendelowitz, Loran, and Park, he quietly
pursued his own vision, giving the whole rectangle presence, working out
problems of composition on thinly painted panels and small canvases,
developing relationships, always staying on guard against abstract or intel-
lectual color, sometimes overworking a canvas seeking a balance between
positive and negative. Even though Park was absent, his influence must be
acknowledged in some of the small canvases of headlike images, derived
from Picasso's double portraits. *Advancer*, 1946–47, from the Woodstock
period, has been related to radar receivers (technology that at the time was
viewed with apprehension and fear). Maurice Tuchman finds other refer-
ences in the Woodstock canvases to Picasso's *Guernica* with its spiky forms
and electric-light imagery. [23] As money was restricted, the artist worked
on small panels and canvases, painting leanly with inexpensive materials.
"I was stingy with paint in Woodstock; little money; careful."[24] At the same
time he was indulgent with time, often working from mid-morning until

ten o'clock at night. He was confirming in practice much of what he had learned in the last five years, consolidating his own discoveries and insights, making his own criticisms and drawing his own conclusions.

Diebenkorn was fortunate in meeting a number of interesting artists during his Woodstock sojourn, including Raoul Hague (1905–1993), a wood sculptor of distinction, Melville Price (1920–1970), a New York artist in experimental media, and Judson Smith (1880–1962). Smith was an experienced elder painter with broad exhibition credits, who permitted Diebenkorn the run of his substantial art library. At the suggestion of Smith, Diebenkorn made contact with Bradley Walker Tomlin (1899–1953), a summer resident of Woodstock who lived in New York City and who was at this juncture finding his way out of cubism into a personal conception of abstract expressionism.

The Diebenkorns made several trips into New York City during the Woodstock stay, for the purpose of seeing the works of Baziotes and Motherwell and visiting leading galleries and museums. The artist was well received by Samuel Kootz (1898–1982), the dealer who showed him works by William Baziotes (1912–1963) and Robert Motherwell (1915–1991) from storage and introduced him personally to Baziotes. Diebenkorn was invited to dinner at the Baziotes home, where he saw new works. However, they seemed less concentrated and full of meaning for him than had been the earlier cubist-derived works he knew from *Dyn* magazine.

After nine months in Woodstock, with the Bender grant depleted, the Diebenkorns drove back to San Francisco. Prior to the New York experience, Richard had been offered a contract to teach at the California School of Fine Arts for the 1947–48 school year. Upon his return, he found that the atmosphere of the school had changed considerably. "I had been perhaps one of the very first G. I. Bill people at the school . . . you could count them on one hand when I first registered . . . but by the time I got back . . . it was predominantly G. I. Bill. And [there was] really quite a marvelous activity."[25] Clyfford Still had been recruited to the faculty by Douglas MacAgy, as well, and a new spirit of exploration was evident. The new students were older, a bit rebellious, questioning of authority, but quite serious and open to new ideas. The emphasis had turned from still life and figure painting to abstract art, and the school was on its way to becoming viewed as a hotbed of modernist activity.

John Grillo (born 1917), who had been a fellow student with Diebenkorn in the spring of 1946, was working on large-scale canvases in a bold abstract manner. Diebenkorn was somewhat restrained in showing Grillo the product of his Woodstock interlude—about twenty paintings. The modest size of his panels and canvases and the careful, rather precise building-up of composition seemed almost academic beside the very spontaneous and extravagantly painted big-brush, house-paint work he saw in the studios and galleries of the school. Diebenkorn sensed that Grillo was disappointed in the work, and he felt like a hermit returning to the world where things were happening. "It was very exciting, but at the same time, it made me very uncomfortable."[26]

Clyfford Still (1904–1980) had become the principal instructor in the

Clyfford Still, *Untitled*, 1946–48. Oil on canvas.
61 ¾ x 44 ½ in. The Metropolitan Museum of Art,
New York, Arthur Hoppock Hearn and George A.
Hearn Funds, 1977

painting department. He had already exerted an obvious influence on the school's atmosphere, and at that very moment, in the late spring of 1947, the California Palace of the Legion of Honor was presenting a one-man show of his work—thirteen canvases, which seemed enormous by the conventions of the time. These works were heavily painted in dark, earthen colors, "with lots of black." There were dull, heavy surfaces, great dark grounds, greasy patches. It was a brutal new view of painting, one that was not easily accessible and that seemed to be unrelated to Picasso, cubism, surrealism, Mondrian, or any of the cubo-constructivist developments. At the same time, the work seemed to discredit the scale, the color, and the lightness of French painting as exemplified by Matisse and Bonnard. It spoke of unequivocating commitment to originality. Diebenkorn said, "I stayed quite awhile. It began to come together. I went back in a few days and then it all came together for me at that second viewing."[27]

The Diebenkorns set up a house and attic studio in Sausalito that summer. Their second child, Christopher, was born in August 1947.

As a junior faculty member at the California School of Fine Arts, Diebenkorn had few opportunities to see or interact with Clyfford Still. They did exchange a few polite words, but their paths did not often cross. Diebenkorn was teaching his first classes, on the basis of the way he had been taught by Mendelowitz, Arnautoff, Loran, and Park. He realized that Still was doing something fresh and he was curious about it. He learned from Still's students a little of the way he conducted his classes—seldom speaking specifically about painting, tending to make broad pronouncements and emphasizing an artist's professional attitudes and responsibilities. He did not want his students to emulate his painting but to adhere to his morality of independence and professionalism. "This was essentially what he presented, and he just inspired his students and steamed them up ... [he] was responsible for the excitement at the school."[28]

Diebenkorn's teaching schedule included Life Drawing, Drawing and Composition, and Introduction to Painting. As a new faculty member, he did not attract the most obviously gifted students. Edward Corbett (1919–1971) was another new faculty member that year, and the two artists discussed the curriculum and the students together. When a student of superior gifts would emerge in his classes, as Ernest Briggs (1923–1984) did, he would tend to move on at the end of the year to study with Still. Still's friend Mark Rothko (1903–1970) was invited to teach a summer session at the school in 1947 and 1948. Diebenkorn had much admired the Rothko painting *Slow Swirl by the Edge of the Sea*, 1944, at the San Francisco Museum of Art, and he had a few encouraging talks with Rothko during one summer session.

The "School" was the place where the new art (only later termed abstract expressionism) was currency. A pre-flowering took place wherein the total gamut of abstract-expressionist possibility was run through by roughly twenty artists and students, mostly ex-GIs, as though in dress rehearsal for the New York mid-50s. It is doubtful that anyone who was closely involved with that scene was ever surprised by later abstract-expressionist developments in New York or elsewhere. This is not to say

that there was *in depth* development by these painters and the earlier, germinal formulations by a few New York–based artists should not be confused with ensuing "scenes" occurring early at the CSFA or somewhat later in New York. Needless to say it was a good place for a young painter to spend several formative years.[29]

The San Francisco Museum of Art had held solo exhibitions for both Still and Rothko and regularly exhibited works retained from the exhibitions—Still's *Self Portrait*, 1945, and Rothko's *Slow Swirl*. Diebenkorn said on more than one occasion that, "It was always worthwhile visiting the SFMA, if only to see the Rothko canvas."[30] There were only two additional advanced contemporary American paintings to be seen at the museum at the time—Arshile Gorky's bow to Picasso, *Enigmatic Combat*, 1936–37, and Jackson Pollock's *Guardians of the Secret*, 1943. While this is a splendid nucleus for the study of the emerging American abstract painting, none of them save the Rothko is a fully mature work. The Gorky demonstrates his absorption of the Picasso still-life method and his ability to make a workmanlike painting following his master. The Pollock documents an important stage in the artist's evolution toward the overall abstract paintings. The ominous guardians, the watchdog, and the layered space would soon be purged in favor of a unitary edge-to-edge composition, only hinted at in the central panel of this canvas. The Still canvas marks a stage in the artist's development toward the works shown in the 1947 Legion show. It is important to recognize that the experience of contemporary painting was so restricted at this time that only close attention to the magazines could give one a sense, if only partial, of the vital activity taking place in other art centers.

Diebenkorn traveled from his Sausalito house and studio to the school each day, met his classes, occasionally saw an art exhibition, and returned to his studio to paint. He was continuing his abstract evolution, verging close to geometry, on larger canvases, with a suggestion of architectural space. He met with David Park and Elmer Bischoff once a week in one studio or another to talk about the work and to share experiences. Hassel Smith (born 1915), who had been away on a Rosenberg Grant in 1945–46, had returned to the faculty, and joined the three artists in these weekly sessions. Diebenkorn also established a sympathetic relationship with two of the most talented student painters—John Hultberg (born 1922) and Frank Lobdell (born 1921)—who were referred to as the "Sausalito Group," which also included James Budd Dixon (1900–67), Walter Kuhlman (born 1918), and George Stillman (born 1921).

Teaching required an expenditure of energy very like that required for painting itself. It also demanded that the artist search for words and verbalize some of the experiences he had previously allowed to be wordless feelings relative to his work and the process of improvisation he had developed. He had too much respect for the creative process to tell his students what they ought or had to do, and he recognized that they were the arbiters of their own unique vision. He sometimes found himself overcome with reservations about how to assist a student in moving forward, which may have given some the impression that he did not know what he

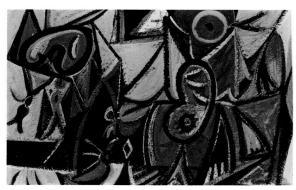

Mark Rothko, *Slow Swirl by the Edge of the Sea*, 1944. Oil on canvas. 75 ⅜ x 84 ¾ in. Collection, The Museum of Modern Art, New York, Bequest of Mrs. Mark Rothko through The Mark Rothko Foundation, Inc.

Arshile Gorky, *Enigmatic Combat*, 1936–37. Oil on canvas. 35 ¾ x 48 in. San Francisco Museum of Modern Art, San Francisco, Gift of Jeanne Reynal

Jackson Pollock, *Guardians of the Secret*, 1943. Oil on canvas. 48 ⅜ x 75 ⅜ in. San Francisco Museum of Modern Art, San Francisco, Albert M. Bender Collection, Albert M. Bender Bequest Fund Purchase

felt. Lobdell recalls Diebenkorn's teaching differently, saying, "Diebenkorn was very good at talking about art. He read a lot and was careful with words. He was introspective, retiring, but curious-minded."[31]

The Woodstock-period paintings slowly evolved into carefully composed canvases vaguely suggestive of romantic cityscapes. Softened rectangular forms were arranged in organic relationships with loose overall geometric relationships. The artist carefully avoided a centered form floating in a field, establishing a relationship with each of the canvas edges, anchoring the entire picture space in one plane, and controlling the whole surface of the thinly painted canvas. Every element of line or color was conceived in support of the work's holistic image. These works of the last quarter of 1947 were the ones that impelled Jermayne MacAgy to invite Diebenkorn to show the following year at the California Palace of the Legion of Honor.

Judged by current standards, the Legion show was composed of fourteen rather small paintings, though they were more that twice the size of the works from the Woodstock period. The paintings have a structural base that rests in cubism and a division of the picture surface that takes the form of a softened abstract geometry. Blocks of color, anchored in the framing edges, establish an overall composition of flatness with occasional passages suggesting shallow depth. Vertical and horizontal planes are clearly developed. The artist said of the work, "I thought I was being non-objective—absolutely non-figurative—and I would spoil so many canvases, because I found a representational fragment. . . . It was impossible to imagine doing a picture without it being a landscape, to try to make a painting space, a pure painting space, but always end up with a figure against a ground."[32] Despite the rectilinear underpinnings of the work, Diebenkorn consciously eschewed hard-edged formalism, feeling with Park that it equated with

Legion Show, 1948. Oil on canvas. 40 x 29 in. Mr. and Mrs. Richard Diebenkorn collection, Santa Monica, California

Legion Show, 1948. Oil on canvas. 45 x 31 in. Mr. and Mrs. Richard Diebenkorn collection, Santa Monica, California

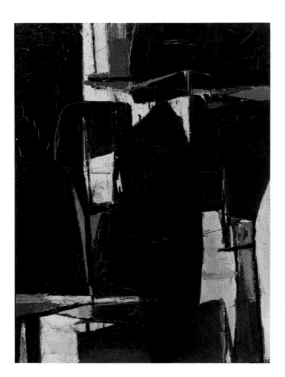
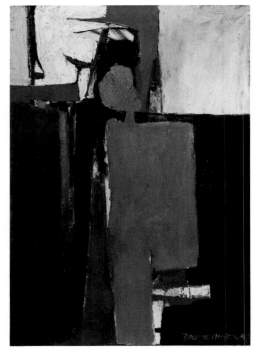

sterility and with Bischoff that it was a mark of "intellectual" painting. Diebenkorn worked consciously for a nonreferential balance in which positive and negative would find an equivalence. The balance he searched for was for the "ground" to change place with the "figure" and for the two-dimensional unity to be retained while offering multiple readings.

Diebenkorn spoke in interviews on a number of occasions about the impact he felt from a set of postcards received in childhood of the Bayeux Tapestry. This triple-banded composition, arranged like a strip cartoon, is flanked by upper and lower margins embroidered with illustrations of historic events relating to the Norman Conquest. Its story line and specifics resonate with the youth's interest in the illustrators Pyle and Wyeth. In later years Diebenkorn felt an immediate correspondence with the tapestry upon encountering Mark Rothko's *Slow Swirl by the Edge of the Sea*. The work has a fluidity, calling up the beginnings of life beneath the sea, and features arabesques, infinity symbols, suggestions of musical bars, clef signs, violin scrolls, and calligraphic flourishes associated with musical notation. There is a flat no-stage upon which the calligraphic characters seem to dance. This flatness and the dispersal of invented incidents must have inspired Diebenkorn with the idea of the capacity of abstract imagery to convey human feelings in as real and moving a manner as figurative imagery could.

Even many years later, Diebenkorn stated that he continued to recognize something of himself in Rothko's paintings. "They are familiar, almost as my own works."[33] Rothko was an influence on Diebenkorn's formative years, and Rothko and Adolph Gottlieb's letter to the *New York Times* expressed two principles that are also Diebenkorn's:

(1) To us art is an adventure into an unknown world, which can be explored only by those willing to take risks. . . . (4) We favor the simple expression of the complex thought. We are for the large shape because it has the impact of the unequivocal. We wish to reassert the picture plane. We are for the flat forms because they destroy illusion and reveal truth.[34]

But, Diebenkorn was more profoundly influenced by what he saw than by even the best-stated principles of art theory. He found a painterly space in Rothko's work that was useful to him: a pure painterly space that was flat, allusive, flexible, capable of endless development. He was moved by the work and he "understood" it, without any need for explanations. He found in Rothko visible validation of Matisse's dictum that art exists not to represent the world but to create a parallel world—"a condensation of sensations."

After the Legion exhibition Diebenkorn's painting seemed to ripen and mature quickly. It may well have been that seeing the work together, displayed in a large room for the first time, helped to clarify where he wanted to go and what he wanted to abandon. Irregular forms and calligraphic interlacings composed in dynamic emotive relationships, suggestive of automatism, appear in *Untitled No. 22*, 1948 (p. 28). The colors seemed less harmonic and more wildly dissonant and innovative at the

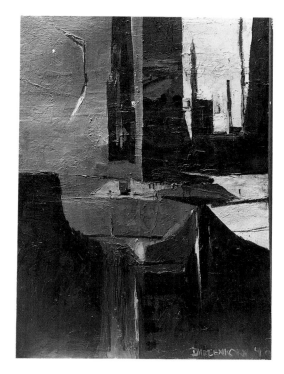

Untitled, 1948. Oil on canvas. Dimensions unknown. Private collection

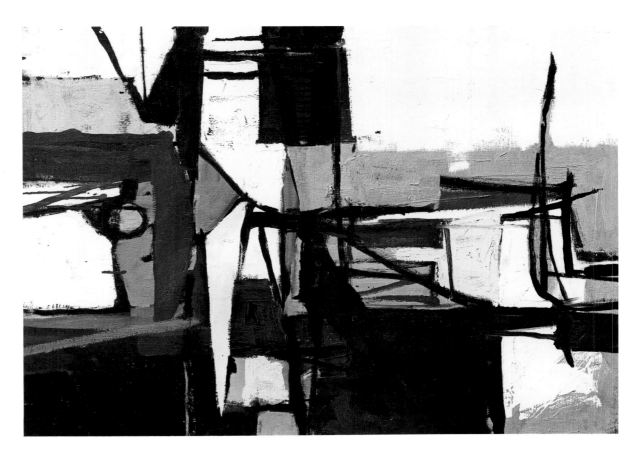

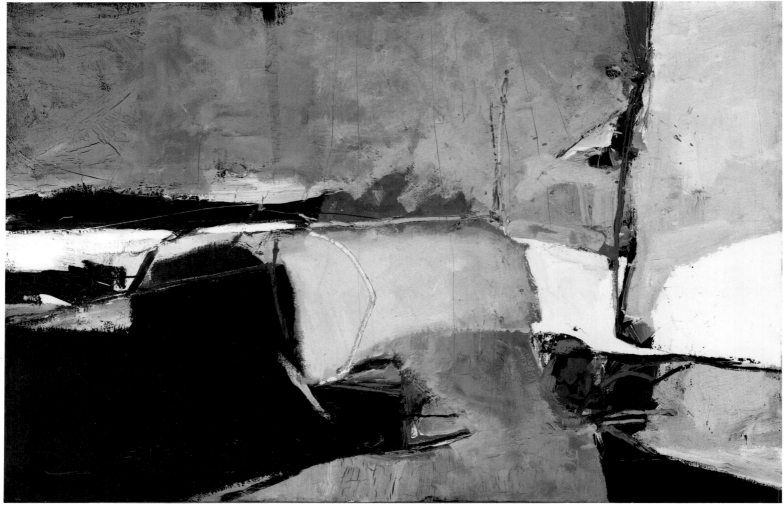

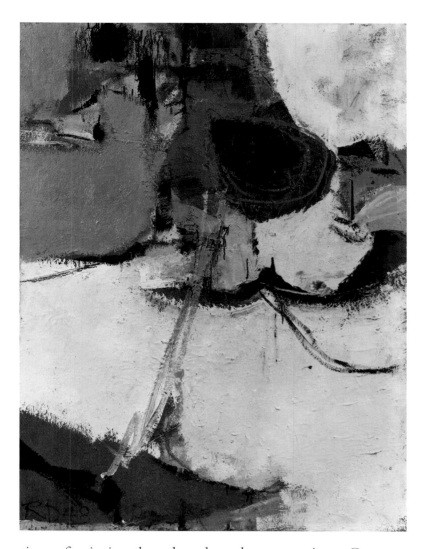

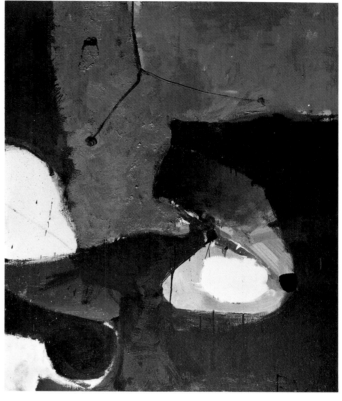

time of painting than they do today, suggesting a German expressionist resonance rather than a more familiar French one. "The problem was to give the whole rectangle presence," the artist said. "There were some fairly good pictures in the Legion show. I hadn't gotten everything together yet, but by 1949 things did start to come together."[35] Works such as *Painting II*, 1949 (p. 31), show a Clyfford Still influence in the heavy pigment, troweled on with few modulations, but mark the artist's surpassing need to maintain his own intuitions. The integration of incidents in each margin and the ragged knife handling coalesce with the tense surface to convey a strong sense of the style that would become known as abstract expressionism. *Untitled*, 1949 (p. 32), achieves the same success with a lighter use of pigment, which is characteristic of the artist's technique. It also backs away from the ragged Still-like effects while retaining the linear elements that had been growing in Diebenkorn's work since Woodstock. Perhaps *Untitled*, 1949 (p. 33), is the most masterful example of Diebenkorn's painting to that date. This canvas, like most of those of the 1949 period, has little sense of atmosphere, only a very shallow space, and the medium is not exploited for textural effects. A clear control and utilization of the full field is evident, and color is not expressed so much in dark and light as it is in a key of red-orange-brown. Drawing is held to a minimum and seems to be vestigial—left over from the growth of the color forms. While heavier in

Opposite:
No. 3, 1948. Oil on canvas. 27 x 38 in. San Francisco Museum of Modern Art, San Francisco, Gift of Charles Ross

Untitled No. 22, 1948. Oil on canvas. 30 x 45 in. Norton Simon Museum of Art, Pasadena, California, Gift of Mr. and Mrs. Paul Kantor, 1965

This page:
Sausalito, 1948. Oil on canvas. 51 x 37¼ in. Private collection

Sausalito, 1949. Oil on canvas. Dimensions unknown. Private collection

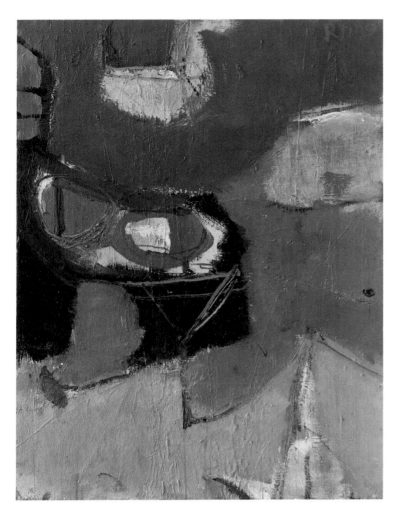

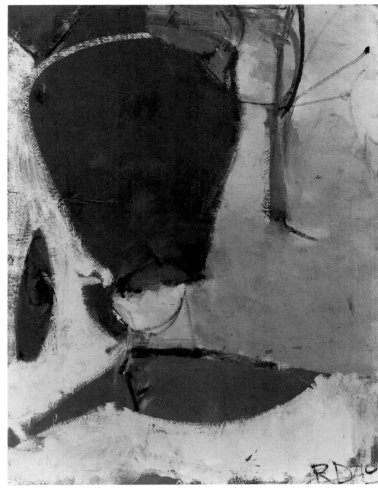

Sausalito, 1949. Oil on canvas. 45 x 33 ½ in.
Mr. and Mrs. Richard Diebenkorn collection,
Santa Monica, California

Sausalito, 1949. Oil on canvas. 45 ½ x 34 ¼ in.
Mr. and Mrs. Richard McDonough collection,
Berkeley, California

Opposite:
Painting II, 1949. Oil on canvas. 47 x 35 ½ in.
Collection of the Oakland Museum, Oakland,
California, Gift of the Estate of Howard E. Johnson

paint substance than works by Rothko of the same period, this is a work that is closer to that artist's work than it is to Still's facture. There is a suggestion of the banded structure but also an impressive new unity of field. Every color-form and linear embellishment combines to evoke serenity. The entire arrangement—its color, proportion, and spaces—expresses resolution and harmony in a fashion fresh to 1949.

The earliest record of Diebenkorn's painting process was described by his friend, the playwright James Schevill:

His concept of a painter is one who doesn't know when to stop and who wears himself out painting. This approach is obvious in the scope of his work which reflects the nervous, dynamic energy of our time. The dribbles of paint that are often evident on his canvases are accidental and are not there deliberately as they might be in a painting of Jackson Pollock. Diebenkorn's methods of painting prohibit this kind of technique. In one moment he is working feverishly, up and down, side to side and the whole painting changes rapidly. As a result it is impossible for him to revise around an area of a painting that has pleased him. One form he sees only in relationship to another form and these relationships to him are in constant flux. The result is a singular quality of movement, of action in his work, and the dribbling, the scraping of some of his lines, merely underscore

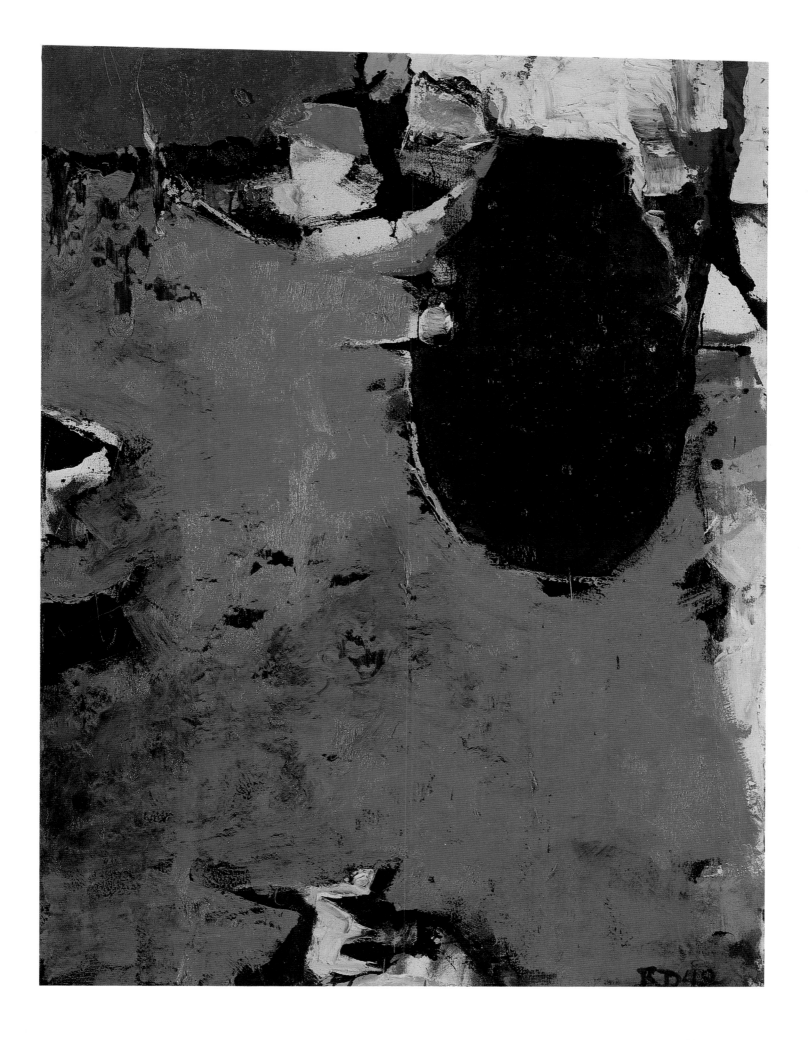

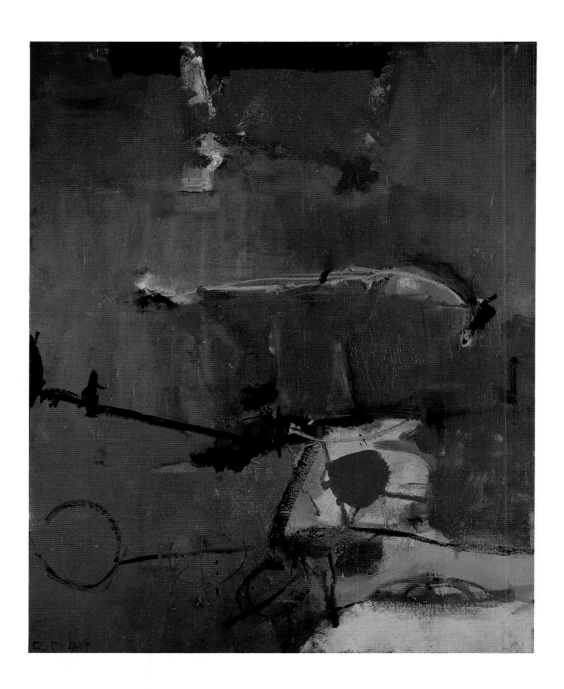

the individuality of his vision. It is this sharp, crude, dramatic division of space that has given many viewers an impression of the loneliness, the jagged opposition and distances, of western landscapes.[36]

By the beginning of 1948 Still was hearing approving reports of Diebenkorn's painting from their associates at the California School of Fine Arts. The younger artist was invited to the Still studio at the base of the school's tower. Only three canvases were set out, solemnly disposed on separate walls, and they seemed closely related to the works Diebenkorn had seen in the Legion show, less than a year before. Diebenkorn took a long look, speaking little. These were large canvases, boldly composed, heavily pigmented in an emotional and even defiant manner. Here was self-consciously independent, anti-European work, full of energy and responsive only to Still's demon. It had dramatic, even Wagnerian overtones—

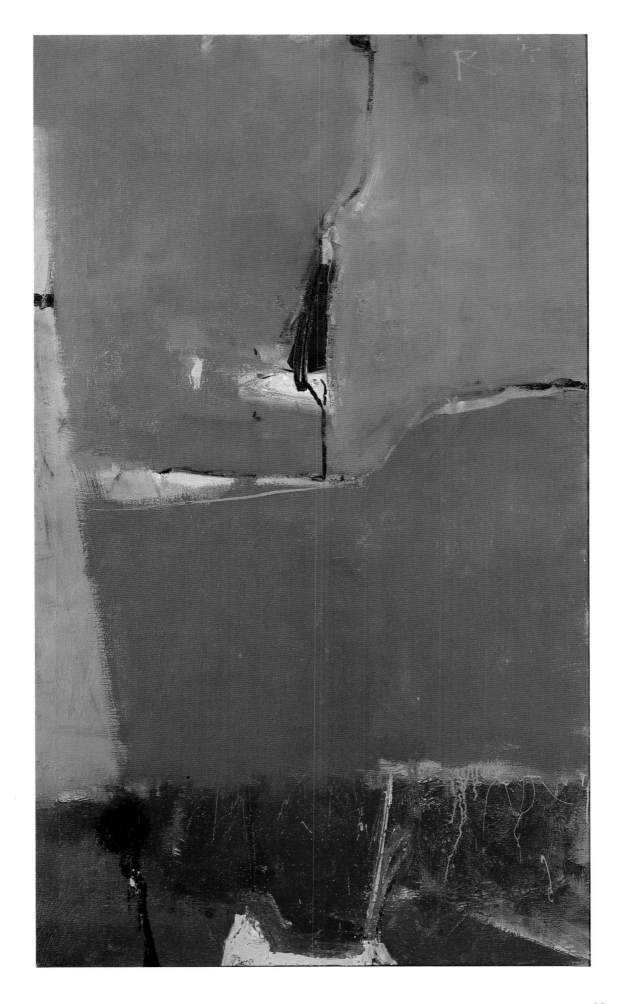

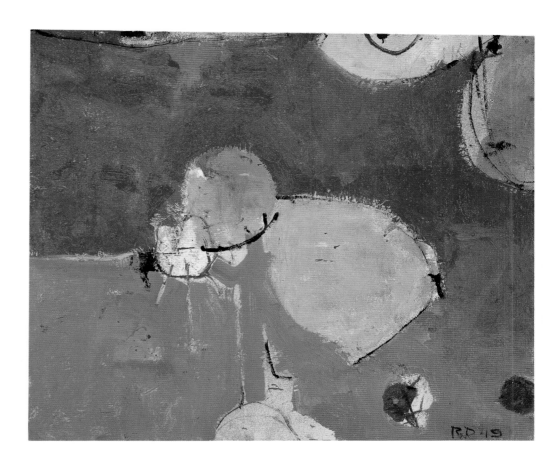

a sweeping power. One yellow canvas was particularly memorable for its proclamation of the possibilities of color after all the darkness of primal matter. Diebenkorn thanked Still for giving him the opportunity to see the new work. Still responded by saying that he wanted to visit Diebenkorn's studio in the coming week, and the date was established.

Still arrived in the late morning and was expected to stay for lunch following the studio visit. Diebenkorn showed him a number of works from the past year, some complete, others in progress. As Still moved downstairs following the studio session, he caught sight of the painting that later won the Emanuel Walters Purchase Prize at the San Francisco Art Association Annual, saying, "that is quite a good work." Diebenkorn made a deprecating remark to the effect that "perhaps the color doesn't quite work." Still "froze" and very shortly excused himself to return to the city, without taking lunch. That comment may have been perceived as a professionally unacceptable way of thinking about color or as a disrespect to Still in Diebenkorn's casual willingness to discount an outright appraisal of the painting's success. Still and Diebenkorn saw each other irregularly as circumstances brought them together, but they never visited each others' studios again.

The weekly sessions with Park, Bischoff, and Smith were meaningful to Diebenkorn in that he appreciated the exchange of criticism with older and more experienced painters, as he did their camaraderie in the vocation of painting. He admired Hassel Smith's painting and the amusing drawing that often animated it. Bischoff found humor in the work of both artists, saying, "One can see a kinship in their drawing. They had a different perception of color. Diebenkorn was keen about Krazy Kat cartoons,

cultivating a deliberate awkwardness. Neither man was ever clumsy."[37]

The drawing that Bischoff found amusing and Diebenkorn found engaging was a making of marks that didn't look like "drawing." It was untrained-looking, improvisational, a kind of inspired scribbling. Sometimes it was lost in the painting process, and most of what can be seen of Smith's controversial drawing is developed in the late stages of the painting—curlicues, writings, intersecting marks, meanderings. Sometimes a bit of drawing emerges from a painted area as a visual non sequitur. There is a vulgarity of subject matter, as though it might have been drawn from graffiti or from cartoons, and often a sense of humor about the work that is surprising for a period in which artists took their work very seriously.

Diebenkorn believed that "Hassel's drawing had grown out of Maurice Sterne's teaching at the CSFA, an exuberant system of lines in opposition."[38] He saw that spontaneous drawing as cubist derived but expressively independent and involving a vitality that was entirely original. "We became friends, and in fact we painted a big canvas together in Hassel's studio. He would be there one afternoon when I was teaching, and we had different schedules. Later, I'd come into the studio and work on the painting."[39] "I thought he made very powerful pictures. . . . I felt really influenced."[40] Smith acknowledged the relationship warmly: "Dick & I were at that time in different parts of the forest though very interested in each others work & respectful of it. In regard to the painting that we worked on together . . . this enterprise was aborted . . . we persistently obliterated one another's work."[41]

Other influences during this period of time included the criticism of Clement Greenberg in *The Nation*, which Diebenkorn found to be "just like artists talking," and the artist sought out copies of the publication on occasion, to get a sense of what was happening in New York. He also came upon issues of *Partisan Review* from time to time, often months or even years after their publication, and was very much impressed by four paintings reproduced in black and white by Willem de Kooning (1904–1997) in the April 1948 number. These paintings made immediate sense to Diebenkorn, and he absorbed how they were made, revised, and given their autographic form. It would be years before he would see one of the works in life, but he was convinced of their authenticity on first viewing.

In 1949 the San Francisco Museum of Art invited Elmer Bischoff, David Park, and Hassel Smith to hold a three-man show of their new abstract expressionist paintings. Even as this endeavor was being developed, Diebenkorn and Smith were invited to hold a two-man show of painting and sculpture at the Lucien Labaudt Gallery, scheduled for 1950. The artists were pleased by the invitation and felt a visual relationship between their work that justified the pairing. Both were involved with the spontaneous and the unpredictable in drawing, and both courted a deliberate awkwardness that avoided stiffness or heaviness while adding an element of shock and excitement. The *San Francisco Chronicle* reviewed the show:

Vast pretentious canvases, reliance upon runs and dripping . . .
fabulous richness and energy . . . took one into a new domain of

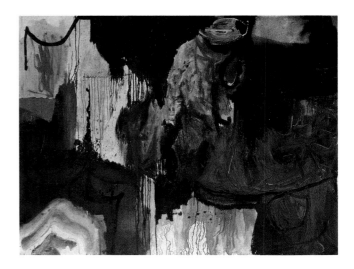

Hassel Smith, *Untitled*, 1949. Oil on canvas.
56 x 71 in. Private collection

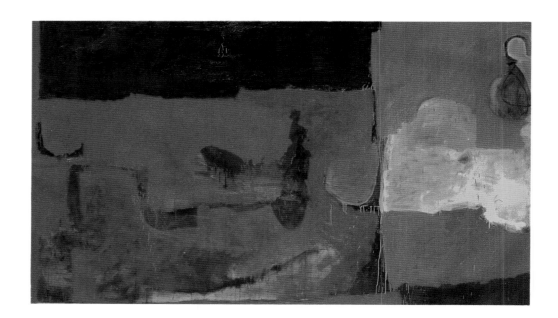

visual expression that could be entered by no other road—
important and profound.[42]

Feeling the need for a change of ambience, Diebenkorn decided to
resign his teaching position at the California School of Fine Arts and
to leave the state to study for a master's degree at the University of New
Mexico in Albuquerque. As he later reflected:

> I could kind of see the handwriting on the wall. I was the bottom man
> on the totem pole of the school. Still was at the top. But at any rate,
> I had all the G. I. Bill that I hadn't touched. I was struggling to make
> ends meet and to buy paint. My students could go to the school
> store and come back loaded with these bags of art materials plus a
> monthly check.... I decided I was going to be on the the G. I. Bill.[43]

> I think [it was] complicated why I left.... I could sort of sense that it
> wasn't going to be long for us there. Also ... there was a kind of line
> to be toed, and this bugged me a little bit. I wanted to get away and
> look at myself and do my own assimilation, and so that was another
> reason for going....[44]

There was also the issue of independence, self-determination, and a
need to get away from the San Francisco community and from the influences
of David Park and Hassel Smith. He looked forward to the freedom to
work independently and without interruptions, as he had in Woodstock.

Diebenkorn had driven through New Mexico at least once and had
also traveled through by train. He liked the look of the state and thought
that one day he would like to spend some time there. He applied for
his undergraduate degree, which he had never officially received, from
Stanford based on his three years completed (1940–43), the semester at
Berkeley, the semester at the California School of Fine Arts, his military

service, and his subsequent teaching record at the California School of Fine Arts. The degree was granted in 1949, and Diebenkorn was ready for New Mexico. He could have chosen another school, but New Mexico was recognized for its professional curriculum, its studio thesis project, and its attractive surrounding landscape.

He enrolled at the school in January of 1950 (prior to the Labaudt show, which he never saw). His reputation as a young faculty member from a professional art school made him seem a potential problem to the department. He established himself in a painting studio and seemed to occupy more space than was expected, possibly being perceived as mildly disruptive. Rather quickly, through the good offices of his thesis committee chairman, he was allocated a studio space in a nearby quonset hut, where he could work independently for as long as he liked. At that time he was the only graduate student to have a separate studio made available. As a result he was seldom in the Art Department and "the instructors would come to the quonset hut, once or twice in a semester. They *really* left me alone."[45]

Diebenkorn developed a good relationship with Raymond Jonson (1891–1982), a faculty member and later the head of Richard's thesis committee. Jonson was thirty years his senior and a recognized American abstract painter. "I visited his home and studio fairly often and we would discuss different approaches to abstract painting. He was the only one who was eager to know and talk about new directions."[46] Enrique Montenegro (born 1917), a young teaching assistant in the department when Diebenkorn arrived, had studied at the Art Students League with Kuniyoshi and Reginald Marsh. Only five years older than Richard, he felt more like a colleague of Diebenkorn's than an instructor, and described him as "humbly a student but with a strong background and a great deal of excitement for painting."[47]

Edward Corbett, an old friend, visited the Diebenkorns early in the first year in Albuquerque. A managerial revolution had taken place at the California School of Fine Arts, MacAgy and Still had left, and a number of faculty members, including Corbett, had been dismissed. Corbett stayed for about three weeks and shared his gossip about the school and old friends, chief among which was the word that David Park had turned to painting in a figurative manner. Corbett became a Southwesterner overnight, moving to Taos, where he entered into one of his best periods, working in chalk, charcoal, and pastels on paper. He had been influenced by Mondrian in the early postwar years and had moved into an organic abstract painting in San Francisco, utilizing house paints and enamel and developing an imagery of cobwebby tracery, often in monochrome. In Taos he made chalk and pastel paintings, drawing on the mood and atmosphere of the Southwest, rubbing, correcting, responding to the linear patterns he developed. The sensuous material and subtle color forms emerged as seductive landscape or cloudscape metaphors which Diebenkorn admired.

The Diebenkorns lived in the house of the caretaker of a ranch for the first year and a half. Pigs and other farm animals found their way into

the artist's drawing and painting, often in the form of caricature. He had always been delighted by Krazy Kat comics, and he came upon a book compilation of George Herriman's work from this time, which he found stimulating in its artful drawing and faux-naive effects. All of these proclivities—the witty shapes of Miró, the surprising contrasts of Klee, the linear slapstick of Hassel Smith—were related to his painting. These tendencies were explored in drawings and monoprints, and some were integrated into his works in oil, *Disintegrating Pig*, 1950 (p. 39), among others.

During the early months in Albuquerque, Diebenkorn began to experiment with sculpture, making at least two pieces in welded found-metal scrap while working in a friend's sculpture studio. One of the works suggests a body with long tendril-like "feelers." Mark Lavatelli described it: "The whole variously suggests such creatures as a praying mantis, a walkingstick, a coatimundi, or an anteater . . . linking the piece to the several "beasts" that can be detected in some of the paintings of the time."[48] The insect simile seems to break down on close examination, as one cannot discern a front or back or coordinated symmetry. It is a three-dimensional linear exercise, grown out of the openwork sculpture of such contemporaries as David Smith, Ibram Lassaw, and David Hare.

Coexistent with the linear works of humorous or beastlike origin are the nonobjective paintings, which have been tied to landscape. These are clearly abstract works, juxtaposing large areas of color space with congested linear concentrations, color patches, and overpainted sections. The New Mexico landscape was a part of Diebenkorn's daily life, and it filtered its way into his painting almost as soon as he began to work in Albuquerque. "The flat line of the western mesa of Albuquerque . . . influenced my work. Temperamentally, perhaps, I had always been a landscape painter, but I was fighting the landscape. . . . In Albuquerque I relaxed and began to think of natural forms in relation to my own feelings."[49]

In the first works of the early months of 1950, more-or-less rectangular color patches, curvilinear drawing, and ambiguous color grounds suggestive of atmosphere can be traced. The only real vertical or horizontal lines are read from the edges of the stretched canvas. Even when paint densities are heavy, there is a lightness both of key and of openness that identifies the Albuquerque period. By the following year, in *Untitled,* 1951 (p. 40), one can read a vertical canvas in a golden yellow that saturates seven-eighths of the surface, with a few invasions from each of the four framing edges. The irregular charcoal patch at the upper right is tied into the paint fabric with linear markings that suggest sewing or collage. Green, orange, and gray passages connect to the upper margin, while red, blue, and light yellow elements are tied to the left edge. A spontaneous and calligraphic complex of lines rise from the lower right corner, linked to the right and lower margins. There is a vivacious quality to a thumblike form at the lower right, which is amusing and related to Matisse's drawings in which his own hand appears at his sketchpad in the lower righthand corner of a still-life or figure drawing. In other canvases one finds a similar scattering of incidents around the edges with a rhythm of formal repetition in the center, as in *Miller 22,* 1951 (p. 44), in which nonarabesque forms take the

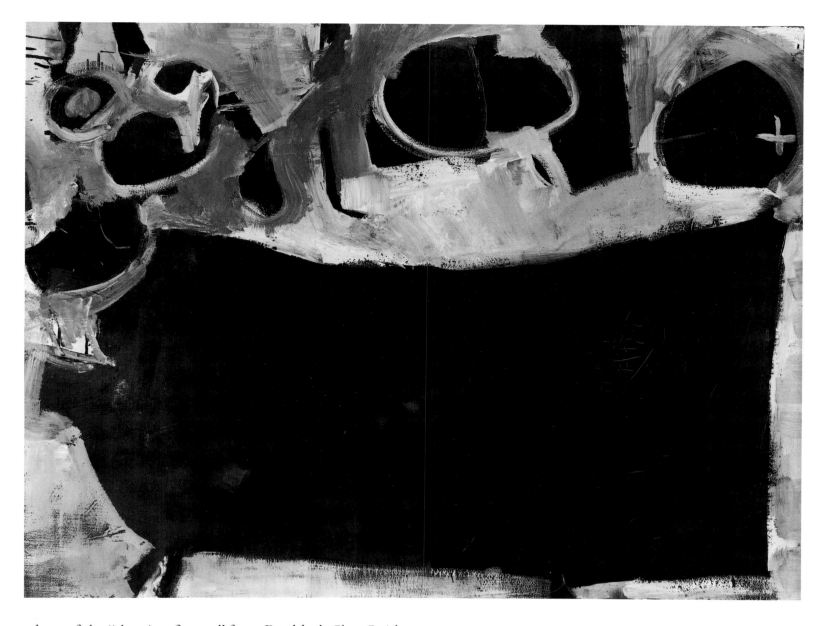

place of the "dancing figures" from Rothko's *Slow Swirl*.

Within eighteen months of his arrival in Albuquerque, Diebenkorn
mounted his Master's Degree Exhibition in the foyer of the university's
old art building. The exhibition had a very personal look. A few paintings
seemed reminiscent of Sausalito and San Francisco works—darker, overtly
layered, with minimal drawing. *Disintegrating Pig* and two metal sculptures
were among the works shown, but the bulk of the grouping was divided
between the linear improvisations and the more atmospheric landscape-
inspired paintings. These arbitrary classifications tended to merge and
interpenetrate. Light was a primary element in all the work, and sand
and flesh colors, yellows and light grays recurred often. A looping drawing,
with a rhythmic crudeness in the line, appeared regularly. Deposits of color
often revealed underpaint, reflecting revisions and new shapes created out
of those revisions. Little conventional "fine handling" and few seductive
surfaces occur in these works; they have the toughness of the New Mexico
desert. With these paintings the artist's directness becomes a positive element

Albuquerque, 1951, from Master's Degree
Exhibition. Oil on canvas. 38 ½ x 56 ¼ in.
Paul Kantor collection, Beverly Hills, California

Untitled, 1951, from Master's Degree Exhibition.
Oil on canvas. 55 x 35 in. University Art Museum,
University of New Mexico, Albuquerque

of style rather than a simple indifference to studio practices, and they dramatize his freshness, excitement, and passion. The works are drumhead flat, strongly evocative of desert landscape, activated by linear tracery that relates to the Hassel Smith exchange and to the influences of reproductions of works by Gorky and de Kooning. There is a sparseness to the work, with large open spaces, dry surfaces, and painted-out incidents that still retain a presence. These canvases were occasionally worked on from different orientations, and evidence of that process can be seen in the final imagery.

Diebenkorn was pleased with his showing; it had reflected his most productive period to date. With no immediate prospects for employment and with continued G. I. Bill assistance, he petitioned the department to extend his enrollment as a special student. After a visit to California, the family found new living quarters and he was assigned a second campus studio. It was during this time that the artist encountered two new influences that he integrated into his Albuquerque work and would resurface in his later painting.

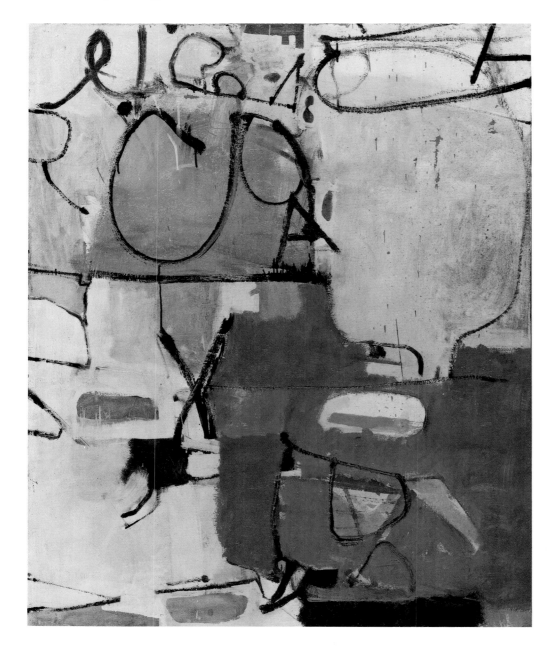

Albuquerque, 1951. Oil on canvas. 55 ⅝ x 45 in.
Private collection

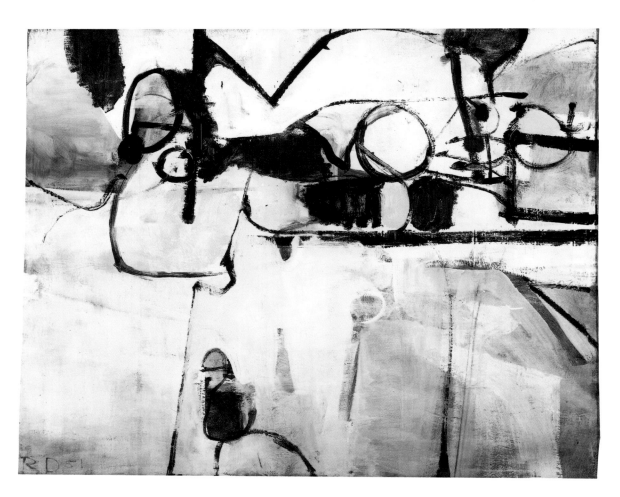

Albuquerque, 1951. Oil on canvas. 40 ½ x 50 ¼ in.
Oklahoma Art Center permanent collection,
Oklahoma City, Museum purchase, Washington
Gallery of Modern Art collection

Albuquerque (Motorcycle Wreck), 1951, from
Master's Degree Exhibition. Oil on canvas.
48 x 40 in. University Art Museum, University of
New Mexico, Albuquerque

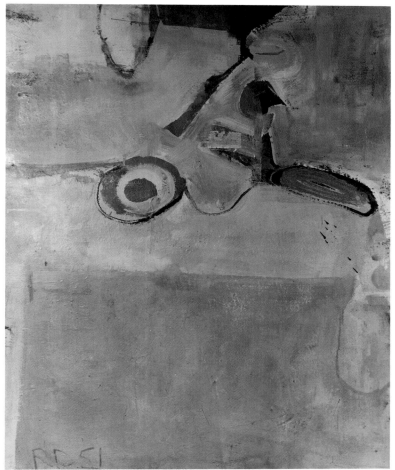

In the late spring of 1951 (at the time of his thesis show) Diebenkorn took his first flight over the desert to San Francisco, where the San Francisco Museum of Art was showing the *Gorky Memorial Exhibition*, organized by the Whitney Museum of American Art. He had admired the work of Arshile Gorky (1905–1948) but had not seen any of the artist's best efforts firsthand. He found Gorky's example, in working through Picasso, Miró, and Kandinsky to achieve an elegant and individual expression, profound and moving, confirming Diebenkorn's own directions at the same time that it opened up new possibilities in virtuoso drawing and sumptuous color.

The flights across the desert had been almost as remarkable as the Gorky exhibition. Propeller-powered, at medium altitude, they provided exhilarating views of the landscape. Earlier on, the painter had been receptive to the ways in which driving through a particular terrain would influence his impressions of it—impressions that would find their way into his work. He had always responded to the influences of the course of a river, the ways in which it could re-form strictly geometric areas of cultivation. From the air he could see that even the rigid forms of towns and villages were shaped by rivers, rises, and other natural contours. Colors varied from section to section, and the bird's-eye perspective revealed a logic and extreme economy that excited the artist. "The aerial view showed me a rich variety of ways of treating a flat plane—like flattened mud or paint. Forms operating in shallow depth reveal a huge range of possibilities available to the painter."[50]

The last ten months in Albuquerque were even more productive than the earlier period had been. Linear improvisations and atmospheric patches of color landscape became integrated into shallow compositions of increasing originality. Rough paint handling, loose and deliberately unbeautiful drawing, became recognizable in this later work. The elegance of Miró and the dazzling brushwork of Gorky began to seem increasingly overrefined to Diebenkorn, and he came to see Willem de Kooning's agitated and fragmented drawings and paintings as more directly relevant to his work at this time. De Kooning's emotionally and erotically charged paintings were records of how they were made, with modifications superimposed upon one another, requiring adaptations and transitions that might go on until an entire canvas had been reworked. Diebenkorn sensed a relationship with his own explorations and swiftly developing working methods. The loosened geometry of the San Francisco period dissolved first into rounded rectangular forms and then into irregularly shaped forms and calligraphic interlacings related to organic or anatomical forms. Recognizable subject matter was carefully painted out, and the vestigial drawing continued as an abstract matrix for the color statement. Joining a sky-view simplification of landscape to freer, vigorous drawing, Diebenkorn produced a striking series of paintings.

Albuquerque No. 3, 1951 (p. 46), completed in the summer after the thesis show, shows a strong sense of the original canvas shining through the drawing and the large irregular paint patches of sandy beige, gray, red, and charcoal. A calligraphic drawing in black and a grayed dilution establish a linear matrix that reaches from edge to edge, looping, corrected, accented

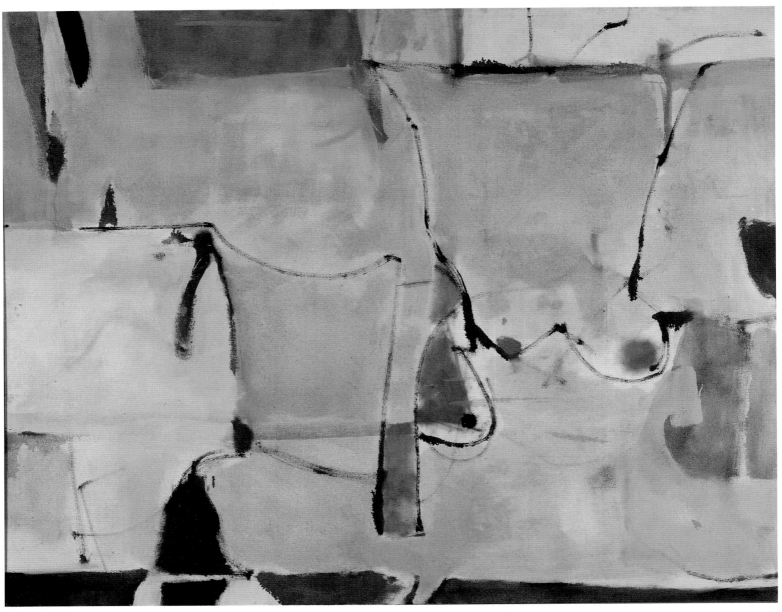

Miller 22, 1951. Oil on canvas. 45¼ x 57 in.
Josephine Morris collection, Mill Valley, California

with red, reinforced as required, and anchored in the margins. Some under-drawing, largely submerged, is visible on close observation. Revisions in overpainting are readily apparent at the center and center right, where passages of heavier paint can be read, clarifying a form, making still another area more mysterious through a rosy sfumato. The closer one looks, the more complex the facture becomes. What at first seems to be a clear and graspable composition becomes increasingly equivocal—similar to what is experienced on first viewing Jackson Pollock's works.

Albuquerque No. 4, 1951 (p. 48), presents a richer color range and a heavier paint body than is typical of the Albuquerque period. Revisions and overpainting are effected with a large brush, and drawing as a variable slender line is replaced with drawing as an edge delineating two separate areas of color—green, red, and lavender in addition to black and white. The triple-banded division is again apparent. Letter or symbol forms appear and are partially effaced—a "v" at the middle of the lower margin, an "o" and a "T" superimposed at the center, a fragmented Maltese cross at the

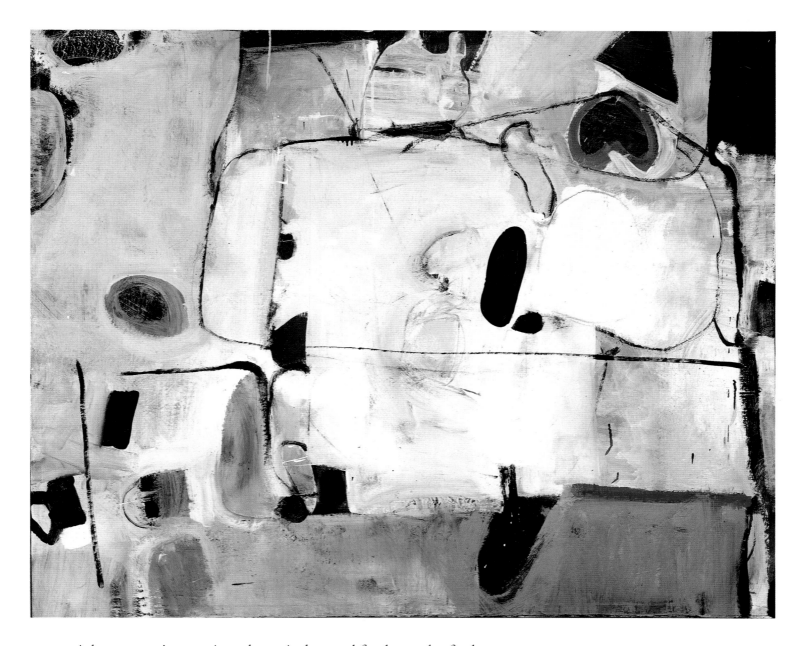

Untitled "M," 1951. Oil on canvas. 43 x 52 ⅞ in.
San Francisco Museum of Modern Art,
San Francisco, Gift of Rena Bransten

upper right center. At one time the artist lettered freely on the fresh canvas
as a method of becoming engaged with the painting, using his own initials,
reflective of de Kooning's methodology. These are not "symbolic" carriers
of meaning like the pictographic diagrams of Adolph Gottlieb, of which
Diebenkorn was aware at this time. Rather, they are vestiges of formal
steps in the development of the canvas. The cross form relates to the artist's
childhood enchantment with heraldry. Like a cubist wineglass or violin—
distorted, transposed, and reconstructed—the fragmentary cross is as real
to the eye as a photographic depiction, but much more consistent with
the freshly brushed and searching process that Diebenkorn followed.
The eye returns again and again to this curious talisman, moving through the
vibrant large fields of color to sample again the elusive predictability of
the fractured quatrefoil.

Some commentators insist on finding a reclining figure in the canvas
entitled *The Green Huntsman*, 1952 (p. 53), painted toward the end of
the Albuquerque period. In his manner of direct revision on the canvas,

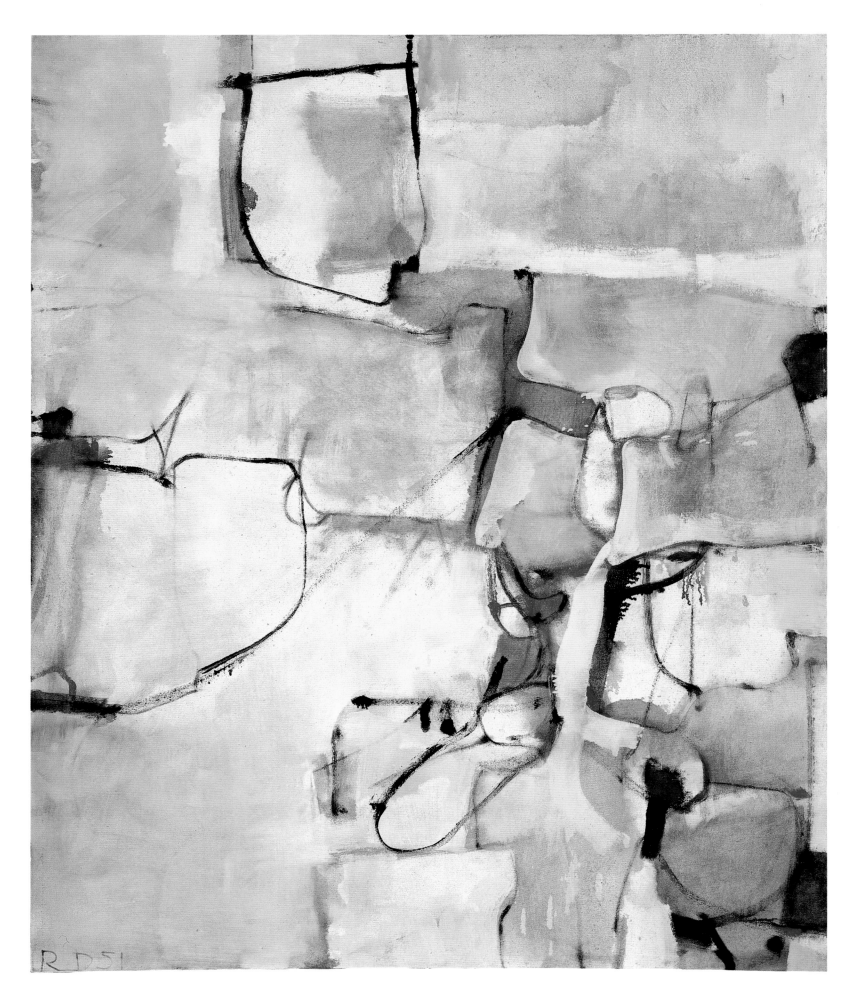

R D 51

46

Diebenkorn established a banded horizontal composition, which was then overpainted in a warm off-white in the central section and with a rich black above. The reds and red-browns are reminiscent of the desert's colors in changing light, and the painting could as easily be related to landscape as to figurative inspirations. Diebenkorn had been reading Stendahl at the time that he was working on the canvas and he took the title from one of the writer's novels. Maurice Tuchman said that this painting is "quite opposite from the logical clarity of the French writer" and has called it "disturbing, dramatic, [and] menacing."[51] Mark Lavatelli asserted that "Diebenkorn chose the title somewhat flippantly, saying that green is the complement of red and the painting was mostly red."[52]

During his two and a half years in Albuquerque, Diebenkorn had worked through many influences—those of his Bay area colleagues, Park and Smith, as well as of Miró and Gorky—and come to terms with his feelings for landscape and the suggestive powers of the light of his environment. He had produced a number of powerful paintings and he had developed his own way of working that served his expressive purpose.

That method of working began in improvisation—content tended to be developed through the relationship of marks made on the new canvas surface. The resulting forms and colors, suggestions of spatial relations, established a painting process that became a primary element of its own content. Concerned with rhythm and balance, with total design, the artist searched to understand his own moves and to predict what their effects would be in the work. While he created from an emotional basis, he was constantly analytical and reflective, striving for a logical totality. Some years later he gave a statement on the process:

> [A painting] came about by putting down what I felt in terms of some overall image at the moment today, and perhaps being terribly disappointed with it tomorrow, and trying to make it better and then despairing and destroying partially or wholly and getting back into it and just kind of frantically trying to pull something into this rectangle which made some sense to me. . . . [53]

One understands the frustration the artist felt in the painting process he had established, a process that led to fallow periods as well as productive ones. It is, however, that process which permitted the challenging dialogue between the artist and his work, and allows the dialogue between the viewer and the work to continue today.

Diebenkorn left Albuquerque in June 1952, having accepted a teaching position at the University of Illinois at Urbana. Before taking up residence in Illinois, the family moved back to California for the summer. The stay enabled Diebenkorn to see the major Matisse retrospective of that year—an inspiring experience for the artist—organized by Alfred Barr of the Museum of Modern Art, New York, and circulated to the Los Angeles Municipal Gallery. During this period the newly established Paul Kantor Gallery, in Los Angeles, contracted to exhibit the work of Diebenkorn's Albuquerque years. Josephine and Paul Kantor, dedicated collectors of

Albuquerque No. 3, 1951. Oil on canvas. 55 x 46 in. Private collection

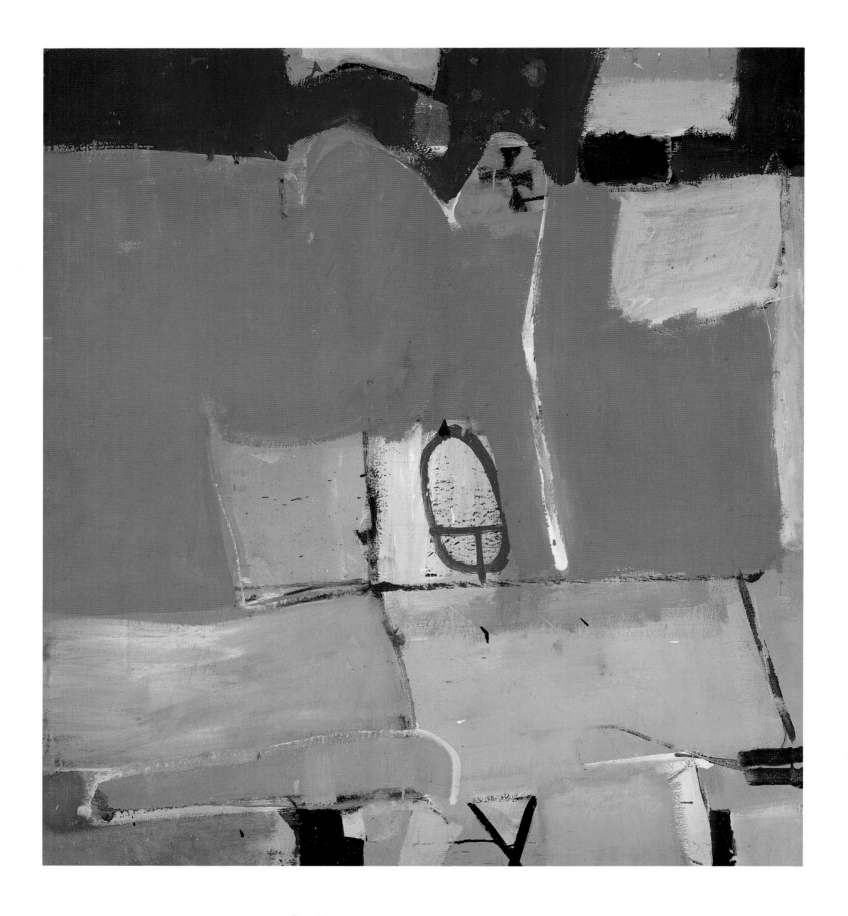

Albuquerque No. 4, 1951. Oil on canvas. 50 ¼ x
45 ¼ in. The Saint Louis Art Museum, St. Louis,
Missouri, Gift of Joseph Pulitzer, Jr.

Opposite:
Albuquerque No. 9, 1952. Oil on canvas. 69 ¾ x
54 ⅝ in. Arthur N. and Audrey Greenberg collection,
Los Angeles

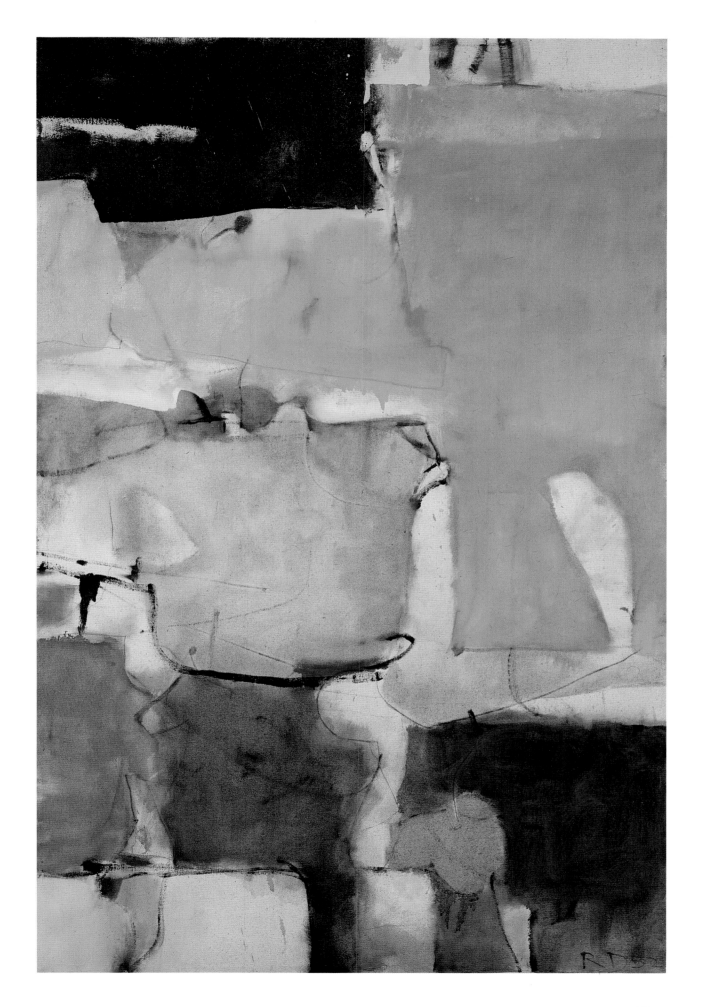

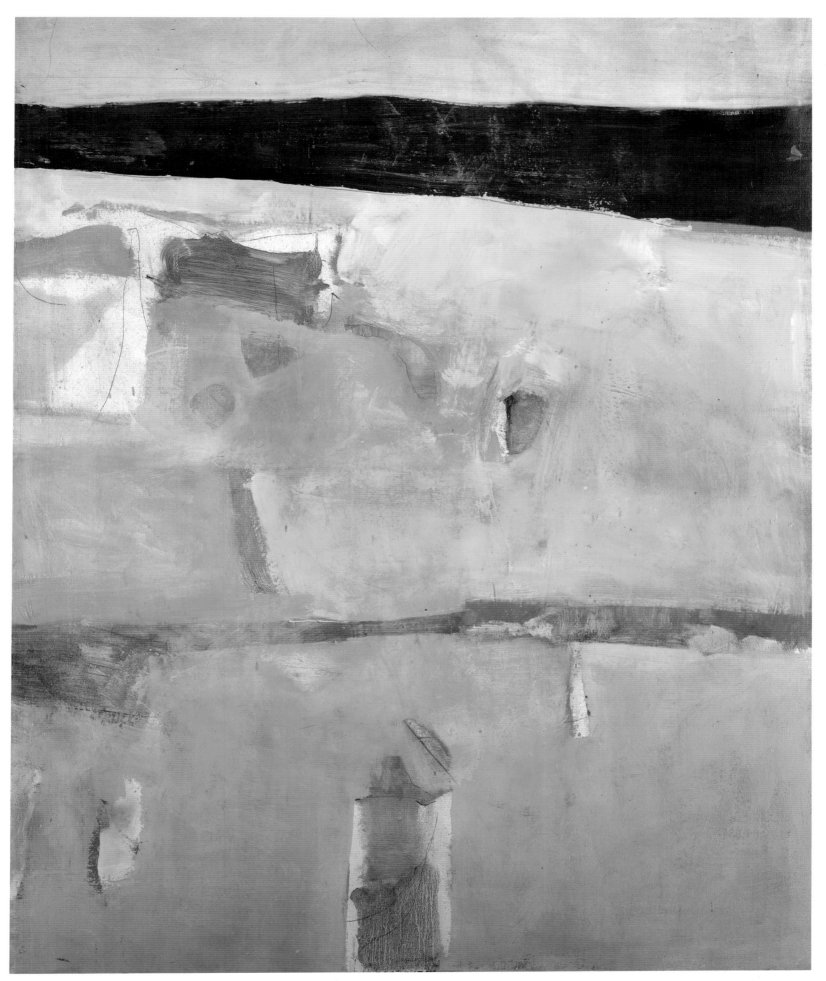

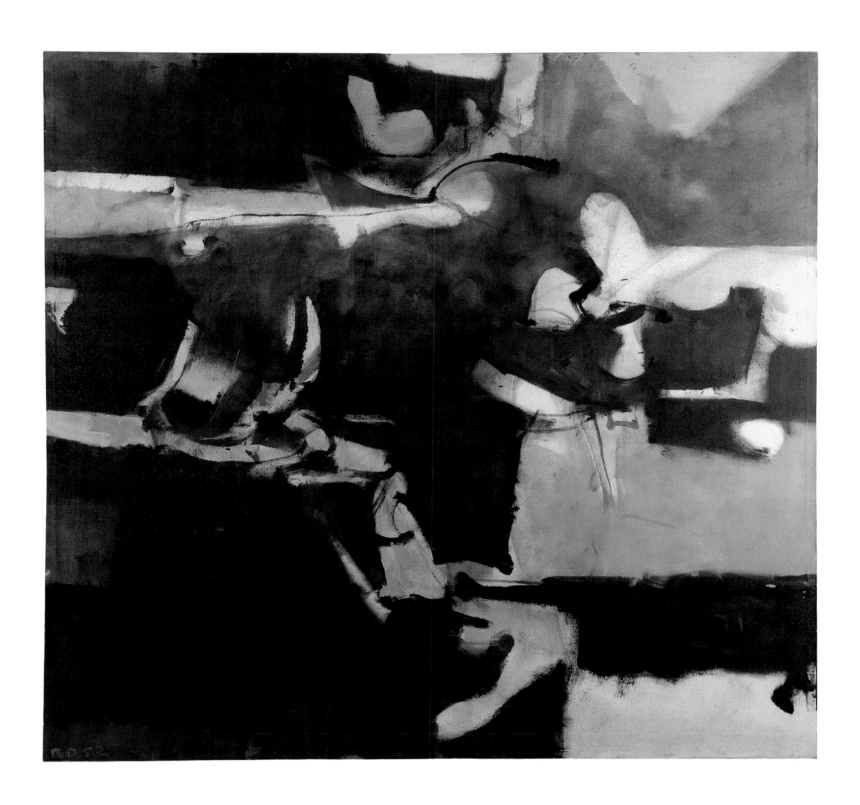

Opposite:
Albuquerque No. 11, 1951. Oil on canvas. 56½ x
44½ in. Private collection, Kansas City, Missouri

Above:
Albuquerque No. 20, 1952. Oil on canvas. 54½ x
57 in. Byron Meyer collection, San Francisco

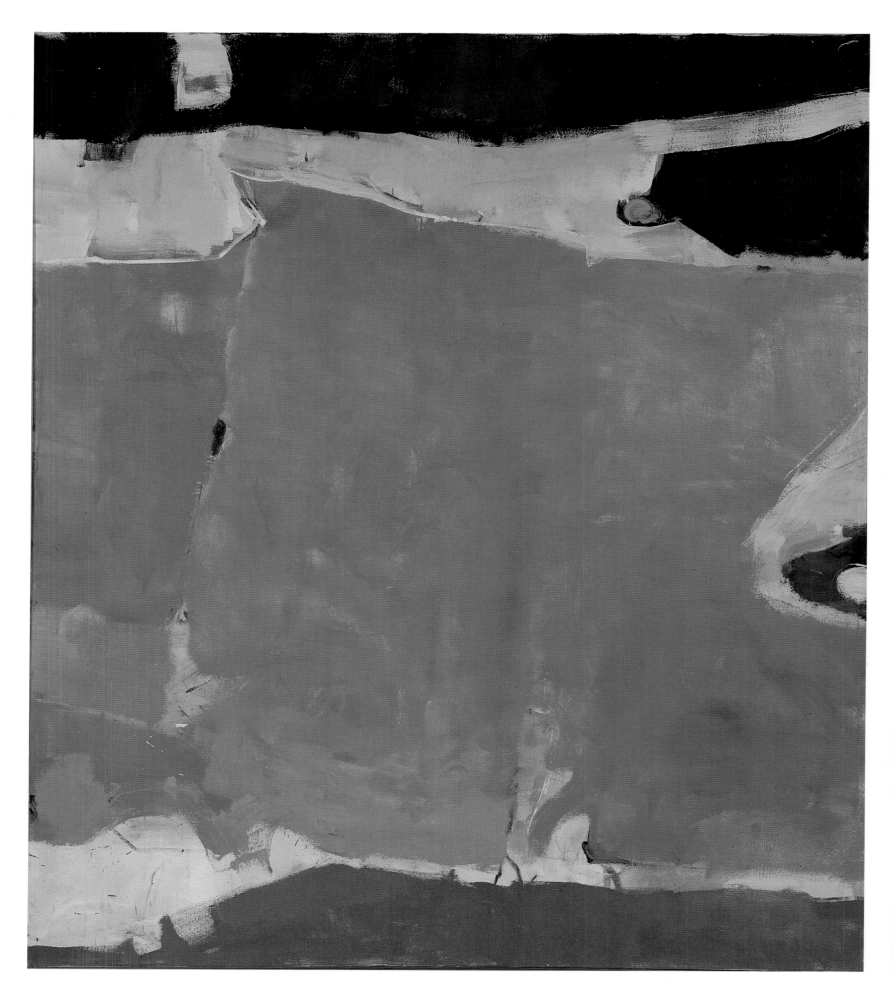

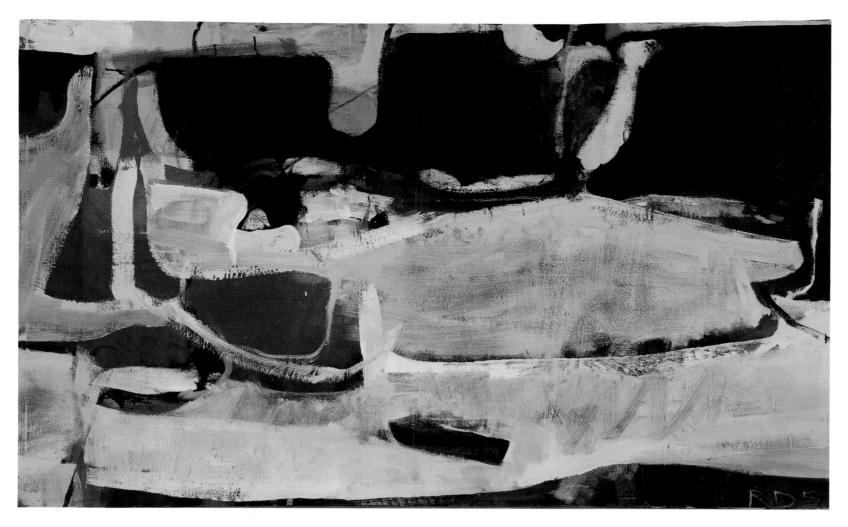

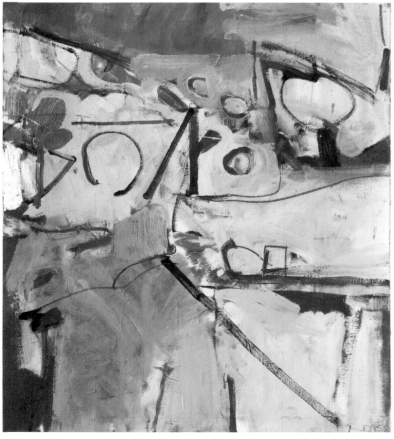

Opposite:
Untitled (Albuquerque), 1952. Oil on canvas.
69 ⅛ x 60 in. Vincent Price collection, Beverly Hills,
California

Above:
The Green Huntsman, 1952. Oil on canvas.
42 ¾ x 69 in. Mr. and Mrs. Richard Diebenkorn
collection, Santa Monica, California

Left:
Albuquerque, 1952. Oil on canvas. 41 x 36 in.
Private collection

contemporary art, had visited the Diebenkorns at least once in Albuquerque and had purchased works for themselves and brought others to Los Angeles for private showings to museum professionals and critics. William R. Valentiner and James B. Byrnes, both of the Los Angeles County Museum of Art, first saw the new work in this context, and subsequent invitations to exhibit at the museum grew from the exposure. By the time the Paul Kantor Gallery exhibition was installed the Diebenkorns were on their way to Illinois.

The Albuquerque period has never been presented in full and as a result, has not been perceived as a whole. As Diebenkorn was preparing to leave for California he separated the work into three rolls for the trip. Those rolls were stored temporarily in a barn at his wife's stepfather's home near Pomona, where the Diebenkorns were staying, and only two of the three rolls were initially retrieved. In 1996 the missing roll of unexhibited Albuquerque paintings was recovered by the Estate.

In Urbana, the Diebenkorn family rented a house on a pleasant residential street, with sufficient bedrooms to permit one to be used as a studio. As a beginning instructor, Diebenkorn was assigned to classes that no ranking faculty member wanted to teach—drawing and painting for students in the architectural curriculum. The formalistic arrangement for teaching, carefully prescribed week to week by the School of Architecture, with a joint committee of five giving grades to all of the students in the various sections of the enrollment, was very different from Diebenkorn's experience teaching at the California School of Fine Arts or from his relationship with the faculty at the University of New Mexico. He did not enjoy the assignment, and he often felt that his efforts to help a student discover his unique abilities worked against the student's academic success.

The Diebenkorns made friends among members of the music, English, and physics departments at the university and became involved with a drawing group, but in general they found the gray Illinois light uninspiring and they missed both the vistas of the ocean in the Bay area and the exhilarating skies of New Mexico. They decided that they would leave at the end of the school year.

Perhaps as an antidote to the somber light, but more likely because of the experience of the Matisse retrospective he had seen in Los Angeles, Diebenkorn found himself exploring color more fully in Urbana than ever before. He sublimated the bleak landscape and gray skies and brought forth a chromatic complexity entirely fresh to his work, an orchestral grandeur, with many new colors. Although the artist produced comparatively few works during the nine-month period, the level of quality was remarkable.

Urbana No. 2, 1953 (p. 56), often called *The Archer*, is a complex painting that combines the familiar layered structure with biomorphic elements reminiscent of earlier painting and a diagrammatic outline of a kneeling figure flexing a great bow. The bold flex of the bow suggests impending action and release. The seemingly exclusive images of a flat patterned abstract landscape and a tension-filled figure aiming and cocking a weapon do not contradict one another but overlap in mutual support.

Urbana No. 3, 1953 (p. 57), is a layered horizontal canvas consisting of

mauve-gray, green, and red divisions and powerful black-and-white drawing elements. The dark upper bands convey a menacing mood. Perhaps the Illinois climate, light, or an impending storm have combined to evoke an abstract imagery reminiscent of landscape. The bold drawing recalls de Kooning's Attic period in a tough and yet appealing canvas.

Urbana No. 4, 1953 (p. 58), suggests the influence of Matisse in its high-keyed colors. The inspiration for the painting appears to be a table-top still life. The layered organization continues with a fresh scaffold of color. Most of the still-life arrangement has been painted out, and only hints of drawing remain visible in the vigorous and free brushwork.

Urbana No. 5, 1953 (p. 59), nicknamed *Beachtown*, is one of the most widely known paintings of this period. On one level it is a flat-patterned patchwork abstract painting in full Fauve palette. On a second level it is an aerial perspective on a tilted earth plane, receding toward the upper margin; a strong diagonal line at the upper left establishes a border for color patches which represent buildings. The painting has a striking similarity of composition to the urban *Cityscape I*, 1963 (p. 112), in which the painter's observation seems more objective. The subject is a different landscape, and the degree of abstraction is less pronounced, but the impetus for both paintings appears related.

One of the most remarkable paintings of the Urbana period is an unnumbered work of 1953 (p. 62) (belonging for years to close friends from the Urbana days and seldom exhibited). Patches of strong, clear colors are linked in the lower half of the canvas without landscape or figurative references. The darker upper section of the canvas holds the same plane without a suggestion of aerial perspective. No reliance is put upon a Cézannian diagonal to create a recessive space, nor on a counter theme of figure or still life. This is pure abstract painting in the heightened coloration associated with *Urbana No. 4* and *No. 5*, carried to a new level of nonobjective painterly sophistication, and recalling Matisse's "harmony of intensely colored surfaces."

Having moved more than halfway across the country to Illinois, the Diebenkorns decided to move on to New York. In June they settled in Manhattan in a studio on East 12th Street. They saw old friends: the painters John Hultberg from Sausalito, Ray Parker (1922–1990), a mid-western transplant, and Franz Kline (1910–1962), all of whom were welcoming and helpful. It was a very hot summer and the humidity was oppressive. The car was broken into and a typewriter stolen. The circumstances did not seem right to Diebenkorn, and one afternoon he announced that he and his family were going back to the Bay area. The next morning they set out.

The Diebenkorns rented a house in Berkeley but they had arrived too late in the summer for the artist to be considered for a teaching position in the 1953–54 academic year. Nevertheless, they reestablished themselves quickly and Richard began to paint, building upon his Albuquerque and Urbana work, with the additional influences of his new environment. The adjustment to working in Berkeley appears to have been one of the least disruptive of his career. To be sure, there were backward looks at earlier

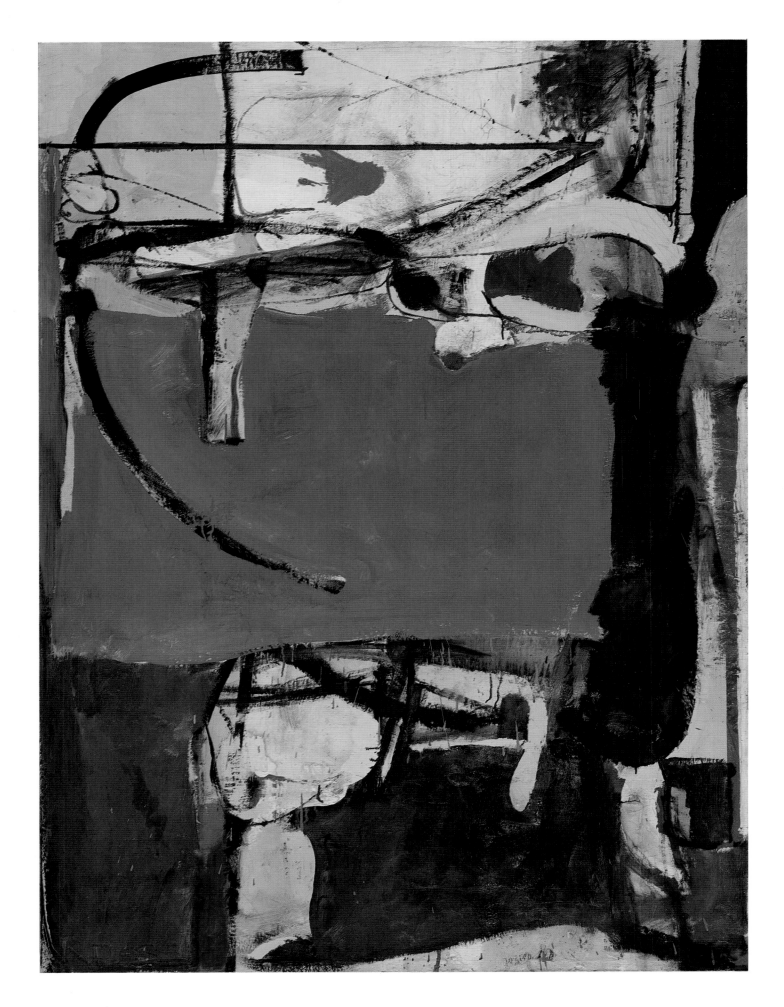

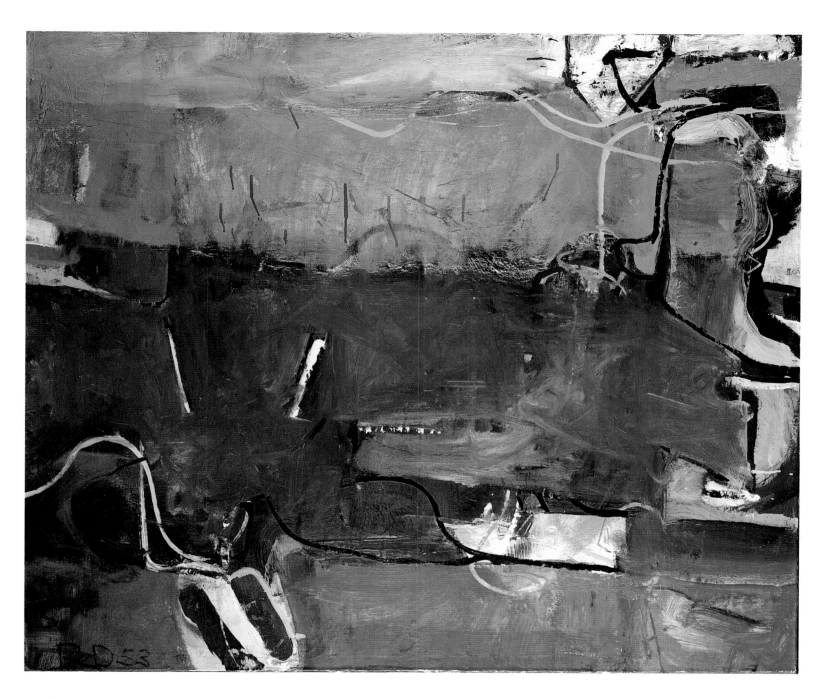

work. More importantly, there were rich new paintings keyed to golden ochre, and as before, an occasional dark canvas that was tough and deliberately uningratiating in the earlier San Francisco tradition. Before long, however, the Berkeley light and climate began to assert themselves in the development of verdant and colorful, luminous compositions.

Diebenkorn appeared secure in his ability to control his abstract language and to improvise within it without repeating himself. The personal interpretations of landscape and the use of aerial perspective developed during the Albuquerque period found new expressive possibilities in the Berkeley canvases. The horizontal compositions, punctuated with diagonal thrusts drawn from Cézanne landscapes, began to accumulate with a new ease. Since 1948–49 Diebenkorn had been building overall paintings in which there was no specific figural focus but instead a holistic surface that

Opposite:
Urbana No. 2 (The Archer), 1953. Oil on canvas. 64 ½ x 47 ½ in. Mr. and Mrs. Richard Diebenkorn collection, Santa Monica, California

Above:
Urbana No. 3, 1953. Oil on canvas. 33 ¼ x 39 in. Courtesy, John Berggruen Gallery, San Francisco

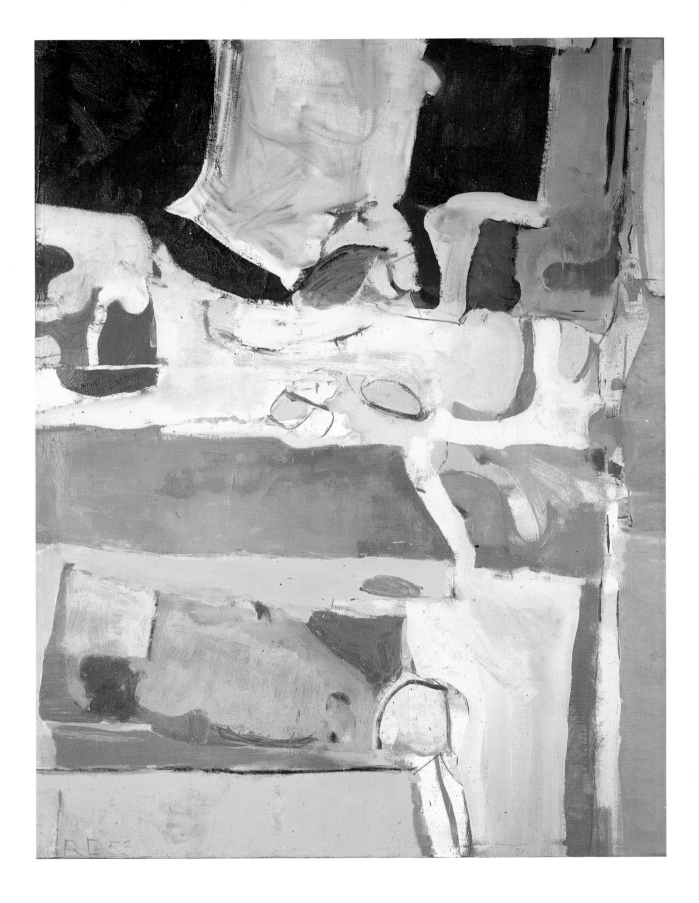

Urbana No. 4, 1953. Oil on canvas. 66 x 49 in.
Colorado Springs Fine Arts Center collection,
Colorado Springs, Gift of Julianne Kemper

Opposite:
Urbana No. 5 (Beachtown), 1953. Oil on canvas.
68 x 53 ½ in. Mr. and Mrs. Gifford Phillips collection,
New York

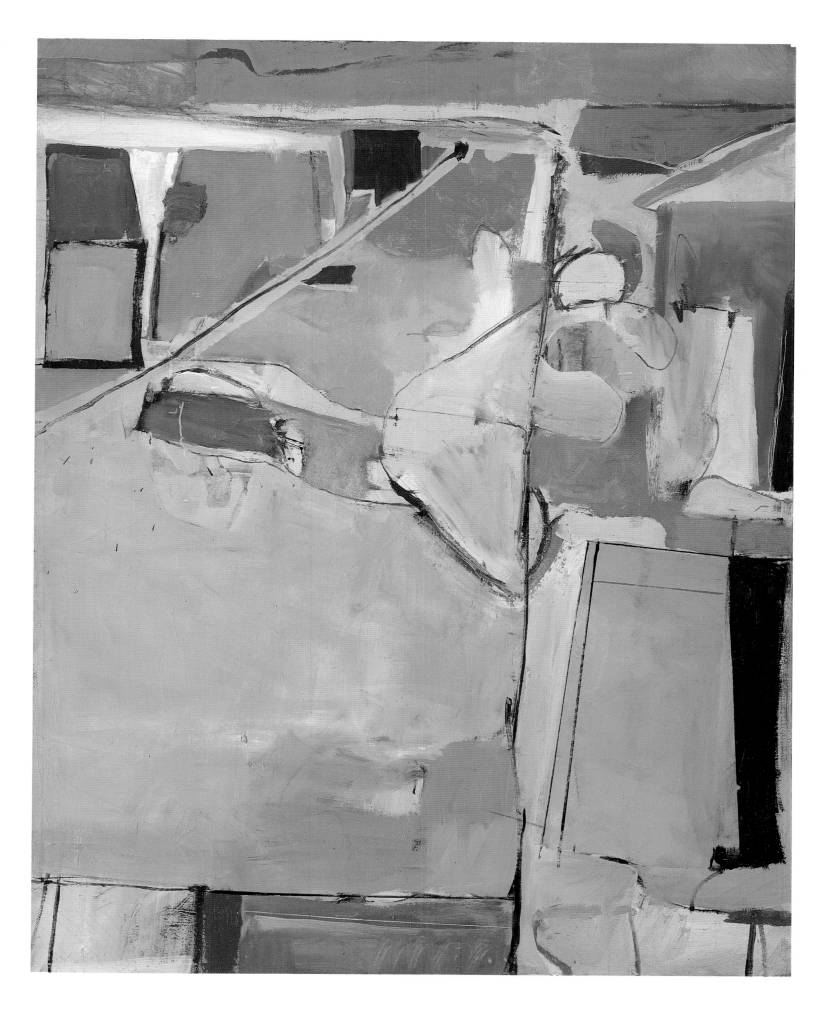

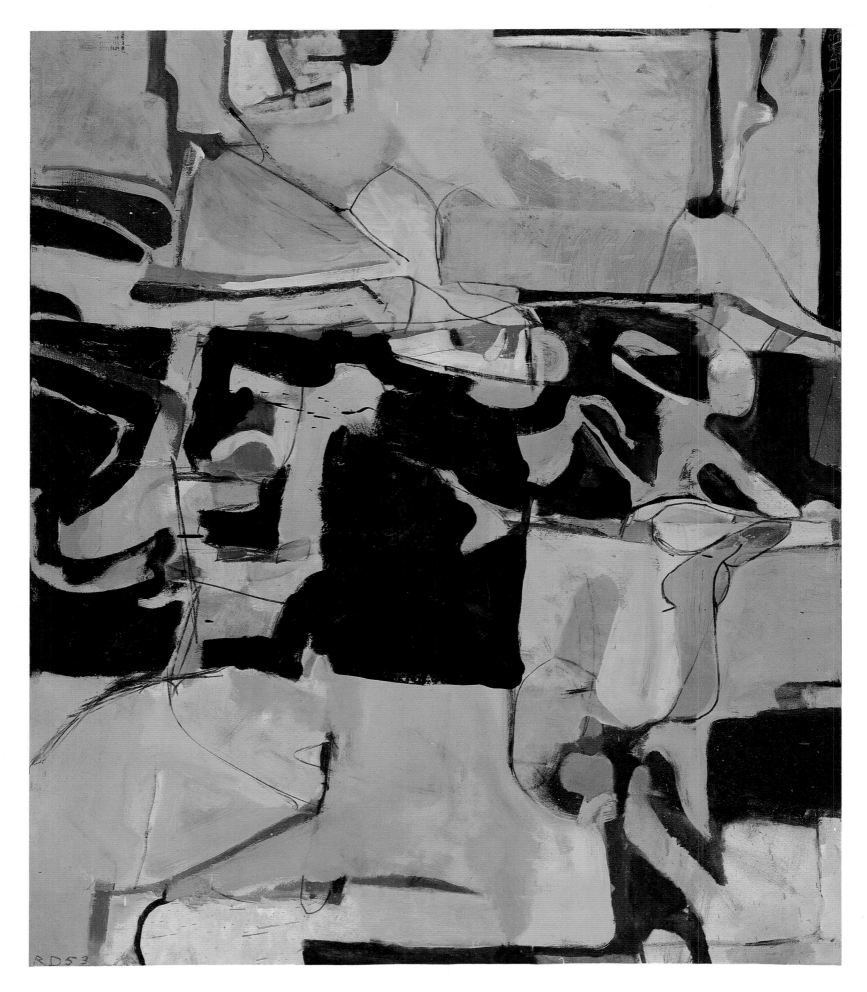

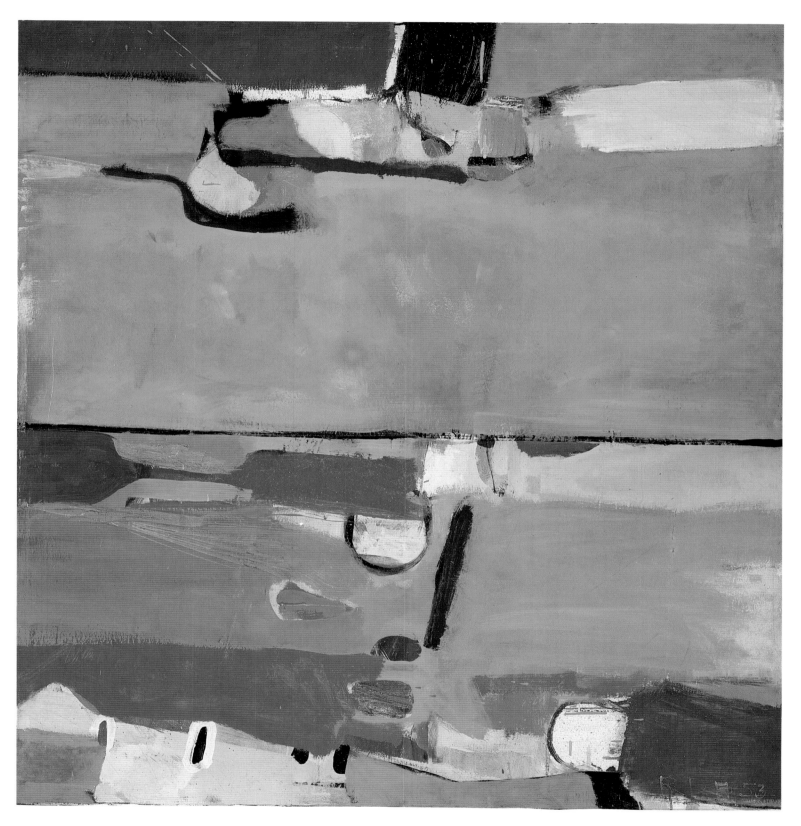

Opposite:
Urbana No. 6, 1953. Oil on canvas. 57 ¾ x 69 in.
Private collection

Above:
A Day at the Race, 1953. Oil on canvas. 56 x 52 ¾ in.
The Carnegie Museum of Art, Pittsburgh, Patrons
Art Fund, 1953

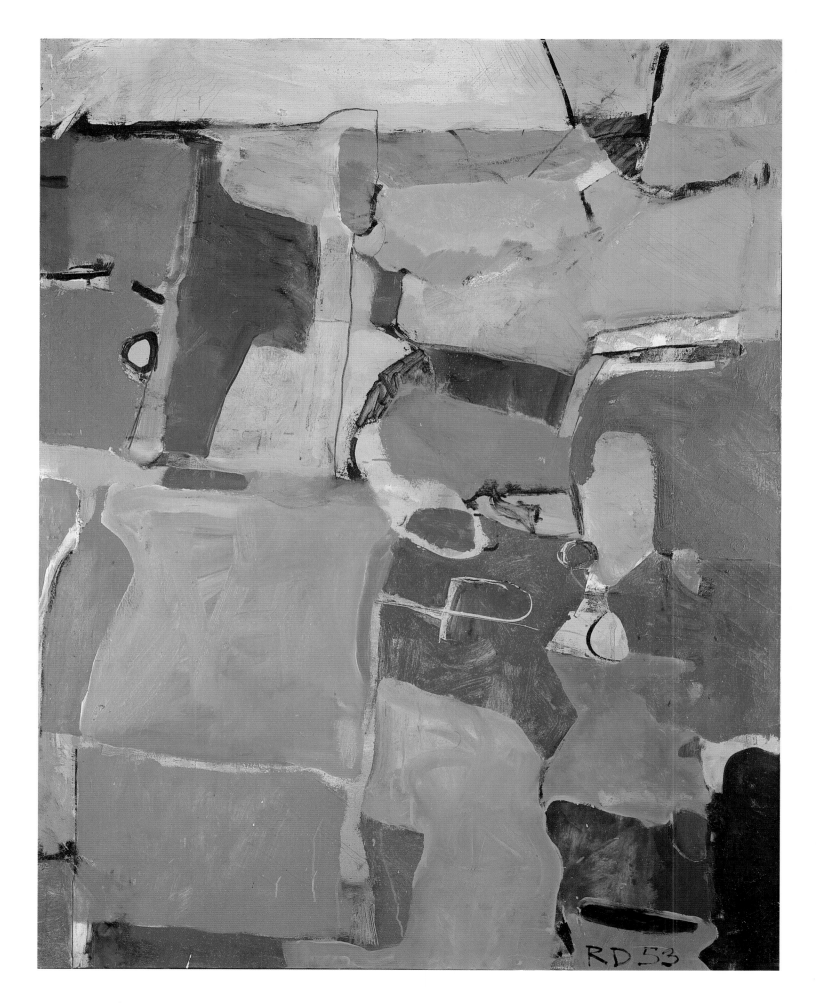

embraced drawing and painting, color and form, and anatomical, geometric, and landscape impulses, intuitively joined into a seamless unitary fabric. In Berkeley he entered into a period of unusual productivity, following the lean year since Albuquerque. The release of color experienced in Urbana through the Matisse exhibition was joyfully extended.

Berkeley No. 8, 1954 (p. 66), reflects a new intensity of light through the merging, folding, and interpenetration of the layered bandings influenced by landscape. The painting establishes an orchestral sense of color—color that had been liberated during the Fauvist Urbana period but that was now expanded through the environment and qualities of light experienced in the Bay area. The bright yellows, oranges, and greens are entirely different from the clangorous reds and oranges of Urbana or from the more subdued expanses of color of the New Mexico paintings. Here is a chromatic fantasy prophetic of the full palette that would be explored throughout the Berkeley period.

Each new painting was *sui generis*, true only to itself, seeking to find a new approach to both form and color. The horizontal banding appeared from time to time, but in varying forms. Ghosts of earlier approaches reemerged, and motives might appear against a ground, reaching out to upper and lower margins. Still-life subjects would recur, only to be systematically painted out. Each formal innovation was pushed to its furthest possible extension. Color was exploited in the same fashion—brought into unanticipated relations, as he explored and searched for possibilities left undiscussed in color classes. There came to be an openness to freedom and search, to risk and inquiry that would have been inconceivable in earlier years. Academic ideas of laws and boundaries were rejected in favor of a personal, more subtle, and more intimate play with the painting experience. Every work of art had to have its own internal coherence and sense of wholeness, and the forms and colors chosen had to present an expressive unity through a powerful charge of feelings in the composition and the juxtaposition of painterly elements. The painter was not seeking to be original but to be true to his personal methodology and to his convictions.

Manuel Neri (born 1930), a student at this time at the California College of Arts and Crafts, a protégé of Peter Voulkos (born 1924), and an expressionist potter, painter, and sculptor, recalled Diebenkorn's paintings of the Berkeley period:

> God damn it, it was pretty strong stuff. It was a type of painting we hadn't seen on the West Coast before. Diebenkorn had a wildness— not the controlled wildness of Hassel Smith but an out-of-control feeling. Those were urgent times, wild times. He brought us a new language to talk in.[54]

The artist was not so secure in his financial circumstances. Savings were running out, and he was far from ready for an exhibition. He interviewed with art school deans, made a grant application, and investigated employment opportunities. He concluded that driving a taxi would be better than taking a job that might demand his investing creative energy in the work

Urbana, 1953. Oil on canvas. 61½ x 47¾ in.
Mrs. Johanna Zimmerman collection, Pittsburgh

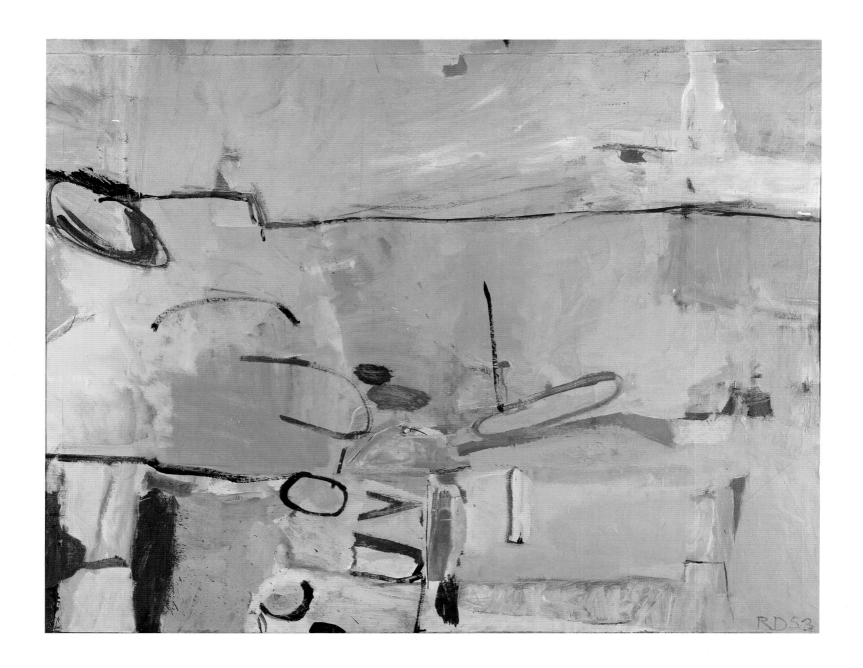

Berkeley No. 3, 1953. Oil on canvas. 54 ⅛ x 68 in.
Josephine Morris collection, Mill Valley, California

Opposite:
Berkeley No. 7, 1953. Oil on canvas. 47 ¾ x 43 ⅛ in.
Washington University Gallery of Art, St. Louis,
Missouri, Gift of Joseph Pulitzer, Jr.

Page 66:
Berkeley No. 8, 1954. Oil on canvas. 68 ⅞ x 59 ⅟₁₆ in.
The North Carolina Museum of Art, Raleigh, Gift of
W.R. Valentiner

Page 67:
Berkeley No. 13, 1954. Oil on canvas. 69 ½ x 55 in.
Mary Grant Price collection, Honolulu

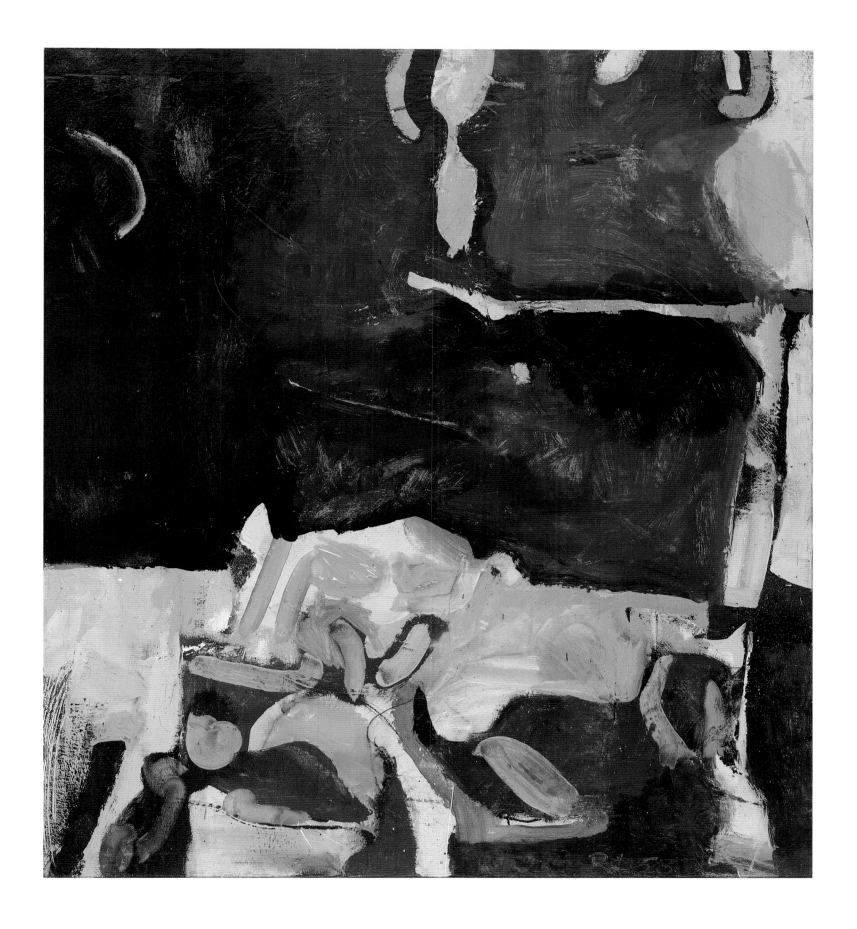

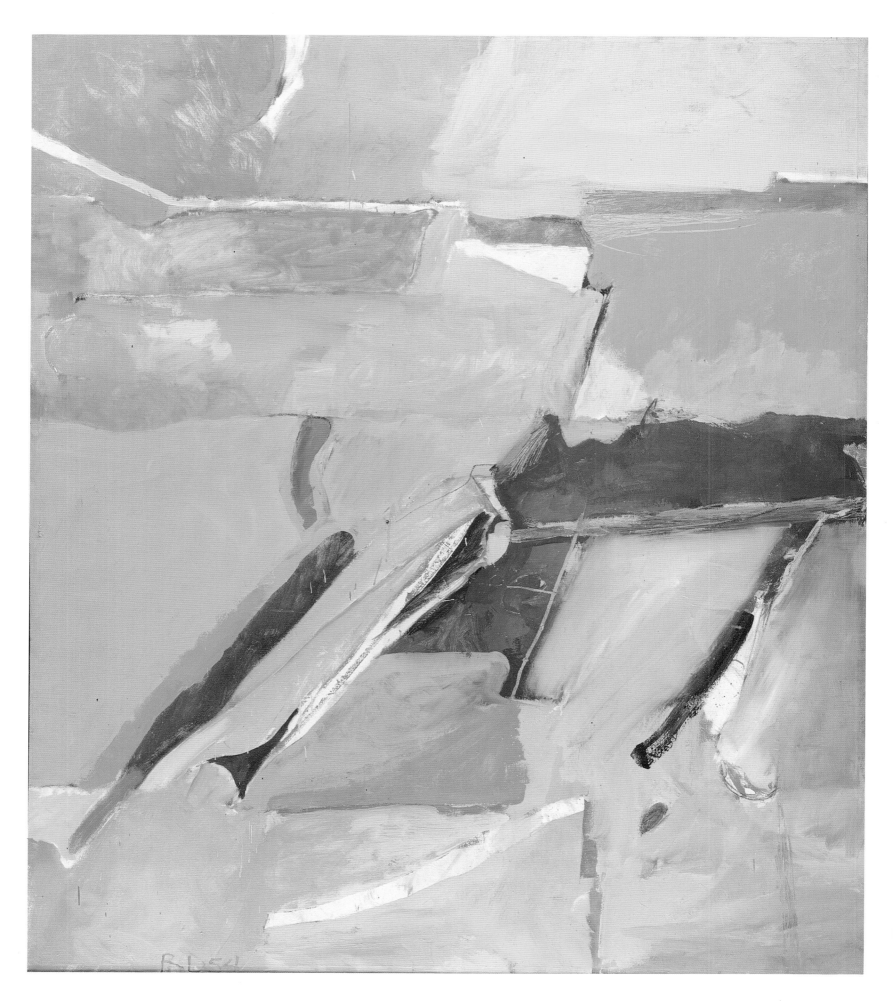

66

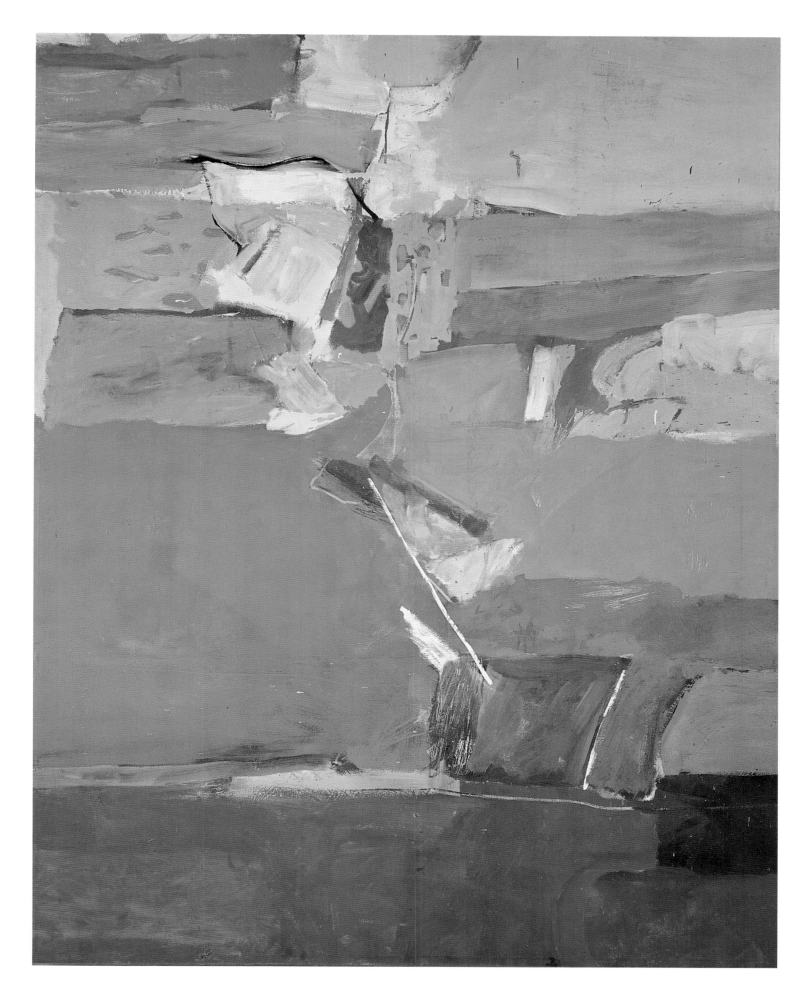

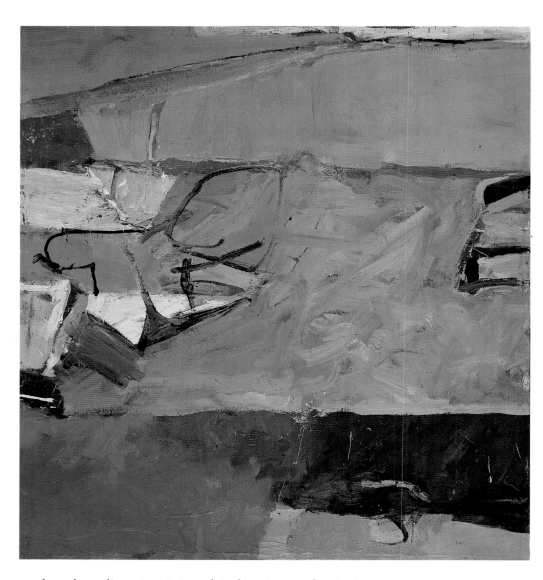

Berkeley No. 17, 1954. Oil on canvas. 57⅛ x 53½ in.
Private collection

rather than directing it into his drawing and painting.

 In early 1954, just as every financial possibility had run out, Diebenkorn was about to begin taxi driving when he received the Abraham Rosenberg Traveling Fellowship for the Advanced Study in Art grant for that year. The sum offered was not large, but it permitted the artist to continue painting on a full-time schedule, facilitating the most concentrated and fulfilling body of work in his life until that time. The achievement of Albuquerque and Urbana was growing together into an unpredicted strength and beauty that might otherwise have been delayed or even lost.

 As soon as Diebenkorn sensed a pattern of what to expect in his work, he began to reverse himself or turn in another direction. *Berkeley No. 20* (p. 70) is a dark painting, with a monochrome charcoal field. Beginning in the Berkeley years, Diebenkorn periodically produced an occasional dark painting, perhaps as a kind of catharsis to his continuing exploration of the full color palette. A horizontal line, approximately one-third of the way up the canvas, divides the field into two subsections. An irregular rectangle emerges from the lower left corner margin. A richly painted complex element, asymmetrically awkward (in earth colors, white, and pink against the charcoal field), emerges in the right center of the upper

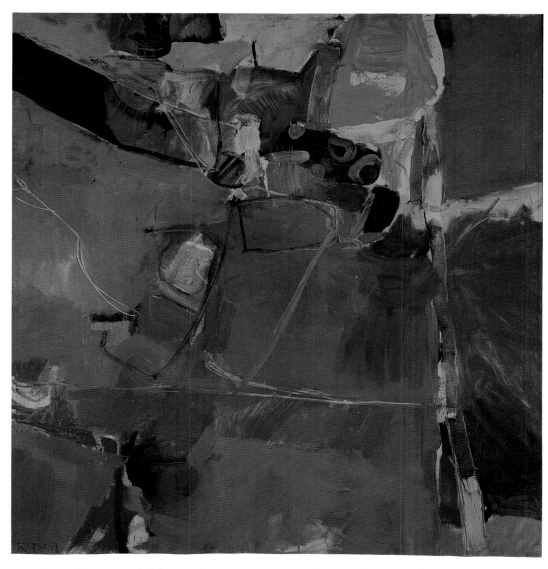

section. There is a deliberately uninviting quality to the dark field, calling to mind the California School of Fine Arts dictum that color was dangerous because it was too seductive. Viewed today, the charcoal field reflects an understated restraint that seems almost elegant. The canvas has its own internal order, its own formal coloristic unity, and an expressive force of personal, charged feeling.

Berkeley No. 32, 1955 (p. 74), is the polar opposite of *Berkeley No. 20*. Its colors are emphatic, brilliant: red and yellow, blue and green, tan and taupe. Horizontal layers of these colors pile up, one upon another, interpenetrate, and interact. Brushstrokes are agitated, directional, suggestive of the force and vigor of the artist's gestural workmanship. Tans and ochres are superimposed over a great red section, creating a nonperspectival recession. The intensity of the colors, their weight as pigment, and their exuberance of application give the viewer a sense of the painting's having been created with eloquent directness, in one session, and with pleasure in the materials. One may see the work as totally nonreferential, or one may attempt to read the foreground, middle ground, background, and "sky" of an abstract landscape into the canvas. However it is read, it is a moving, unified work of high-keyed coloristic excitement and energy.

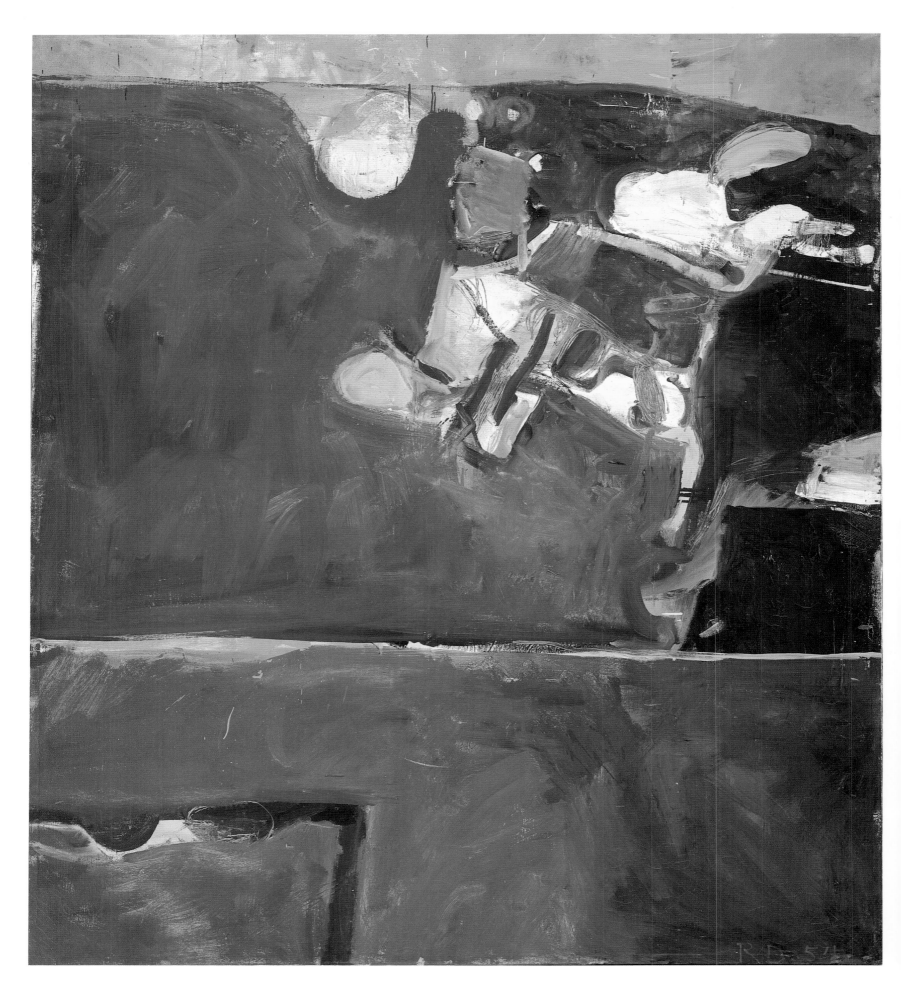

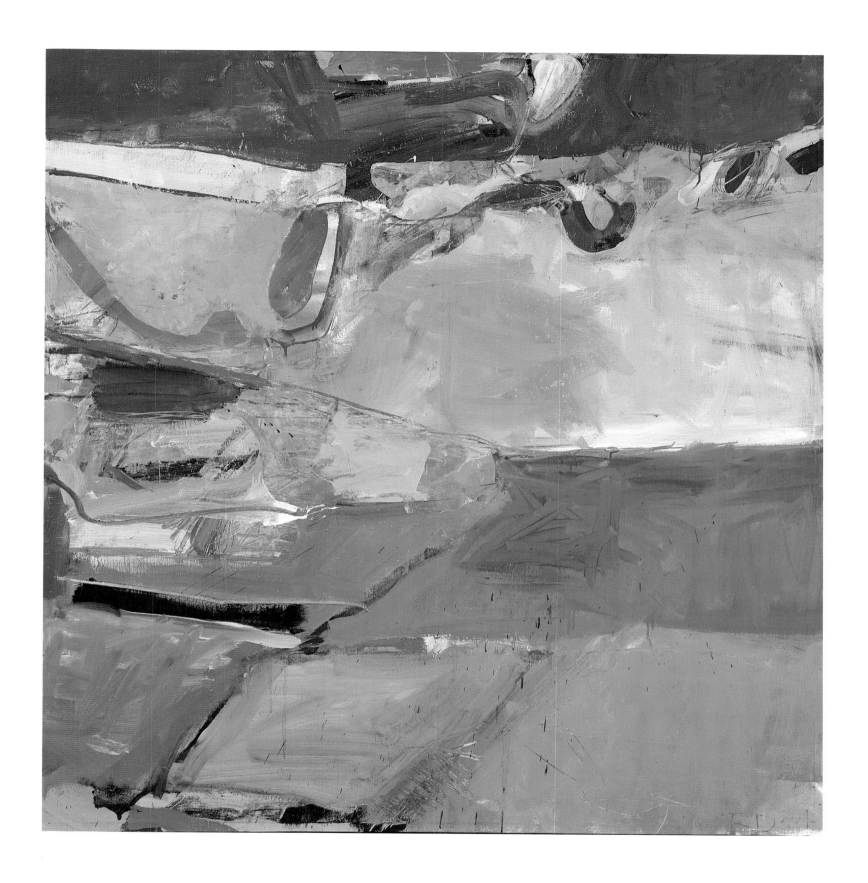

Opposite:
Berkeley No. 20, 1954. Oil on canvas. 72 x 63 ¾ in.
Collection of the Oakland Museum, Oakland,
California, Gift of the Estate of Howard E. Johnson

Berkeley No. 22, 1954. Oil on canvas. 59 x 57 in.
Hirshhorn Museum and Sculpture Garden,
Smithsonian Institution, Washington, D.C., Museum
purchase with funds provided under Regent's
Collections Acquisition Program, 1986

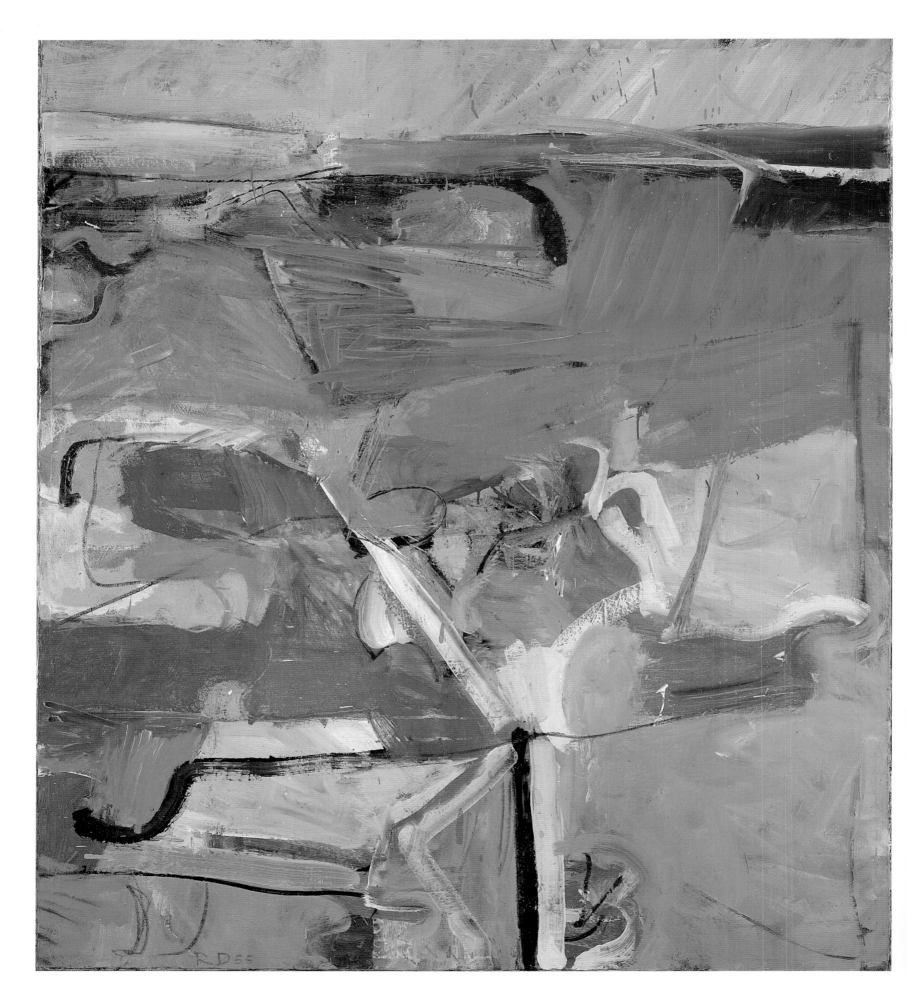

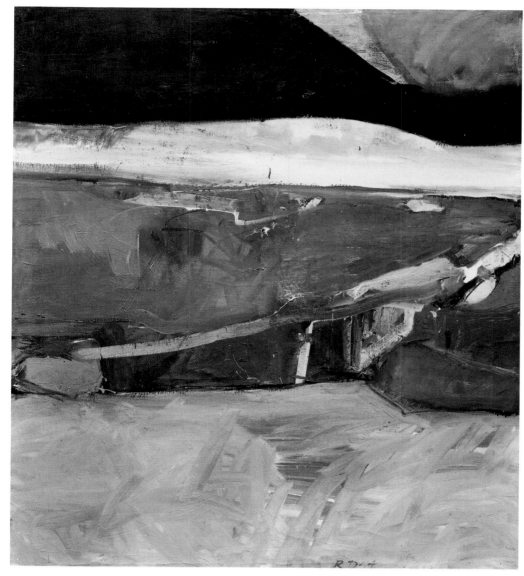

Berkeley No. 57, 1955 (p. 81), is a late example from the series, a work of baroque complexity of color in which yellow, oranges, and red-oranges dominate a composition that also calls upon greens and blues. The scattered balances of incident show no trace of contrivance, nor any suggestion of thematic inspiration. The painting is a masterful, nonobjective composition, suggesting a disciplined emotion and a rigorous control that at the same time is innovative in its richness and harmony of color.

Upon returning to the Bay area, Diebenkorn had renewed contact with David Park and Elmer Bischoff, and before long the three artists had resumed weekly sessions visiting each other's studios. Park had turned to figure painting in 1950, and Bischoff had followed in 1952. The sessions involved drawing from the nude model, and discussions tended to relate to Park and Bischoff's figurative concerns. This shifting between the figurative and the abstract did not interfere with Diebenkorn's work, as the artist was painting prolifically, developing new forms, finding new combinations of colors and new compositional balances as never before. Park somewhat grudgingly respected Diebenkorn's latest paintings. At the same time he subverted them by referring to them as "performances" or "improvisations."

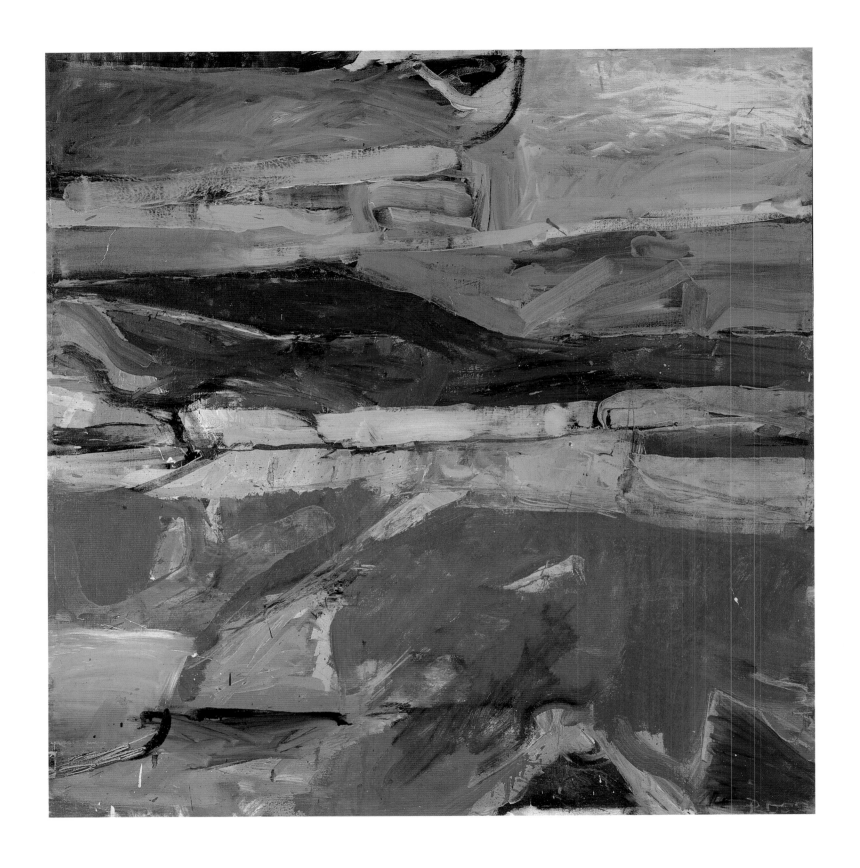

Berkeley No. 32, 1955. Oil on canvas. 58 ¾ x 57 in.
Richard and Dorothy Sherwood collection,
Beverly Hills, California

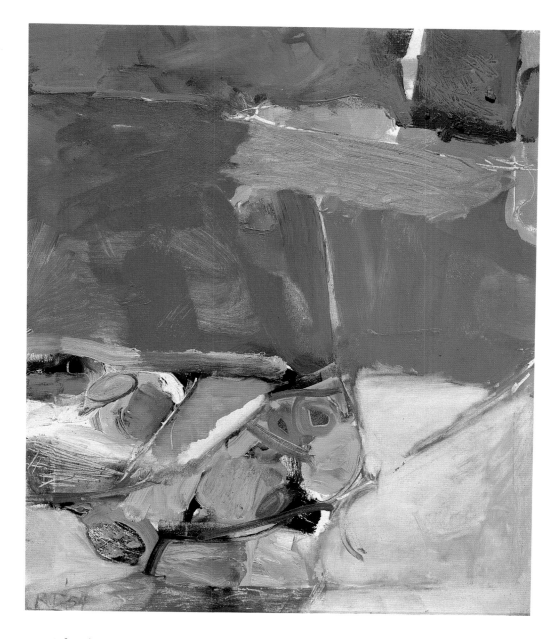

Berkeley No. 33, 1955. Oil on canvas. 24 x 20½ in.
Mr. Paul Wilson collection, San Francisco

After he received the Rosenberg grant, Diebenkorn had a number of
showings that established an atmosphere of success. Park looked upon suc-
cess as being received in response to an individual's need, implying that to
be successful was somehow a weakness and irrelevant to the practice of
serious art. A show at the Paul Kantor Gallery in Los Angeles; James
Johnson Sweeney's invitation of a Berkeley painting to the Guggenheim
Museum's "Younger American Painters" exhibition; and solo shows at the
San Francisco Museum of Art and the Allen Frumkin Gallery in Chicago
contributed to Diebenkorn's being hailed as the West Coast's leading
abstract expressionist. He certainly felt a closeness to the then ascendant
painters of the New York School, and he wrote: "I've been content to
accept the label of an Abstract-Expressionist, because I do feel a kinship
with the honest search of these painters."[55]

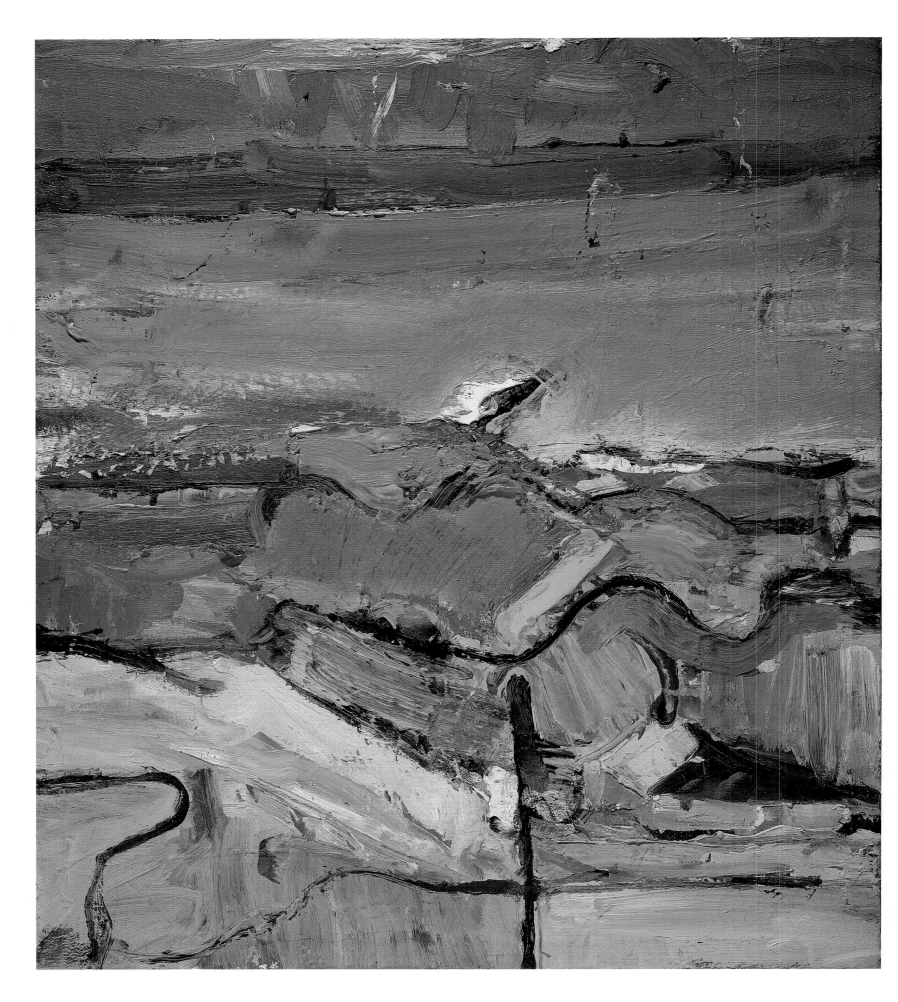

76

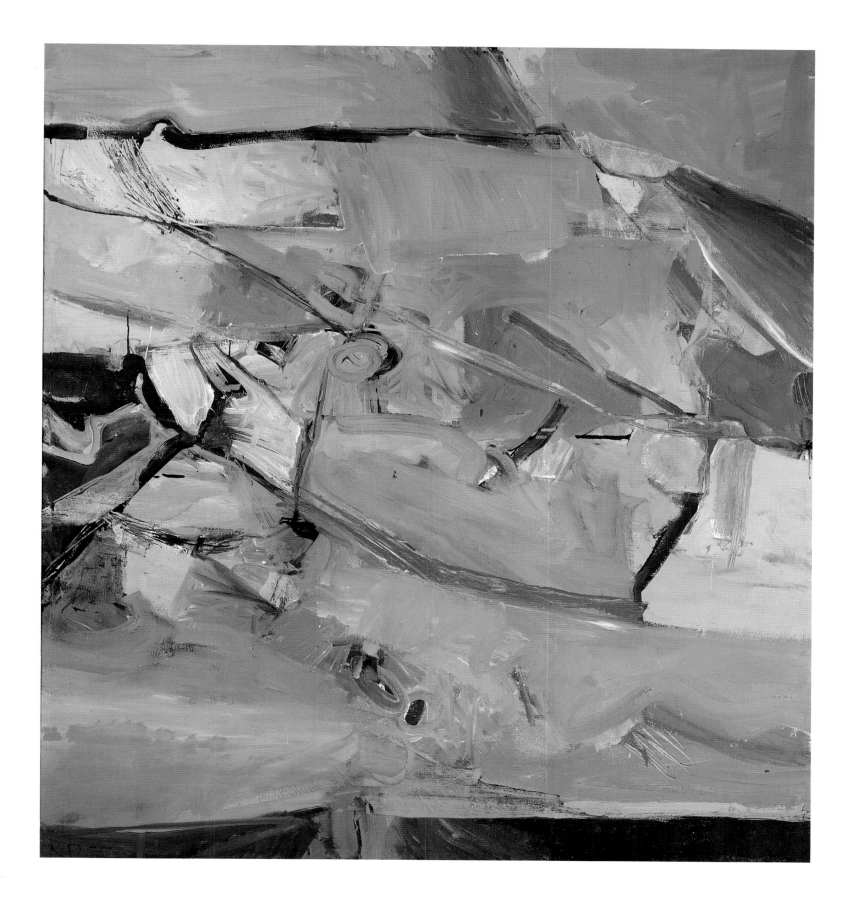

Opposite:
Berkeley, 1955. Oil on canvas. 24 x 21⅛ in.
Michael and Dorothy Blankfort collection,
Los Angeles

Berkeley No. 38, 1955. Oil on canvas. 63¾ x 58¾ in.
Sidney Feldman collection, Promised gift to
The Carnegie Museum of Art, Pittsburgh

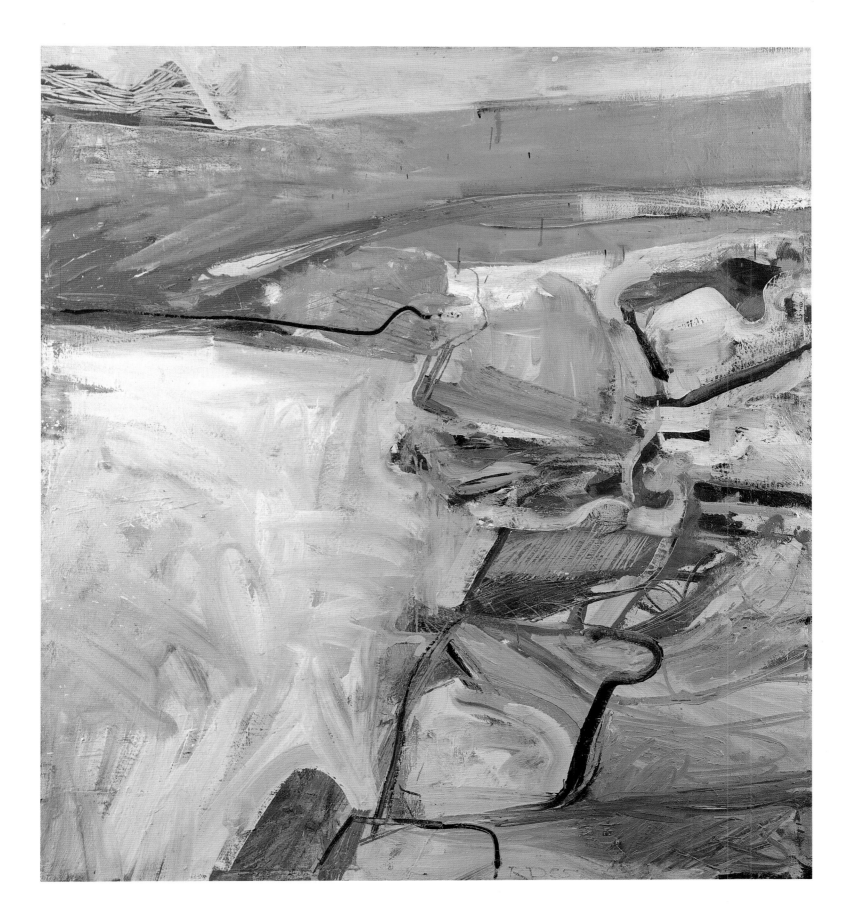

Berkeley No. 42, 1955. Oil on canvas. 57 ½ x 51 ½ in.
Contemporary Collection of The Cleveland Museum
of Art, Cleveland

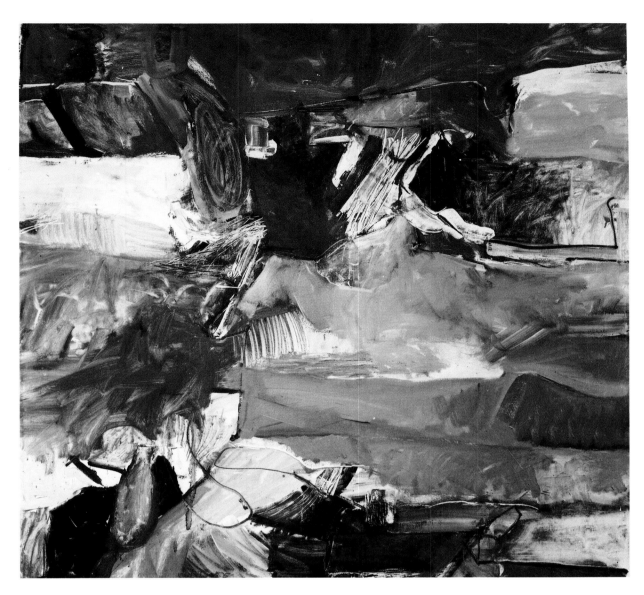

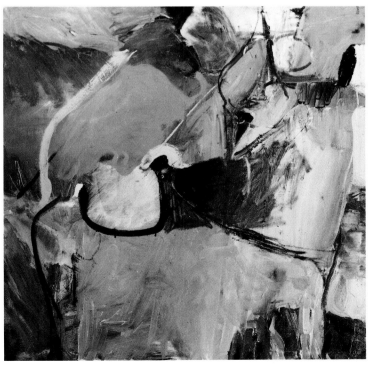

Above:
Berkeley No. 46, 1955. Oil on canvas. 58⅞ x 61⅞ in.
Collection, The Museum of Modern Art, New York,
Gift of Mr. and Mrs. Gifford Phillips

Left:
Berkeley No. 41, 1955. Oil on canvas. 28¾ x 28¾ in.
Private collection, Kansas City, Missouri

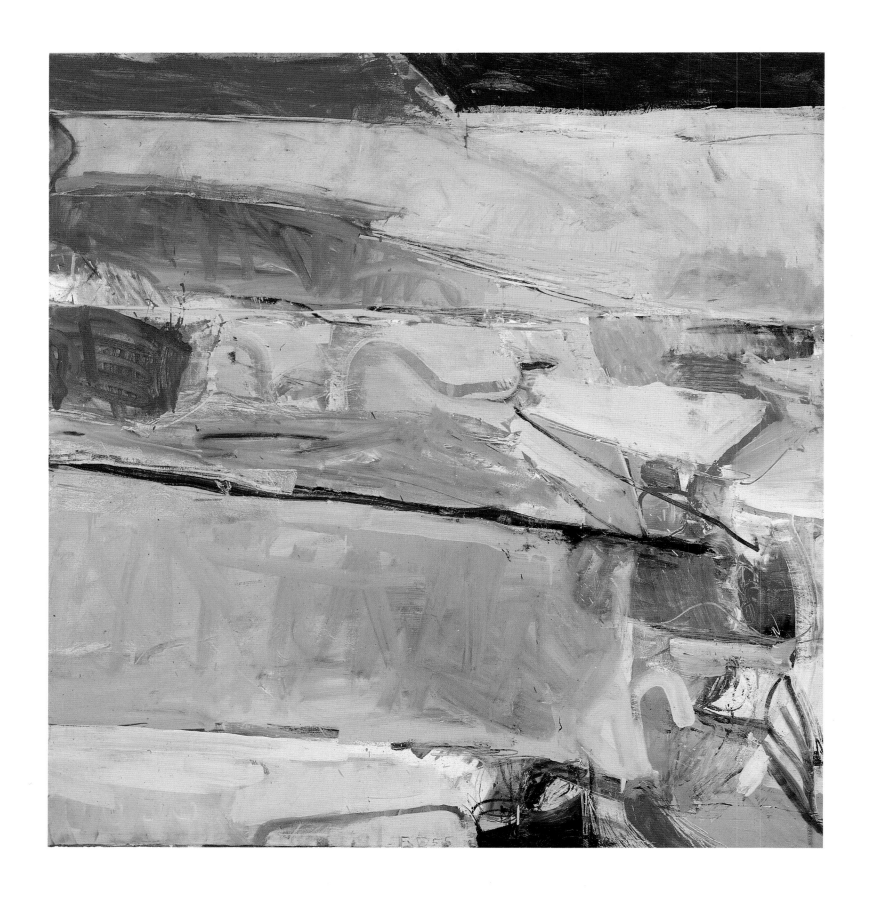

Berkeley No. 54, 1955. Oil on canvas. 61 x 58 in.
Albright-Knox Art Gallery, Buffalo, New York,
Gift of the Martha Jackson collection, 1977

80

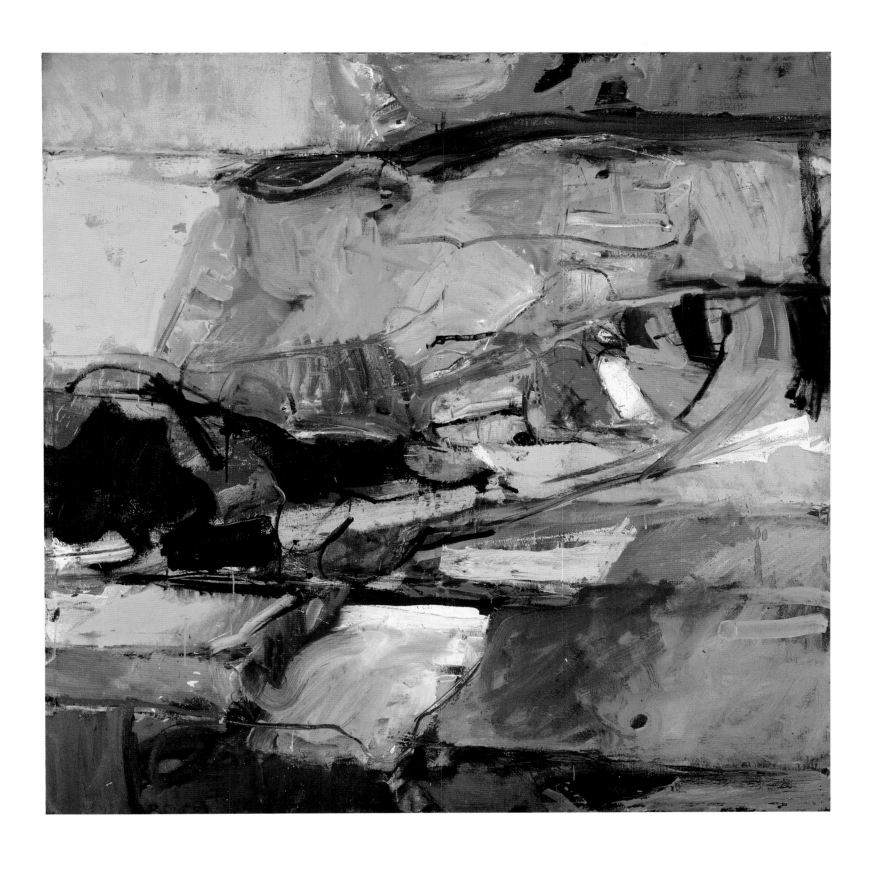

Berkeley No. 57, 1955. Oil on canvas. 58 ¾ x 58 ¾ in.
San Francisco Museum of Modern Art, San Francisco,
Bequest of Joseph M. Bransten in memory of Ellen
Hart Bransten

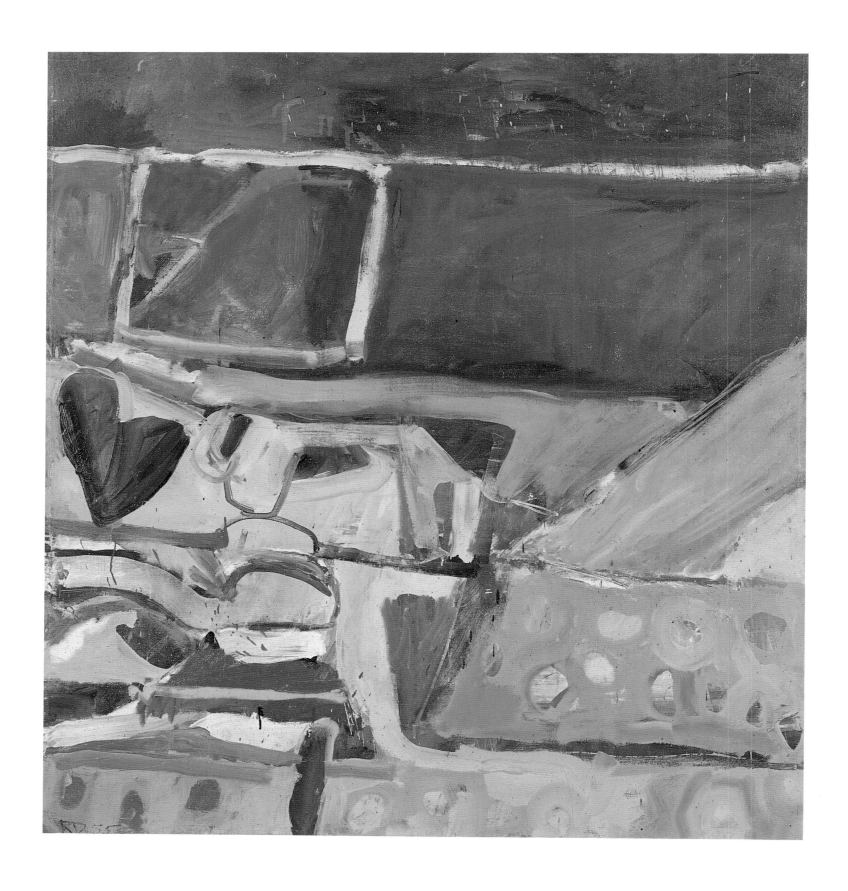

Berkeley No. 58, 1955. Oil on canvas. 64 x 59 in.
Private collection

82

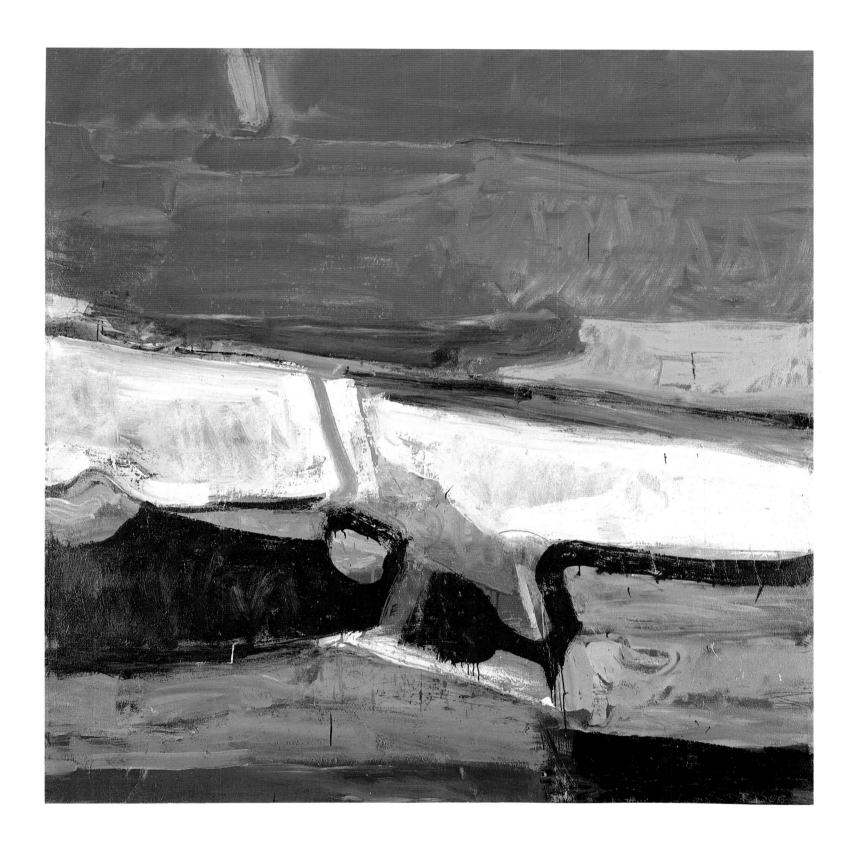

Berkeley No. 59, 1955. Oil on canvas. 59 x 59 in.
Mr. and Mrs. Walter Haas, Jr., collection,
San Francisco

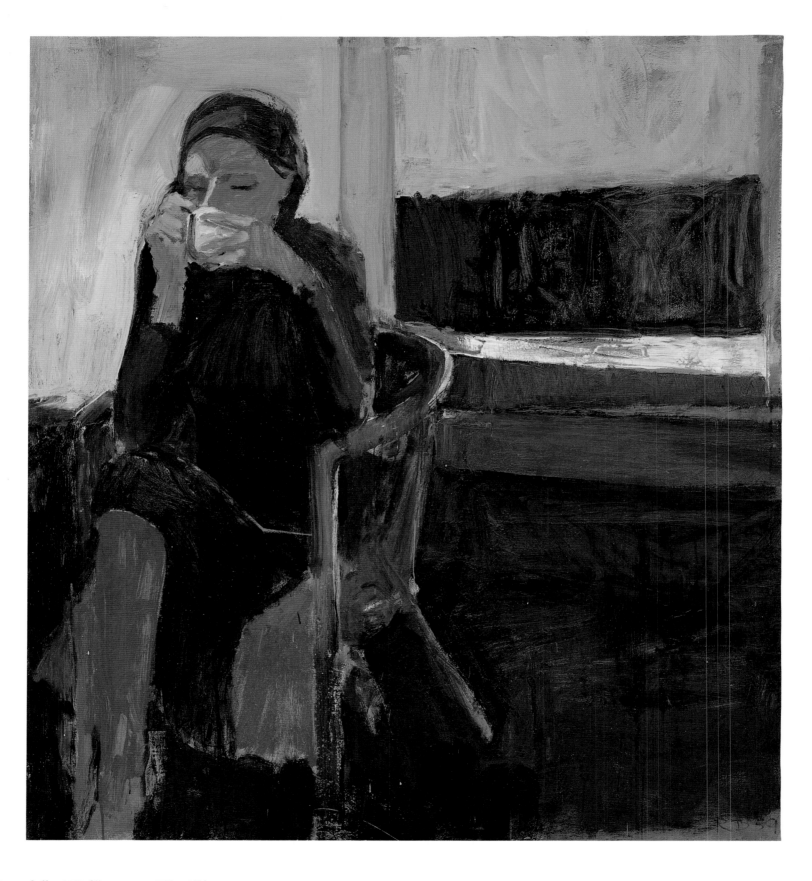

Coffee, 1959. Oil on canvas. 57 ½ x 52 ¼ in.
Edwin Janss collection, Thousand Oaks, California

David Park, *Berkeley Jazz Band*, c. 1951–53.
Oil on canvas. 38 x 48 in. Private collection

Elmer Bischoff, *Two Figures in the Garden*, 1958.
Oil on canvas. 57 x 58 in. Courtesy, Staempfli Gallery,
New York

T here seems to be no reason to doubt that Diebenkorn's Berkeley series of abstract expressionist paintings could have continued as long as did the New York style abstract works of de Kooning and Motherwell. A rising tide of approval greeted abstract expressionist painting, and second-generation artists were receiving serious recognition. It was to be more than five years before the pop art and minimalist counter insurgencies were felt, and, in fact, abstract expressionism was far from its peak of gallery, magazine, and museum enthusiasm in 1955, when Diebenkorn began to suffer some disturbing second thoughts about his work. While his respect for the first-generation leaders of abstract expressionism never flagged, he began to see only "some pretty poor contemporary work" among second-generation followers. He sensed a problem in abstract expressionist painting and he was testing his own work against the tradition of modernism he had encountered.

> I came to mistrust my desire to explode the picture and super-
> charge it in some way. At one time the common device of using
> the super emotional to get "in gear" with a painting used to serve
> me for access to painting, but I mistrust that now. I think what
> is more important is a feeling of strength in reserve—tension
> beneath calm.[56]

For a variety of reasons, no one of which is conclusive, Diebenkorn began to question his abstract expressionist work. Park's implicit criticism may have played a part—undoubtedly the sessions with Park and Bischoff in drawing from the figure and their discussions of figurative painting problems got him thinking about new possibilities and concerns he had not explored. His profound regard for such stalwarts of modernist figure painting as Hopper, Bonnard, and Matisse also may have led him to

reconsider nonabstract work. Certainly Diebenkorn was dealing with the issues of mode when he stated:

> all paintings start out of a mood, out of a relationship with things or people, out of a complete visual impression. To call this expression abstract seems to me often to confuse the issue. Abstract means literally to draw from or separate. In this sense every artist is abstract . . . a realistic of nonobjective approach makes no difference. The result is what counts.[57]

Toward the end of 1955, as Diebenkorn told it in 1985, dissatisfied with the way his painting was going, he picked up a small canvas and a paint kit, went out to his car, and drove around until he found a landscape subject that looked as if it might make a good painting. Working directly on the canvas, without a sketch, he completed the work on the spot.[58] The painting, *Chabot Valley* (p. 87) was a cityscape, viewed from a bluff across the roofs of a clutter of buildings, out over the bay and its mists. Paint was richly handled, as it had been in the nonfigurative work, impastoed and expressively applied. A strong vertical, perhaps a ladder or a lamp standard, provides an echo for the canvas's right margin. The work is clearly related to the urban cityscape and yet its paint handling has the plastic qualities of the artist's abstract expressionist paintings.

Over the next ten days Diebenkorn painted a few still-life experiments in his studio, and he felt that he might be ready to take on a figure composition on a larger canvas. The early results were not entirely satisfying to him, but they seemed promising and he was encouraged to continue. The mistrust he had for "using the super emotional" was sublimated in his responses to the challenge of the constraints presented by a "traditional" mode. Making that style his own demanded all of his sensitivities and skills, and he welcomed the challenge and was pleased to recognize the fresh flow of ideas that issued from his new involvement.

Diebenkorn did not exhibit any of these new figurative paintings but kept working at them and evaluating them, feeling his way into this new mode. The artist never knew in any programmatic way where he was going, and there was always the possibility of his returning to abstraction, if he were to find the authentic motivating force he would require of himself to do so. He was responding to the evolution of his own work, as he would to the demands of a specific canvas: if a passage needed to be moved, or painted out, or reversed, it would be done. Although Paul Kantor and some of his collectors attempted to dissuade him from his course when they learned of his new experiments, Diebenkorn followed his own convictions, insisting, "I wasn't going to let considerations about career influence me as to whether I continued the figurative painting or not."[59] It was his view that modern art was closely related to individual freedom. Whatever he did had to arise from his freedom to respond to the freshness and satisfactions of the work itself.

During the summer of 1956 the artist took time out from painting

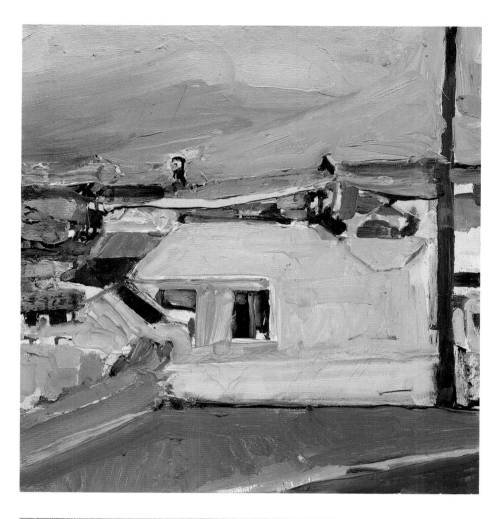

Chabot Valley, 1955. Oil on canvas. 19 ½ x 18 ¾ in.
Mr. and Mrs. Richard Diebenkorn collection,
Santa Monica, California

Landscape with Figure, 1956. Oil on canvas.
50 ¼ x 47 ⅝ in. Private collection, Boston

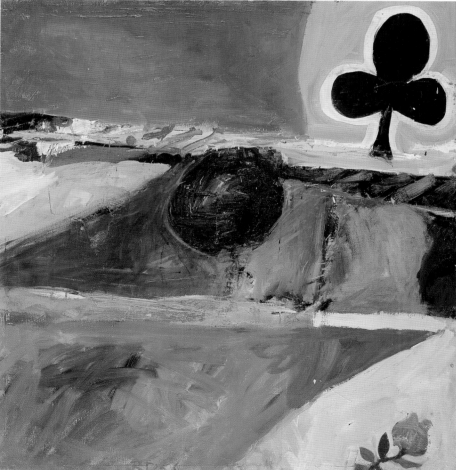

for about two months to build a studio in the backyard of his house in Berkeley. "It was a crucial time for he had just made his change in painting style and subject. He wondered if this were to be a permanent move, and during this period while he wasn't painting, he was still involved, thinking about his former landscape style."[60]

In the midst of questioning his artistic direction, the artist was achieving unprecedented recognition and success for his abstract works. In 1956 Diebenkorn exhibited a number of Berkeley abstractions at the Poindexter Gallery, his first one-man show in New York City. Although financially encouraging, the show received nondescript reviews, except for the notice by Dore Ashton in *Arts and Architecture*: "In the best works—which are really splendid—the forms don't matter much, for Diebenkorn is able to sustain a flow which is far more important. . . . He appears to me to be a born painter."[61] Later in the year, the Whitney Museum invited a painting to its Annual Exhibition, as did the Oakland Museum and the San Francisco Museum of Art. In the latter two cases Diebenkorn received prizes. The Swetzoff Gallery, in Boston, held a small one-man show of works from the Poindexter Gallery the following year.

In 1973 Diebenkorn responded to a questionnaire about his move toward figurative painting, saying, in part:

When I made that change, I wanted my work to be more inclusive. What constituted painting, for me, changed hardly at all—at first. For someone who was intending to continue as an abstract painter I was clearly consorting with the wrong company. Park, Bischoff, and I drew regularly from live models, and we met often at which time we talked about painting problems—but with a heavy emphasis on their relation to representation. I was without doubt influenced by Park and Bischoff and their figure drawing and I finally took the step in my painting. And what happened as a result of trying to keep my painting conceptions intact while dealing with figure spaces, and the effect that a represented human presence had on the mood and flavor of my work, was, for me exciting and compelling. I didn't at first realize the extent to which features of great importance to me were necessarily to fall away or be sacrificed in this process. It was enough to feel (new to me) that a whole picture might develop out of a simple figure idea and that its parts, in a sense, were in place at the beginning. Also, a delusion appeared, but only momentarily, which was that I knew what I was doing.[62]

In 1969, while he was entering into the Ocean Park paintings, Diebenkorn recalled his thinking about the beginning of his figurative period, in an interview with Gail Scott:

I can remember that when I stopped abstract painting and started figure painting it was as though a kind of constraint came in that was welcomed because I had felt that in the last of the abstract paintings around '55, it was almost as though I could do too much, too easily.

There was nothing hard to come up against. And suddenly the figure painting furnished a lot of this. . . . [63]

Art News magazine commissioned an article, in a series, to be titled "Diebenkorn Paints a Picture" on the basis of the 1956 Poindexter exhibition of the powerful Berkeley period abstractions. Dr. Herschel Chipp a modern art historian and professor at the University of California, Berkeley, wrote the article, published in 1957, about the painting of a figurative canvas. It was something of an unusual event at the time, documenting the work of a West Coast artist in a key national magazine.

Chipp described Diebenkorn's working habits and then recorded the development of *Woman by the Ocean*, 1956. The artist began by sketching a male figure against a shoreline in light lines and washes on a previously sized and primed canvas. The following day, after intent study, he repainted the canvas, moving the figure forward and into a standing position. The artist then developed the background in a geometric manner, changed it into a cultivated field scene, and finally scraped it out altogether, returning to a simplified, layered, and spacious landscape. This new landscape changed his feeling for the figure and it was repainted as a woman. Further study of the canvas prompted the artist to paint the figure out and move it to the left side of the canvas, where she was seated. Some structural aspects of the previous state were retained, and some of the earliest aspects returned to be included at the end. The painter then closed in the space by painting in a canvas canopy and providing a diagonal line as a porch structure reinforced by a broad echoing bar of yellow on the floor.

Diebenkorn was accused of "hesitancy" and "indecision" in his painting process. He had begun with a rough self-portrait sketch as his subject, subsequently placing the figure in a landscape, only to keep adjusting it within its environment. His trial-and-error methodology, evident from his earliest abstract days, was not economical either in terms of time or of materials. It was improvisational, based on the artist's intuitive approach and his necessity to develop the work in the process of painting. Honest response to personal search was his driving imperative. Fidelity to what occurs between the artist and the canvas, no matter how unexpected, was a central working principle. He once said:

I keep plastering it until it comes around to what I want, in terms of all I know and think about painting now, as well as in terms of the initial observation. One wants to see the artifice of the thing as well as the subject. Reality has to be digested, it has to be transmuted by paint. It has to be given a twist of some kind. [64]

In one of the artist's miscellaneous studio notes, he once wrote, "I can never accomplish what I want, only what I would have wanted had I thought of it beforehand." This somewhat Delphic statement demands interpretation. He could never go directly to a solution, but had to paint what he thought he wanted, react to that by modifying, correcting, painting

Still Life with Orange Peel, 1955. Oil on canvas.
29 ¼ x 24 ½ in. Private collection, San Francisco

Still Life with Matchbook, 1956. Oil on canvas.
26 ½ x 30 in. Mr. and Mrs. Richard McDonough
collection, Berkeley, California

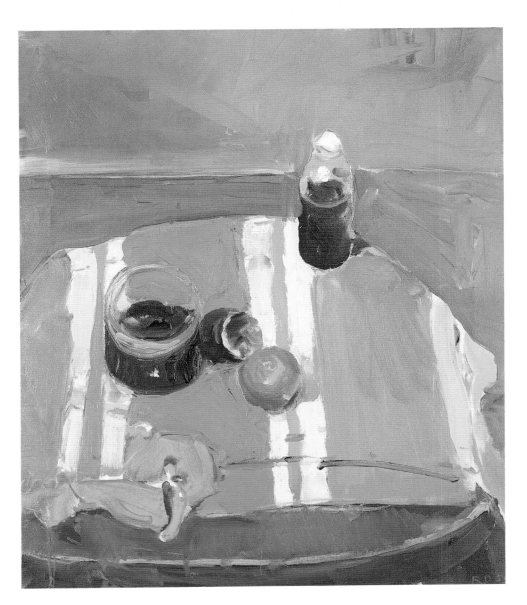

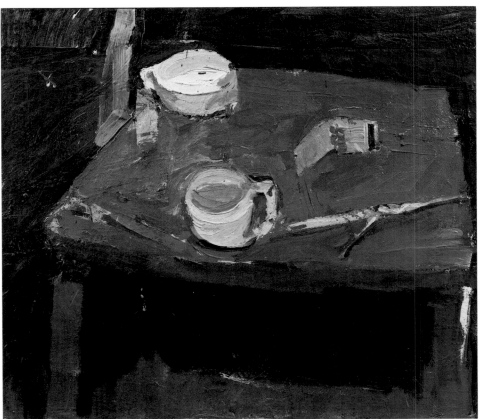

90

Girl and Three Coffee Cups, 1957. Oil on canvas.
59 x 54 in. Yale University Art Gallery, New Haven,
Connecticut, Gift of Richard Brown Baker, B.A. 1935

Portrait of the artist, 1956

it out, and then continue to work until he sensed the coherence and balance he had originally sought.

> The painting of things is involved with the logic of how they go together. Have to make compromises. That is something that is not necessary in abstract painting and I wish that it were. The conflict between the conception and how to realize it helps to keep the ball rolling, it creates a struggle that is important to painting. That can fall away in abstract painting.[65]

The presence of a human figure in a painting created a new and demanding atmosphere for Diebenkorn:

> There are numbers of problems in figure painting as opposed to abstract painting. They sound very elementary when discussed. The figure that takes over and rules the canvas. The problems of gravity in that you can't float around in space like Chagall. Ordinarily one stands on a floor, and there is ordinarily a requirement to complete an object once you've begun or suggested it. You don't leave only a half of an objective element painted. You have to finish it and maybe it doesn't conform to your wishes that way.[66]

In 1957–58, Paul Mills, curator of the Oakland Art Museum, organized an exhibition entitled "Contemporary Bay Area Figurative Painting." Diebenkorn, Bischoff, and Park were represented, among nine other artists. Mills was struck by the fact that three well-recognized local abstract painters had moved to figurative work within the same short time span, continuing their use of expressive paint handling. Although the exhibition was the first devoted entirely to new figurative paintings, Mills was pledged by Diebenkorn to avoid the suggestion of a "movement" in his catalogue essay and noted, "whatever these paintings may have in common, the different, individual personalities of the painters remain the stronger factor. . . . I would rather have this exhibition be thought of as a kind of introductory sampling rather than as a definitive survey." At the close of his essay he asserted "there is nothing the principal artists involved in this [new painting] want less than a new movement. What they are doing now they are doing partly because they are tired of the whole business of movements and trends in the first place."[67]

Nevertheless "Bay Area Figurative" did come to be perceived as a trend, and artists began to identify with it or to oppose it, and the art world took notice. Individuals and institutions with an investment in abstract expressionism tended to feel that the return to figuration was a defection from the mainstream of contemporary work. Those who had always questioned abstraction or expressive abstraction felt a validation in the defection of serious artists and particularly in that of a fast-rising figure such as Richard Diebenkorn. All of this extra-art ferment interfered with a fair viewing of the paintings and an unbiased response to their qualities and achievements.

Diebenkorn pushed ahead into his figurative work with an increasing

excitement and a sense of powerful purpose. In the first few years of representational work the artist could not keep up with the flow of his ideas and the opportunities to realize stimulating possibilities. His bold and vigorous paint handling was applied to figurative imagery, giving his work a rewarding freshness. As always he worked from his own feelings, developing, criticizing, reassembling, and synthesizing his visual concepts in the complex evolution of a painting.

Diebenkorn tended to think of the still life as the most objective form of figurative painting. He then ranked interiors, landscapes, and figure compositions in a rising hierarchy of complexity and challenge as subjects for the painter. He began with more objective exercises, but once well launched in the period, he moved freely back and forth between different levels of complexity in representational painting.

The still-life paintings demand rather intimate viewing, at a short distance, with an intense focus on the tabletop plane. The angle of vision is concentrated so as to exclude foreground and background, making representational elements dramatic characters on a tilted field. This abrupt angle of vision is no accident. It is not a traditional Western angle, but Diebenkorn took his suggestion from Matisse's *The Painter's Studio* (*L'atelier du peintre*), 1911, *The Window* (*La fenêtre, intérieur*), 1916, and *Interior at Nice* (*Grand intérieur, Nice*), 1921. In *The Studio, Quai Saint-Michel* (*L'atelier, Quai Saint-Michel*), 1916, Matisse positioned a taboret table dissonantly at odds with the floor plane, the easel and chair, and the window perspective. The tilting of planes upward toward the vertical had been utilized by van Gogh and Gauguin and with great boldness and even greater conviction by Cézanne.

In *Still Life with Letter*, 1961 (p. 94), the viewer looks down into a matter-of-fact depiction of the artist's studio table with a match-striker, opened sketchbook, letter, coffee cup, and can lid scattered across a blue-gray plane. As forthright as these elements seem, they must be perceived as unconscious expressions of choice, renditions of familiar objects for which the artist feels sentiment. His father's match-striker occupied an available spot in every studio he had. The keen observation and effective translation of ink surfaces is demonstrated in the cropped sketchbook. Likewise the subdued illusionism of the classic roadside-diner coffee cup touches a quality of imagery that is both routinely familiar and satisfyingly universal. "I have found in my still-life work that I seem to be able to tell what objects are important to me by what tends to stay in the painting as it develops."[68] The artist's affection and respect for these apparently trivial counters is communicated through the close-up vision, the subtleties of the blacks, and the dynamic character of the cropping.

Poppies, 1963 (p. 95), places the table in a centered space, tilting it at an exaggerated angle. The off-centered vase of poppies leans slightly to the right. The translucent gray-blue tablecloth permits a shine-through of parallel stripes from a second cloth, which underlines the severe angle of the table plane and questions the "rightness" of the seating of the vase. Two small wedges of black-and-white striping at the unbalanced right-hand corners of the table can be read as a corroboration of the transparency of the table cover. A ribbon of blue, white, and red extends from the upper

Portrait of the artist, 1958

canvas margin to the tabletop, asserting the background plane and forcing
it forward, and gives the illusion (in one of those particular Diebenkorn
twists of observation) of running into the yellow-gold of the poppies,
creating a visual tension.

Still life tends to center on the private, the domestic, or the convivial,
in that it consists of objects that are subordinate to man as elements of
use and enjoyment, smaller than human scale, evoking man's sense of
ownership and control. The still life brings to awareness the complexity
of human experience and the interplay of perception and artifice in repre-
sentation. It tends to invoke a mood of objectivity but may be equally
expressive of passion as of cool observation.

In Diebenkorn's work the objects seem distanced from the personal, and
their significance tends to be veiled. The purpose is the artist's aesthetic
one. The objects are usually taken as they come in the workshop, scattered,
yet creating overtones of harmony between the parts. As in all works by
Diebenkorn the interplay of imagery and how it is painted is open to a
range of expressive treatment, from barely recognizable to trompe l'oeil.

The still-life genre is both intellectual and emotional. Its message can
be tremendously varied, from serving as identification or a pretext for
painting to conveying conscious and even unconscious expressions of
personal feeling associated with the subject matter or the way in which
content is presented, or through serving as symbolic carriers of meaning.

Four still-life paintings from 1959–63 combine the humor of extremely

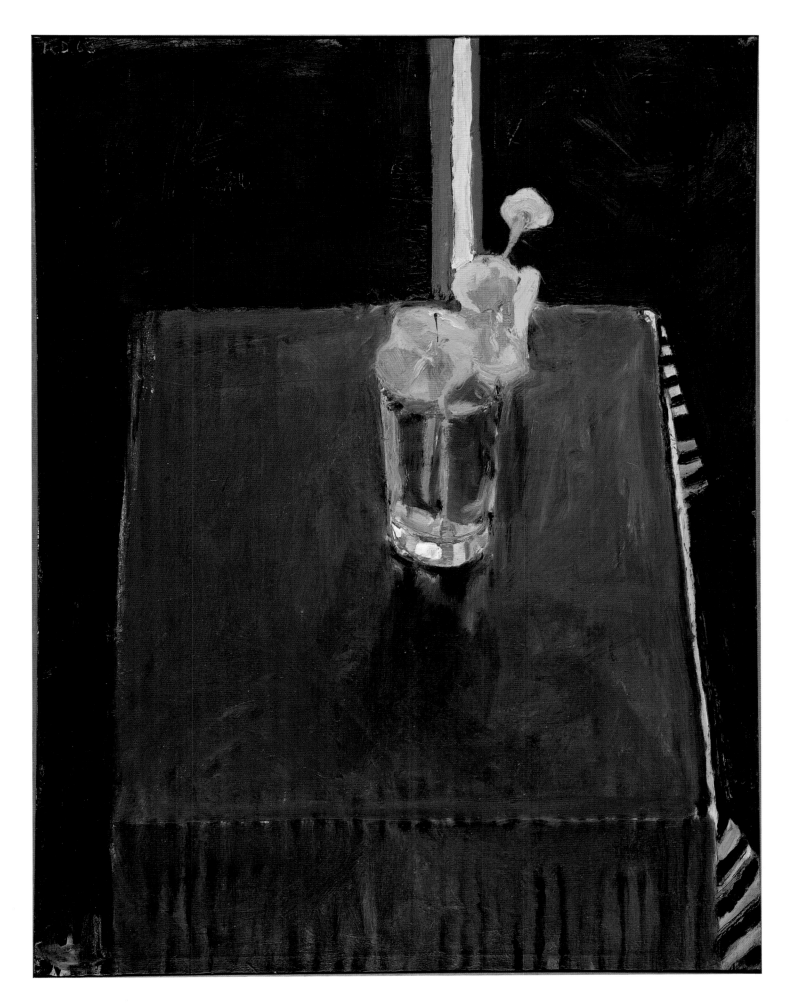

95

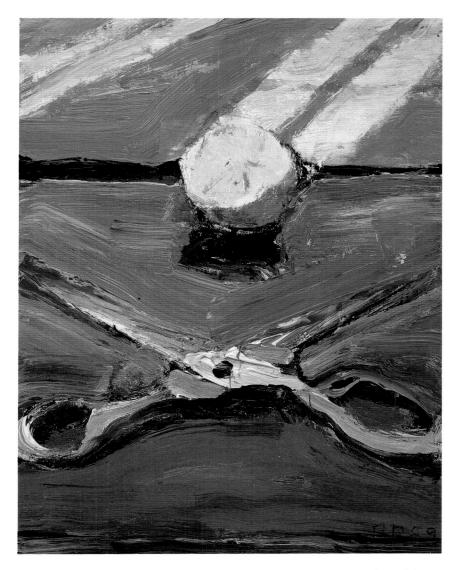

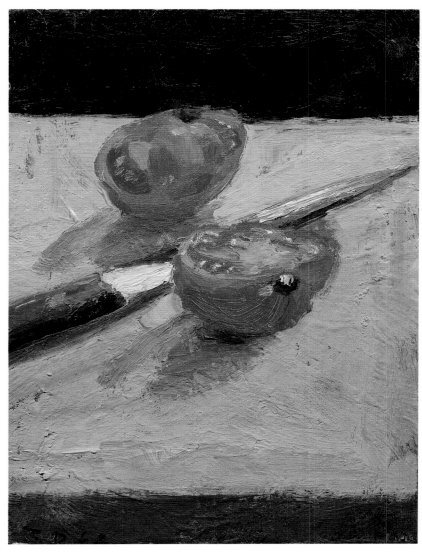

Scissors and Lemon, 1959. Oil on canvas. 13 x 10 in.
Private collection

Tomato and Knife, 1962. Oil on canvas. 13 ¾ x 10 ¼ in.
Private collection

prosaic subject matter with a frank sexual symbolism in a manner that is atypical of the artist's work. *Scissors and Lemon*, 1959 (p. 96), is a small canvas, measuring only 13 x 10 inches. A heavily painted green–and–white striped table cover, used in many of the still life compositions, occupies the upper one-third of the picture space, and the double white stripes serve as an emphasis for the placement of the halved lemon and its intense cast shadow. The lower half of the painting is dominated by a heavily impastoed pair of opened scissors menacing the fruit, which is pushed forward by the bold striping upon which it is displayed. *Tomato and Knife*, 1962 (p. 96), disposes a pointed kitchen knife flat on the table between two hemispheres of a presumably just halved, almost palpable tomato. *Tomato and Knife*, 1963 (p. 97), a companion painting, recasts the previous subject on the vertical axis of an even smaller canvas. The knife handle falls outside the lower margin while the blade touches the upper one, resting upon the severed flesh of the tomato.

In *Knife in a Glass*, 1963 (p. 97), the same ivory-handled knife is propped up in an off-centered glass, with the blade partially submerged in a clear liquid, half distorted by the upper curve of the glass and half seen emerging from the glass. Of this breathtaking work Hilton Kramer wrote:

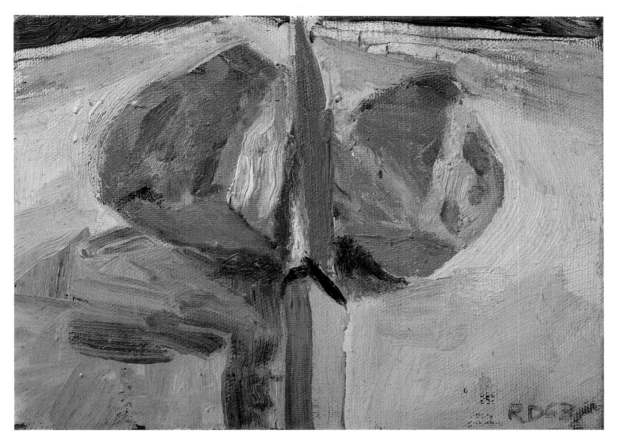

Tomato and Knife, 1963. Oil on canvas. 5 ⅝ x 7 ⅞ in.
Private collection

Knife in a Glass, 1963. Oil on canvas. 8 ½ x 11 in.
Unknown collection

Cup and Knife, 1964. Conté crayon, ink, and gouache on paper. 11¼ x 11⅛ in. Mr. and Mrs. Richard Diebenkorn collection, Santa Monica, California

Lemons and Jar, 1957. Oil on canvas. 18 x 24 in. Private collection

Bottles, 1960. Oil on canvas. 34 x 26 in. Norton Simon Museum of Art, Pasadena, California, Gift of the artist, 1961

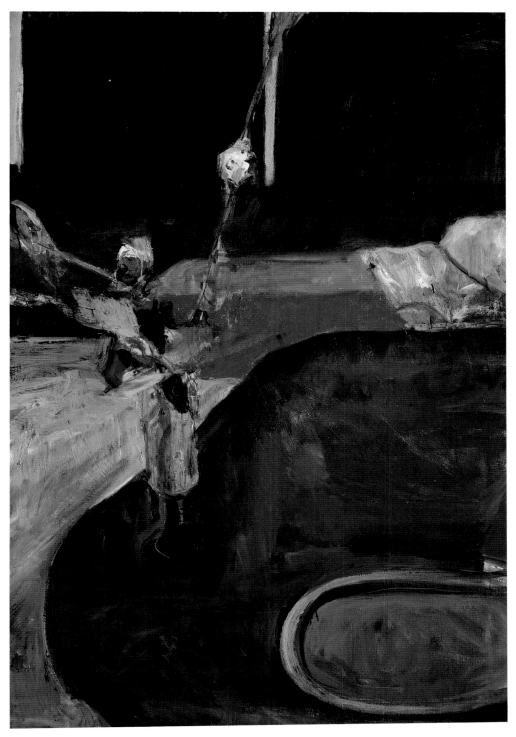

The single most impressive painting in the Poindexter exhibition last month was, for me, one of the smallest, the still life called *Knife in a Glass* (1963). Here the advance in realism has thrown the artist back about a hundred years in the history of style: impure Diebenkorn is, in this instance, the purest Manet. Only a painter of the greatest skill and sensitivity could have produced it, yet there is something almost anonymous in its old-fashioned emulation of a received vision and a practiced technique. One hardly knows whether to embrace its audacity—it is certainly a very beautiful painting—or shudder at such naked esthetic atavism. . . .[69]

Interior with Flowers, 1961. Oil on canvas. 57 x 39 in. Private collection, San Francisco

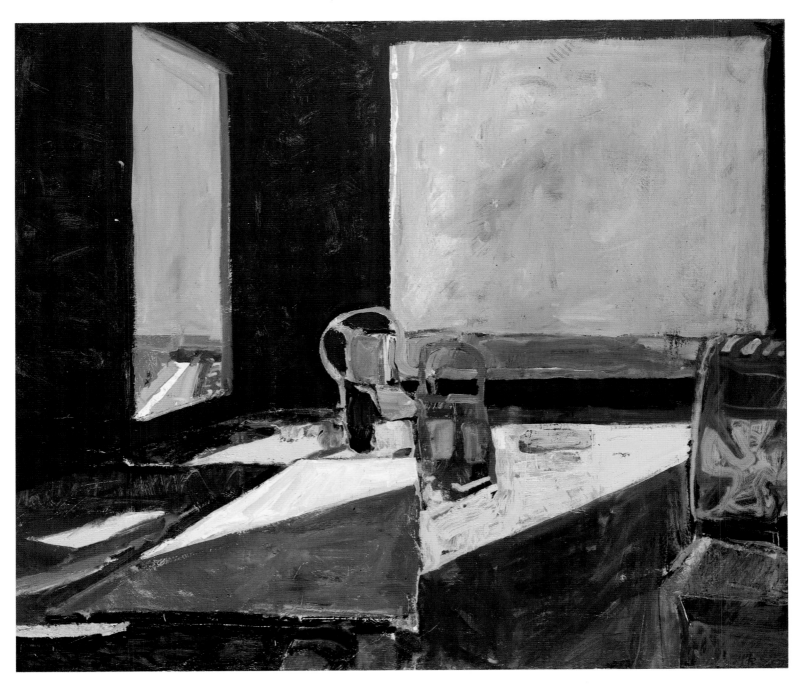

Interior with View of Ocean, 1957. Oil on canvas.
49 ½ x 57 ¼ in. The Phillips Collection,
Washington, D.C.

The still life can easily be expanded to an interior, taking in the room environment, the related furniture and decorative appointments, even an open window or doorway looking into another room or upon nature. *Interior with View of Ocean*, 1957 (p. 100), presents a large dark-walled room with three chairs, a table, and two windows with light pouring in, falling dramatically on the floor, angling across the table, and puddling unpredictably. Ocean and sky can be seen through the large window and a second window. The smaller window in the receding left wall reveals a view of a road rising to a distant horizon and water. Bright skies, palpable direct sunlight, contrasting shadows, and dark walls establish a powerful pictorial architecture. Each of the color blocks is built up characteristically of transparent layers, reflecting underpaint, ghosts of revisions, and a distinct light for each color area. A sumptuous painterliness pervades the entire composition.

Corner of Studio—Sink, 1963 (p. 101), is an interior with still-life concerns, handled in an architectonic manner, without the window or doorway light source. It typifies a number of works from the early 1960s in which the artist utilized a corner mirror for telling reflections and surprising effects. In this case the viewer recognizes an industrial sink with double faucet and single spigot assembly. Above the sink can be seen a shelf with jars and bottles, soaps and packages. Below the sink one follows plumbing and a disconnection device to a pail. A corner cabinet with a hanging mirror reflects an angled view of the sink faucet. The sobriety of the color scheme—black, brown, and dark gray (with pale gray chest and sink), accented with oranges and reds—is reminiscent of Chardin. The canvas has a monumentality that contrasts with the mundane nature of its subject matter. Compositional development is expressed so subtly that the artist's techniques disappear into the subject matter on one hand and on the other into the abstract arrangement of color spots and patches.

Interior with Book, 1959 (p. 105), is a carefully constructed painting that evokes a powerful illusion of three-dimensional space in the corner of a windowed porch. An armchair, its back to the window, faces a table on

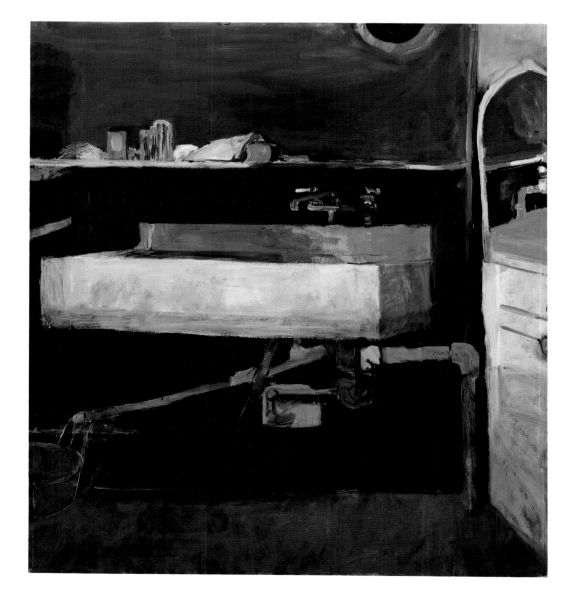

Corner of Studio—Sink, 1963. Oil on canvas. 70 x 77 in. Mr. and Mrs. David N. Yerkes collection, Washington, D.C.

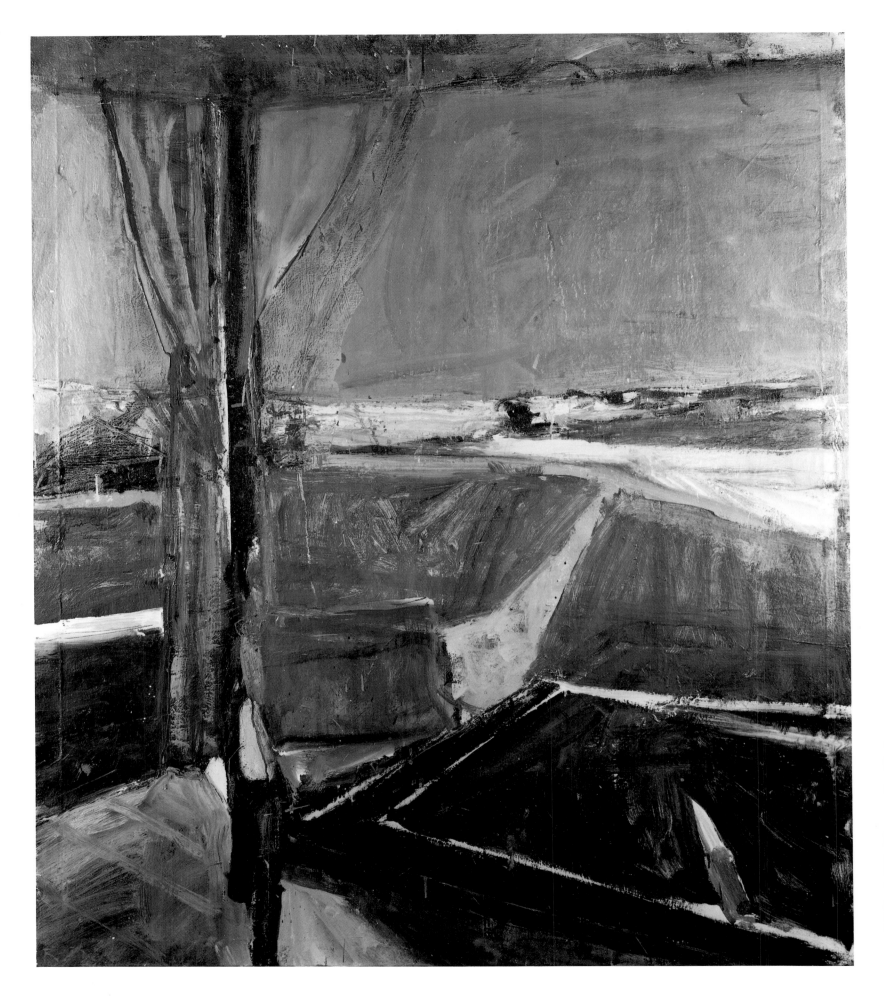

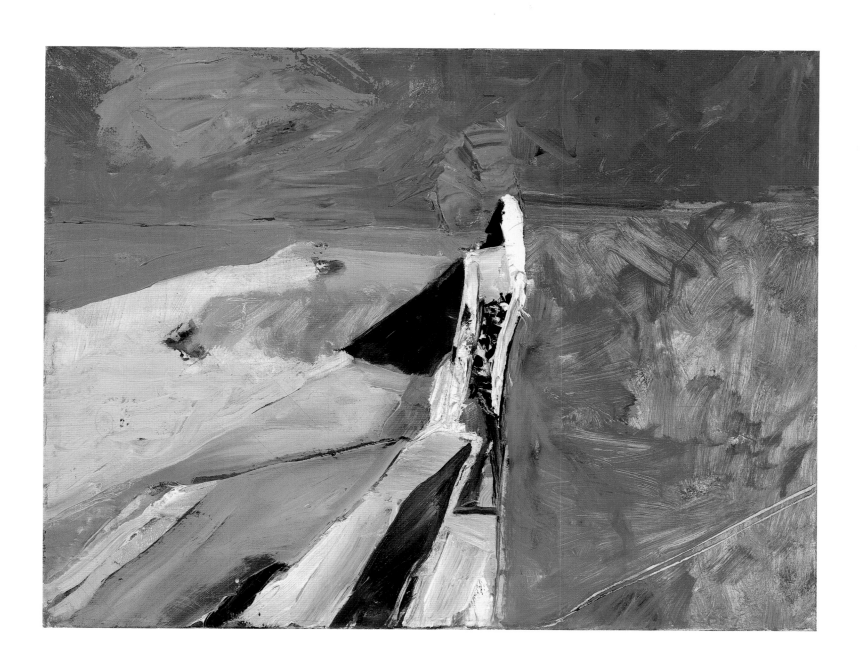

Opposite:
Black Table, 1960. Oil on canvas. 55 ½ x 47 in.
The Carnegie Museum of Art, Pittsburgh,
Gift of Mr. and Mrs. Charles Denby, 1970

Above:
Seawall, 1957. Oil on canvas. 20 x 26 in.
Mr. and Mrs. Richard Diebenkorn collection,
Santa Monica, California

103

which a book, tumbler, and plate are vivid subjects. A sun-drenched landscape stretches out behind to a saturated blue sky. *Horizon—Ocean View*, 1959 (p. 106), is a companion painting and perhaps even more unusual for its bonding of the three-dimensional illusion to the surface effect with the integration of a two-dimensional scaffold as relentless as any of those of Piet Mondrian. The window plane corresponds to the picture surface, with incidents established along every margin and at every corner. The picture plane is tied to deep space through the device of telephone poles with their sagging wires, at the same time that the expressionist handling of the modulated field and layered effect of land, sea, sky, and sunshade recall the spontaneous effects of the Berkeley abstractions. Whereas the flattened Berkeley works are diagrammatic in their layering of space, the new landscapes maintain a tension between the implicit picture plane and the unabashed depiction of recessive space.

View from the Porch, 1959 (p. 107), is a painting of a northern California vista, looking across farmland toward a distant city, with light reflecting off white buildings. The porch and stair railings, a vertical column, and the tilted deck establish the flattened picture plane through which the view is experienced. The dark fields are enlivened by sunlight falling on red, green, yellow, and gold patches in steep perspective, reaching toward the distant horizon. The expressive paint handling and the strong color of this masterful work carry a convincing sense of landscape and the personal way in which it is seen.

Ingleside, 1963 (p. 111), is an austere, reductive composition, depicting a suburban neighborhood with macadam streets, sidewalks, cross streets, houses and trees, and a hill traversed by two streets and banked with houses that merge in the distance. Gray-blue and white predominate, with some red-roof accents and scattered greens suggesting vegetation. The painting makes use of a deep illusionistic space and is worked with finesse at the expense of the flatness achieved in other canvases of the period.

Cityscape I (Landscape No. 1), 1963 (p. 112), treats the San Francisco hillside as if it were a tilted table plane. The painting presents an aerial perspective of a hill street, observed on the left and imaginatively invented on the right by the removal of a line of buildings and the improvisation of a field used with a wash. The powerful effect of using the shadows of the massed buildings on the left side of the street to darken the grassy field, while throwing alternating triangles of bright yellow-green into sunny relief, is seductive. This painting is closely related to *Cityscape (Landscape No. 2)*, 1963 (p. 113), which depicts two-thirds of the hillscape and examines precisely the same roof and building forms from a slightly different aerial perspective, while omitting the upper cluster of buildings and the park opposite. There can be no question of the artist's fidelity to his subject matter, and those elements play a significant role in the light and shadow drama of the canvas. On another level of viewing the artist's choice of perspective angle made the work a broadly patterned, quasi-abstract canvas.

Compositions involving one or more human figures, whether in an enclosure, on a porch, or in nature, are perhaps the best known of Diebenkorn's works in the representational vein. He certainly felt that

Interior with Book, 1959. Oil on canvas. 70 x 64 in. The Nelson-Atkins Museum of Art, Kansas City, Missouri (Gift of the Friends of Art)

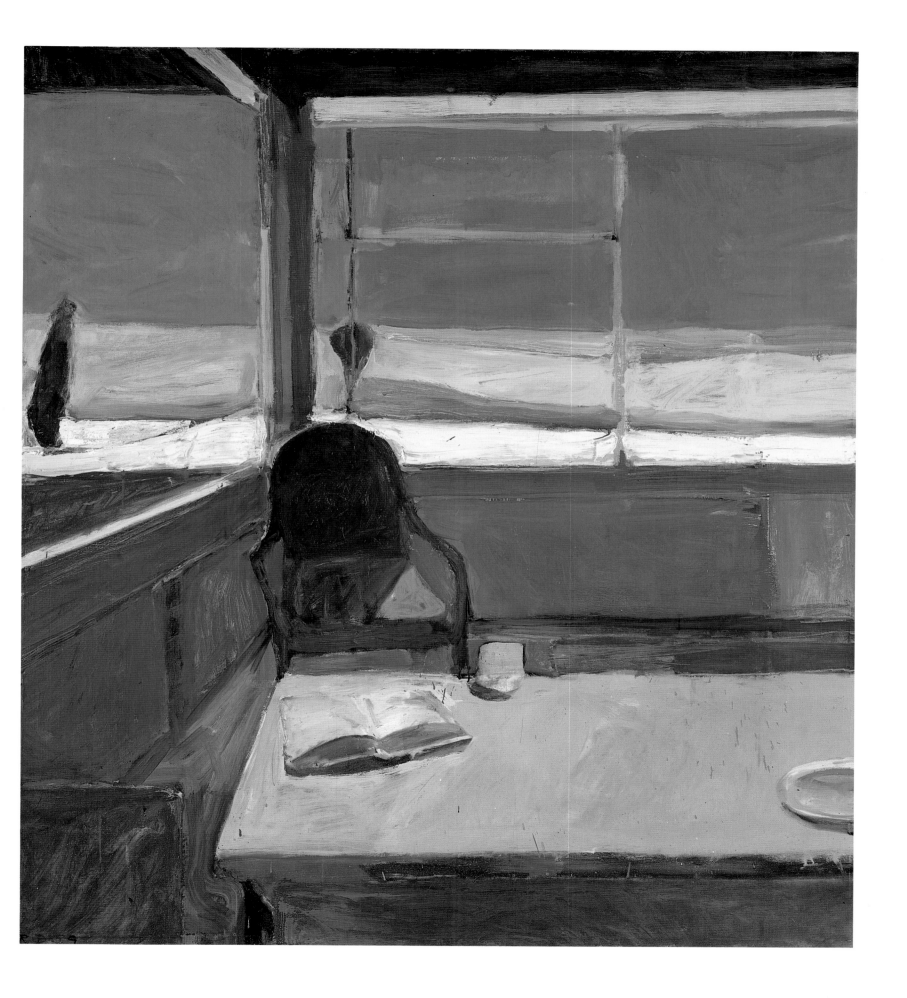

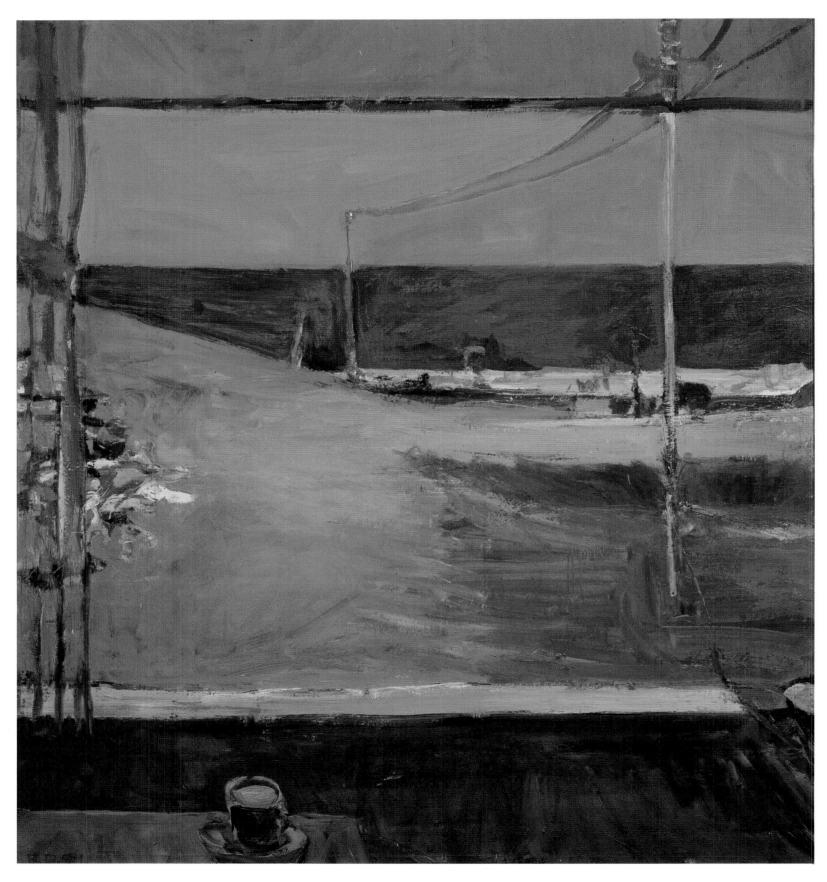

Horizon—Ocean View, 1959. Oil on canvas.
70 x 64 in. Courtesy, The Reader's Digest
Association, Inc.

Opposite:
View from the Porch, 1959. Oil on canvas.
70 x 66 in. Mr. and Mrs. Harry W. Anderson
collection, Atherton, California

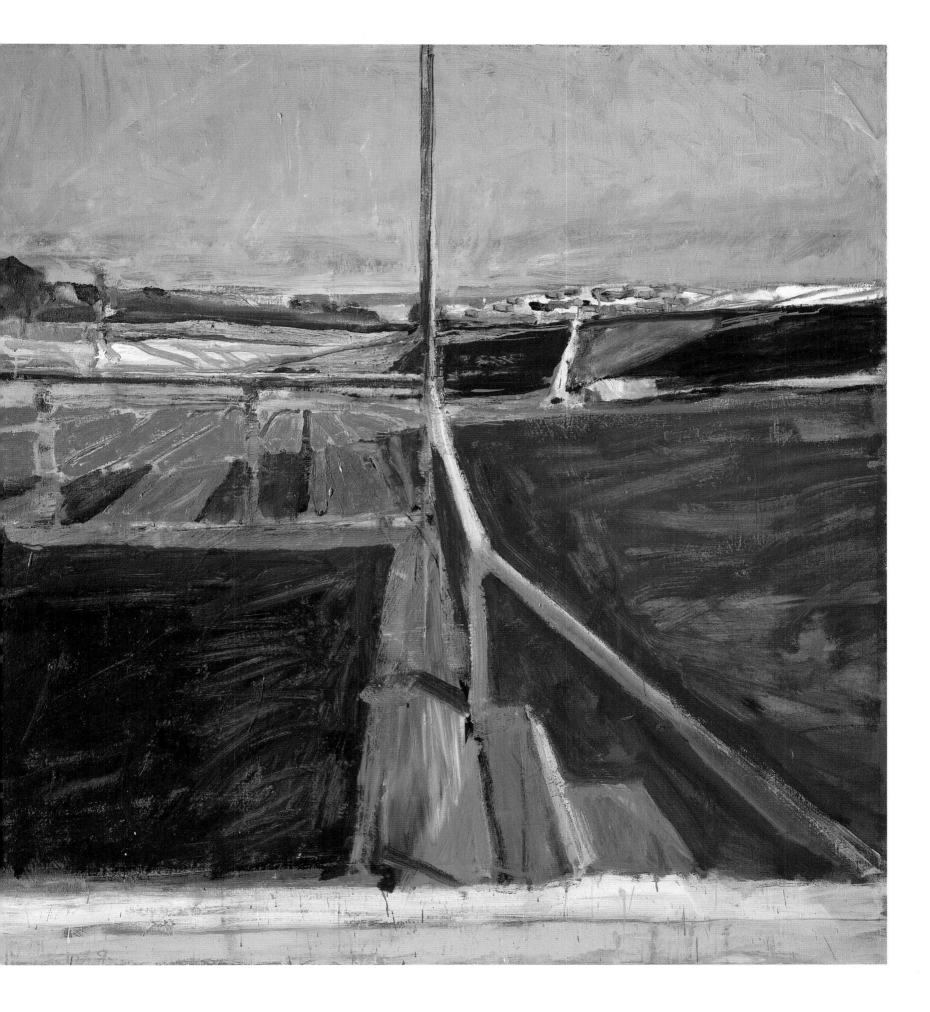

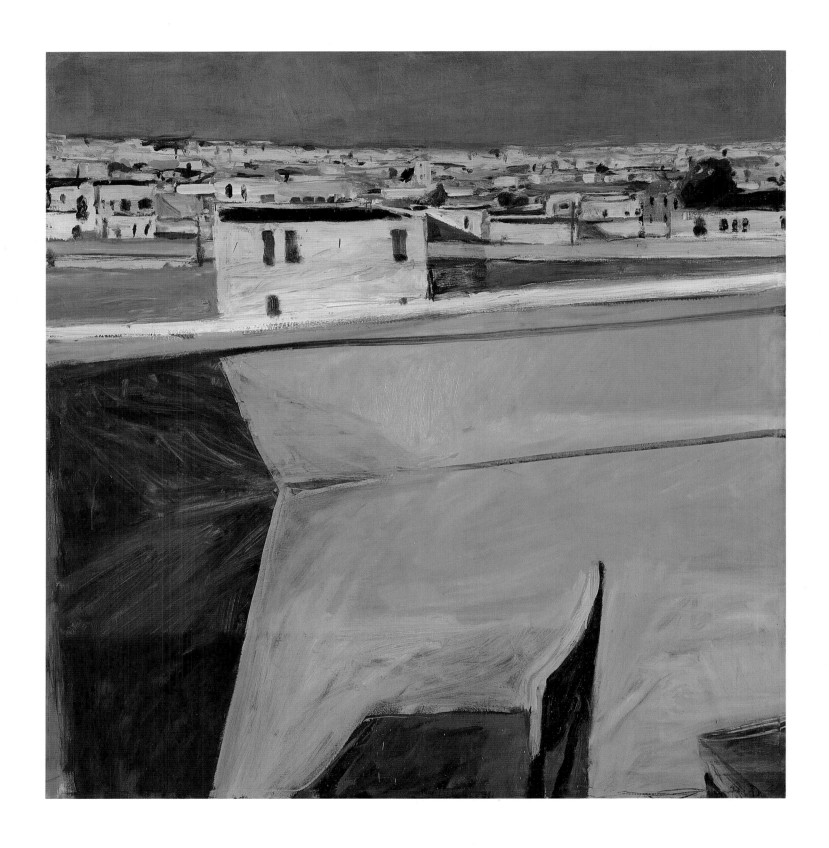

Yellow Porch, 1961. Oil on canvas. 70 ½ x 67 in.
California collector

Opposite:
Interior with Doorway, 1962. Oil on canvas.
70 ¼ x 59 ½ in. Pennsylvania Academy of the
Fine Arts, Philadelphia, Gilpin Fund Purchase

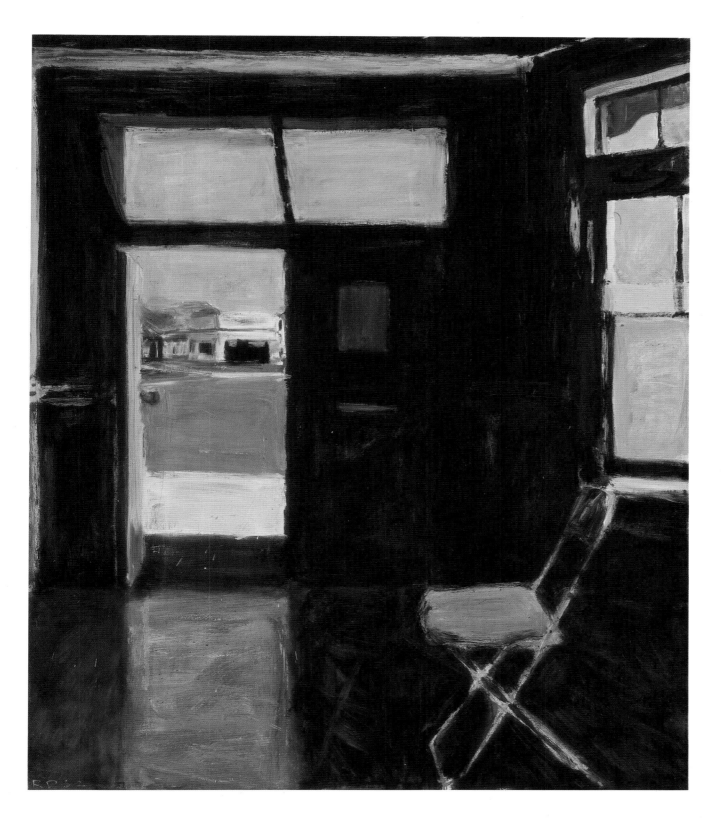

Page 110:
Interior with View of Buildings, 1962. Oil on canvas.
84 x 67 in. Cincinnati Art Museum, Cincinnati,
The Edwin and Virginia Irwin Memorial

Page 111:
Ingleside, 1963. Oil on canvas.
81 ¾ x 69 ½ in. Grand Rapids Art Museum,
Grand Rapids, Michigan

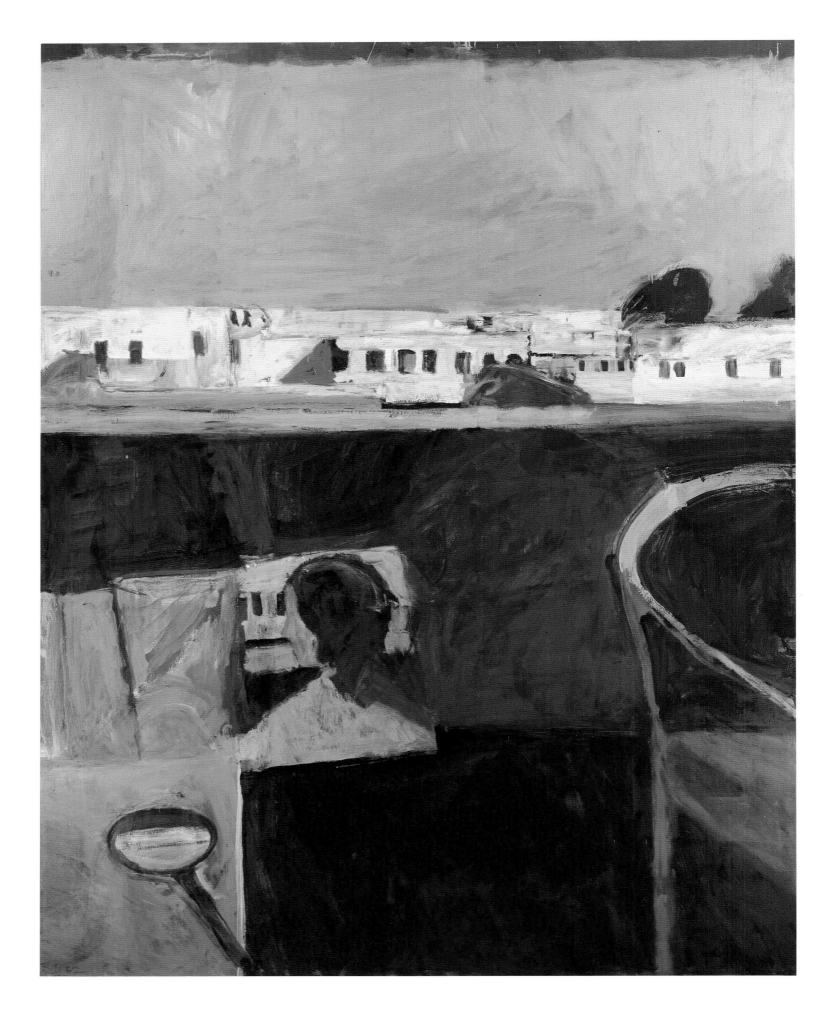

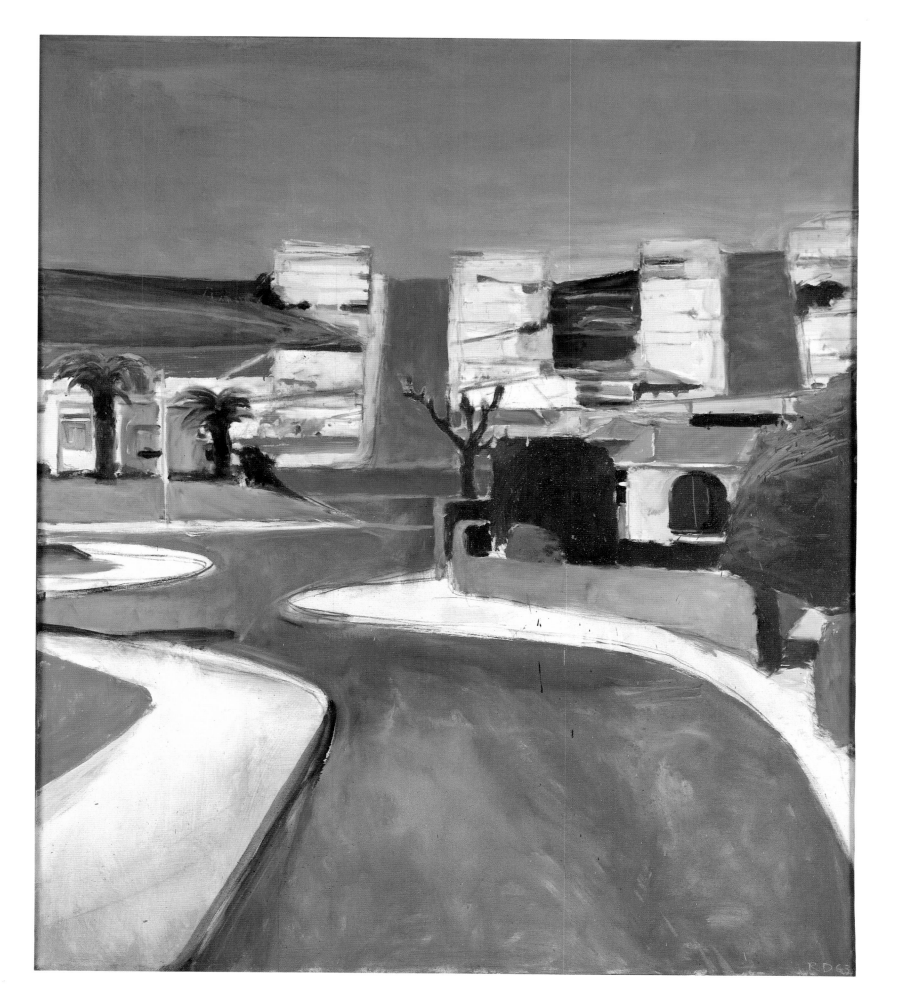

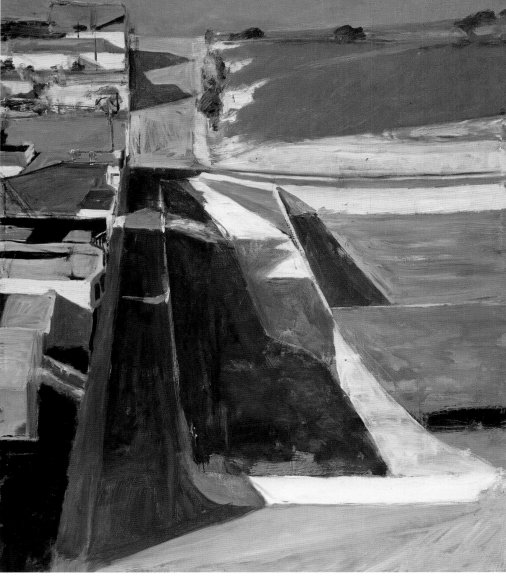

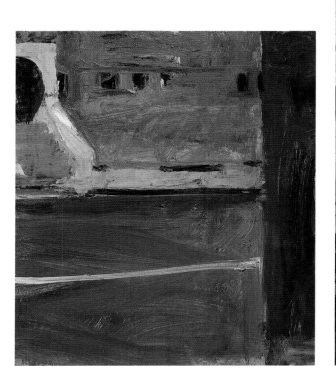

they were the most challenging subjects in his objective work. Very often a single figure is embedded in the frontal plane, in opposition to the illusion of space suggested by massings of color and suggestions of perspective. About such works Diebenkorn said, "in a [successful] painting everything is integral—all the parts belong to the whole. If you remove an aspect or element you are removing its wholeness."[70] The entire arrangement of the composition is essential—the figure or objects, the negative spaces between elements, the proportions, lines, shadows, and colors.

Girl on a Terrace, 1956 (p. 115), is an early ambitious figure painting and has been widely reproduced. It invokes a mood of reverie with a standing female figure, her back to the viewer, gazing at a landscape, with a table and chair and furled lawn umbrella at her side. The artist did not intend to suggest a particular state of mind in his subject, avoiding melancholy or sentimentality. The painting is of a figure standing quietly in a sunny landscape, yet Diebenkorn acknowledged, "It isn't as easy as 'painting what you see' with a figure. A figure exerts a continuing and unspecified influence

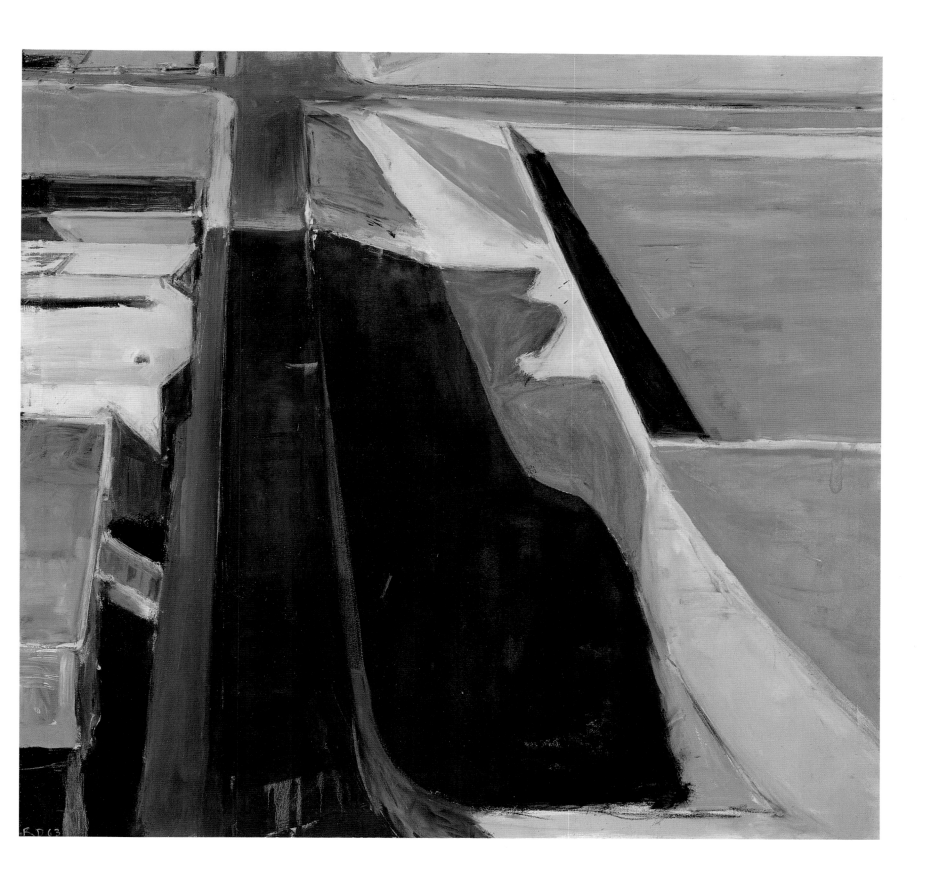

Cityscape (Landscape No. 2), 1963. Oil on canvas.
47 x 50¼ in. Mr. and Mrs. Richard McDonough
collection, Berkeley, California

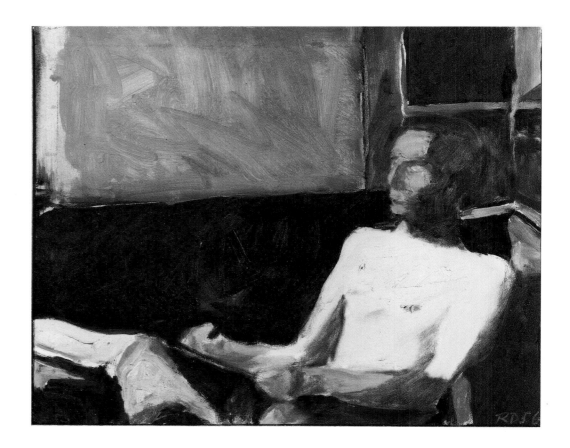

on a painting as the canvas develops. The represented forms are loaded
with psychological feeling. It can't ever just be *painting*. That kind of feeling
can be enriching to the total work, but it can also be continuously trouble-
some, setting up overtones and talking back [to the painter]."[71]

Diebenkorn seldom painted directly from the figure. He worked as a
rule from drawings made from the figure, moving synthetically to assemble
a vision that achieved an integration of figure with environment. Often, as
in *Woman in a Window*, 1957 (p. 117), the subject's face is turned away from
the viewer, as she looks out a window. The weight of her head, elbow, and
hand are focused at the corner of the table where the chair arm, table leg,
and window aperture coordinate their visual forces. Personal thoughts
and physical geometry are tied together in an evocation of mood. Ruled
lines and geometry are no longer stigmatized as sterile and intellectual.
The artist worked on at least two levels: constructing a picture in which
shapes (colors and spaces) form a set of unique relationships, independent
of subject matter; at the same time he captured and preserved the physical
and emotional overtones aroused in him by visual experience.

In those few works that pose two human figures, the subjects may be
standing or sitting in a room with a steeply tilted floor plane (*Man and
Woman in a Large Room*, 1957; p. 118) or closely grouped in an indeterminate
landscape (*Women Outside*, 1957; p. 119). Perspective is expressed emotion-
ally, abruptly, without the imposition of academic procedures. Space is
invoked only to be denied by internal evidence and the energy of the
surface plane. The limited space asserts its own tensions with the flatness of
the canvas and the matter-of-factness of the paint application. Diebenkorn
tended to move toward the reductive, through simplification of form,

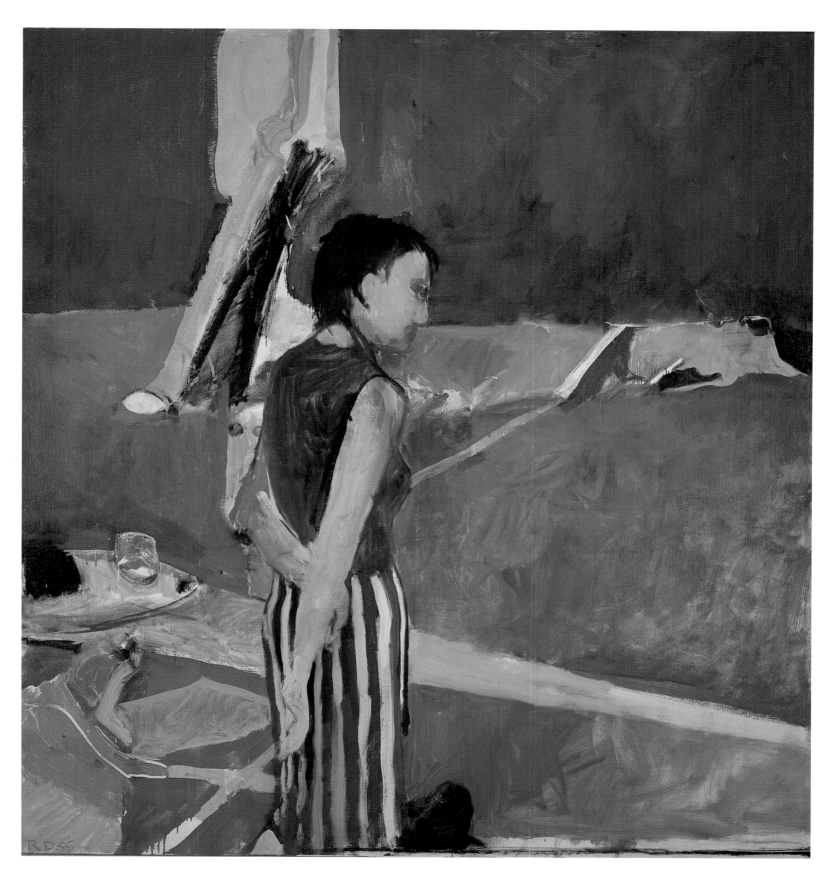

Girl on a Terrace, 1956. Oil on canvas.
76 x 66 in. Collection of the Neuberger Museum,
State University of New York at Purchase,
Gift of Roy R. Neuberger

115

July, 1957. Oil on canvas. 59 x 54 in. Private collection

Girl Looking at Landscape, 1957. Oil on canvas.
59 x 60¼ in. Collection, Whitney Museum of
American Art, New York, Gift of Mr. and Mrs. Alan
H. Temple

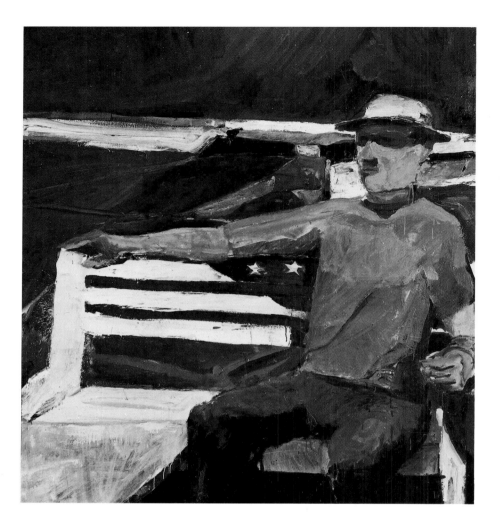

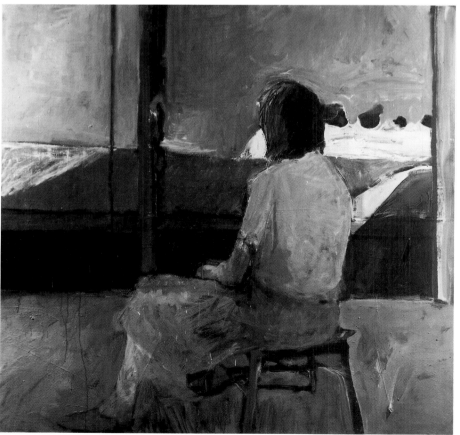

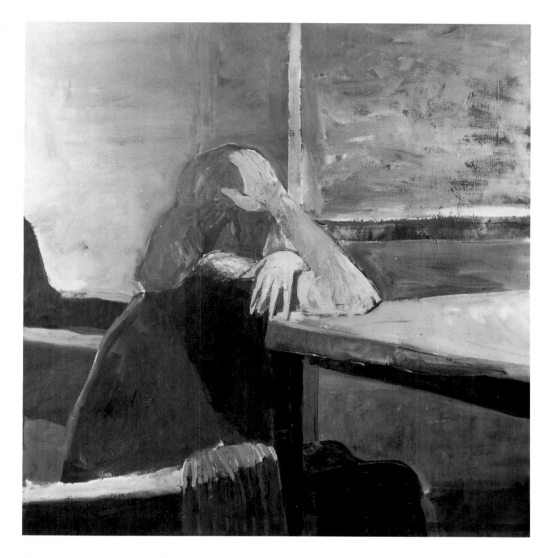

Woman in a Window, 1957. Oil on canvas. 59 x 56 in.
Albright-Knox Art Gallery, Buffalo, New York,
Gift of Seymour H. Knox, 1958

the structuralizing of elements, the stripping away of inessentials in the modernist tradition. If not turned away from the viewer, the faces of his subjects tend to be minimized, serving as an impression rather than as a likeness. At the same time psychology is expressed in the wholeness of the work rather than in the singularity of its composite figures. The effort is to express a universal rather than a specific, to avoid particularization, illustration, or sentimentality, despite the feelings called up by the subjects and their continuing power to affect the paintings. As a result there tend to be a monumentality to the figures and an ambiguity about their relationship to the environment, despite their "locked-in" structural relationship to it.

Woman in Profile, 1958 (p. 123), sets out a female figure in profile against a large window with a geometrically organized landscape. The figure's profile overlaps and coincides with a perspective element in the landscape's deep space, pulling the landscape to the picture plane, rendering the subject's nose triangle ambiguous. This is another of those "twists" or "mutations" that the artist looks for and in which he took delight.

Woman with Hat and Gloves, 1963 (p. 130, bottom right), is one of those memorable paintings in which the figure dominates the surface plane and the remainder of the picture space falls into shallow staging. The subject is one of the self-embracing figures, such as is found in *Girl Smoking*, 1963

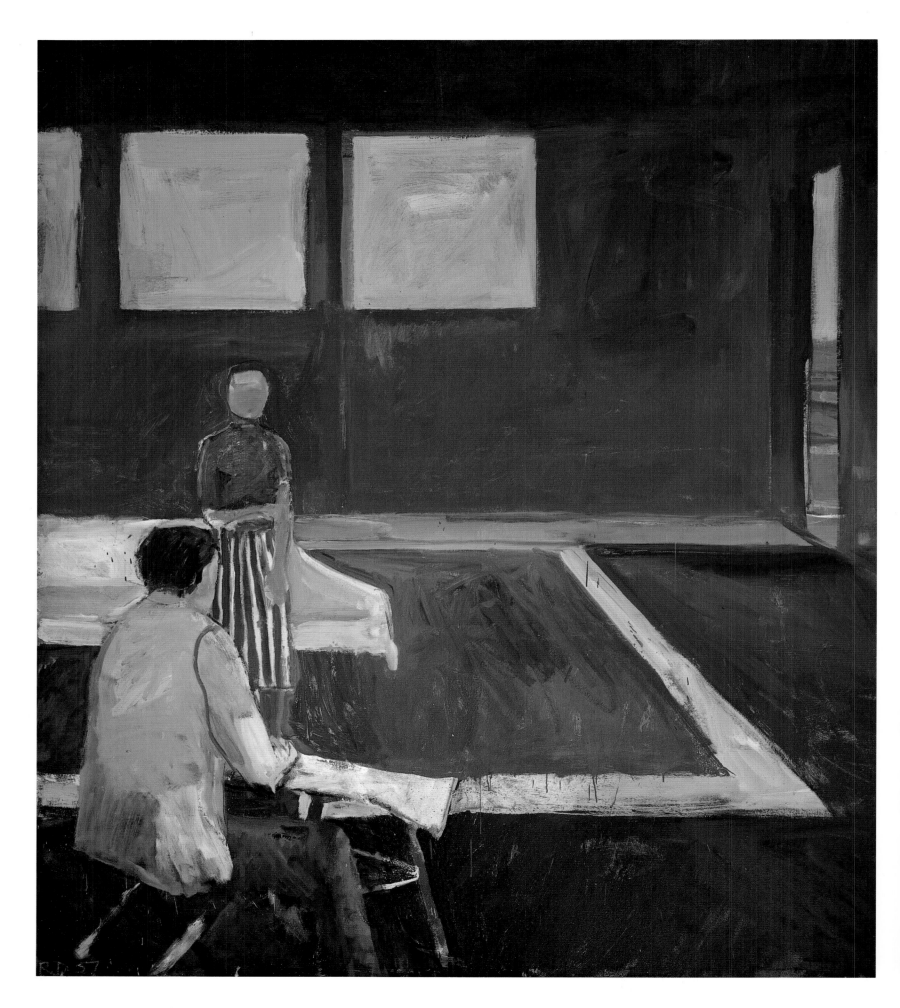

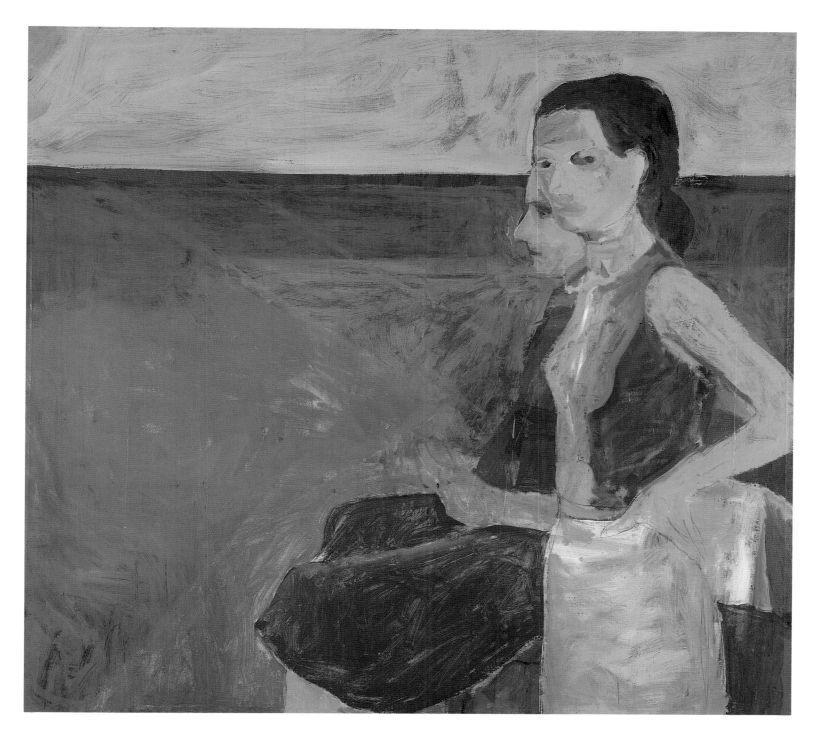

(p. 130, top right), to which the artist so often responded. The woman is seated on a divan, leaning forward with her right leg drawn up under her, and her left leg extended out to the lower right. A high-heeled shoe establishes a bright incident at each lower corner of the canvas, while the crossed weight of gloved hands rests on the centered knees and the hatted head turns to its right, looking out of the picture space. A gray nude figure, depicted reclining in the upper right corner, suggests a framed drawing, and it draws the viewer's attention back into the painting and redirects examination of the painting's idiosyncratic structure.

In his figurative period Diebenkorn—a confirmed modernist—came to trust his improvisational creative method as it applied to his new subject

Opposite:
Man and Woman in a Large Room, 1957.
Oil on canvas. 71 ⅛ x 62 ½ in. Hirshhorn Museum and Sculpture Garden, Smithsonian Institution, Washington, D.C., Gift of Joseph H. Hirshhorn Foundation, 1966

Above:
Women Outside, 1957. Oil on canvas.
54 ¼ x 58 ¾ in. Art Gallery of Ontario, Toronto, Gift from J.S. McLean, American Fund, 1960

Woman by a Large Window, 1957. Oil on canvas.
71 x 65 in. Allen Memorial Art Museum, Oberlin
College, Oberlin, Ohio, R. T. Miller, Jr., Fund

Girl and Striped Chair, 1958. Oil on canvas.
60 x 60 in. Private collection

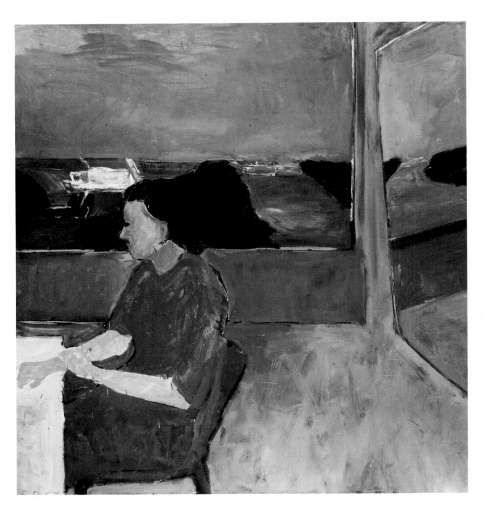

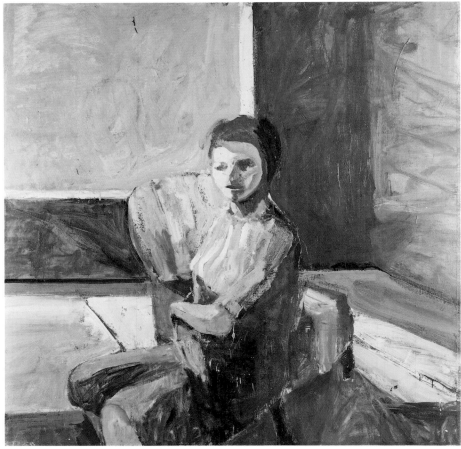

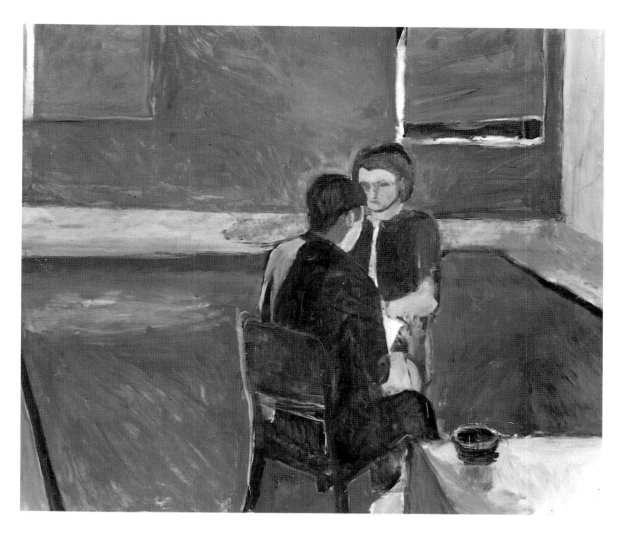

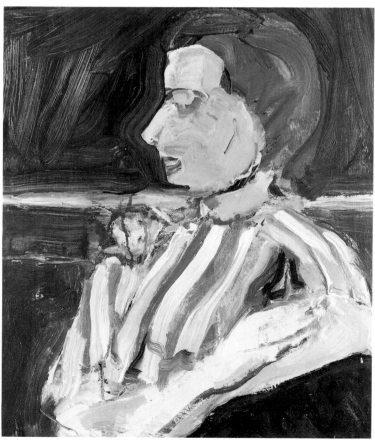

Man and Woman Seated, 1958. Oil on canvas.
70 ⅜ x 83 ½ in. Museum of Art, Pennsylvania State
University, University Park

Woman Wearing a Flower, 1958. Oil on canvas.
26 x 22 in. The Contemporary Collection of the
The Cleveland Museum of Art, Cleveland

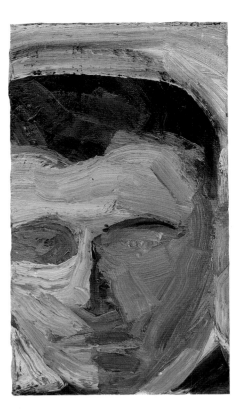 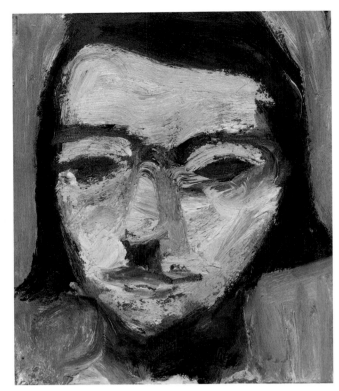

matter. His slow trial-and-error system proved effective and every subject was vitalized by expressive paint handling—broad, rough brush strokes. He learned to play the picture plane against illusionistic space with a variety of modern techniques. His color, though often intense, is essentially tonal and an exaggeration of local color. He eschewed perspective for the most part, but took occasional detours from flat modern painting to explore deep recessive space in land- and cityscapes and could paint a still life in a manner Hilton Kramer read as atavistic Manet.

The year 1964 was a hectic and unusual one in that Diebenkorn put his painting on hold due to a combination of factors. His father died that year. He served as artist-in-residence for a time at Stanford University, where he did a great deal of drawing, and held an exhibition of the drawings at the University Museum during the spring. In addition, he had taken to making etchings and drypoints and spent increasing time working on them at Crown Point Press in Berkeley (which published a series of them in 1965). Diebenkorn agreed to a retrospective exhibition of his work at the Washington Gallery of Modern Art, which would travel to New York and California, and he was invited to visit the U.S.S.R. as a guest of the Soviet Artists' Union under the aegis of the U.S. State Department.

During his trip to the Soviet Union (now Russia) Diebenkorn presented slide talks about his work to artists' union assemblies. The abstract, formalist, and anti-narrative elements in his work were sometimes commented upon negatively by audiences. Even so, the impact of the Soviet trip, particularly his experience of paintings by Henri Matisse, part of the remarkable Shchukin Collection in Leningrad (now St. Petersburg) and Moscow, was profound. Diebenkorn's post-Leningrad painting reflects the deep impression made by those Russian-owned works, which were

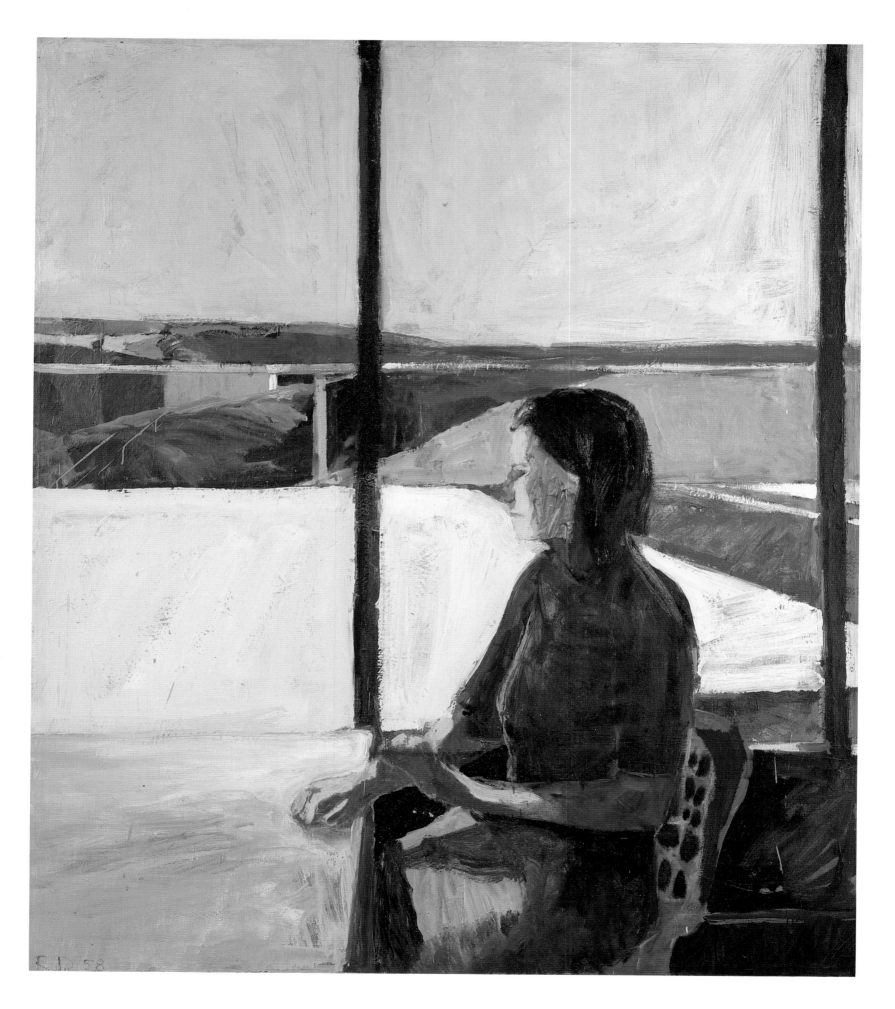

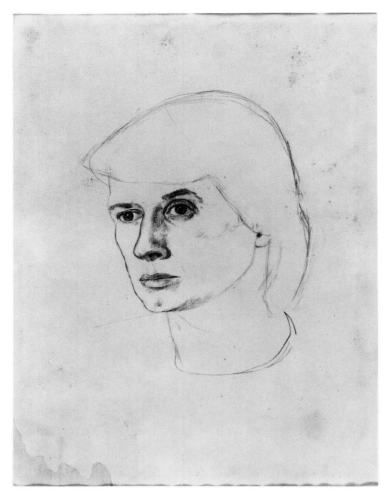

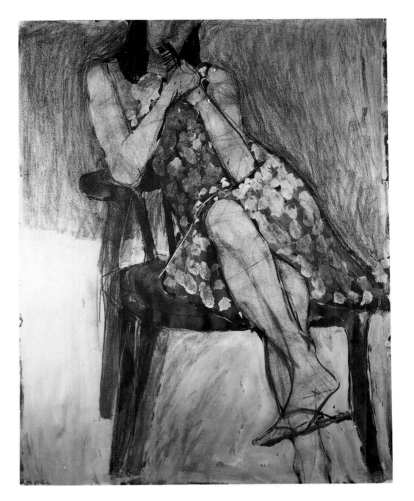

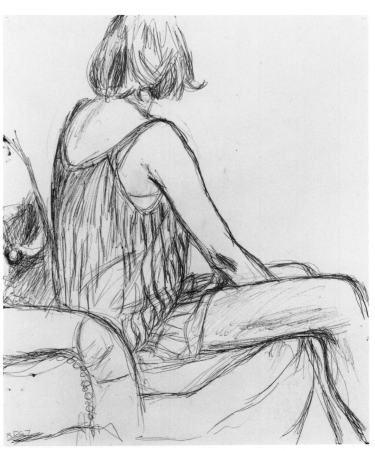

Above left:
Head (Phyllis), 1953. Pencil on paper. 14 x 10 ½ in.
Mr. and Mrs. Richard Diebenkorn collection,
Santa Monica, California

Above right:
Seated Woman No. 44, 1966. Watercolor, gouache,
and Conté crayon on paper. 31 x 24 ¼ in. Collection
of the University at Albany, State University of
New York, Gift of President Evan R. Collins to the
Fine Arts Study Collection

Right:
Seated Woman/Striped Shift, 1967. Ballpoint pen
on paper. 17 x 14 in. Mr. and Mrs. Richard Diebenkorn
collection, Santa Monica, California

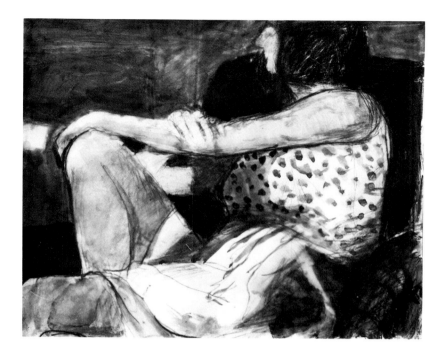

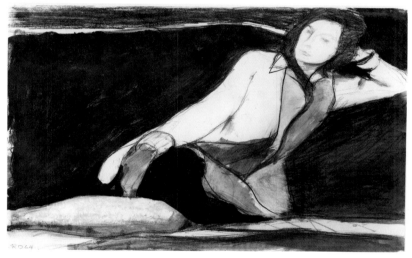

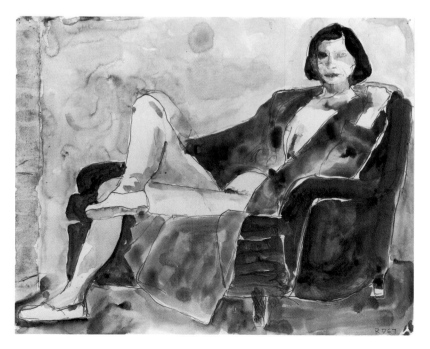

Seated Woman, 1967. Watercolor and pencil on paper. 14 x 17 in. Mr. and Mrs. Richard Diebenkorn collection, Santa Monica, California

Reclining Woman, 1964. Ink, wash, and pencil on paper. 11 x 18 in. Mr. and Mrs. John Berggruen collection, San Francisco

Untitled, 1967–68. Ink, wash, and Conté crayon on paper. 13 ¾ x 16 ¾ in. Mr. and Mrs. Richard Diebenkorn collection, Santa Monica, California

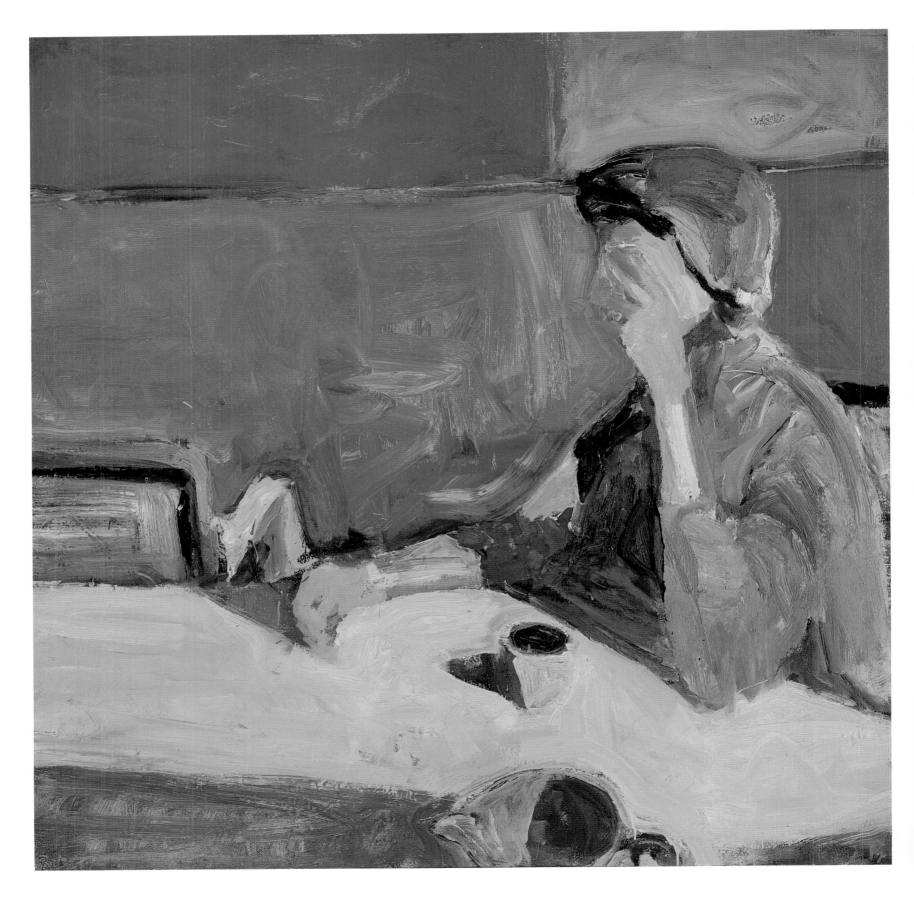

Woman at Table in Strong Light, 1959. Oil on canvas.
48 ½ x 48 ½ in. Private collection

Opposite:
Woman with Newspaper, 1960. Oil on canvas.
48 x 33 ¾ in. Private collection

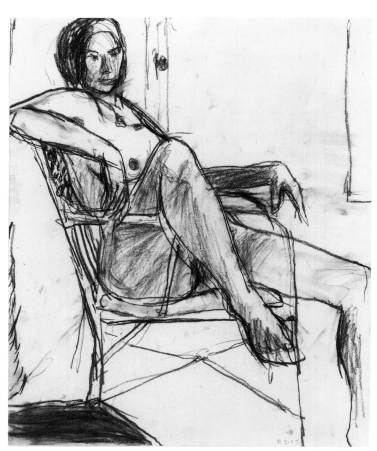

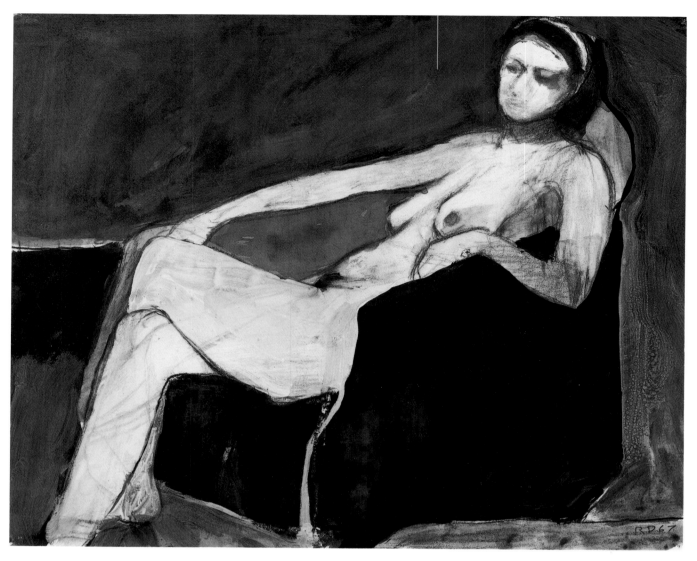

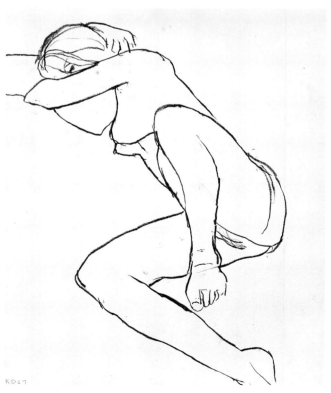

Opposite (clockwise, from upper left):
Nude/Reading Folio, 1967. Charcoal on paper.
17 x 14 in. Mr. and Mrs. Richard Diebenkorn
collection, Santa Monica, California

Seated Nude/Hand to Face, 1967. Pencil on paper.
17 x 14 in. Mr. and Mrs. Richard Diebenkorn
collection, Santa Monica, California

Seated Nude/Knee Up, 1967. Conté crayon on
paper. 17 x 14 in. Mr. and Mrs. Richard Diebenkorn
collection, Santa Monica, California

Untitled, 1967. Conté crayon on paper. 17 x 14 in.
Mr. and Mrs. Richard Diebenkorn collection,
Santa Monica, California

Above:
Woman in Dark Upholstered Chair, 1967.
Conté crayon, ink, and gouache on paper. 14 x 17 in.
Mr. and Mrs. Richard Diebenkorn collection,
Santa Monica, California

Left:
Reclining Woman, 1967. Ink and wash on paper.
17 x 14 in. Mr. and Mrs. Richard Diebenkorn
collection, Santa Monica, California

129

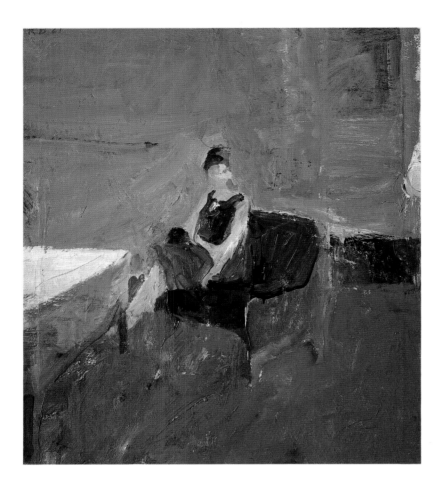

Clockwise, from upper left:
Seated Woman, Green Interior, 1961. Oil on canvas.
32 ¾ x 28 ½ in. Private collection

Girl Smoking, 1963. Oil on canvas. 33 ¼ x 25 in.
Peter Salz collection, San Francisco

Woman with Hat and Gloves, 1963. Oil on canvas.
34 x 36 in. Mary Heath Keesling collection,
San Francisco

then little known in the West. *Recollections of a Visit to Leningrad*, 1965 (p. 138), an interior scene painted after his return to Berkeley, is divided vertically into two spaces: the room on the left with its elaborate wall covering in a garland pattern and a vista through a window wall at the painting's right. The active wall-covering pattern is made more complex and yet also subdued by shadowed sections on either side of the brilliantly lighted central panel that soften its colors and linear energy. One senses an analogy between this device and the horizontal elements of field, sea, and sky seen in so many earlier window-interior compositions and landscapes. The view through the window wall on the right is simplified into geometric forms of green (lawn) and yellow (field), with two trapezoids of blue (water and sky). A patch of dark green at the merging point of grass-green and sea-blue suggests a cluster of trees. The painting is boldly but precisely constructed; vigorously brushed, it is an astonishing painting anchored in observation but packed with references to early modern painting.

Recollections of a Visit to Leningrad is an homage to the genius of Matisse and a salute to the paintings by him that Diebenkorn had seen on his Russian visit. Such works as *The Painter's Family* (*La famille du peintre*), 1911, *Conversation*, 1909, and *Harmony in Red* (*La desserte—harmonie rouge; La chambre rouge*), 1908–09, had provided astonishing visual experiences and left Diebenkorn with much to think about. These paintings had been known to him from his reading of Alfred Barr's *Matisse—His Art and His Public* and lesser monographs, but their full force could only be experienced in their presence. Tilted floor planes and proliferating patterns, saturated

Left:
Nude with Hat and Shawl, 1967. Pencil on paper.
17 x 14 in. Private collection

Right:
Untitled, 1966. Pencil, inkwash, and crayon on paper.
13 ¾ x 11 in. Private collection

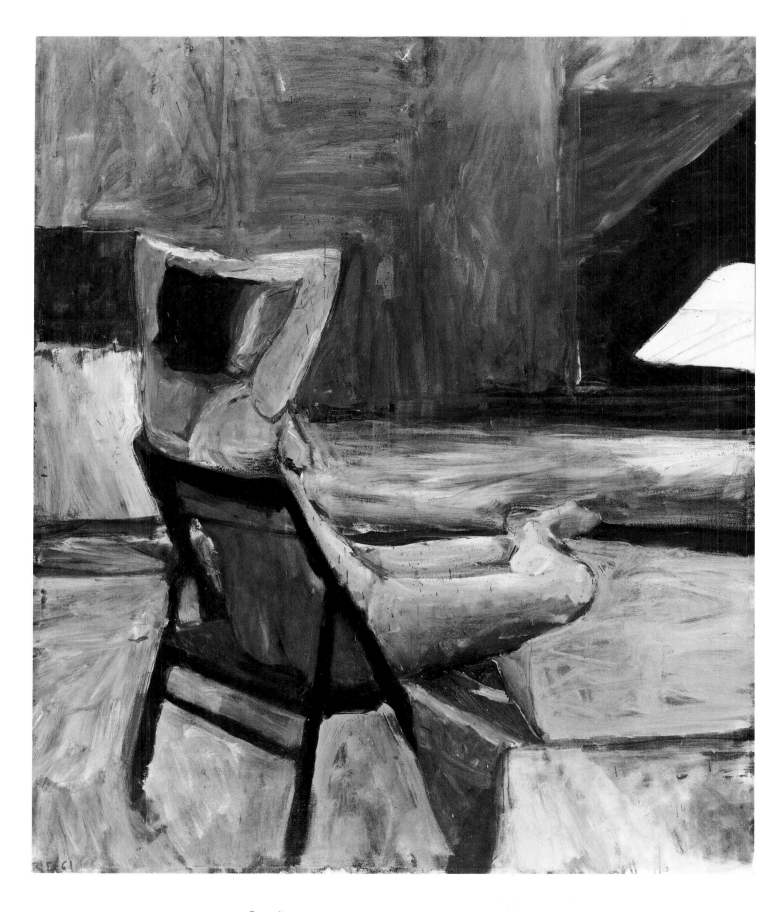

Seated Nude/Hands Behind Head, 1961.
Oil on canvas. 84 x 69 in. Private collection

Opposite:
Nude on Blue Ground, 1966. Oil on canvas.
81 x 59 in. Private collection

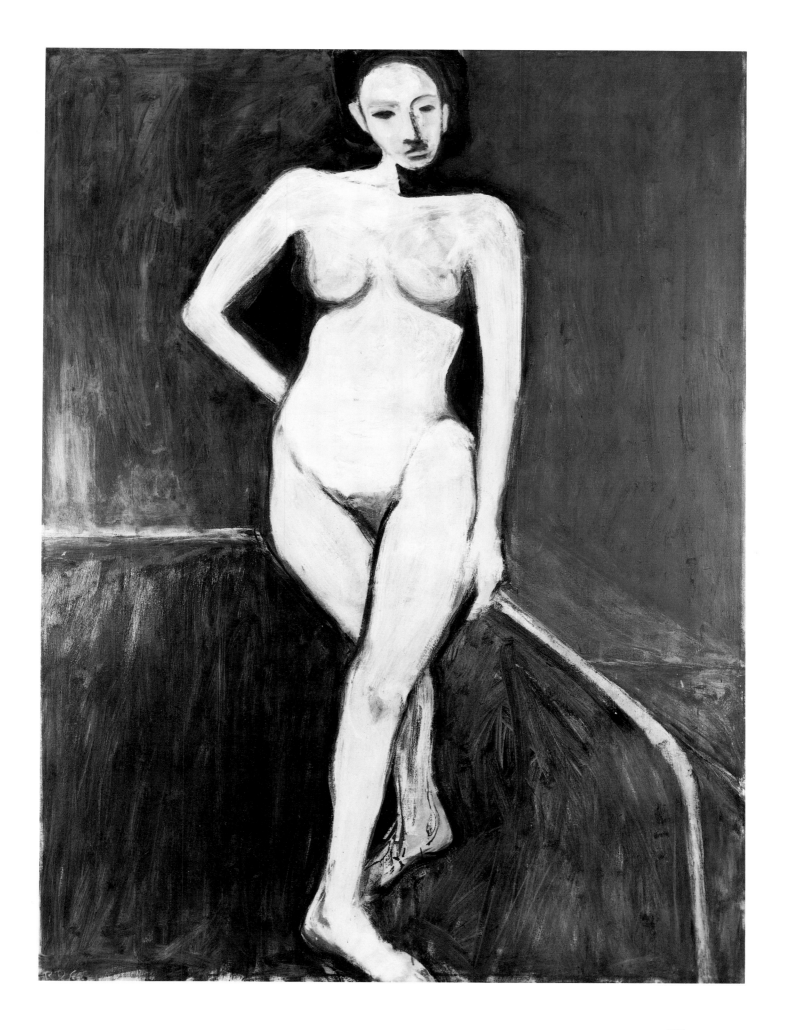

Above:
Portrait of the artist, 1961

Right:
Portrait of the artist, c. 1963

Opposite:
Seated Nude—Black Background, 1961. Oil on canvas. 80 x 50 in. Shidler collection, Honolulu

color intensities and contrasts, and an entire canvas painted in an intense violet-red over which was imposed a bold traditional French garland and flower basket design known as *toile de Jouy*, made unforgettable impressions.

Large Still Life, 1966 (p. 139), emerges from the same inspirational sources as *Recollections*, and yet it is solved in a totally different manner. Diebenkorn began this monumental still life with a tilted table plane juxtaposed with a powerfully decorated rear wall with the garland-patterned fabric. The table occupied more than half of the canvas—similar to the domination of the interior in the *Recollections* canvas. *Large Still Life* began in a vertical format, slightly taller than wide, but after two separate states in that format the canvas was repainted completely as a horizontal. The repeated pattern, taken from an East Indian batik bedspread that Diebenkorn often used as a studio prop, is abstracted and simplified on a grayed blue wall, softening the reference to both earlier paintings but nonetheless acknowledging them. The table plane is colored in an inimitable pink-rose-orange that complements the dusty-blue wall. A clutter of papers, books, notes, reading glass, coffee cup, and ink bottle are scattered across the table in casual disorder. One senses in this canvas, as in most of Diebenkorn's ambitious works, that no effort has ever been spared in evolving a solution in the most searching and consistent manner. *Large Still Life*, like many other canvases, was in process for several months. The artist understood the risks associated with building an art with references to earlier landmarks. He chose to acknowledge that he was engaged in a dialogue with the heroic years of the modernist movement. He was a spontaneous, energetic, and emotional painter who was also prone to self-torturing criticism—hence paintings are often long in process, subject to countless repaintings and revisions, before they met with his satisfaction, with every element, line, and color playing the role he gave it. Diebenkorn wrote: "Everyone makes mistakes. I'm a little ashamed of them in my pictures, so I obliterate them. You can't see what I consider mistake in my work. . . ."[72] Everything that remains then is considered verified and confirmed by repeated examination and acceptance.

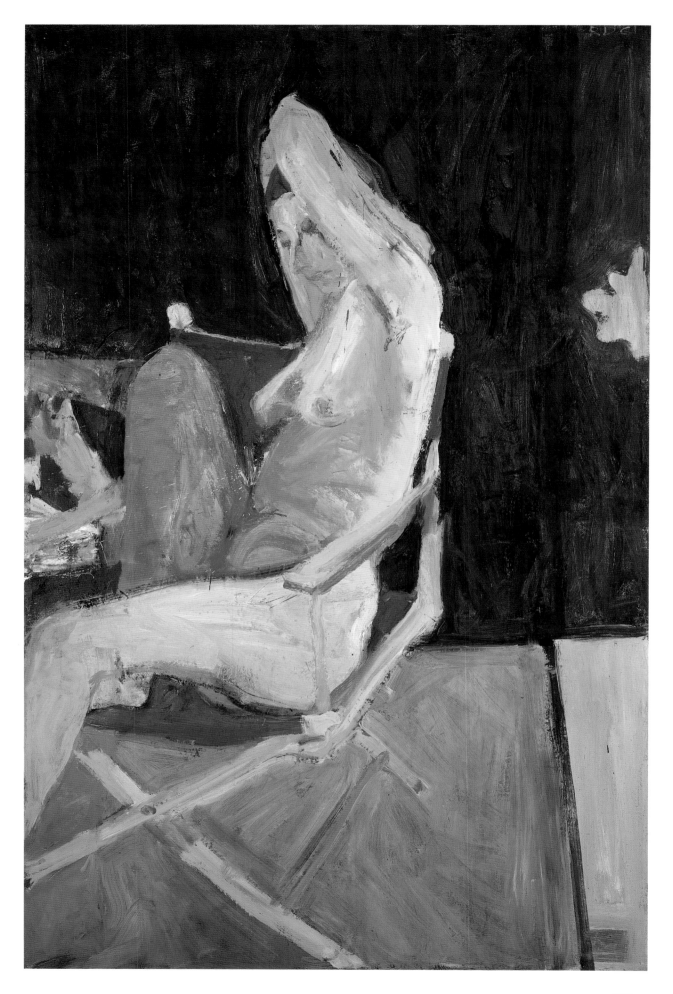

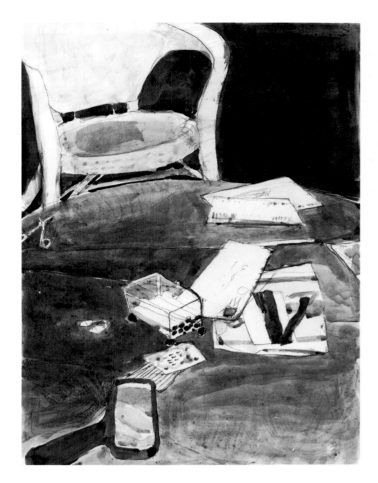

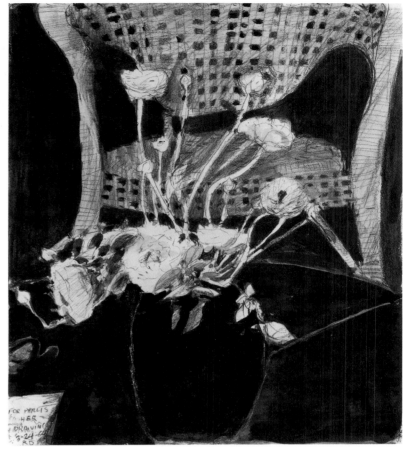

Above left:
Table Top/Cane Chair, 1964. Ink, wash, and Conté crayon on paper. 17 x 12½ in. Christopher Diebenkorn collection, Santa Monica, California

Above right:
Ranunculas and Cane Chair, 1964. Conté crayon and ink on paper. 18 x 12 in. Mr. and Mrs. Richard Diebenkorn collection, Santa Monica, California

Below right:
Still Life/Cigarette Butts, 1967. Pencil and ink on paper. 14 x 17 in. Mr. and Mrs. Richard Diebenkorn collection, Santa Monica, California

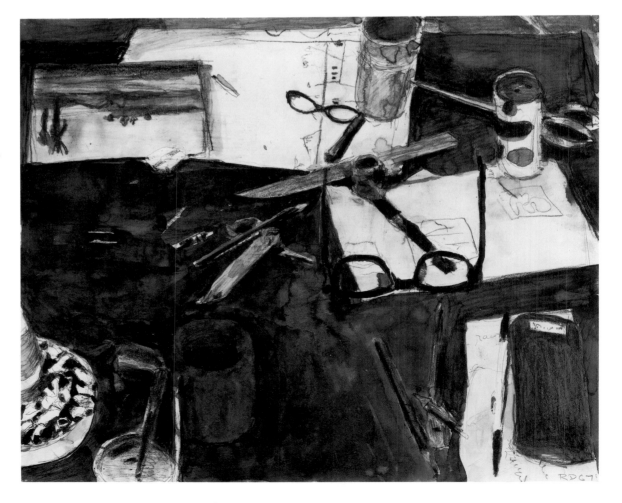

Still Life/Ashtray and Glasses, 1967. Ink, wash, and pencil on paper. 12½ x 17 in. Mr. and Mrs. Richard Diebenkorn collection, Santa Monica, California

Shoes, 1966. Conté crayon and ballpoint pen on paper. 14 x 17 in. Mr. and Mrs. Richard Diebenkorn collection, Santa Monica, California

Recollections of a Visit to Leningrad, 1965.
Oil on canvas. 73 x 84 in. Mr. and Mrs. Hunter Land
collection, San Francisco

In the autumn of 1966 Diebenkorn moved from Berkeley to assume a professorship in the art department of the University of California in Los Angeles. When an ideal studio space did not turn up, he rented an interim studio just eighteen feet square, with a low ceiling, a room without windows, in the Ocean Park section of Santa Monica. He felt that the room was too small and without the natural light he required for oil painting, so for a number of months, until another studio became available, he worked exclusively on paper. The artist referred to works on paper as "drawings" since the mid-1940s, regardless of whether they utilize color and might be seen by others as mixed-media paintings. He wrote:

Large Still Life, 1966. Oil on canvas. 64 ½ x 70 ¼ in. Mr. and Mrs. Richard Diebenkorn collection, Santa Monica, California

My reasons for doing "drawings" (many of them are fully developed paintings) are roughly twofold. [My drawings] often begin as sketchy explorations of ideas, which then hook me into further and then complete development. This activity, up to the point where it becomes for me a serious work, is related to my larger oil on canvas pieces and is a kind of tryout or rehearsal of general possibilities. It ceases to be this, however, at the point of becoming an independent work. The other reason, which somehow in no sense excludes the first, is my need to do relatively small works, independent of others and complete in themselves. But a small *canvas* usually becomes for me an unfeasible miniature. Paper, however, I find is something else, lending itself to the different scale of the small size. It is almost as though if I can call my work a large drawing instead of a small canvas it becomes possible.[73]

Window, 1967 (p. 141), was the first painting executed in the new day-lighted painting studio in Ocean Park. The window is located in a room possibly on the second floor. The viewer looks across the room, past a metal folding chair to a large window and an abutting transparent door with a decorative metal bracing to a group of low-lying buildings. A post or wall element at the right, a detail of the upper margin of the door at the left, and the folding chair at the lower right establish the limits of the interior picture space. This is a spare Diebenkorn interior, pre-Leningrad in feeling, with a flat edge-to-edge compositional structure in shallow space within the room. The sense of deep space in the vista is contradicted by the strong orange-ochre coloration of the yard between the window and the white buildings. With this work Diebenkorn had returned to his American vision and to the proven disciplines of his late-1950s interiors and landscapes, while making reference to the California cityscapes and the wrought-iron balconies of the Matissean hotels of Nice. *Window* is an austere yet grandly composed design, with large open areas of color and a few concentrations of visual activity in the folding chair, the ornamental brace, and the arrangement of windows and of shadows on the distant buildings. The artist's attitude toward his medium is never more clear—he preserves its character as liquid and transparent, revising freely, painting in corrections, and developing a tough and honest film.

Seated Woman, 1967 (p. 143), was the last figurative painting, completed in the new daylighted studio. The work is unusual in scale since the seated female subject measures nearly eight feet in height. The nonchalantly posed figure is placed forward in the picture space against the picture plane, her crossed arms and legs establishing a pinwheel of flesh-colored form. The location of the figure and her chair is ambiguous, but it is clearly in front of the blue-green and red plantlike element at the right corner, which hints at landscape space. The woman's features are only suggested and the posture of the figure in its indeterminate setting carries the entire message. Development of the features might well have diminished the figure's overwhelming presence and scale.

Diebenkorn had been drawing for months, producing a great many

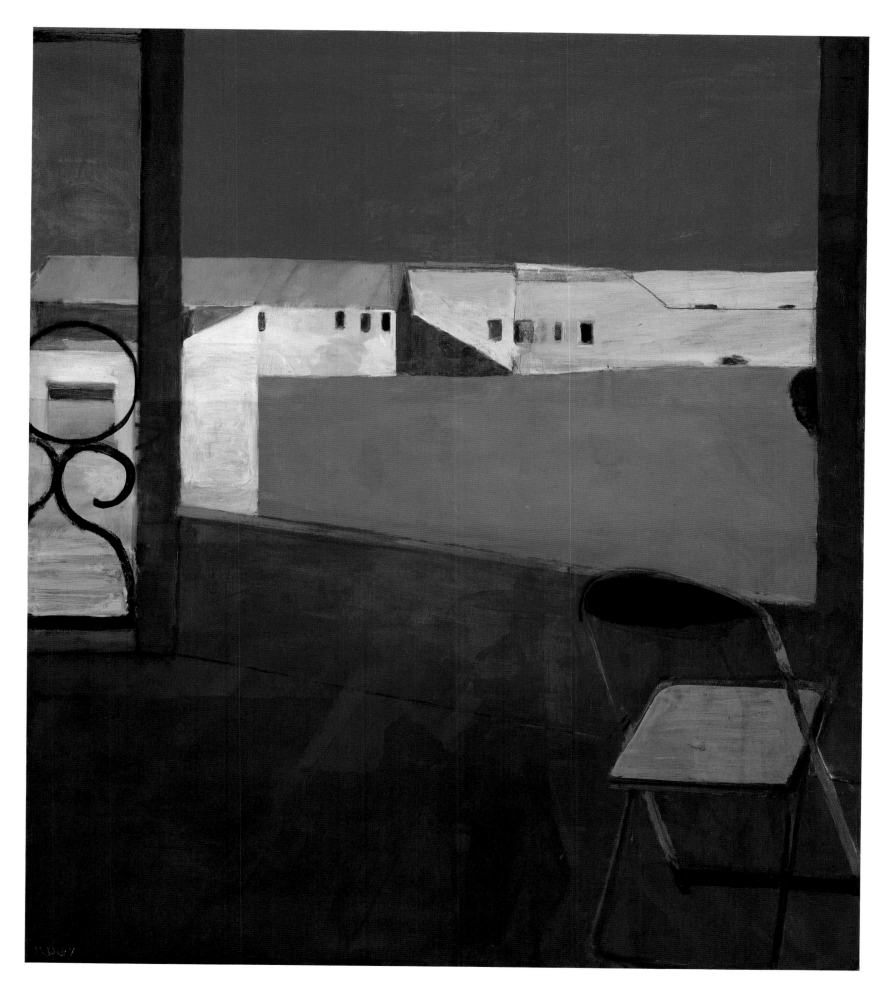

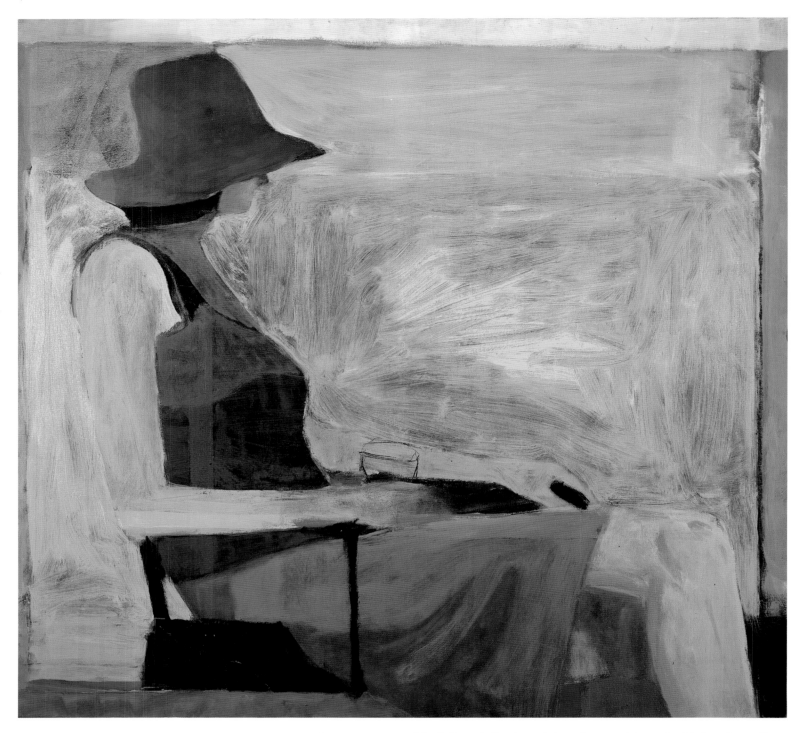

Seated Figure with Hat, 1967. Oil on canvas.
60 x 60 in. Lawrence Rubin collection, New York

Opposite:
Seated Woman, 1967. Oil on canvas. 80 x 90 in.
Mr. and Mrs. John Berggruen collection,
San Francisco

works on paper with full satisfaction. Now located in a daylighted studio, he was painting, returning to his fundamental themes: interiors with views of landscape or the city, and figure paintings. The interior (as depicted in *Window*) seems to have become somewhat too austere, too spare, too qualified in color, too inhibited. At the same time *Seated Woman*, despite its scale and elegant design, lacked the architectonic power of earlier works. The pictorial solution was assuming priority over the painterly modernist unity that the artist sought. Diebenkorn was beginning to think about abstract painting again and to feel that it might be time to discontinue his figurative work and to attempt a fresh course. His transition from the figurative to the new abstract paintings was somehow a natural outgrowth of

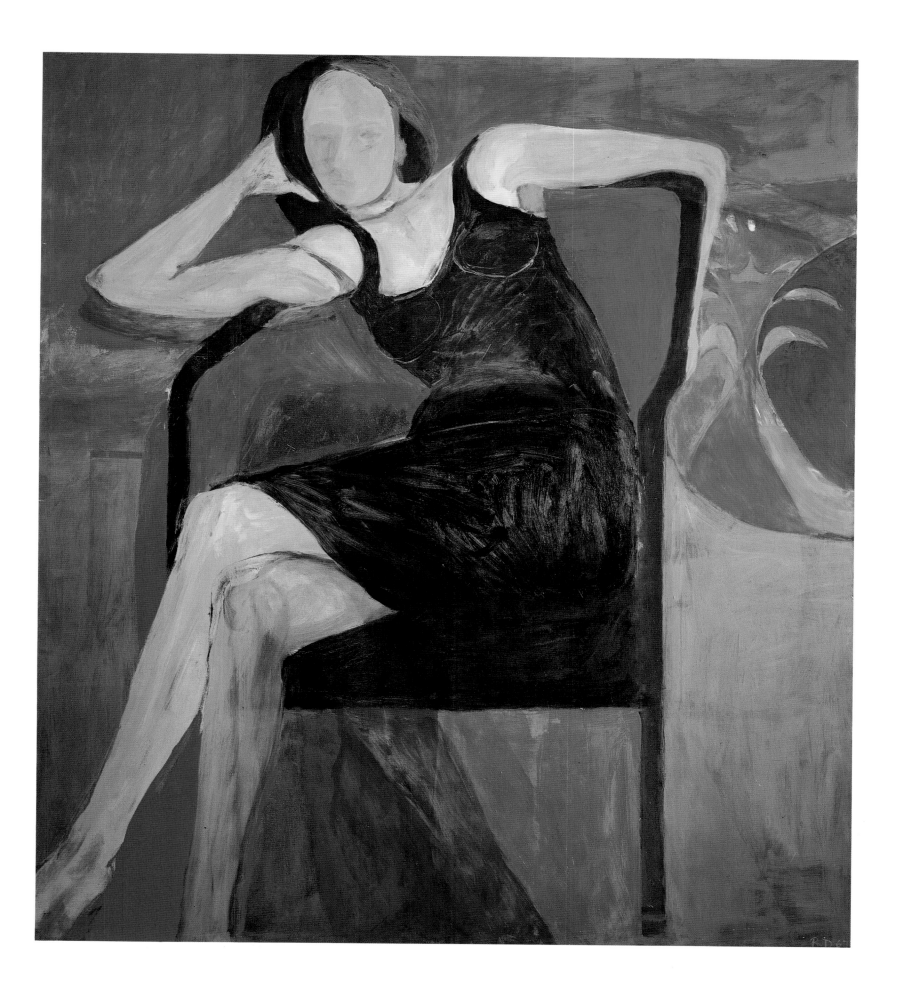

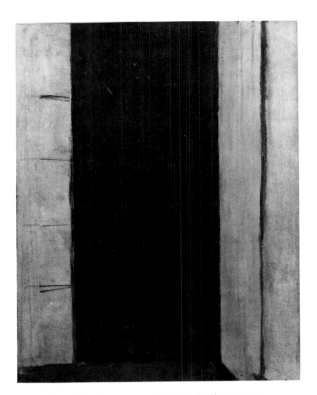

Henri Matisse, *Open Window, Collioure*, 1914.
Oil on canvas. 45 ⅞ x 34 ½ in. Musée National d'Art
Moderne, Paris

the way he had been working and the thinking he was involved in regarding the Leningrad experience, the move to Los Angeles and seeing two previously unfamiliar Matisse paintings of 1914—*View of Notre Dame*, and *Open Window, Collioure*—at a Matisse retrospective held at the University of California Art Galleries in Los Angeles. The Notre Dame painting had a breathing and open quality of surface, and a spontaneity of brushwork and openly corrected drawing that seemed to anticipate American abstract expressionist painting of the 1947–52 years. The composition can be traced to the view of the cathedral from Matisse's apartment on the quai. Notre Dame is blocked in as a cratelike shape, settled in the upper third of the canvas. The trial-and-error method of drawing, brushwork, and color application reveals placements, corrections, and finally a definitive location of a primary perspective line, defining the diagonal flow of the river, its banks, walkways, and streets, and the bridge that crosses it. The painting has the unfinished look of a work suspended in its development, rendering the imagery inaccessible on a first viewing. Similarly, the Collioure canvas reflects an even more severe geometry of vertical panels, which defied reading until it became apparent that these were inspired by French windows, opened at night. These provocative works suggested numbers of possibilities for new expressions of visual experience.

Whether the subject of the painting is a nude or a still life, an abstraction from nature or a totally nonreferential arrangement of colors and forms, it is inevitably the culture of modern painting that Diebenkorn addresses. The artist's cultural baggage now included what he had admired and learned to use from the work of Hopper, Cézanne, and Matisse, abstract expressionists de Kooning and Rothko, and Mondrian and Bonnard. His commitment was to improvisation, to fidelity to what develops on the canvas, to fresh color, and to expressive paint handling. He would have certainly agreed with Henri Matisse in the following:

> One of the dangers which appears to me immediately is that of contradicting myself. I feel very strongly the bond between my old works and my recent ones. But I do not think the way I thought yesterday. My fundamental thoughts have not changed but have evolved and my modes of expression have followed my thoughts. I do not repudiate any of my paintings but I would not paint one of them in the same way had I to do it again. My destination is always the same, but I work out a different route to get there.[74]

In 1967, shortly after having completed *Seated Woman*, Diebenkorn turned again to nonreferential painting, responding afresh to the particular qualities of the light and landscape of Santa Monica, as well as to the color improvisations and daring formal conceptions of Matisse. The works from this period are called the Ocean Park series (after the beachside community where the artist's studio was located between 1966 and 1988) and are numbered. He wanted "to follow the painting in terms of just what I want for the painting, as opposed to the qualifying that I found I had to do in figure painting."[75] He described the constraint of figure painting this way:

I would start out with brave, bold color and a kind of spatiality that come through in terms of the color. Then I would find gradually I'd have to be knocking down this stuff that I liked in order to make it right with this figure, this environment, this representation. It was a kind of compromise—that on one hand can be marvelous, and what painting seems all about, and on the other becomes inhibiting constraint.[76]

Banishing the figure removed this constraint, allowing him to use color with greater freedom, and to be concerned directly with spatiality, the relationships between color, lateral space, and depth.

For Diebenkorn "a premeditated scheme or system [was] out of the question" in the development of a painting. A drawing could not be directly translated into a painting. The artist had to begin anew with each painting, feeling out the size and shape of the canvas and the rhythms that seem right to the particular proportions chosen on that particular day. Diebenkorn could not "design" a painting in his head, but had to try out his thoughts, adjusting them as necessary. Early stages often appeared to be very promising as they emerged in graphite, charcoal, and color. The artist at times distrusted the ease with which these stages developed at the same time that he pursued the possibilities they allowed. The graphite and charcoal gave him flexibility to erase and correct easily, but once the painting had taken over he felt less able to change and he found himself slower to make changes. Each decision related to every successive one and it was necessary at every stage of the painting's development to work with the conviction that this was the final stage and the work was nearing completion. If adjustments and corrections were required, they had to be handled consistently. At the next studio session he might have found a weakness, and he would then enter the work through that weakness and reconceive the whole. The painting would become fluid again and the whole could change in appearance while the feeling remained very much the same. At the final stage, the painter would find himself freed and his emotion would exist complete and separate from him and his effort.

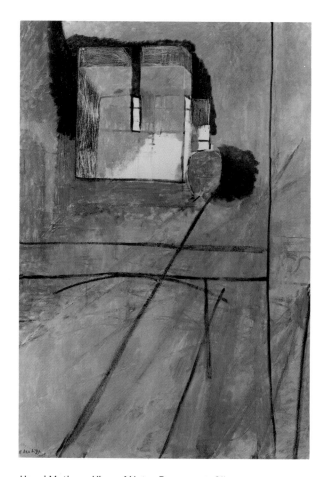

Henri Matisse, *View of Notre Dame*, 1914. Oil on canvas. 58 x 37 ⅛ in. Collection, The Museum of Modern Art, New York, Acquired through the Lillie P. Bliss Bequest and the Henry Ittleson, A. Conger Goodyear, Mr. and Mrs. Robert Sinclair Funds, and the Anna Erickson Levene Bequest given in memory of her husband Dr. Phoebus Aaron Teodor Levene

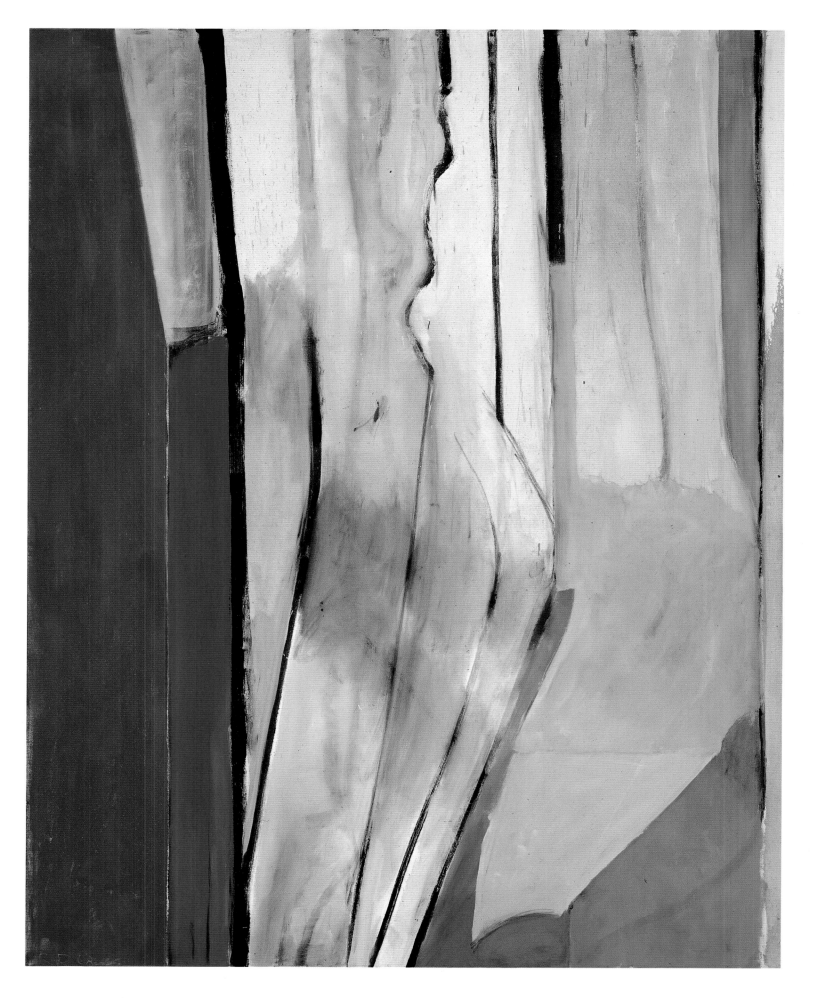

Γhe first showings of the Ocean Park
abstractions were held in 1968, with nine canvases at the Poindexter Gallery
in New York and, in a small group, as part of the San Francisco Museum of
Art's exhibition "Untitled, 1968." The large canvases, averaging around eight
feet in height and slightly less wide, announced a sharp break with the
figurative imagery which Diebenkorn had been associated with for more
than a decade. Ruled lines and suggestions of geometry, which never could
have appeared in the earlier abstract paintings, emerged, mingling with the
personal sense of the color and smudgy pentimenti that resurfaced from
former years. Vertical elements and diagonals provided an abstract scaffold
for color, sometimes suggesting interior spaces, but with which he could
explore the formal possibilities of composition without the constraints of
figurative work. The reception was unequivocally enthusiastic. John Canaday
reviewed the Poindexter exhibition in the *New York Times*:

> Mr. Diebenkorn seems to have found his springboard for a truly
> individual style in some near abstract Matisses of (1909–1916)....
> Structurally, it is as if Matisse at this juncture had developed as an
> abstract painter in the person of his protégé-by-example.
>
> Mr. Diebenkorn says that although, "I don't know whether it
> holds water," the change from his figurative work of the last 12 years
> or so to these abstractions was as simple as a change of subject matter.
> He points out that a normal traditional development for a painter
> is through still life, primarily the painting of objects, into landscape,
> and then the figure. Beyond that is the area of space, mood, and light
> that, he felt, the figure blocked him from. He has not returned to
> abstraction (as I see it) but has discovered it in a form that has little
> to do with abstraction as he knew it before or, for that matter, with
> most abstraction as it is served up to us today.

Ocean Park No. 6, 1968. Oil on canvas. 92 x 72 in.
Courtesy, Margo Leavin Gallery, Los Angeles

Mr. Diebenkorn is, in fact, and most fortunately, still out of step.... He never accepts means as an end (the primary fault of both figurative and abstract painters), and by that token he is not interested in abstraction as a convenience, or as a source for an arbitrarily developed stylistic trademark. He is an artist with a powerful command of expressive structure that he employs in paintings that are—almost incidentally—nonfigurative.[77]

Accompanying the Canaday article was a large black-and-white reproduction of *Ocean Park No. 6*, 1968 (p. 146), an early work from the series. The painting's imagery appears to be derived from organic forms. Geometric elements are introduced at the left margin with a strong red vertical, reinforced by an abutting tall rectangle of deep blue. The smudgy drawing, partially overpainted, suggests motion, the passage of air currents, and perhaps other natural contexts. The color is unique, different from the hot colors of Urbana and Berkeley, or the clear bright colors of *July* or the indoor-outdoor figurative period. Pink, green, gray, and a sliver of yellow play against the dark red and deep blue in an orchestration that Canaday referred to as "discovering" abstraction, in a form that "has little to do with what [the artist] knew of it before." This is not cubist painting, clinging to representationalism through fragments of a pipe or a violin, nor is it the chaotic emotional colorism of Kandinsky's experiments of 1910. Rather, Diebenkorn's new grappling with abstraction presents the viewer with a biomorphic expressionism, intuitively composed, with a varied use of space and a continuing personal sense of color. The painting revels in the autographic and the scumbled, broken color effect. In a period when industrial finishes gave inspiration to artists of pop, optical, and minimalist tendencies, Diebenkorn's nuance and sense of touch reestablished the values of early modernism.

The painter's first showing of the Ocean Park paintings in his own community was held at the Los Angeles County Museum of Art in June and July of 1969. All of the nine 1968–69 canvases reflect the artist's hand; some are more involved with geometry and others with atmospheric color space. The artist moved freely back and forth between these extremes in his early Ocean Park works. In the somewhat less painterly but more architectonic canvases, represented by *Ocean Park No. 19*, 1968 (p. 152), and *Ocean Park No. 22*, 1969, a neutral scaffolding sets off a wide range of the artist's color improvisations. These canvases appear to be metaphors for interior architecture, and they may even refer to the rooms in which they have been created. They do not "read" as isometric projections but are spatial crystals that conduct a dialogue with perspective and illusion and the flatness of the plane upon which they have been delineated. Asymmetric compositional balances are made taut through color or become mazes of color trapezoids. One of the painter's central concerns is reflected in such work: moving between flatness and illusion with form and color, seeking the original solution, avoiding the cliché, pushing himself to find a workable mutation. Despite the freshness of these images, there is an inner consistency between the early Ocean Park paintings and earlier work in

Ocean Park No. 9, 1968. Oil on canvas. 82 x 79 in.
The Times Mirror Company, Los Angeles

150

Opposite:
Ocean Park No. 16, 1968. Oil on canvas. 92 ½ x 76 in.
Milwaukee Art Museum collection, Milwaukee,
Gift of Jane Bradley Pettit

Left:
Ocean Park No. 17, 1968. Oil on canvas. 80 x 72 in.
University of Iowa Museum of Art, Iowa City,
Purchased with funds from the National Endowment
for the Arts and Matching Funds from the University
of Iowa Foundation

both the abstract and the figurative modes. *Urbana No. 5 (Beachtown)*, 1953
(p. 59), is notable for its strong color and geometric structure. *Horizon—
Ocean View*, 1959 (p. 106), which shows a wall and sunshade close up, makes
use of a number of vertical elements that confirm the plane and deep space
in the landscape as they reach out to sea and sky.

The paintings that emphasize a more atmospheric sense of space, such
as *Ocean Park No. 16*, 1968 (p. 150), *No. 17*, 1968 (p. 151), and *No. 21*, 1969
(p. 153), feature a "breathing" color area achieved through the application
of many thin layers of pigment that elicits a coherent tension from the
whole surface, substantiating the framework of lines that float forward to
create a plane between the viewer and the paint surface. The color field
dominates, despite the diagonal visual elements that have been used to
intimate spatial depth. Submerged drawing and overdrawn lines coalesce
and pull the atmosphere into an aesthetically charged shallow space.
Fields that at first appear to be nearly monochrome quietly disclose
subtle gradations in value and then reverberate as strong but elemental
structural color forms. Incompletely erased traces of earlier drawing,
as well as pentimenti, are simultaneous reminders of abstract expressionist

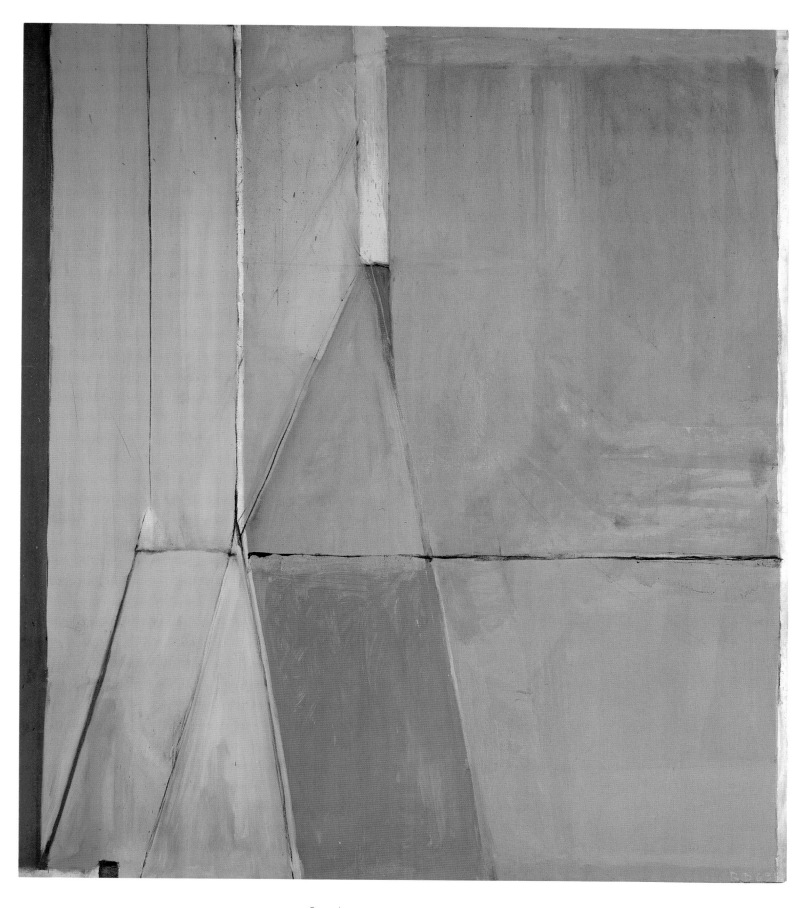

Opposite:
Ocean Park No. 19, 1968. Oil on canvas. 98 x 80 in. *Ocean Park No. 21*, 1969. Oil on canvas. 93 x 81 in.
Mrs. Robert W. Cahill collection, San Francisco Dr. and Mrs. Herbert Schorr collection, New York

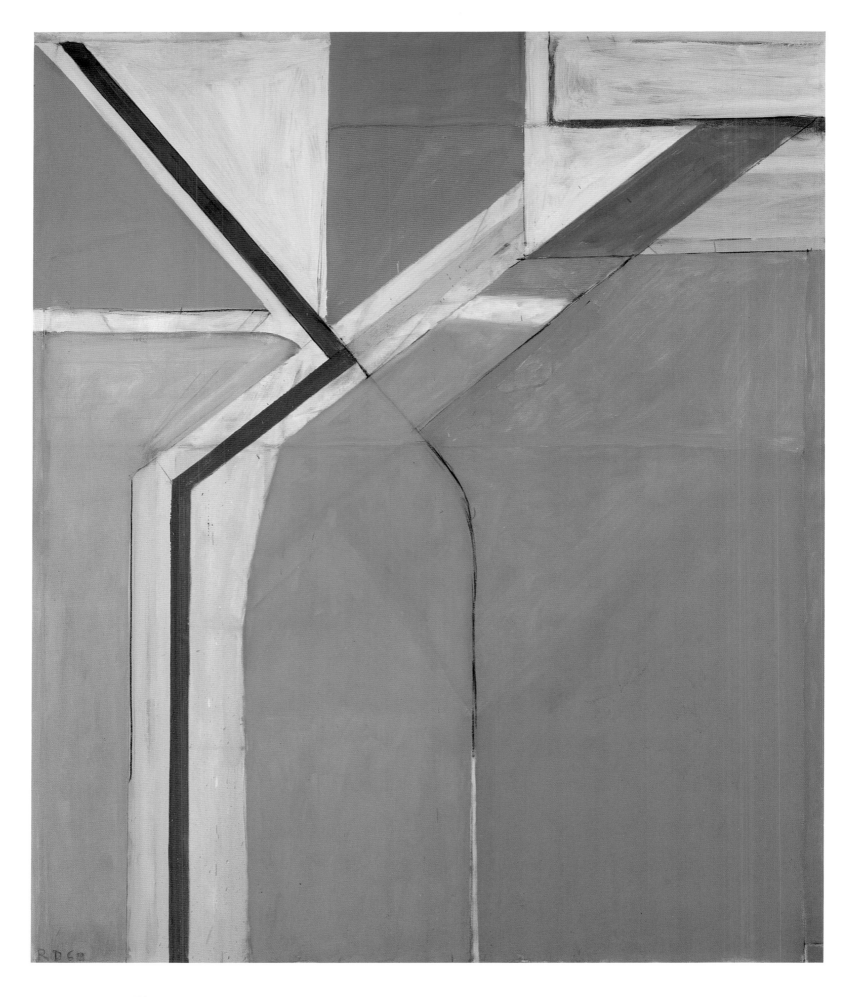

154

painting and of the influential 1914 canvases of Matisse.

Diebenkorn had been advised for years to seek more aggressive representation than provided by the Poindexter Gallery, with which he had been associated with since 1956, but he enjoyed the lack of pressure and the low-keyed dignity of the owner, Elinor Poindexter, as well as the high-ceilinged gallery space. Gilbert Lloyd, of Marlborough Fine Arts, Ltd. New York, became well informed about Diebenkorn's work, and mounted a persuasive effort to have Diebenkorn join Marlborough for "exclusive representation for a period of five years, beginning in 1971." With sincere regret and considerable feeling for Elinor and her commitment to his work, Diebenkorn withdrew from Poindexter Gallery. Marlborough's first Diebenkorn exhibition was mounted in December 1971 and included eighteen canvases and a group of related works on paper. It was the most eloquent showing to date of the Ocean Park work. Fields of lyrical blues, greens, and apricots and veils of tans and grays distinguished the works. Structure seemed dissolved in light, and the atmospheric side of the artist's work dominated. The exhibition catalogue records the following:

> Diebenkorn says of the *Ocean Park* series that "The abstract paintings permit an allover light which wasn't possible for me in the representational works, which seem somehow dingy by comparison."
> At the same time, the larger color areas which have been developing for some years permit an invigorated and intensified color which is expansive and conditioned by his allover light. Conflicts still abound in the artist's working methods and goals. Diebenkorn likes to work thinly with his paints, but he also wants density of layered pigments. Scraping and overpainting result in compromises. He claims that he would like the work to unfold in order and be all laid out as in a diagram, but at the same time, he is severely tempted to push the painting into chaos in order to see what will happen. He searches for a unity that is fresh, and surprising to himself, but that relies upon the nature of perception as well as the experience of art.[78]

Ocean Park No. 34, 1970 (p. 163), relates very clearly to porch and landscape subjects from the 1956–65 period. While the canvas is taller than it is wide, the composition spreads out in an uncharacteristic horizontal fashion, unlike the majority of the canvases of these years. Some canvases disperse forms relatively evenly across the surface in an overall composition, such as *Ocean Park No. 37*, 1971 (p. 164, top), but the artist seemed to be concentrating incident in the upper quarter of the canvas surfaces as in *Ocean Park No. 38*, *No. 41*, and *No. 45*.

Ocean Park No. 38, 1971 (p. 164, bottom), achieves a shifting of planes in the manner of Hofmann and Cézanne by creating a diagonal tension across the canvas between the green rectangle at the lower right and the compressed incident of yellow and sky-blue rectangles in the upper center. The folded V form at the upper left vitalizes the entire composition and, despite its perspective effect, does not interrupt the picture plane. *Ocean Park No. 40*, 1971 (p. 166), presents a more complex structure, similar

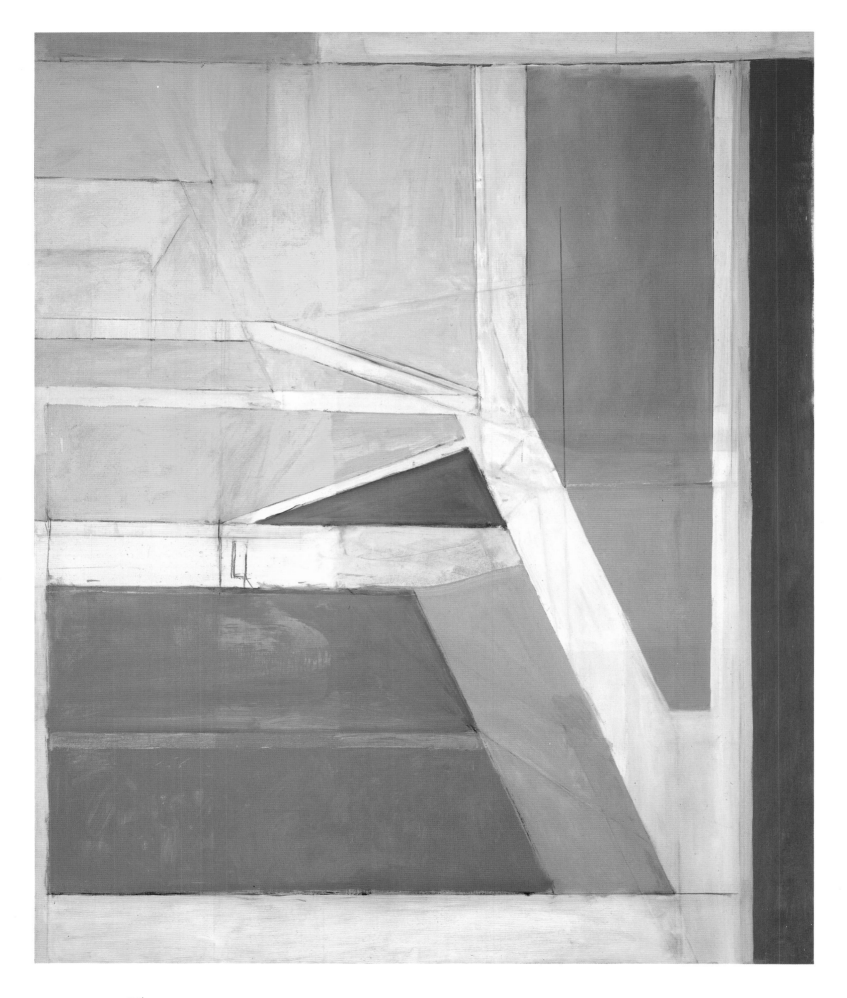

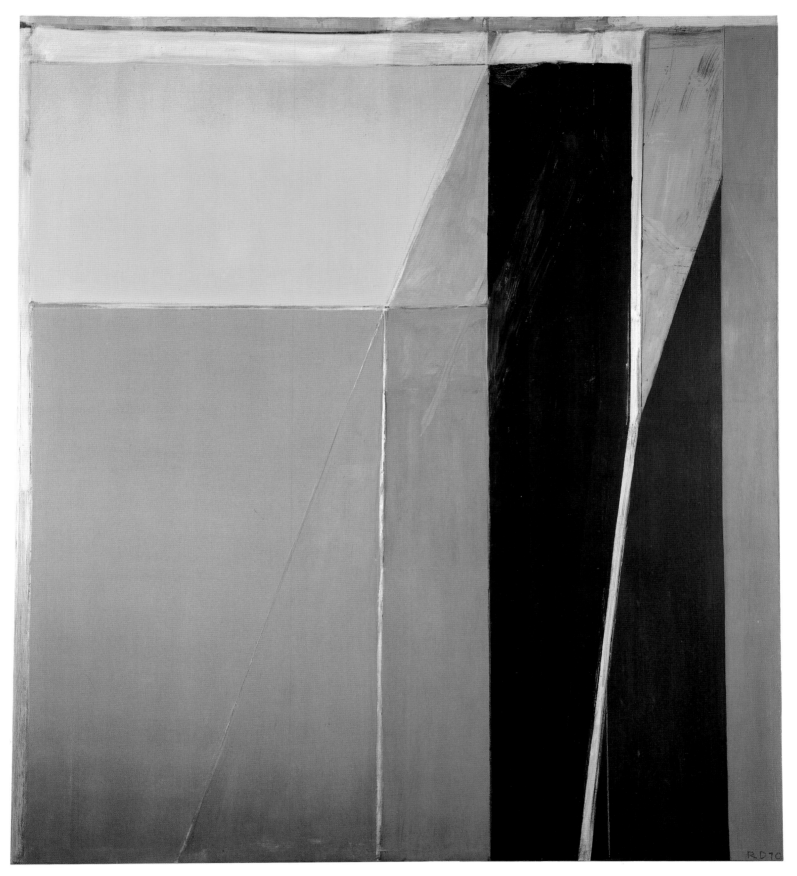

Opposite:
Ocean Park No. 27, 1970. Oil on canvas. 100 x 81 in.
The Brooklyn Museum, New York, 72.4, Gift of the
Roebling Society, Mr. and Mrs. Charles H. Blatt,
and Mr. and Mrs. William K. Jacobs, Jr.

Ocean Park No. 28, 1970. Oil on canvas. 93 x 81 in.
Private collection

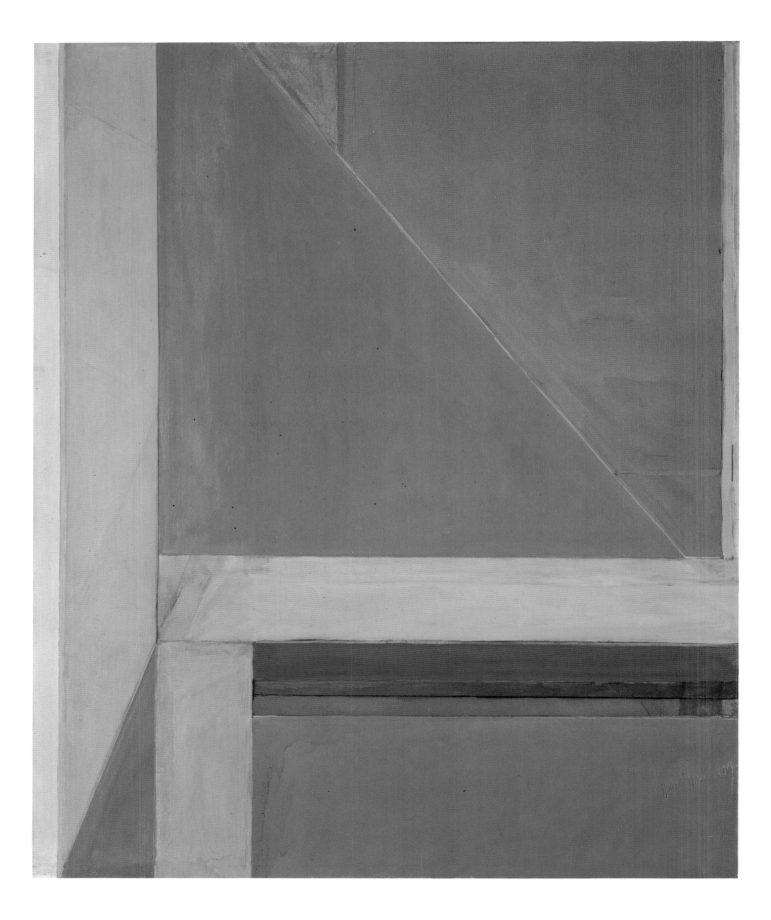

Ocean Park No. 29, 1970. Oil on canvas.
100 ⅛ x 81 ⅛ in. Dallas Museum of Art, Dallas,
Gift of the Meadows Foundation, Inc.

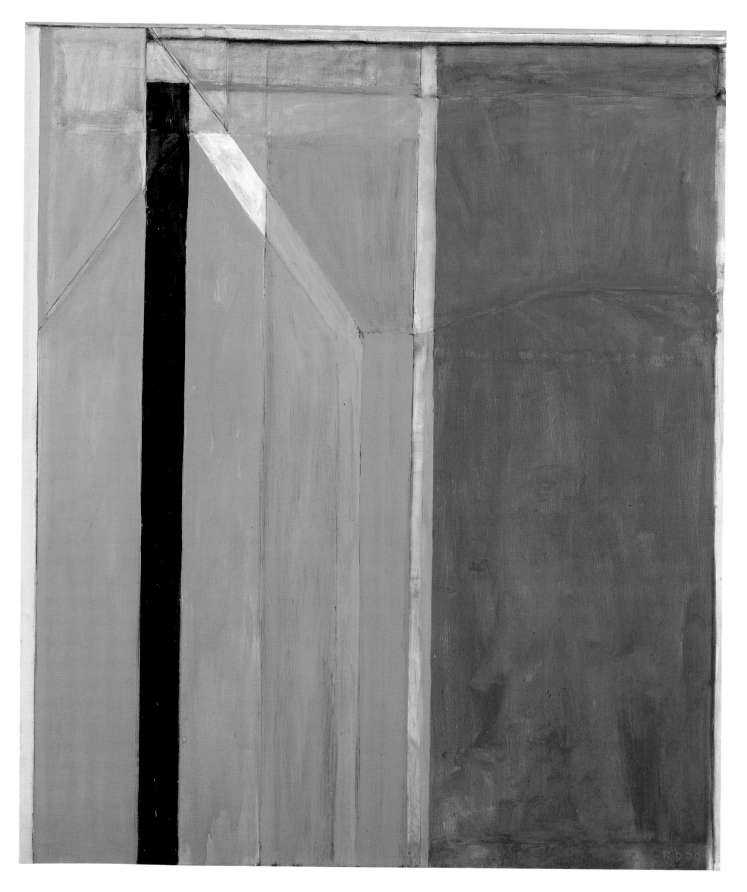

Ocean Park No. 30, 1970. Oil on canvas. 100 x 82 in.
The Metropolitan Museum of Art, New York,
Purchase, Bequest of Miss Adelaide Milton
de Groot (1876–1967), by exchange, 1972

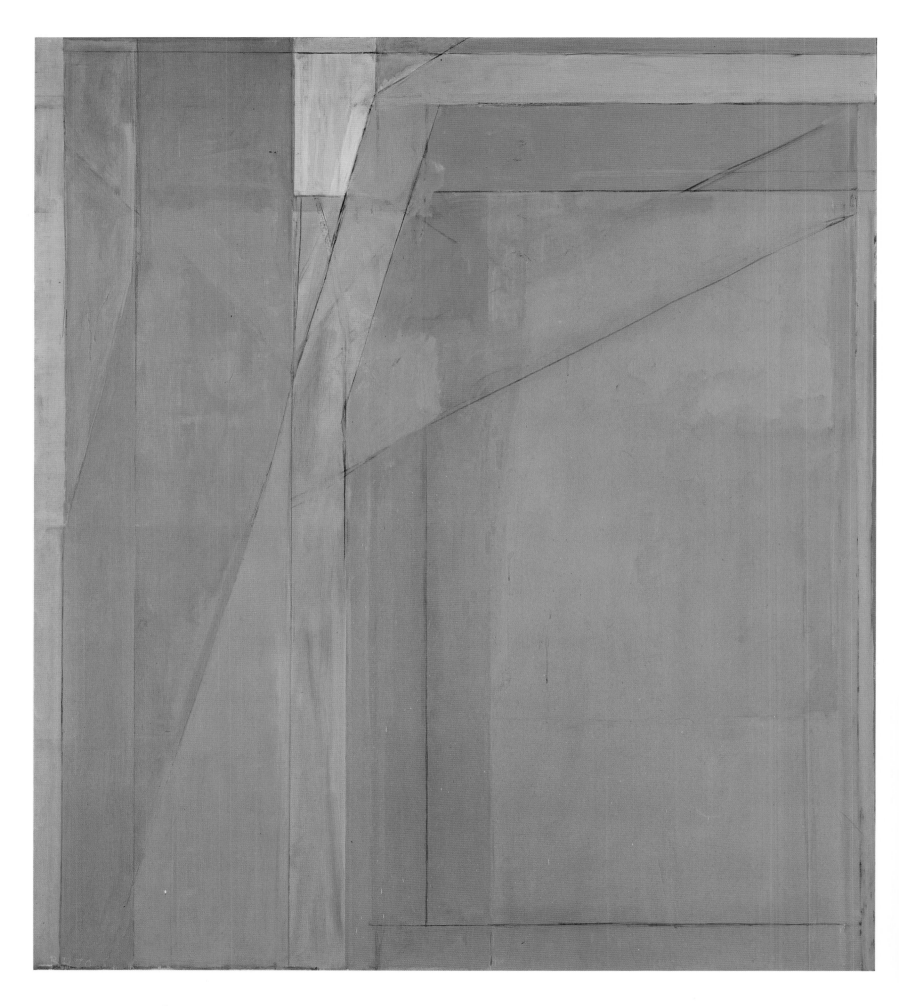

to that of one of the indoor-outdoor compositions of a decade earlier, and is heavily worked and reworked with grays and buffs, blues and greens, and oranges and yellows. The earliest stage of the canvas consisted of charcoal drawing and an initial block of blue-gray. The artist later widened a vertical band at the left center, simplified a complex area at the upper right, and developed a group of parallel vertical bands along the left margin (in blue, off-white, and flesh). An inverted V appeared at the upper center with a ground of dusty pink below and violet-blue and gray above. In the course of a number of weeks, the entire painting shifted and changed, with only the left and upper margins remaining as they were originally. All the colors and most of the forms were altered, and in the final painting blue-greens and oranges predominated. The underpainting activity remains visible, as an important part of the constructive experience that produced the finished work.

Ocean Park No. 41, 1971 (p. 167), is a primarily monochrome work in a gray-blue-green, with a smudgy vertical and horizontal linear scaffolding that in some places echoes the color of the large areas. Three areas of strong color emerge in the upper quadrant of the canvas—a tricolor at the upper left corner, a rectangle of blue at the upper left center, and two bars of yellow and golden brown, horizontally placed one above the other at the upper margin extending to the right edge of the canvas. John Elderfield found the cornered incident of the tricolor to be "a little quirky,"[79] while Dore Ashton felt "drawn immediately into a visual journey by the existence . . . of three small rectangles of color such as you might find on the color photographer's chart. They are the keys to the whole composition. Because they are small but intense in hue, they make everything else seem vast. Because they are rectangular, they insist on a rhyming rhythm of rectangular planes."[80] Each red, yellow, and blue touch in the canvas is given resonant body by the tiny tricolor, invigorating the lines, underpaint, and the rectangles, even as the expansive but shallow atmospheric space provides an embracing environment.

Ocean Park No. 45, 1971 (p. 168), has been perhaps most penetratingly described by Ashton:

> . . . the "purest" Diebenkorn I have ever seen, a quite constructivist approach to rectilinear color forms. But not really: that orange bar across the top reminds me of his other cues. All the forms pend from it. Pending is the nature of the painting—a field of grass green hung like a vernal rug, and falling, falling, because Diebenkorn strokes it downwards. Its neighboring blue vertical plane is falling also. Yet, wait: that slender interstice in the green plane with its hint of charcoal line has riven the plane, made a recessive space. And in the delicate whitish vertical at the right border, there is a half-stated line which once perceived becomes the insistent focus of the painting. In that wavering line, which dies midway up the canvas, lies the life of the painting.[81]

In his move away from figuration, Diebenkorn achieved a more independent and lyrical color within an undogmatic personal geometry.

Ocean Park No. 31, 1970. Oil on canvas. 93 x 81 in. Private collection

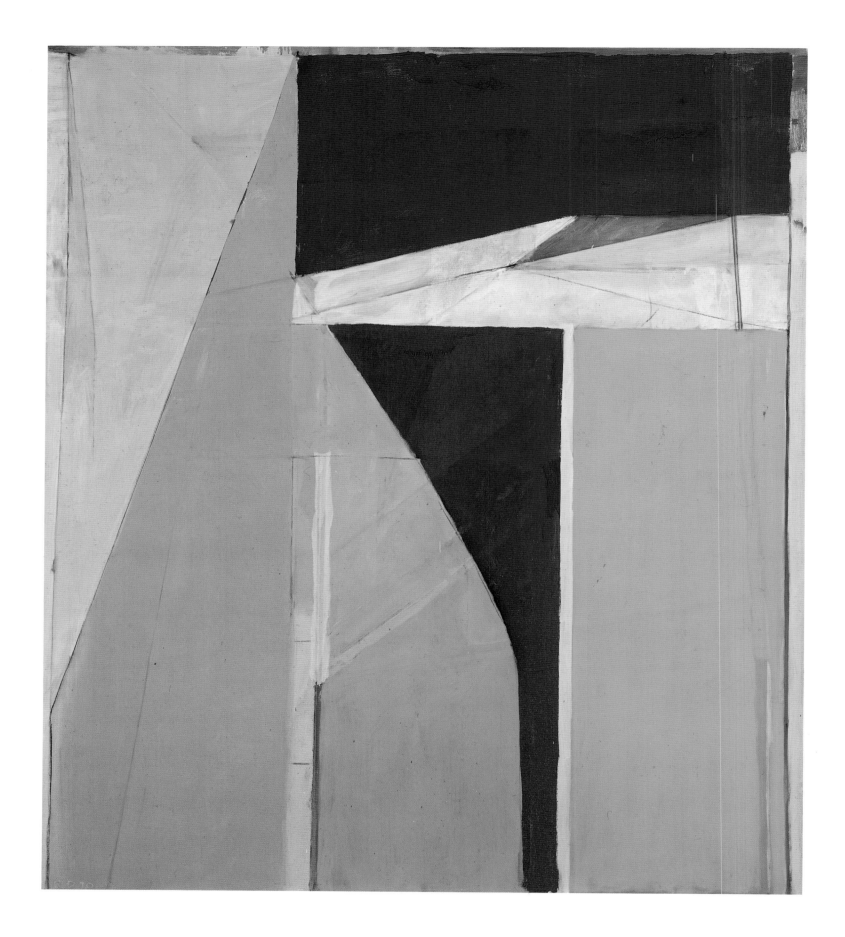

Ocean Park No. 32, 1970. Oil on canvas. 93 x 81 in.
Private collection

Opposite:
Ocean Park No. 34, 1970. Oil on canvas. 100 x 82 in.
Heublein Inc. collection, Hartford, Connecticut

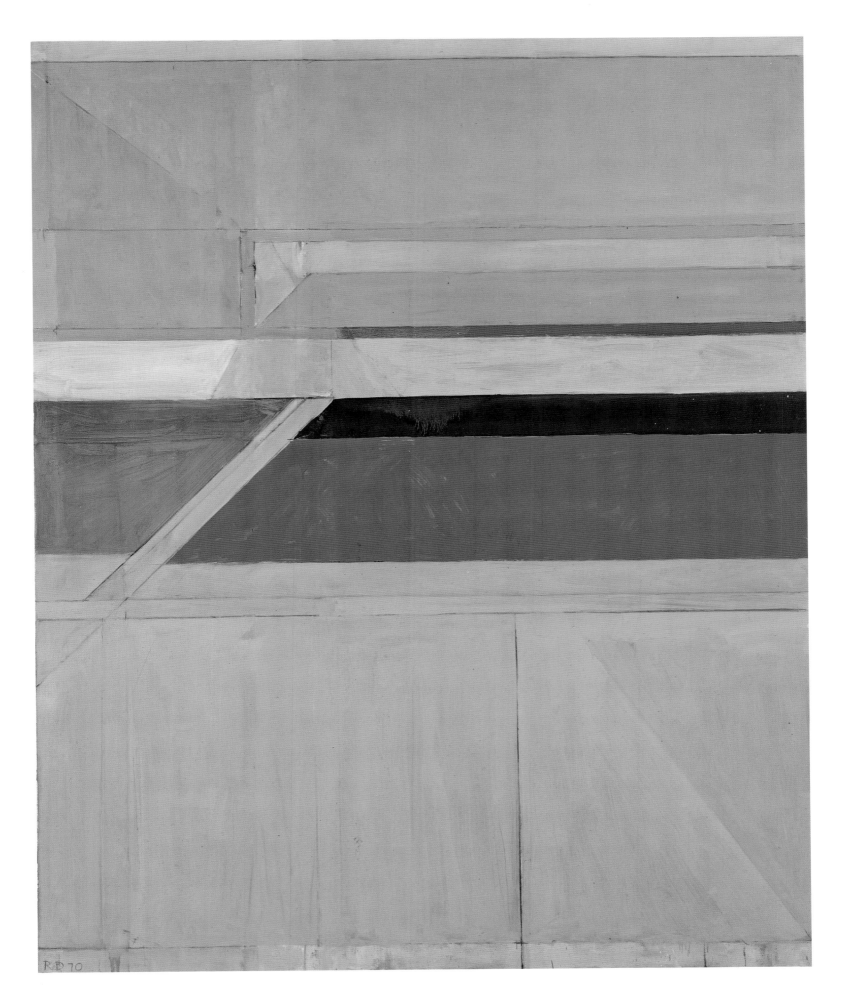

Above:
Ocean Park No. 37, 1971. Oil on canvas. 50 x 50 in.
California collector

Below:
Ocean Park No. 38, 1971. Oil on canvas. 100 x 81 in.
Mr. and Mrs. Gifford Phillips collection, New York

Opposite:
Ocean Park No. 39, 1971. Oil on canvas. 93 x 81 in.
Collection of Chermayeff & Geismar Associates,
Inc., New York

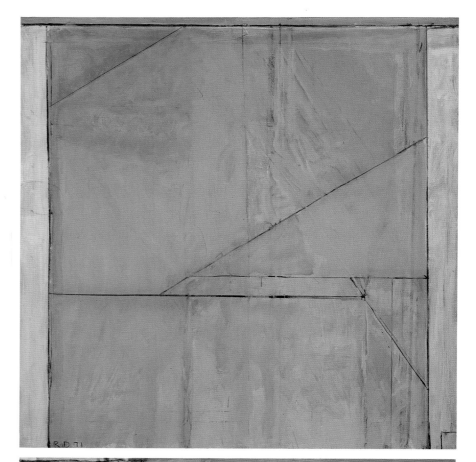

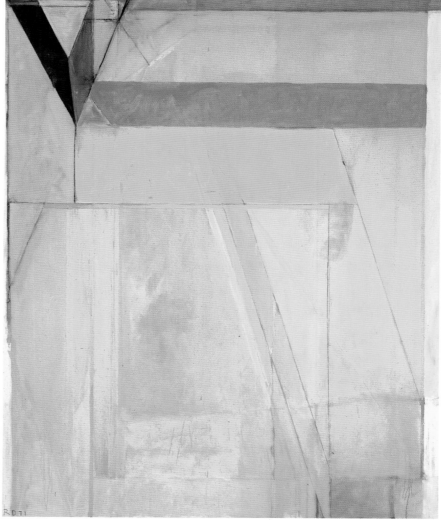

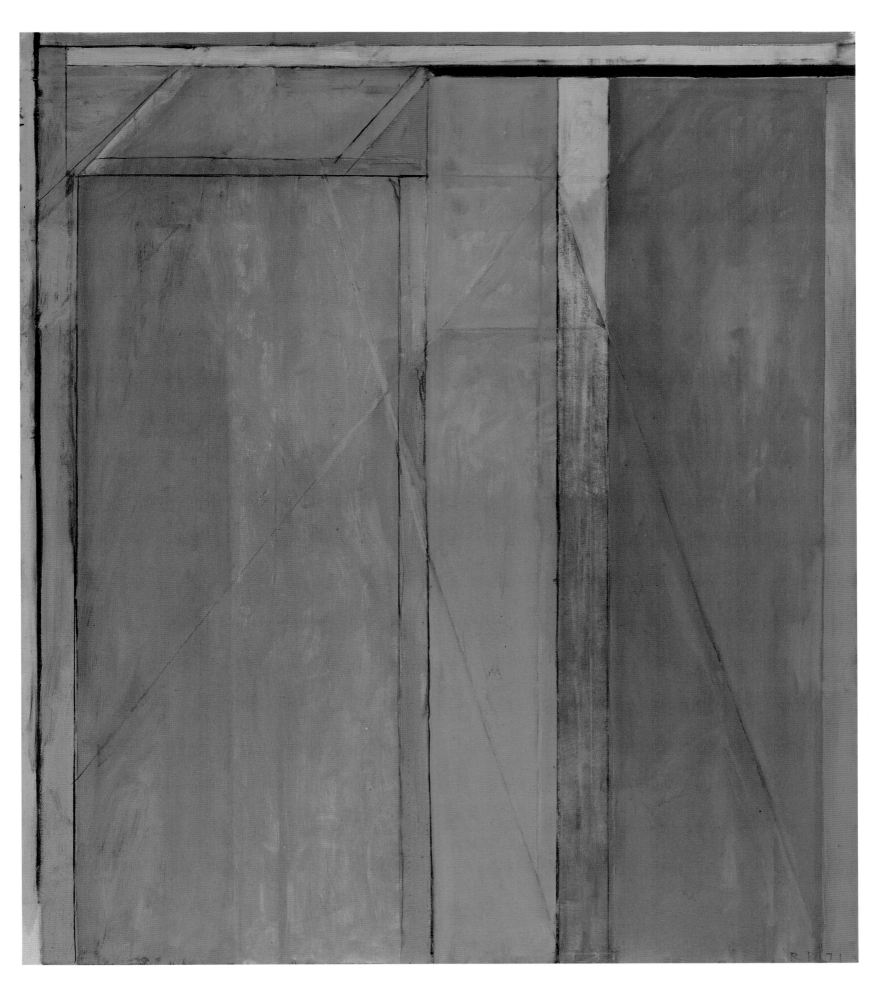

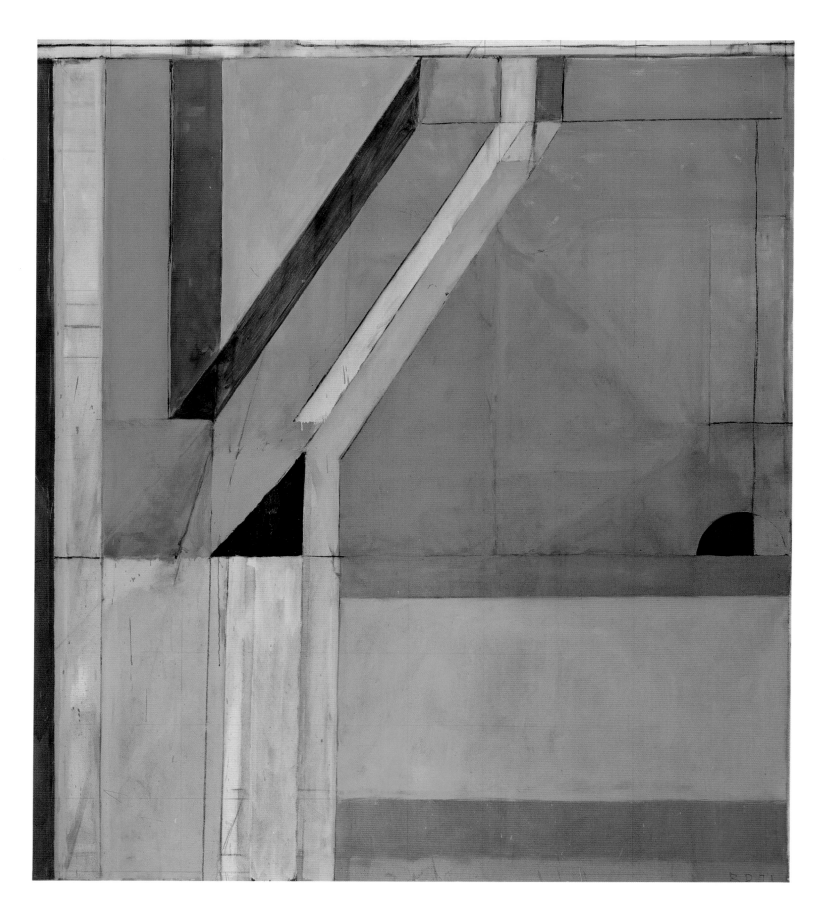

Ocean Park No. 40, 1971. Oil on canvas. 93 x 81 in.
Private collection

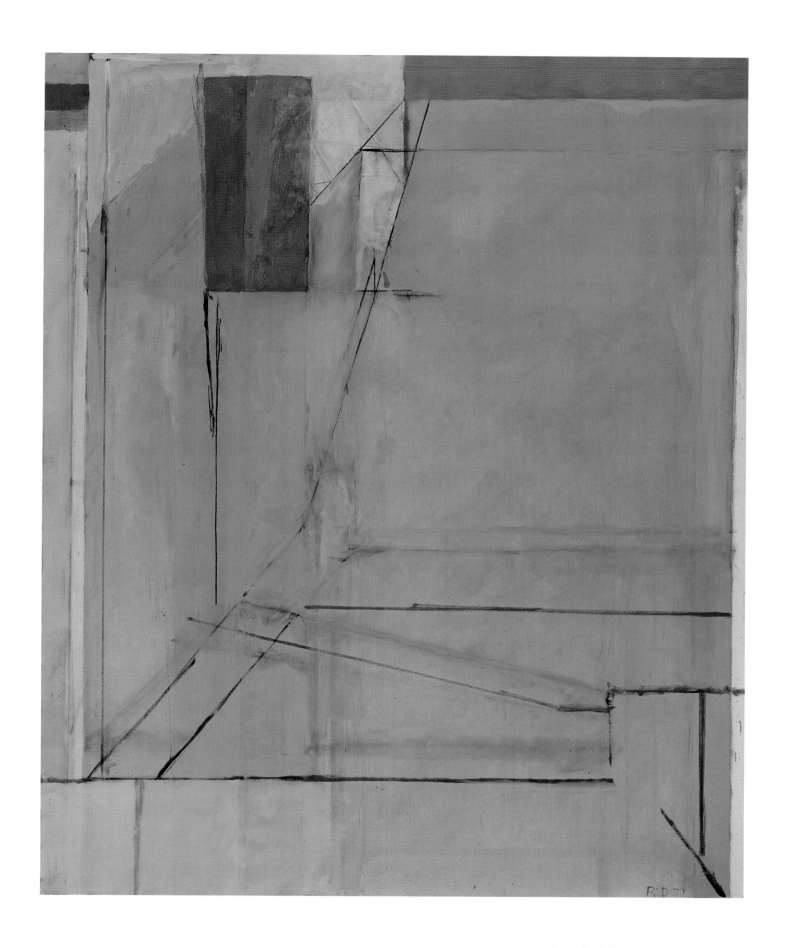

Ocean Park No. 41, 1971. Oil on canvas. 100 x 81 in.
Morris Bergreen collection, New York

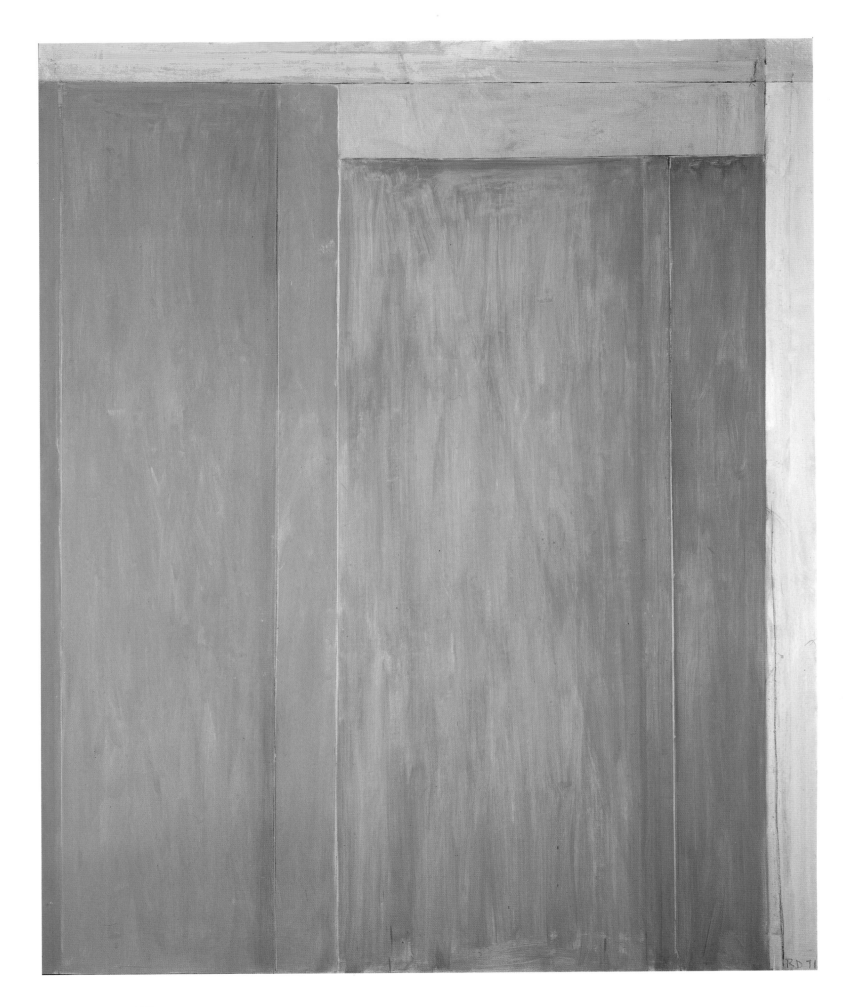

From this came a clarity and grandeur consistent with Hopper, Cézanne, and Matisse. *Ocean Park No. 45* offers an accomplished example, worked in larger areas of strong color, bordered with indeterminate grays and whites. The color is saturated, intense, yet inflected and unabashedly hand-painted. A few paint spatters and traces of his process are allowed to remain. One of his studio notes clarifies his practice: "When I arrive at the idea, the picture is done. There seems something a little immoral about touching up an idea."[82]

One of the most expressive and adventurous works in the early part of the series is *Ocean Park No. 43*, 1971 (frontispiece, p. 2). It is a big free-wheeling canvas, which utilizes combinations of vertical elements at both the left and right margins to frame a vast central panel. A geometric structure has been fragmented; the light center is criss-crossed with pentimenti, reminiscent of Matisse's *Notre Dame* and the late unfinished Mondrians, and its light is dramatically enhanced by the strong turquoise and yellow-green on the right and the ochre, orange, blues, and violet on the left.

Ocean Park No. 48, 1971 (p. 170), recalls Harold Rosenberg's well-known allusion to the canvas as an arena in which the artist acts. A chorus of verticals at the right margin provides an active opposition to the opaque field of stacked colors on the expansive field to the left—a strong turquoise on the right is opposed by a dark green and a violet on the left. In the complex and overpainted verticals to the right, grays painted over pinks and cut across by charcoal and black lines have been repainted and adjusted until they are indescribable. The painting is a battleground, retaining vestiges of warring passions. Of such passages Henri Matisse once wrote: "A large part of the beauty of a picture arises from the struggle which an artist wages with his limited medium."[83]

Ocean Park No. 54, 1972 (p. 172), features a richly painted veil of luminous and transparent light blue, over and under which appears a familiar linear structure of vertical and horizontal divisions. Blues and greens, violets and yellows assume roles in the post-and-lintel structure. Diagonals cross the vertical panel-fields, vitalizing the lower two-thirds of the canvas, while a nest of geometric color spaces establishes a tension-charged balance in the upper third.

It is a sensuous, light-filled space, a field of breathing color, the idea of which may go back to the artist's experience of Rothko's work. The complex references to geometry incorporate sophisticated approximations of cubism as well as allusions to the crystalline skies and ships of Lyonel Feininger. The handling is many-layered, urgent, nuanced. Abstract expressionism surely lies behind it, in the scumbled, corrected, occasionally dripped-on surface, which is then suddenly suspended rather than compulsively "finished."

The first showings of the Ocean Park series in Britain and on the continent occurred in December 1973–March 1974 at the Marlborough Galleries in London and Zurich, respectively. Ten of the exhibition's fifteen canvases were shown for the first time, and the paintings were distinguished by a lyrical quality and a gracefulness. Canvases such as *Ocean Park No. 54*, set the pattern and were followed by a series of paintings

Ocean Park No. 45, 1971. Oil on cotton duck. 100 x 81 in. Courtesy of the Art Institute of Chicago, Chicago, Mr. and Mrs. Frank G. Logan Prize, 1972

169

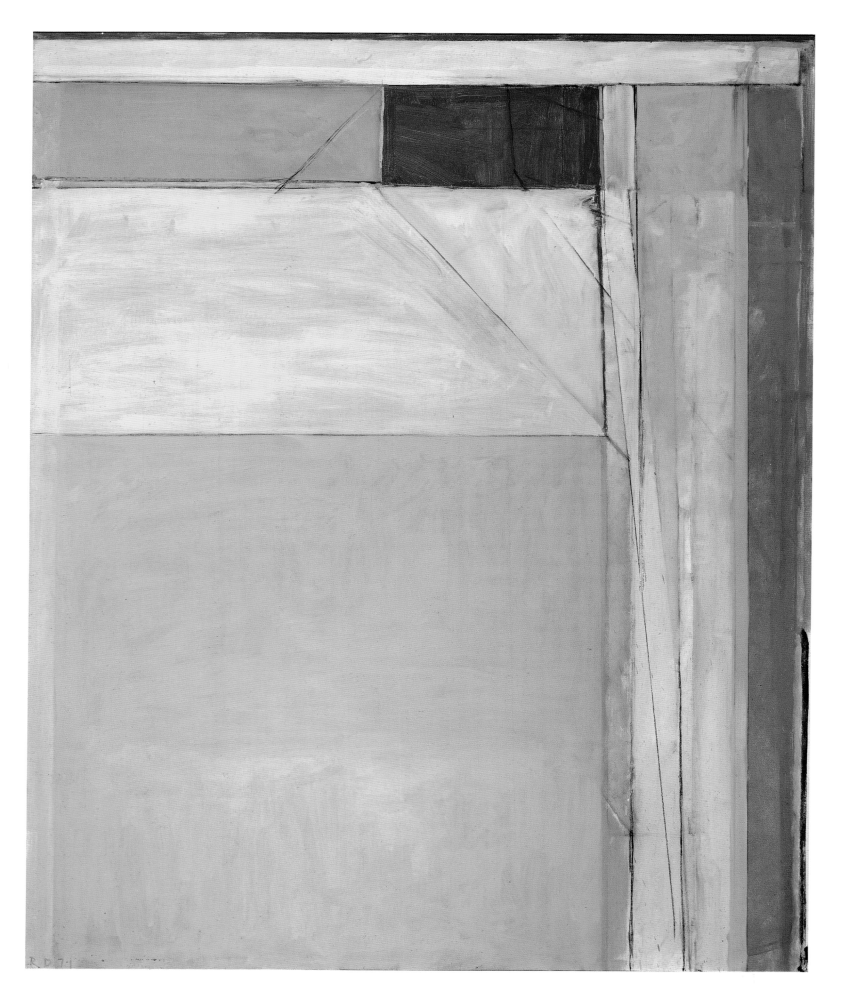

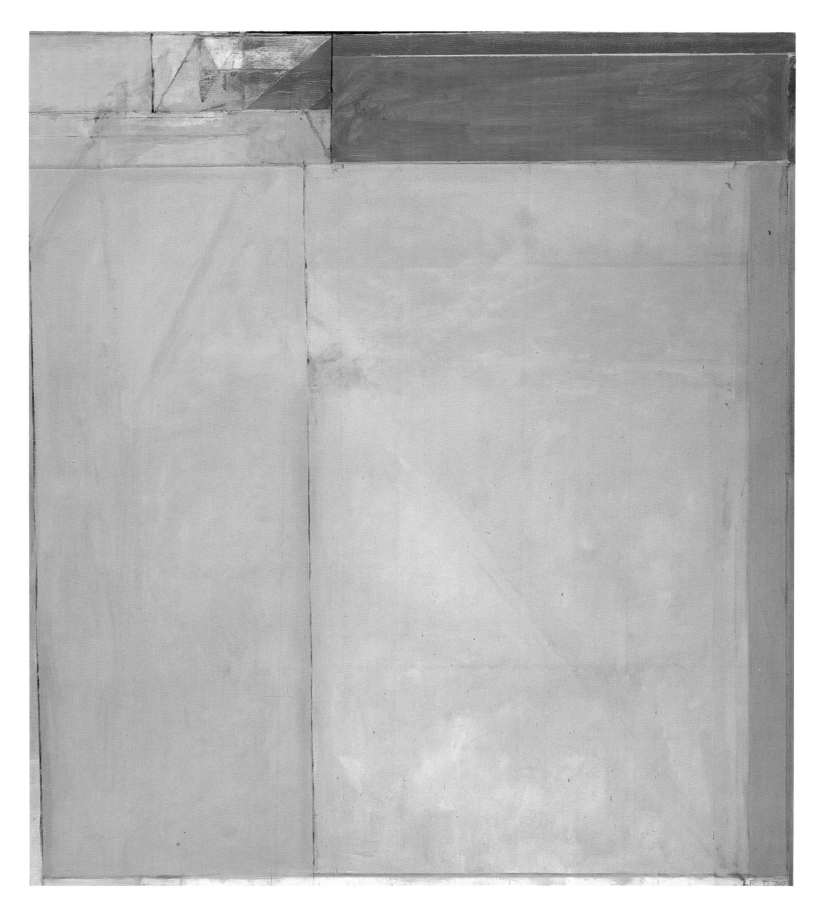

Opposite:
Ocean Park No. 48, 1971. Oil on canvas.
108 x 82 in. John and Zola Rex collection,
Carpenteria, California

Ocean Park No. 49, 1972. Oil on canvas. 93 x 81 in.
Los Angeles County Museum of Art, Los Angeles,
Museum Purchase with funds provided by Paul
Rosenberg and Co., Mrs. Lita A. Hazen, and the
Estate of David E. Bright

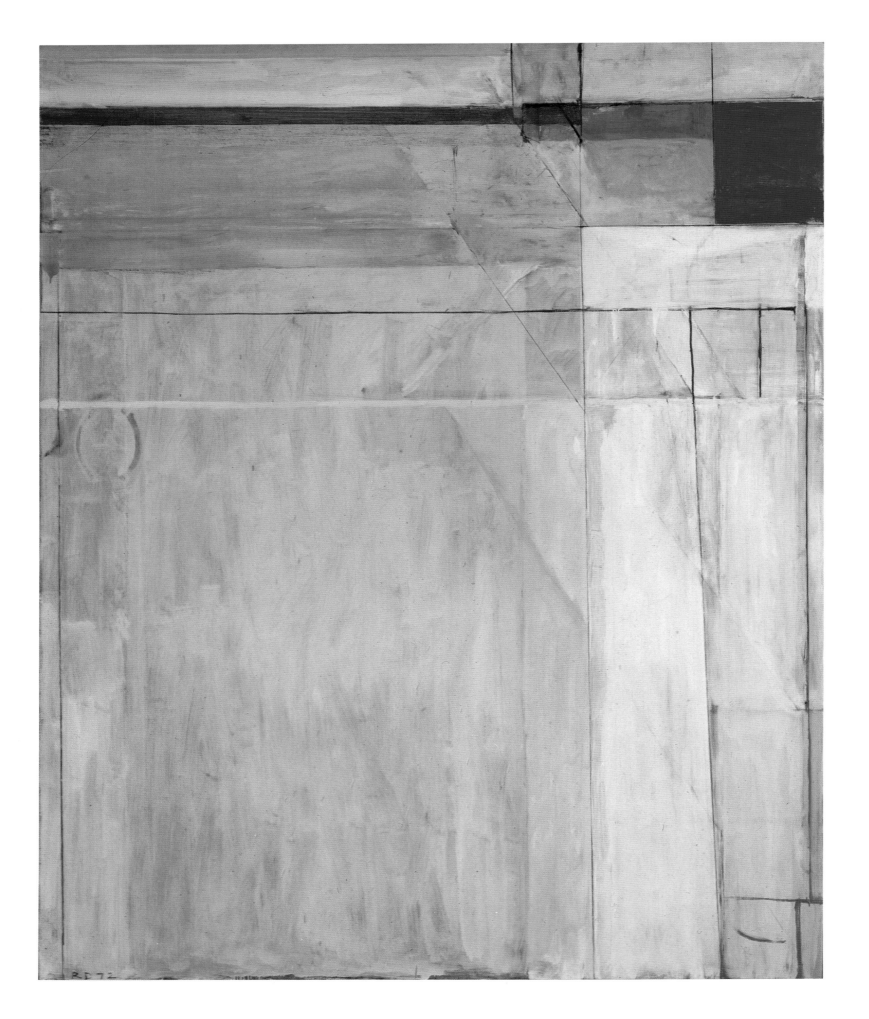

172

with great fields of vibrant yellows and varied blues. Many of the new works, particularly *Ocean Park No. 64*, 1973 (p. 175), reflect the directness of the artist's drawing method and color application, in which the linear trial-and-error process finds an almost instant translation into paint. In these works the unfinished look of pentimenti is used with continually growing power.

The paintings of this period were to attain a new spontaneity and freshness, each canvas infused with a particular and convincing light of its own. The structure of the lyrical *Ocean Park No. 63*, 1973 (p. 174), gives the illusion that it is horizontal—a rare Diebenkorn format. It is however a square canvas, equally unusual in design. That work's lyricism and lightness speaks to *Ocean Park No. 59*, 1973, a very dark and reflective picture plane. Consistently in his most colorful periods the artist tended to take a detour every twelve to eighteen months into a very dark painting (as in *Ocean Park No. 133* of 1985; p. 6) as a refreshing exercise. John Russell wrote in his text for the 1973 Marlborough show's catalogue:

> They make eye-music of quite another kind, even if the sudden sideways thrust of one form or another may occasionally echo the economical spear-thrust of one desert-road as it darts away from another at an angle of 15 or 20 degrees. The pictures are much more about flatness, and about the ways in which the overall flatness can be spiced with forms that seem to overlap, or turn on hinges, or pull sideways and back and forth across the surface of the canvas, like windscreen-wipers in operation. Diebenkorn is also a colourist who can make the merest sliver of an unexpected colour exert an astonishing leverage on the painting as a whole: over and over again in this exhibition there are paintings which, though sober and explicit in their lower halves, come to inhabit a world of wilder adventure as the painter nears the top of the canvas. Great risks are taken, at such times, but with no element of bravado; what is happening is that one idea confronts another in a small space and neither will back down.[84]

Nigel Gosling provided a typically British response to the Marlborough exhibition in *The Observer*:

> A clear and persuasive demonstration of painting fairly planted in its own territory, untainted by any hint of theatre, is at the Marlborough Gallery, which has an impressive array of new works by the American Richard Diebenkorn. They are all recent pictures, huge abstracts in which the hard facts of painting—a square white canvas, a supply of pigment and the utensils of the craft, whether brush or spray or scraper—are openly deployed and then overlaid with hints of place and atmosphere. They are variations on a theme labelled Ocean Park and are visibly based on some light and airy California beachscape. Diebenkorn is better known to us as a figurative artist and, just as an abstract structure gave strength to his landscapes and nudes, so a vision of melting sea and sky, light and form seem to illumine the

Ocean Park No. 54, 1972. Oil on canvas. 100 x 81 in. San Francisco Museum of Modern Art, San Francisco, Gift of the friends of Gerald Nordland

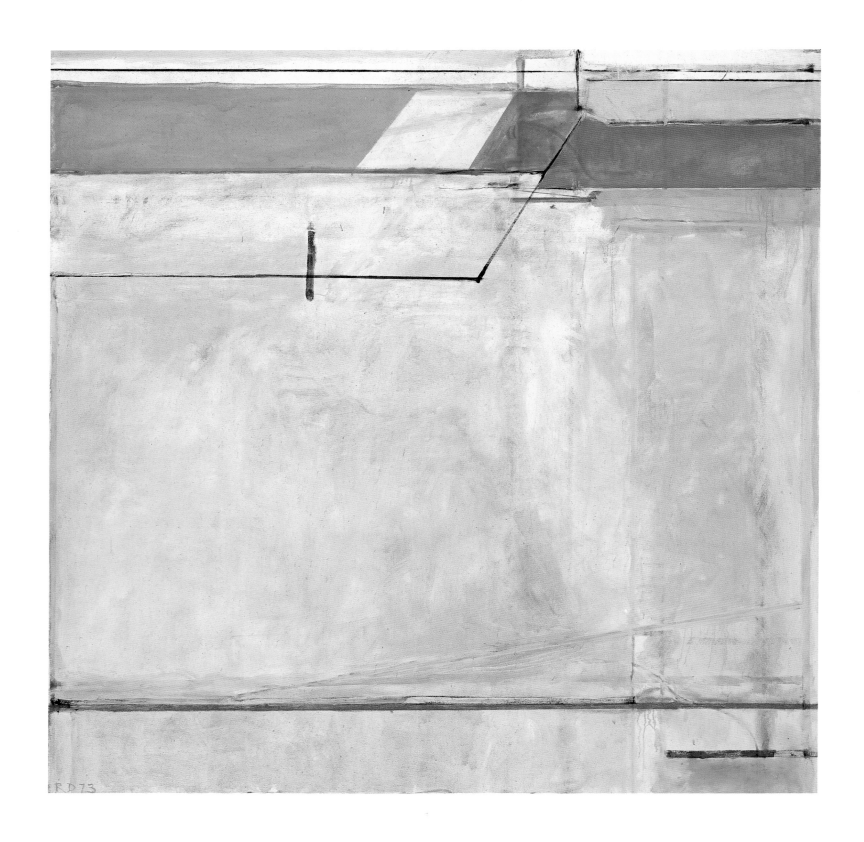

Ocean Park No. 63, 1973. Oil on canvas. 81 x 81 in.
Private collection

Opposite:
Ocean Park No. 64, 1973. Oil on canvas. 99 7/16 x
81 1/16 in. The Carnegie Museum of Art, Pittsburgh,
The Henry L. Hillman Fund in honor of the Sarah
Scaife Gallery, 1974

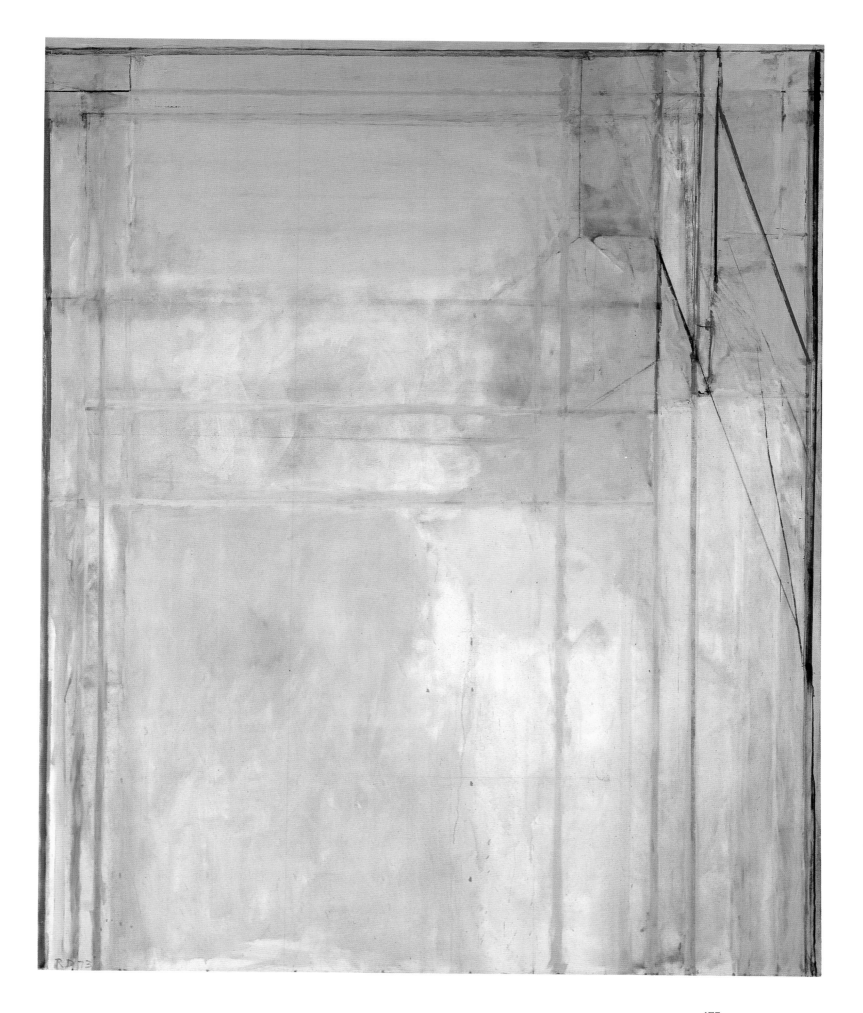

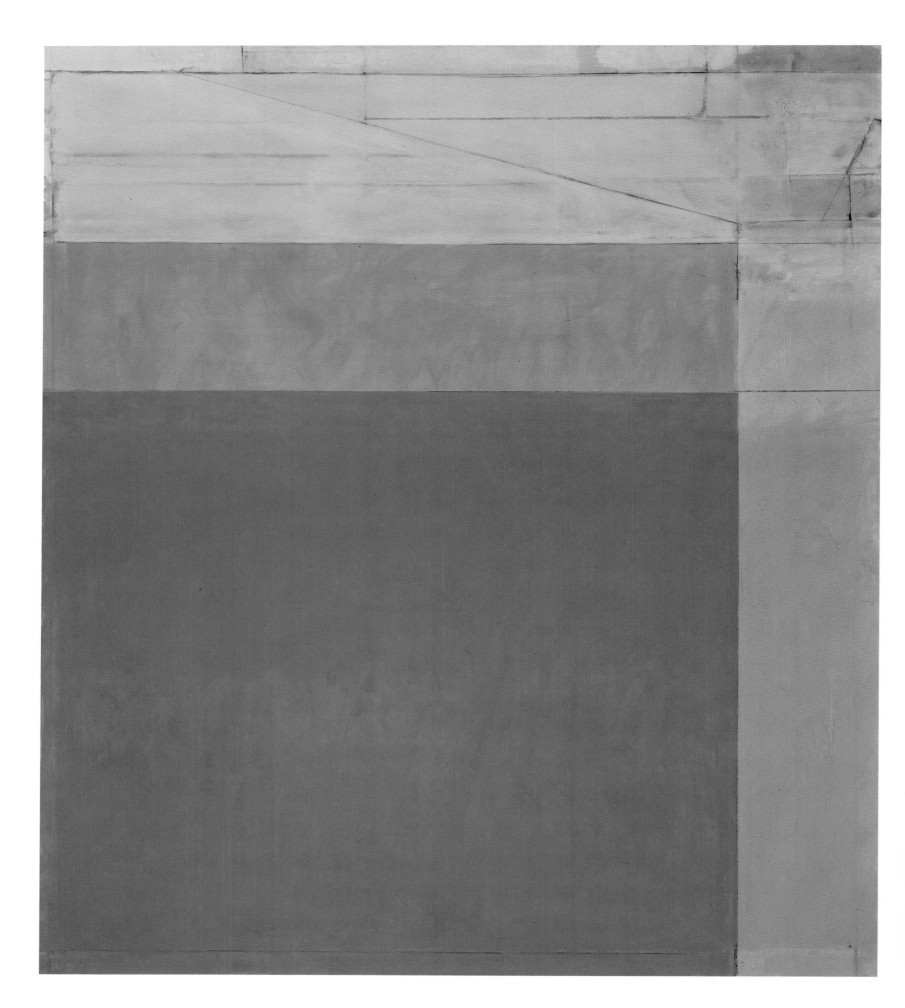

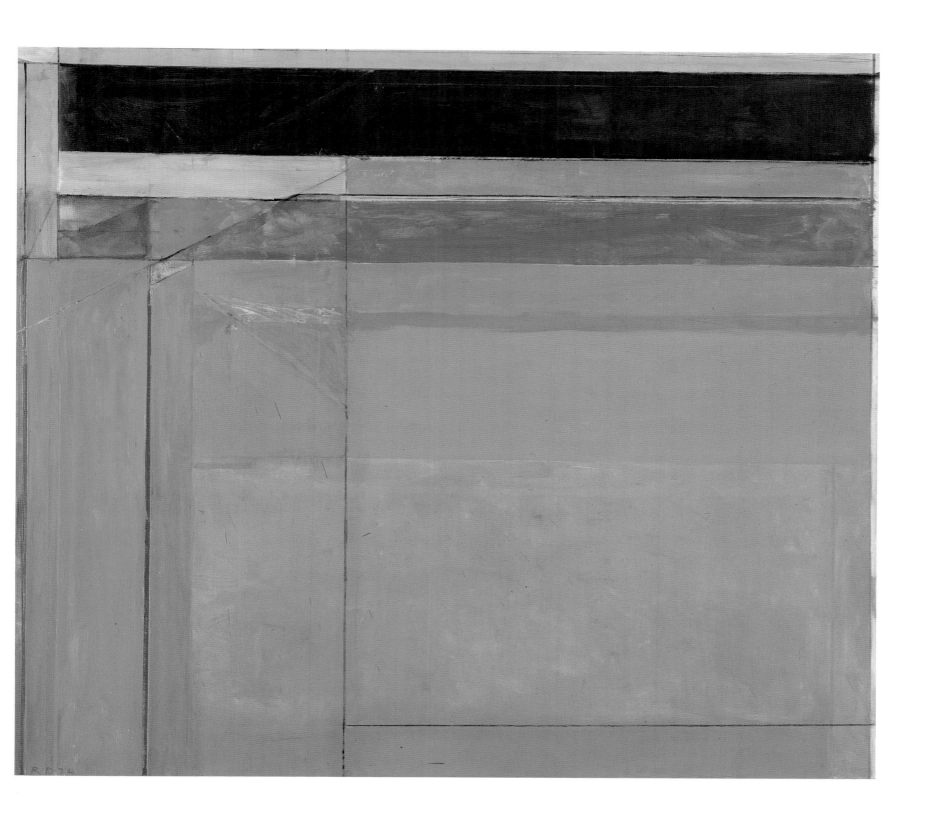

Opposite:
Ocean Park No. 66, 1973. Oil on canvas. 93 x 81 in.
Albright-Knox Art Gallery, Buffalo, New York, Gift
of Seymour H. Knox, 1974

Above:
Ocean Park No. 68, 1974. Oil on canvas. 81 x 93 in.
Milwaukee Art Museum collection, Milwaukee,
Gift of Jane Bradley Pettit

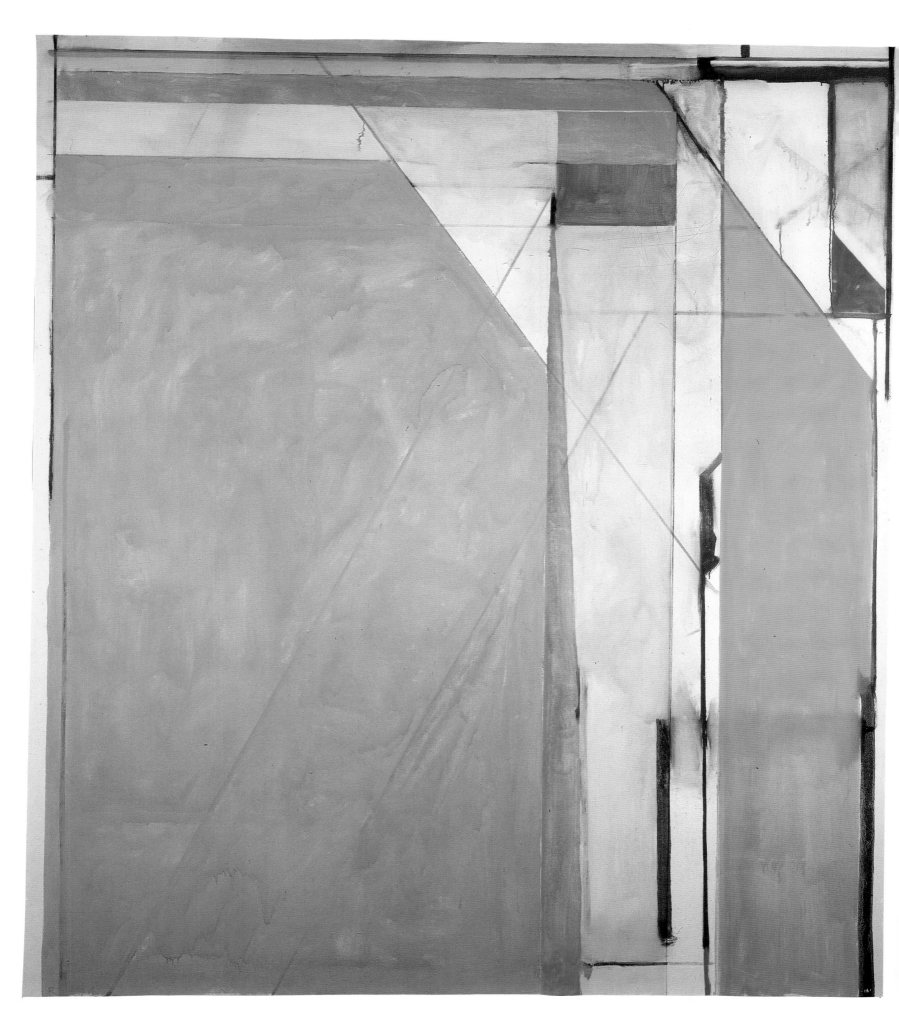

ostensibly austere confections. It is a very English recipe, and the pictures can be seen as a Californian tribute to Turner. I would guess them to be much to our native taste.[85]

The years 1974 and 1975 witnessed a number of important Diebenkorn exhibitions. In 1974 Diebenkorn had his first retrospective showing of drawings at the Mary Porter Sesnon Gallery at the University of California at Santa Cruz. The exhibition ranged over twenty-nine years and featured works borrowed from museums and private collectors as well as from the artist and his family. A major retrospective exhibition had been planned for the Pasadena Art Museum but was subsequently cancelled. In 1975 two private California galleries—the James Corcoran Gallery in Los Angeles and the John Berggruen Gallery in San Francisco—joined forces to fill the vacuum by organizing an exhibition of Diebenkorn's early abstract paintings. Theirs was a museum-quality show, well representative of the Sausalito, Albuquerque, Urbana, and Berkeley years. Borrowed almost entirely from private collectors, the show made a powerful impression on a new audience, unaware of the artist's earlier abstract painting.

Diebenkorn fulfilled his five-year contract with Marlborough but gave notice that he would be leaving the gallery at the close of the third show, which was to run during the month of December 1975. Due to his misgivings concerning the Mark Rothko scandal at Marlborough, and despite his own favorable contract and proper treatment, he felt it necessary to terminate the relationship.[86]

The final exhibition at Marlborough was one of the most varied that the artist had received in a commercial gallery. Twelve canvases and a large group of works on paper reflected the full range of his new work. Shown were six major works in the traditional vertical format, the first, and for many years the most interesting, of the horizontal Ocean Park paintings, two canvases in a square format, and a number of new stretcher shapes just short of six feet in height.

Diebenkorn's working method, as it had evolved through his career, is left exposed on these 1974–75 canvases: the drawing, nearly buried, the color, scraping, and overpainting shifting within the composition. The art is concerned not only with what one sees as a final "stopping place," but also with the viewer's perception of the means and process leading up to the finished piece. The linear matrix exists as a vessel for the luminous color areas built out of the layered and modulated surfaces. There is a tactful coexistence between the now-suggested, now-explicit matrix and the breathing spaces of color. The insistent overall design is always present, but the weight of lines and the elaboration of structure and form is keyed entirely to the color, resulting in a masterful and unique balancing act between flatness and contradictory spatial movement in each work.

Three paintings from this period, *Ocean Park No. 79* (p. 181), *No. 83* (p. 183), and *No. 86* (p. 184), all of 1975, are among the most grandly conceived works of the artist's career. Abutting colors at times fall short of

Ocean Park No. 70, 1974. Oil on canvas. 93 x 81 in. Des Moines Art Center, Des Moines, Iowa, Coffin Fine Arts Trust Fund

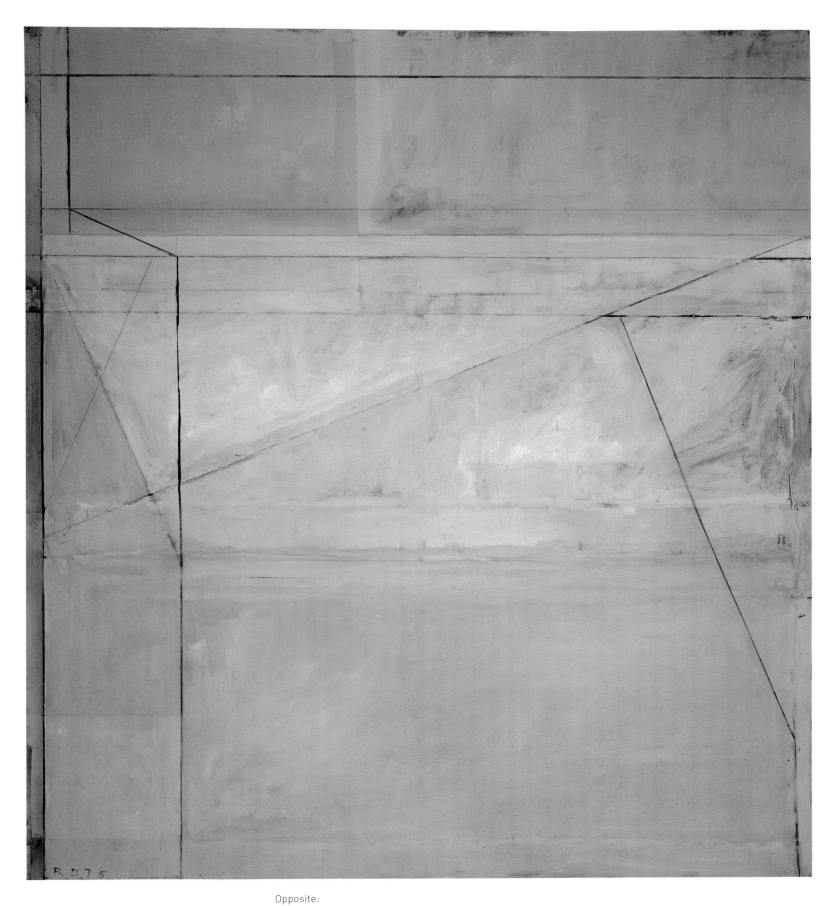

Ocean Park No. 78, 1975. Oil on canvas. 83 ½ x 75 in. Honolulu Academy of Arts, Honolulu, Purchased, 1975, National Endowment for the Arts Grant and Matching Funds

Opposite:
Ocean Park No. 79, 1975. Oil on canvas. 93 x 81 in. Philadelphia Museum of Art, Philadelphia, Purchased with a grant from the National Endowment for the Arts and funds contributed by private donors

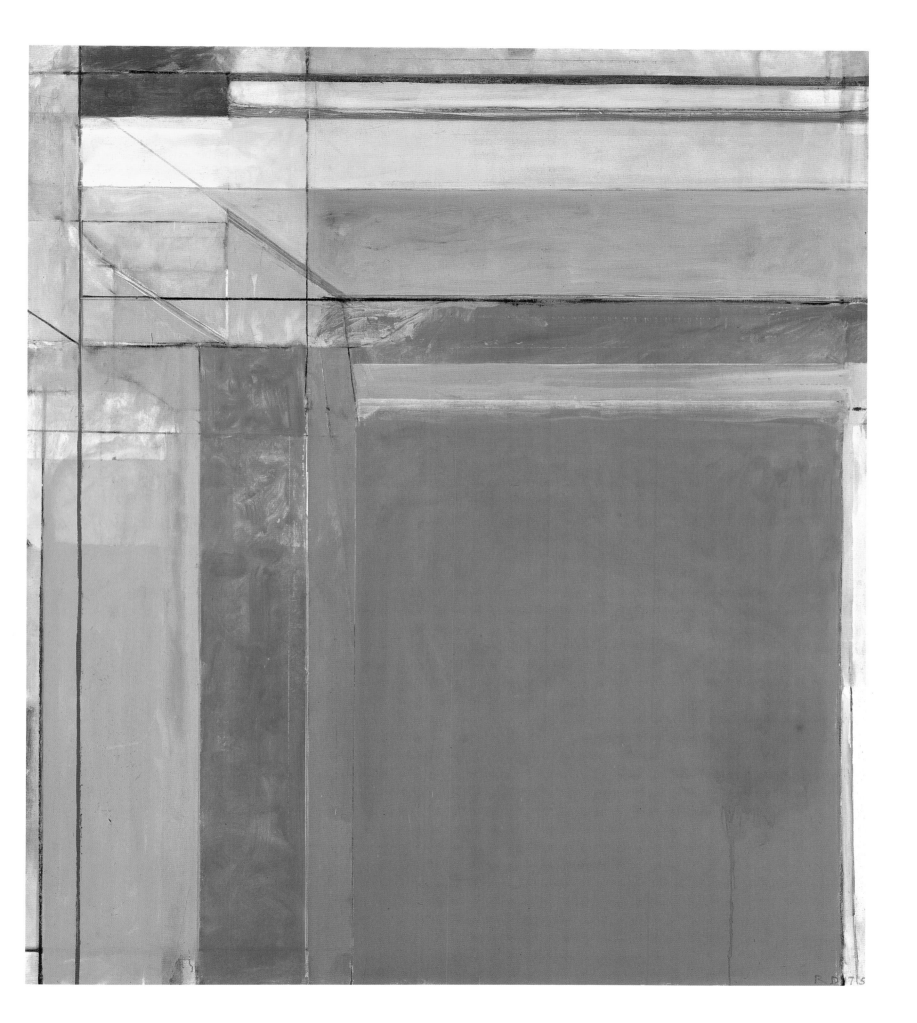

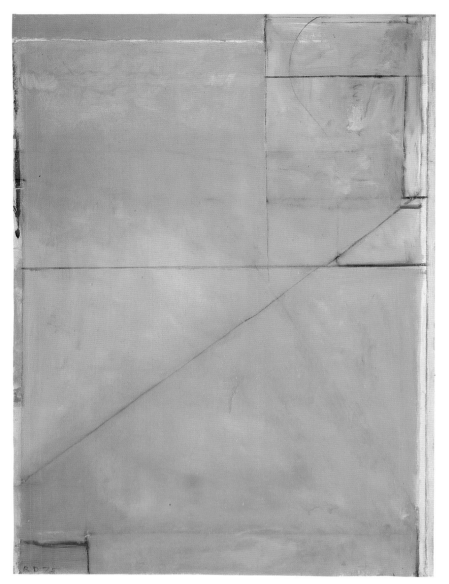 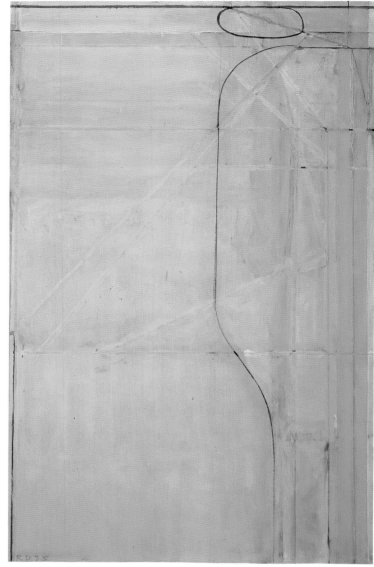

Ocean Park No. 80, 1975. Oil on canvas. 65 x 46¾ in.
Joan and Jerry Serchuck collection

Ocean Park No. 82, 1975. Oil on canvas. 70 x 44¾ in.
Private collection

Opposite:
Ocean Park No. 83, 1975. Oil on canvas. 100 x 81 in.
In the collection of the Corcoran Gallery of Art,
Washington, D.C., Museum Purchase with the aid
of funds from the National Endowment for the
Arts, the William A. Clark Fund, and Margaret M.
Hitchcock, 1975

perfect registry, casually adjusted edges or a meandering line may carry
an idea fully; an imprecise correction, an area of pentimenti, a smudge
here or an accidental drip there underscore the coherence of the artist's
method. All three works have an opacity of color that is in marked contrast
to the breathing lyricism of the 1972–73 paintings. The tactile surfaces
and architectural planes are joined to the picture plane, to each other,
and to the canvas support by the precision of colors and the nuance of
their application. These are paintings that require long and thoughtful
viewing, and with them Diebenkorn presented his credentials as a major
international painter.

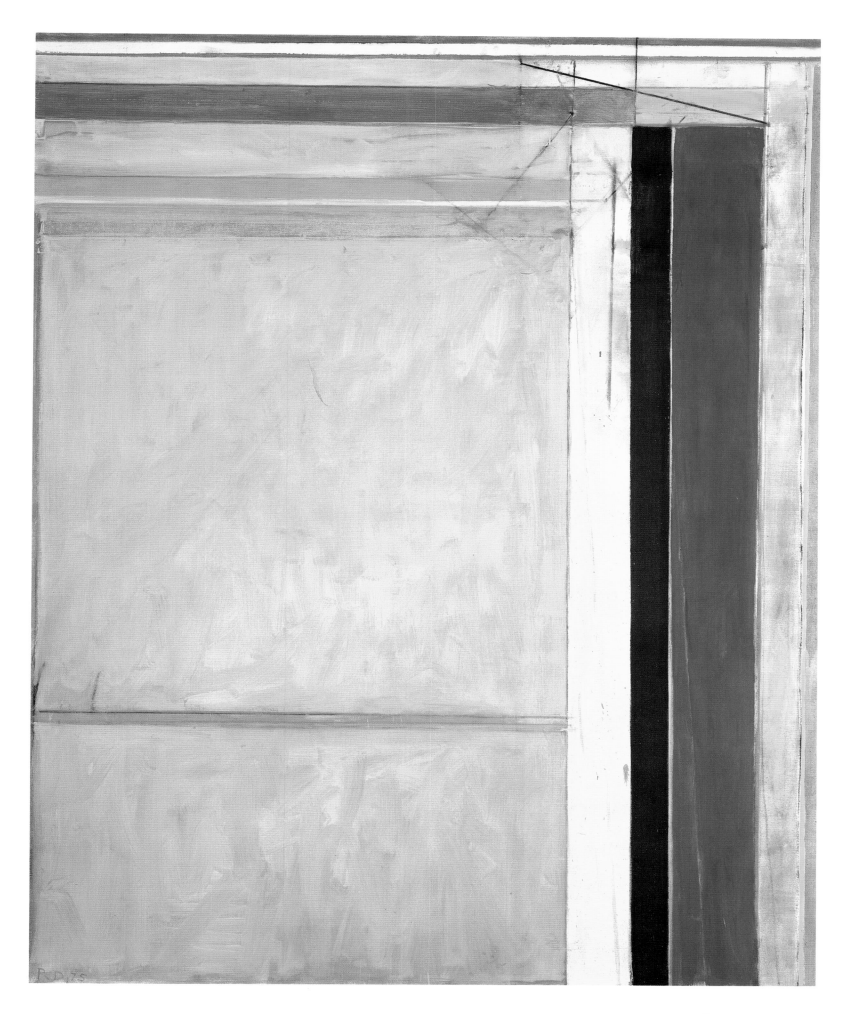

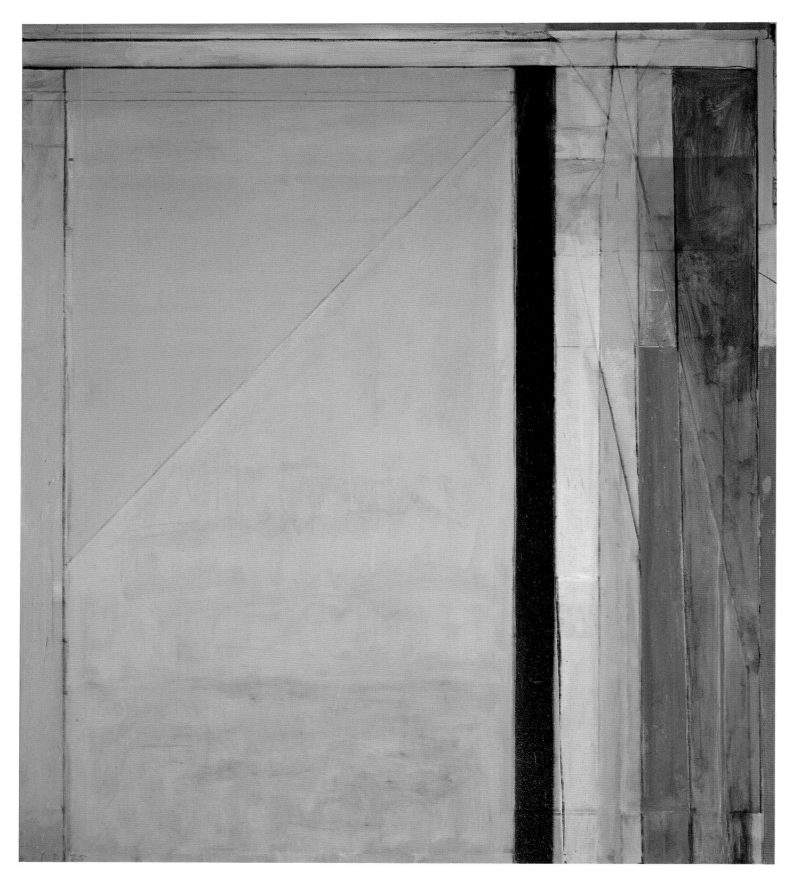

Ocean Park No. 86, 1975. Oil on canvas.
93 ⅛ x 81 ⅛ in. The Saint Louis Art Museum,
St. Louis, Missouri, purchased with funds
given by the Schoenberg Foundation, Inc.

Opposite:
Ocean Park No. 87, 1975. Oil on canvas.
100 x 81 in. Mr. and Mrs. Paul Mellon collection,
Upperville, Virginia

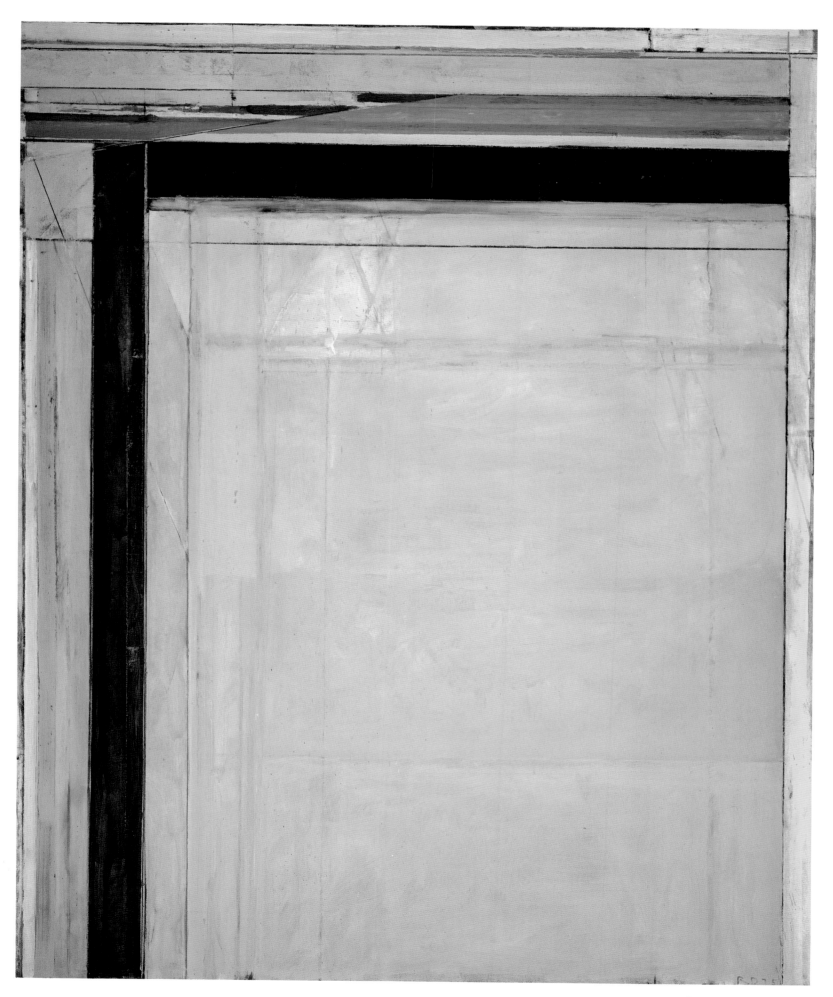

Artists of serious reputation who achieve a measure of celebrity are often pursued by galleries, publishers, and foundries to translate their images into fine-art prints, sculpture, and other multiples. Wary of going into "production," Diebenkorn kept his distance from such arrangements for many years, wishing to preserve time for his primary work, drawing and painting. As a student and instructor at the California School of Fine Arts he had experimented with monoprint and intaglio, and during his thirty months in Albuquerque he had made monotypes, worked in progressive proofs with woodcut, and created a few unique welded sculptures. He had worked for brief periods at the Tamarind Lithography Workshop in Los Angeles and still later produced a suite of lithographs with the Joseph Zirker shop in the Bay area, and subsequently two lithographs with the Collectors Press of San Francisco. In 1961–62, while he was a visiting instructor of painting at the University of California, Los Angeles, Diebenkorn made a few intaglio prints with Wesley Chamberlain in the art department's print studio. In the latter half of 1962, under the aegis of Kathan Brown, the founder and first printer of Crown Point Press, in Oakland, Diebenkorn took to scratching on zinc plates at times when he felt that drawing and painting were not possible for him. The artist was clearly feeling his way into a medium that had its own unique demands—demands he was not sure he wanted to give the time which they required. By 1963, however, he had assumed a more formal working relationship with Brown and gradually became an enthusiast of etching and drypoint. "You could almost say Diebenkorn had an addiction to etching. On vacation in Mexico, he carried several plates along. He took one of them to a bullfight and drew [on] it during the excitement and turmoil.... A year later he took some little plates with him to Russia...."[87] Out of a nearly three-year involvement, Crown Point Press published *41 Etchings, Drypoints*, in 1965. More than one hundred plates were studied

and proofed from which to make the selection. Most of the plates that were rejected were never editioned and exist in only one or two proof impressions.

41 Etchings, Drypoints was printed and assembled in an order dictated by the artist in thirteen bound books and twelve portfolios containing loose, numbered prints, plus ten artist's proofs. More than one-third of the etchings depict the artist's wife: her head pictured as a single or double portrait, seated in a chair or couch, or conversing with a friend. The remainder invoke still life or interior subjects from home or studio, nudes (from drawing sessions), clothed female figure studies, and a few townscapes. *No. 38*, 1965, (p. 187) a hard-ground etching is representative: a severe folding metal chair is centered in an irregular space, with a table at the lower left supporting a potted plant, and a partial figure of a woman either standing in a doorway or perhaps depicted in a painting at the upper left. The folding chair is bisected by what appear to be wall moldings that cut through it vertically and horizontally, flattening the picture plane. A throw rug and a tea service complicate the floor plane. The etching facture of the darkened elements seems irregular, spontaneous, not cross-hatched or perspectival. The artist took pleasure in the folding chair, which is included in *Interior with View of Buildings*, 1962 (p. 110), and in *Window*, 1976 (p. 141).

When he accepted the tenured professorship at U.C.L.A., he separated himself by 400 miles from Crown Point Press, and his intaglio printmaking was suspended for a dozen years. Following his Albright-Knox retrospective (1976) and its tour, he wanted to resume the practice of intaglio with his new Ocean Park ideas in mind. He produced three small groups of etchings, drypoints, and aquatints in 1977–78, all in black and white. Despite his skepticism regarding the possibility of controlling color transparency and his distaste for unduly complicated intaglio processes, he was persuaded to experiment with color etching in 1980. Kathan Brown and her assistants were sensitive to the artist's reservations and evolved strategies and adjustments calculated to reassure him and help achieve his desired results. *Eight Color Etchings*, 1980, was the first issue—a collaboration in which Kathan, the printers and the artist made countless proofs and helped to invent or modify techniques consistent with Diebenkorn's sensibilities. He lost his reserve regarding intaglio color printing through his pleasure in this suite.

In 1985, at Crown Point, Diebenkorn became fascinated by a large copper plate which the printers had been cutting into for various projects. It had been reduced from 90 x 36 to 46 x 36 inches. He tended to dislike large prints as substitutes for work in other media. In this case, however, he sat down and started working, and in forty-five minutes a proof was pulled. He made his usual collage paste-up, cutting up the proof to highlight what worked and combining this with experiments from later proofs, and continued working for several days, but the image didn't seem to progress satisfactorily. After a few days he set it aside. When the two weeks he had planned on working there were over he had given his approval to print three small images, but the big plate remained unfinished. He returned to Crown Point in 1986 with the large etching on his mind. After much scraping and correcting, he carefully strove to render his collage, and then abandoned it to work directly into the plate. "It took one and a half hours

No. 38, 1965. Hardground etching. 8½ x 7⅞ in. Private collection

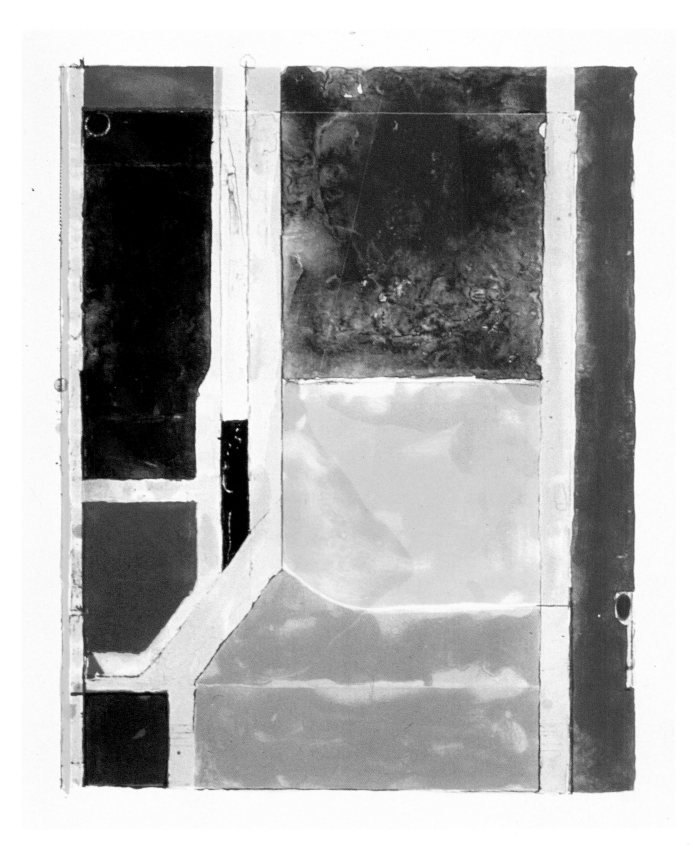

Twelve, 1985. Lithograph. 44 x 34 ¼ in.
Courtesy of Gemini G.E.L., Los Angeles

Opposite:
Green, 1986. Drypoint, aquatint, soapground,
and spitbite. 53 ½ x 40 ¾ in. Courtesy of Crown
Point Press

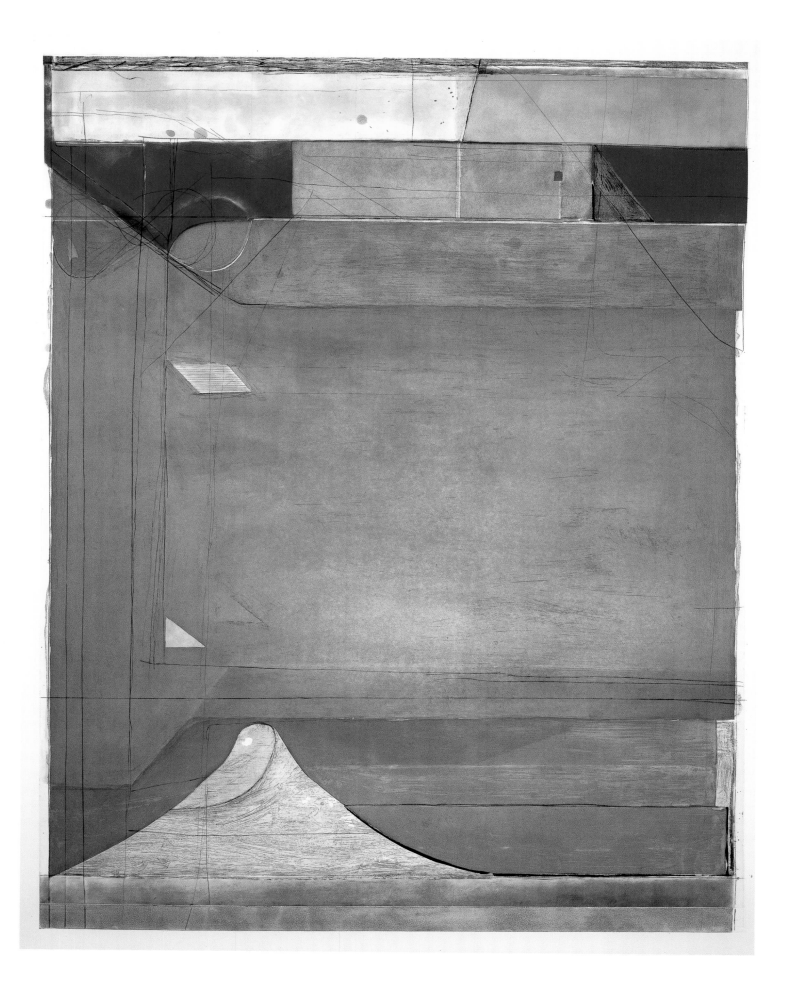

189

to ink the plate. The trail of everything can be followed in the finished print." [88] The outcome, *Green,* is probably the artist's most masterful intaglio print.

The painter had several sessions in lithography during the 1970s—with different presses and some unfortunate results and broken stones. For years he restricted his printmaking to intaglio at Crown Point Press. In 1979, he made a lithograph at Gemini G.E.L., a press in Los Angeles, as a contribution to a benefit for the Museum of Contemporary Art, which turned out well. After repeated invitations, Diebenkorn agreed in 1985 to set aside two weeks for lithography at Gemini. He knew what to expect and was comfortable with the printers. The most significant of the three plates he made was the last (the prints were made from common plates but inked differently). Titled *Twelve,* it is a fourteen-color lithograph which recalls the color harmonies of Pierre Bonnard, whom he had admired since the early 1940s, at The Phillips Collection in Washington, D.C.

With the assistance of Kathan Brown in 1983 Diebenkorn entered into a collaboration with Japanese woodblock printers in Kyoto. He sent ahead two works on paper, in watercolor, acrylic, and collage, and then went to Kyoto himself to participate in the translation of his images into wood-blocks. It was both exciting and frustrating because the carvers' skills were astonishing, but communication about the color was difficult, even with translation. Two prints, *Ochre* and *Blue,* were created out of the visit, with sixteen blocks and eleven colors and nineteen blocks and twelve colors, respectively, evoking Diebenkorn's signature brushwork, layered colors, and treasured pentimenti. Corrective proofs were sent back and forth across the Pacific for a number of months. Diebenkorn went again to Kyoto in 1987 to work on another print, *Blue with Red.* While the carvers and printers were embroiled in the multiple blocks and color effects, he chipped out a new block by himself—*Double X,* 1987—which was printed in black. Related to *X* and *Y,* etchings and drypoints of 1986, it explores the structure of the letter-form as if it were a sculptural object with each arm individually perceived through a distorted rhythmic perspective. Absent of the subtlety of brushwork and color nuance of the multiple blocks, *Double X* remains an unusual achievement.

Despite this considerable record of printmaking experience, as late as 1976 the artist approved a text in which it was clearly stated, "[the artist] does not consider himself to be a printmaker." [89] But from that time onward he scheduled a session of intaglio printmaking nearly every year (all with Crown Point Press), and produced an impressive graphic oeuvre both in black-and-white and in color. He renewed his experience with lithography, although often it was out of a wish to contribute to a cause or celebrate an art-world event.

The essence of printmaking is to produce duplicate originals of an artist's work. Monotype, or monoprint, produces only one impression. The artist paints his design on a glass, metal, or plastic plate instead of paper or canvas, and then impresses it on paper. There is a directness possible in the medium that is not available in the chemistry of lithography. An assistant is not required, and one can at least endeavor to control the entire procedure.

In addition, one can work serially on the plate, building upon the ghost
image remaining on the plate after the impression, correcting, adding to,
removing, and developing alternative ideas in the same sense that one can
in painting. Since Diebenkorn's method of painting relied upon revisions,
corrections, and reorganizations of line, form and color, he was particularly
attuned to process and thus to the monotype medium.

In March 1974, Diebenkorn was invited to make some lithographs with
George Page, the printer at the Sam Francis Workshop, Santa Monica.
He declined since he was still uncomfortable in the medium. In his typical
fashion, however, he mulled over the invitation in the light of having
received two catalogues from artist and printmaker Nathan Oliveira—
Degas Monotypes, by Eugenia Parry Janis, and *Tauromaquia 21*, a series of
Oliveira's own monotypes, variations on an image by Francisco Goya.
Later in the month, Diebenkorn inquired if Page would like to assist him
in the printing of some monotypes. Page was intrigued, the two worked
for ten straight days producing thirty-six monotypes.

A year later Diebenkorn agreed to a working weekend with Oliveira
at Stanford University, making monotypes with the man who had
refreshed his awareness of the process. Each of the three day's works are
documented, and each plate's progressive evolution recorded in a 1976

Ocean Park No. 91, 1976. Oil on canvas.
88 x 81 in. John and Zola Rex collection,
Carpenteria, California

catalogue.[90] On the third day of the session Diebenkorn created ten monotypes titled with and illustrating Roman numerals from I through X. Seen in series, one can trace the vestiges of ghost imagery in subsequent prints and follow the artist's creative path. By monotype *IV* he was using the Roman numerals as a secondary theme. In *V* one can read the depleted *IV* as a negative, and in *VI* one finds the Roman numeral inverted at the lower left of an Ocean Park-type composition. In *VII* a Roman "five" is converted to a double echo of a tumbled Arabic "seven," part of a painterly field of brushed and esthetically smudged black, gray and white, with artfully retained traces of the prior monotype. It is regrettable that it was not convenient for Diebenkorn to devote periodic sessions to monotype, as it was particularly well-fitted both to his sensibility and to his working methods.

From 1975 through the late 1980s Diebenkorn did schedule regular two-week visits to Crown Point, as well as less frequent interludes with lithography at Gemini G.E.L. A very important survey of his Crown Point intaglio production was organized and circulated to twelve prominent American museums in 1981–83.[91]

In 1976 Diebenkorn's work was accorded a major retrospective, organized for national tour by the Albright-Knox Art Gallery in Buffalo, New York. Diebenkorn had enjoyed a positive reception of his work throughout his career, but it had been qualified with such descriptions as "Bay area," "Californian," or "regionalist." With the retrospective, the national press took notice of the artist's achievement, both as a painter and as a draftsman. The exhibition traveled to Cincinnati, Washington, D.C., New York City, Los Angeles, and Oakland, California, and was reviewed ebulliently at each stop. The *New York Times*, among many other media, gave the work an extended and serious analysis:

> One of the most majestic pictorial achievements of the second half of this century, in this country or anywhere else, is the "Ocean Park" series of paintings by Richard Diebenkorn. . . . Diebenkorn here invites comparison with such grandscale enterprises of the past as the series (now in the Louvre) which Rubens painted for Marie de Medici and the decorations which Mantegna made for the Duke of Gonzaga in Mantua. Yardsticks of a more trivial kind could be invoked, but the rationale of Diebenkorn's enterprise is that living art need not necessarily adopt a depressive posture when faced with great art, ancient or modern.[92]

> The Richard Diebenkorn retrospective, which opened this week at the Whitney Museum of American Art . . . is one of the happiest artistic events to come our way in a long time. Diebenkorn is not only a marvelous painter—he is probably the only major painter now at work in this country who is still often denied that status by the historians. . . . Henceforth, it will be impossible to write seriously about the arts of our time—and not only in America—without taking Diebenkorn's achievement into account.[93]

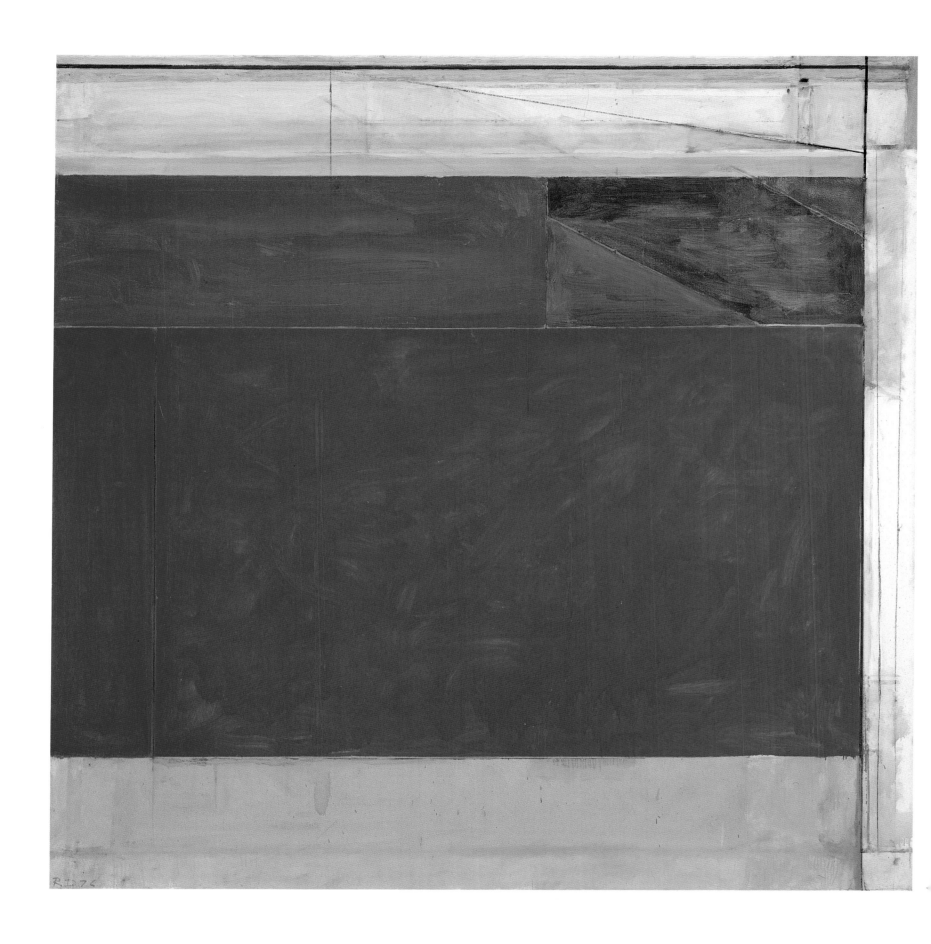

Ocean Park No. 92, 1976. Oil on canvas. 81 x 81 in.
Private collection

Robert Hughes stated in *Time*:

Diebenkorn's retrospective . . . is as masterly a demonstration of a
sensibility in growth as any living painter could set forth. He is not,
as the condescending tag once read, a California artist, but a world
figure. . . . In short, he is a thoroughly traditional artist, for whose
work the words "high seriousness" might have been invented. The
Ocean Parks, the monumental series of paintings Diebenkorn began
in 1967 . . . are certainly among the most beautiful declamations
in the language of the brush to have been uttered anywhere in the
past twenty years.[94]

In the *San Francisco Sunday Examiner and Chronicle,* Thomas Albright noted:

[With the Ocean Parks] . . . one leaves behind labels like "abstract
expressionism" and "Bay Area Figurative" and enters a breathtaking
new world that is unique to Diebenkorn as Mondrian's or Still's or
Rothko's are to their creators. . . . Greatness in art is measured not
necessarily by how much ground is covered, but by how deeply, how
fully and movingly it is explored. . . . As Monet, or Still, or Rothko—
indeed as most other great contemporary artists—Diebenkorn
demonstrates that it is possible to construct a universe by exploring
a single idea to its frontiers.[95]

In his essay for the catalogue accompanying the retrospective, Robert
T. Buck, Jr., director of the Albright-Knox, connected Diebenkorn's blue,
green, gray, and earthen colors and their proportions to sea and sky, and
to natural and urban landscapes, placing the artist in his latest Ocean Park
phase as part of a continuing tradition of landscape painting. While the
artist was clearly responsive to internalized visual experience, the Ocean
Park paintings are condensations of a career-long probing of historic
modernism and the path of pure painting.

Formally they are about how the early modernists made their works,
and equally they are about how Diebenkorn has learned to make his own
paintings. They have a lot to do with sensitivity to materials—to the way
charcoal and oil paint are applied and to how layers of color modify one
another. Everywhere are references to classic modern brushwork, to the
"unfinished" paintings of Mondrian, and to that "fought-over" look that
was one of the chief beauties of Matisse's art.

The paintings of 1975 and 1976 reflect these forces. The unabashed
lyricism of impressionist effect that had been characteristic of the 1972–73
period gave way to a more firm design, a sense of shallow relief space. Color
in general became more opaque, and the works overall appear more con-
structivist. Notable for their sheer mastery are *Ocean Park No. 83, No. 86,
No. 87,* and *No. 88,* all from 1975.

As with all the Ocean Park paintings, these works are numbered and
titled in a series and therefore may be thought of as variations on a theme,
and there are linear and spatial similarities between one canvas and another.

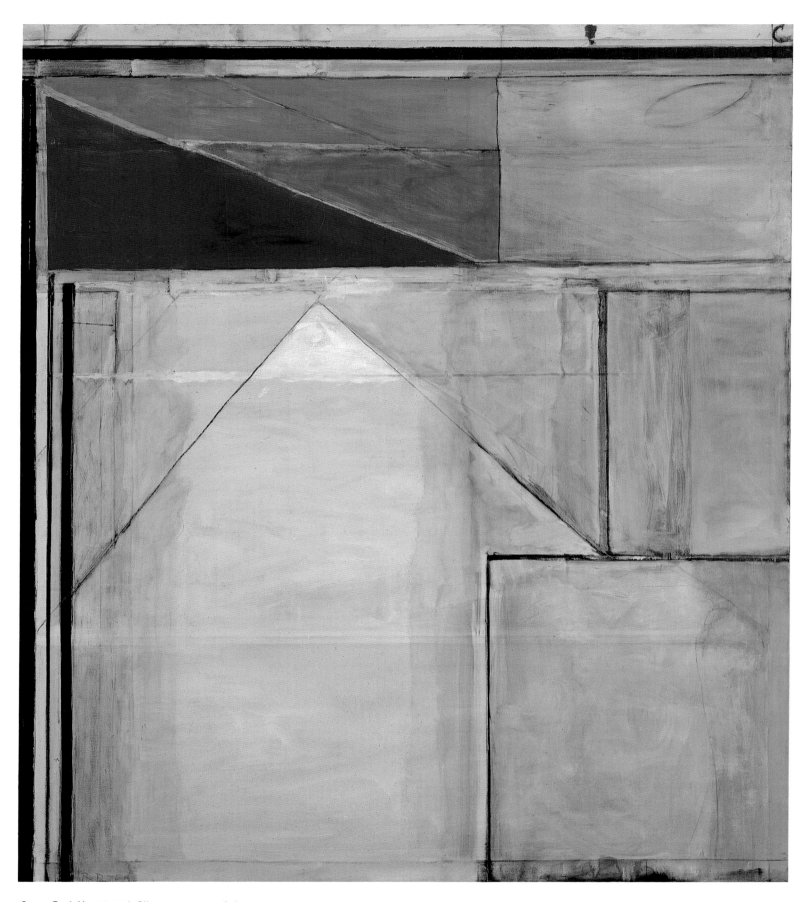

Ocean Park No. 94, 1976. Oil on canvas. 93 x 81 in.
Mr. and Mrs. Richard Diebenkorn collection,
Santa Monica, California

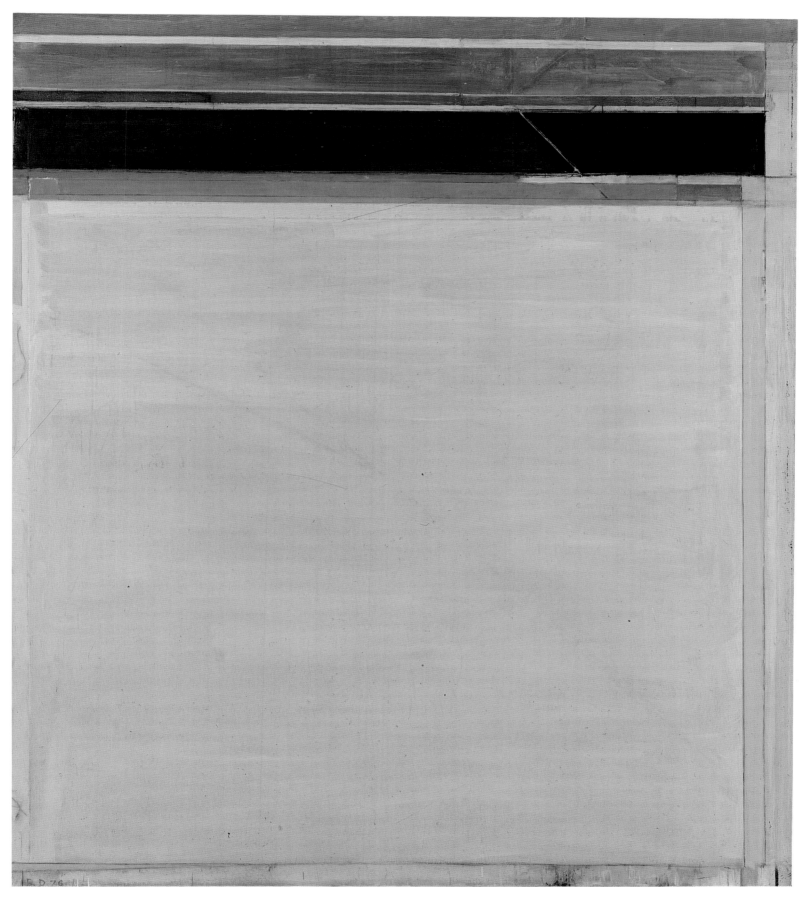

Ocean Park No. 95, 1976. Oil on canvas. 92 x 81 in.
Rita and Toby Schreiber collection, San Francisco

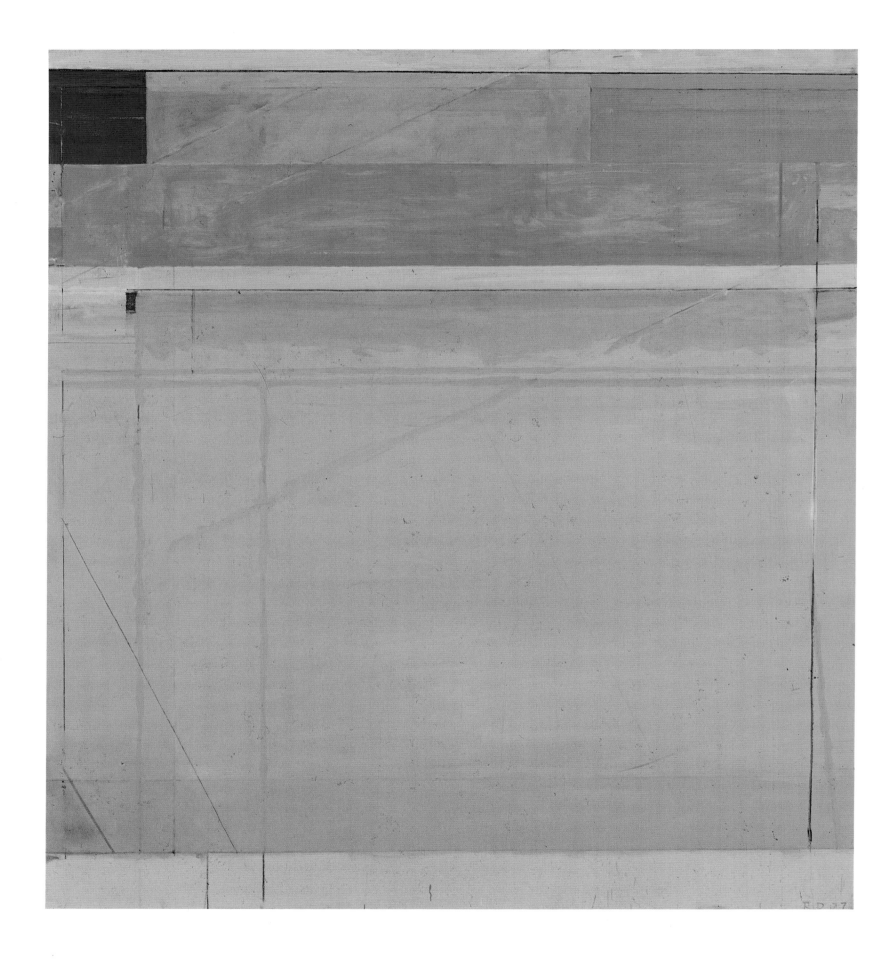

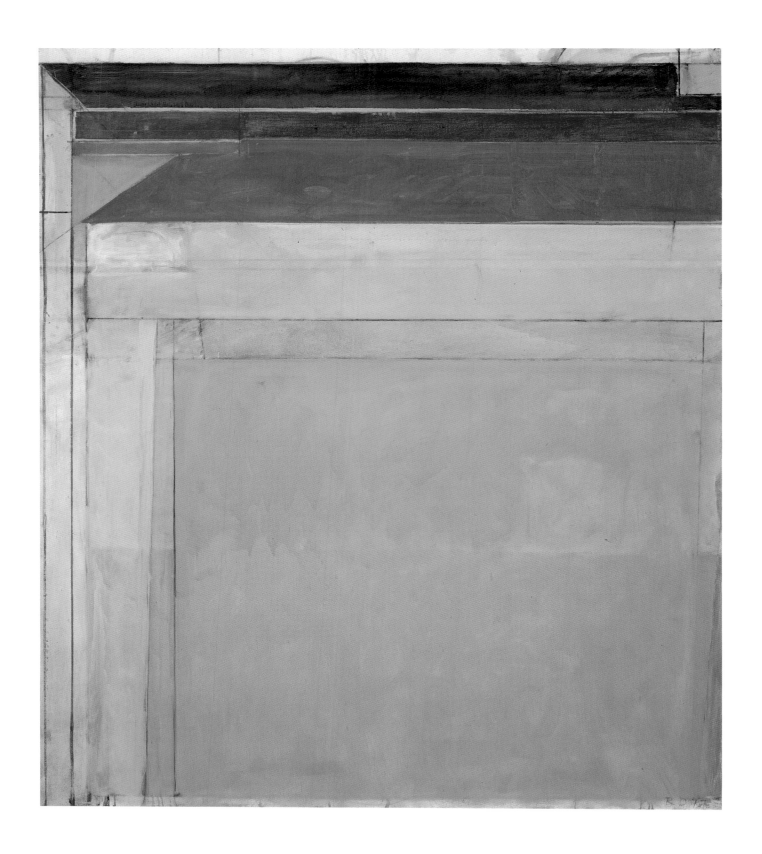

Opposite:
Ocean Park No. 96, 1977. Oil on canvas. 93 x 85 in.
Collection, Solomon R. Guggenheim Museum,
New York, Purchased with funds contributed
by The National Endowment for the Arts; Matching
Gift, Mr. and Mrs. S. Speiser, and Louis and Bessie *Ocean Park No. 98*, 1977. Oil on canvas. 81 x 70 ½ in.
Adler Foundation, Inc., Seymour M. Klein, President Private collection, Fort Worth, Texas

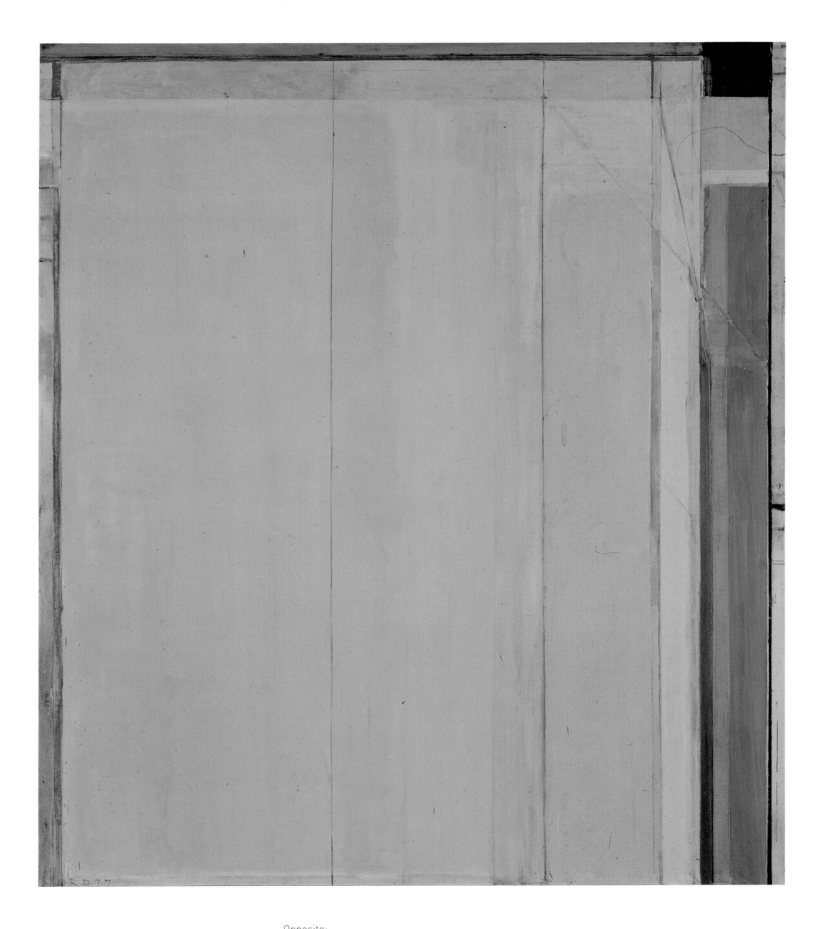

Ocean Park No. 100, 1977. Oil on canvas. 90¼ x 80 in.
California collector

Opposite:
Ocean Park No. 105, 1978. Oil on canvas. 100 x 93 in.
Mr. and Mrs. Graham Gund collection

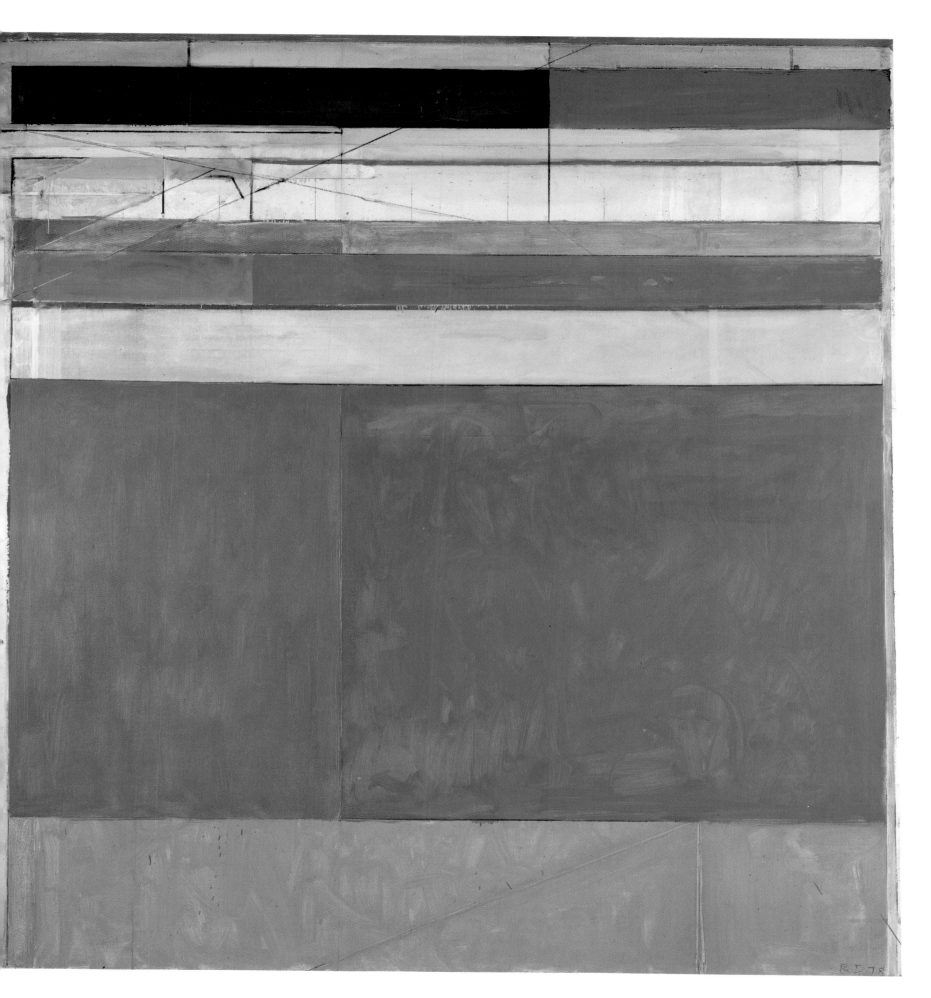

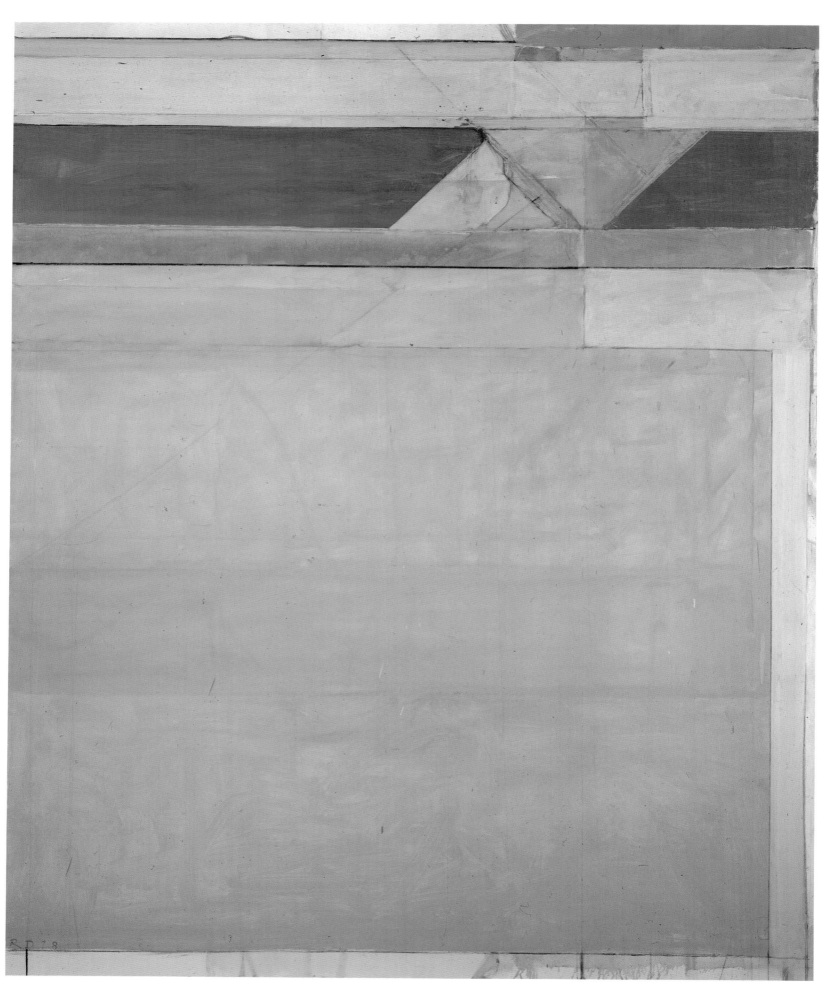

The series title is unfortunate in that it invites comparison with Monet's haystacks, Albers' nested squares, and Warhol's variations on Marilyn Monroe's face. In fact, each work is wholly new, approached perhaps from a similar angle, but nonetheless completely rethought, freshly improvised, and responded to in its composition, proportions, color, and internal balance.

During the Ocean Park period (1968–88), when the artist occasionally found himself perplexed by a compositional knot in a work on paper, he would often prepare a patch of paper to cover the area, and permit himself to rethink it. In some cases he would paint the patch with a specific hue to test a solution. In other cases he might paste in a section of paper and proceed with his work in ink, charcoal or color. The practice of pasting in a small area did not begin as collage, but as the idea of trying out a color change, a compositional adjustment, or a new openness. It became a tool that he used in his drawing and in printmaking. When working at etching he would sometimes make a paste-up from a proof of a plate in process, indicating what he thought he wanted in the work. In the process of getting the line, image, texture, and color into the plate—which can take days—he would revise the paste-up and his intentions. Once the images had been drawn and etched into the plates, they were proofed after each evolving step, while the artist refined and clarified the relationships in the colors. Diebenkorn would often take the opportunity to experiment with new color possibilities within a more-or-less fixed composition. Several different proofings of one image would often be pinned on the studio wall alongside his paste-up model, for comparison. He was known to cut up the proofs and recombine them in collage for further experiment. Finally, when he achieved the image he wished to print, he would sign that impression as "ready to pull," and it became the standard for the limited edition.

While systematically cutting back his cigarette smoking, in the late 1970s, the artist had taken to smoking fine small cigars. Taking pleasure in their wooden boxes, he would paint periodically small "Ocean Park" images on their box lids. These tiny (5 x 6 in., 6 x 6 in., 6 x 9 in., 9 x 7 in.) paintings would be seen occasionally in the artist's home but were never shown in galleries, and their destiny was to become gifts to family members or to special friends.[96] The "cigar box lids" remain the exceptions to Diebenkorn's declared inability to realize his painterly space in small format paintings—"unfeasible miniatures." In creating these works he often incorporated the decorative seals, embossings, wood graining, or lettering on the lid into his composition, through semitransparent paint films which echoed the artist's growing involvement with collage and "pasted paper" in his works on paper. In a sense the "found materials" on the lid were treated in the same way that an errant drip of paint might be allowed to exist when it didn't interfere with the overall intentions of the finished work.

Soda Rock I, 1987 (p. 204), is a rather small work in crayon and gouache on paper, with collage of fabric, plastic and pasted paper, named after the lane on which the Alexander Valley house was located. Since the Diebenkorns did not occupy the Healdsburg house until 1988, the date would indicate that the artist created it in Santa Monica, while thinking

Ocean Park No. 107, 1978. Oil on canvas. 93 x 76 in. Collection of the Oakland Museum, Oakland, California, Gift of the Women's Board

ahead to his new home and studio. Having utilized pasted paper as a tool for making revisions in his works on paper, he also had made from time to time three dimensional assemblages from various found materials—wood, canvas, metal—which coalesced into primitivistic totem constructions, and were displayed in his living spaces. *Soda Rock I* appears to be conceived as a collage from its unexpected fabric and shiny plastic, perhaps a prediction of work to come in the Healdsburg studio, with the deliberate use of materials in the construction of direct collage paintings.

Buck, who was the U.S. commissioner for the 1978 "XXXVIII Venice Biennale," chose Diebenkorn to represent painting at the exposition. The representation was composed of sixteen Ocean Park paintings, dated from 1970 to 1978, and ten works on paper from 1977–78, and the most recent selections demonstrated the artist's development since the retrospective.

During the year of the Biennale, Diebenkorn spent three and a half months in the South of France. During his stays in France and Italy he painted seventeen works on paper. On returning to his California studio he went back into all but one of those papers, and only that one escaped

destruction. The artist later claimed that somehow "the colors were French" and inconsistent with his work.

Three new canvases were shown at the Biennale. They demonstrate a common geometry and sensuous paint application, but they are otherwise quite dissimilar. *Ocean Park No. 96*, 1977 (p. 198), is developed in horizontal bands of blue-violet, turquoise, buff, and sandy yellow-gray. Strong blue and yellow rectangles in the blue-violet band signal an expansive awareness of the painting's breadth. Despite the linear demarcations of verticals and horizontals, diagonal pentimenti, and still other diagonals in ruled oil-paint marks, the artist relies entirely on color for the painting's structure. It is the color that establishes the tension between surface and the illusion of space. *Ocean Park No. 100*, 1977 (p. 200), is composed around a severe multi-paneled vertical gray field with formal incidents massed on the right margin and lesser emphasis given to the upper and left margins. Diebenkorn achieves a masterful balance maintaining flatness with carefully graded colors and no loss of sensual application. *Ocean Park No. 105*, 1978 (p. 201), is a nearly square canvas, composed in horizontal geometric bands, with the thinner upper bands divided into rectangular color units reminiscent of the polychromatic effects in Mondrian's *New York* and *Broadway Boogie Woogie* paintings. The colors and their brushy application engage and give pleasure to the eye as it tours the upper third of the canvas, after which the whole painting, including the nuanced double-paneled green field, commands attention and repeated viewing.

Diebenkorn had no prescription on how to make a painting, and wanted none: he worked until he was no longer challenged, and then he would continue to work until he found a suggestion of something fresh and provocative that could transmute into a new unity. His work was perilous, filled with risks. He wanted to avoid overworking as he was concerned with losing whatever "rightness" he had found. Yet "overworking" was his method, and the procedures were left exposed on the canvas. By the mid 1970s Diebenkorn had found new harmonies and possibilities in his work. Radiant, light-filled color fields were bordered by unusual color chords, massed in complex and original patterns. Dense areas of color and geometry offered compression and a painterly sense of scale. The fields then provided an expansive release. The paintings are constructed with a sense of harmony and integration of all their composite elements— line and plane, surface and space, luminosity and illusion. They demonstrate an achievement of unusual individuality, balance, and serene clarity, showing the artist's hard-fought discoveries through radiant color and two co-existing systems of brushwork from the same painterly hand. As Wayne Thiebaud remarked, "Fast and slow come along together in his work. Passages that are slowly worked out, suffered with, are juxtaposed to swiftly brushed-in and quickly achieved passages. The two together . . . Dick discussed 'crudities' with me. This is something like 'ineptitudes' or 'awkwardnesses' which are retained in one's work in order to avoid the slick, the ingratiating. It is a redirection to avoid getting easy. . . . Diebenkorn retains the stumbling . . . it becomes crucial to the character of his work."[97]

Sometime after the termination of his Marlborough contract Diebenkorn

Opposite:
Ocean Park No. 109, 1978. Oil on canvas. 100 x 76 in.
The Cleveland Museum of Art, Cleveland, Mr. and Mrs.
William H. Marlatt Fund, and gifts of the Cleveland
Society for Contemporary Art and an anonymous donor

Ocean Park No. 111, 1978. Oil on canvas. 93 x 93 in.
Hirshhorn Museum and Sculpture Garden,
Smithsonian Institution, Washington, D.C., Museum
Purchase, 1979

was introduced by old friend and art dealer Irving Blum to Lawrence Rubin of M. Knoedler & Company in New York. The artist agreed to exhibit with the gallery, holding shows approximately every two years, beginning in 1977. The number of paintings brought to completion in an eighteen-month period generally worked out at around ten. In 1979, with the release of three new canvases to the Venice Biennale, the artist sent only six new paintings to his New York show. When called upon to release a group of works, it was Diebenkorn's practice to examine his available recent work and read each one and the group for cohesiveness and for a convincing sense of continuity. If a work did not make a contribution, it would be omitted—one work or another may not lend itself to the grouping. The paintings that were not included might be returned to a working state only to emerge later with a new number. Each new presentation was selected in such a spirit.

The works of 1977–78 seem more open, less constructed, and more lyrical than their immediate predecessors. Two paintings, *Ocean Park No. 107*, 1978 (p. 202), and *No. 111*, 1978 (p. 207), grow out of familiar Diebenkorn devices. The first utilizes the upper quarter of the canvas for a compressed activity in full palette, played off against a gray-blue field with rich layerings of pigment. *No. 111* balances characteristic green and blue vertical panels with lavender-gray and sandy intervals and is edged with a severe, simplified upper border. Other works are developed with less familiar structures, and with unpredictable colors—roses and pinks in *No. 110*, 1978, pale blues, yellow, and green in *Ocean Park No. 112*, 1978 (p. 210), a silver-gray-white with a blue scaffold and subdued red in *Ocean Park No. 109*, 1978 (p. 206).

A grand, light-filled clarity appears in the works of 1979 and 1980. The expansive, lyrical fields become less intense, often pale, and contain minimized contrasts, resulting in simple, broad color areas of a shimmering serenity. *Ocean Park No. 118*, 1979–80 (p. 216), *No. 122*, 1980, and *No. 124*, 1980, create a layered luminous space that invites comparison with Turner and Rothko in the manner in which pigment is transformed into an infinite glowing field of light. The colors reverberate in their horizontal stacks, interacting with one another, in a pure abstraction that is far from the landscape and sea references of earlier years, exuding a charged color energy that is Diebenkorn's alone. Two new horizontal-format Ocean Park paintings were completed in 1980. *Ocean Park No. 117*, 1979 (p. 215), is perhaps the most unusual work in this sequence because of its many-layered complexity, at odds with the general trend of the period. Some seven to ten mainly darker colors in blue-charcoal, grays and various blues, lavender, and greens combine in the upper half of the canvas, playing against a greenish-yellow field. The canvas is painted with an astonishing variety of techniques—scumbled into, reworked, divided on its vertical axis—a visual puzzle ground. Perhaps it was the complexity of this canvas that led the artist to paint *Ocean Park No. 118*, the most high-keyed, light-filled, and evanescent of the new paintings. Tranquility, composure, and a gracious calm are projected in both of these profoundly moving works. At the same time the paintings recall the vast areas of intense color of Clyfford Still and the gestural force fields of Jackson Pollock, engulfed in a boundless web of energy.

The painter's mother, Dorothy Diebenkorn, entered into a severe medical decline in 1981, requiring intermittent hospitalization and finally around-the-clock medical care. During this period of four years, punctuated by frequent visits to the bedside of an alert and conscious woman, the son found himself unable to maintain the concentration required by his paintings on canvas. He turned to working, when he could, at "drawings" in gouache, crayon, acrylic, and sometimes collage, based on playing-card figures such as clubs and spades. He had been fascinated by these shapes since childhood and thought they might engage his interest for a few months. The months extended into a year and into nearly six months after that. He worked only on paper, with quick-drying materials and some pasted papers. In 1982 he exhibited fifty of the papers from the previous year at the Knoedler Gallery. Despite the curvilinear caprice of the playing-card theme, the artist's constants—his awareness of horizontal and vertical supports, his use of the entire paper surface, and the anchoring of visual elements to the edges of the sheet—come from his work in oil. The forms, however, are surprising: rounded or fractured or folded back upon themselves, often looking like collage even when they are developed directly on a single sheet of paper. These forms appear to have shaped and reshaped themselves under the artist's hand, mutating into ever new variations. The spade proliferates into multi-petaled shapes, divides and becomes two forms, imitates the form of the club, or half disappears off the painted surface while always implying its wholeness.

The vertical and horizontal dimensions and proportions of the support constitute a canon of Diebenkorn's work. However, diagonal lines, forbidden by Mondrian, enriched his visual vocabulary. Asymmetrically placed pairings of color, which Diebenkorn utilized so often, can be found in both Mondrian's and Matisse's work. Just as those masters could place one form or color in front of another in violation of the picture plane, Diebenkorn could find visual effect in that shift. His internal command was to understand, to digest, and to develop his own vocabulary. While Mondrian eschewed the curvilinear and Matisse embraced it, Diebenkorn brought the forces together in the club-and-spade papers in a way that could indicate a future pathway for his more ambitious large-format paintings. The spade form can turn into a sail-like element, be inverted and appear heartlike, billow into pendulous breast forms, or be "corrected" and geometricized into a paraphrase of a Ben Nicholson abstraction. Just as Mondrian spoke of "an art of pure relations," Diebenkorn had meanwhile returned to a "relational" mode. By that he meant:

> . . . that the content of certain paintings so labeled is perceived through the relationships of the marks on its surface . . . but if it doesn't depend on sign, symbol, representational functions, or other gestalts and *does* on unelaborated spatial relations it seems reasonable to label it "relational."[98]

From the late months of the club-and-spade excursion, the forms expanded into color fields that resemble the painter's Ocean Park structures,

Ocean Park No. 112, 1978. Oil on canvas.
93 x 87 in. Norman and Irma Braman collection

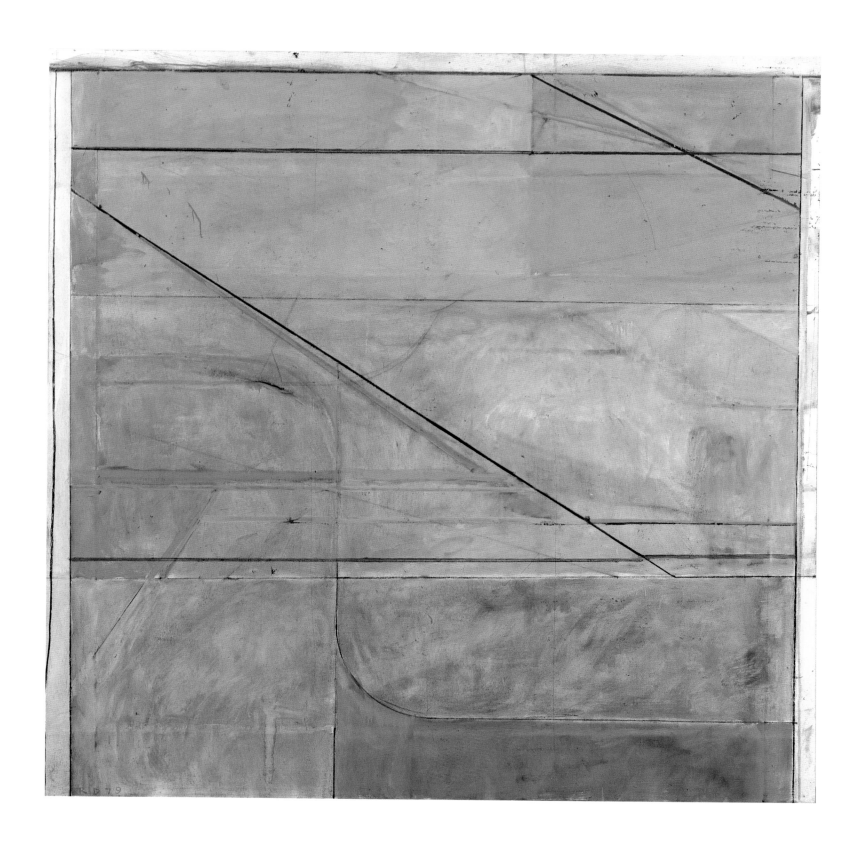

Ocean Park No. 114, 1979. Oil on canvas.
81 x 81 in. Mr. and Mrs. Robert B. McLain collection,
Newport Beach, California

sometimes assuming the proportions and dispositions of the oil-on-canvas essays, occasionally adventuring into a new format, but always demonstrating a flexibility and even a whimsicality that lends itself to a spontaneity uncommon in the works on canvas. In the spring of 1984 the artist held another exhibition of works on paper at the Knoedler Gallery. The playing-card period had passed, and the artist's language had clearly returned to that of the Ocean Park paintings—strongly rectilinear, using geometric color blocks and the familiar diagonal linear explorations suggestive of shallow space. After a period of rather specialized color usage, Diebenkorn had begun to improvise freely with fields of neutral colors, accented with blues and blacks in some cases and strongly contrasting primaries in others. The exhibition proved that the painter was fully committed to his Ocean Park vision, which was continuing to evolve. The concentration of incident was no longer confined to the upper third of the picture surface but became dispersed unpredictably to the side and lower margins, to the lower margin altogether, or pushed into contact with all four margins.

These works on paper are testaments to the handmade and to the exploratory processes. Neutral buffs and grays—complex in their worked and overworked paint bodies—reveal subtle undercolors and drawing, scrapes and drips, in an inimitable personal handwriting. The paint itself alternates between being swiftly and cleanly applied to somewhat hesitantly and even clumsily used in adjoining spaces. Color is saturated and brilliant, or pale and close-valued, or dark and contrasting, in turn.

A charcoal paper in gouache and crayon, *Untitled #29*, 1983 (p. 218), measuring twenty-five inches square, reflects the artist's mature painterly manner with gouache. One can assume that a beginning was made through the opposition of vertical and horizontal linear demarcations, with color being added in the process. Reds and blues may be perceived beneath the surface, but the overall composition has evolved into a charcoal field measured by a gray-white linear scaffold, small white rectangles, and two white triangles, one larger than the other. The scaffold has developed a lozenge shape in the upper right area, tied into each margin, in which the larger of the two white triangles is integrated. The concentration of detail in the matrix and the small white figures impart a sense of scale to the composition. Bold brushwork provides an essential animation, and its direct and unrefined application suggests an authenticity at odds with traditional *belle peinture*. The work has a strong constructive presence, a sense of earthy, unpretty identity.

The gouaches and crayon works have a spontaneity and freshness that speaks of the experimentation, sketchy beginnings, and openness that Diebenkorn prized. The papers seem to have had an effect on later Ocean Park paintings in that the artist's free brush and receptiveness to swift revision were transposed almost directly into the oil medium. The tinted neutrals of *Ocean Park No. 130*, 1985 (p. 239), find contrast in a subdued rose area, balanced by two gray rectangles and a field crossed with red, blue, and yellow ruled lines that suggest a structure but do not confine the color. The artist appears to be seeking to make his constructive procedures even more clear than before—suspending his process at the earliest edge of the

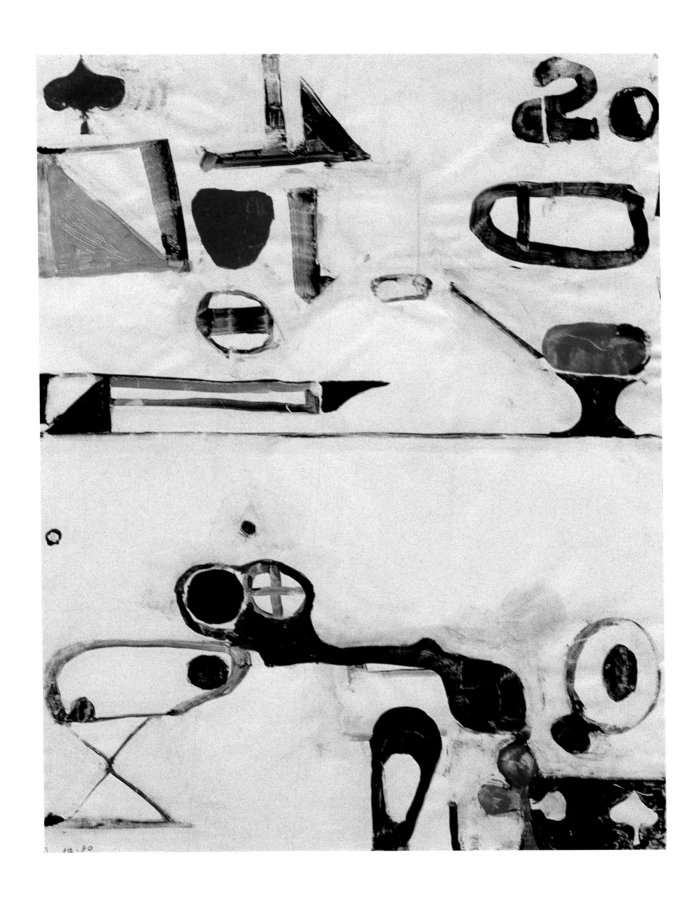

Untitled, 1980. Gouache and crayon on paper.
25 x 19 in. Estate of the artist

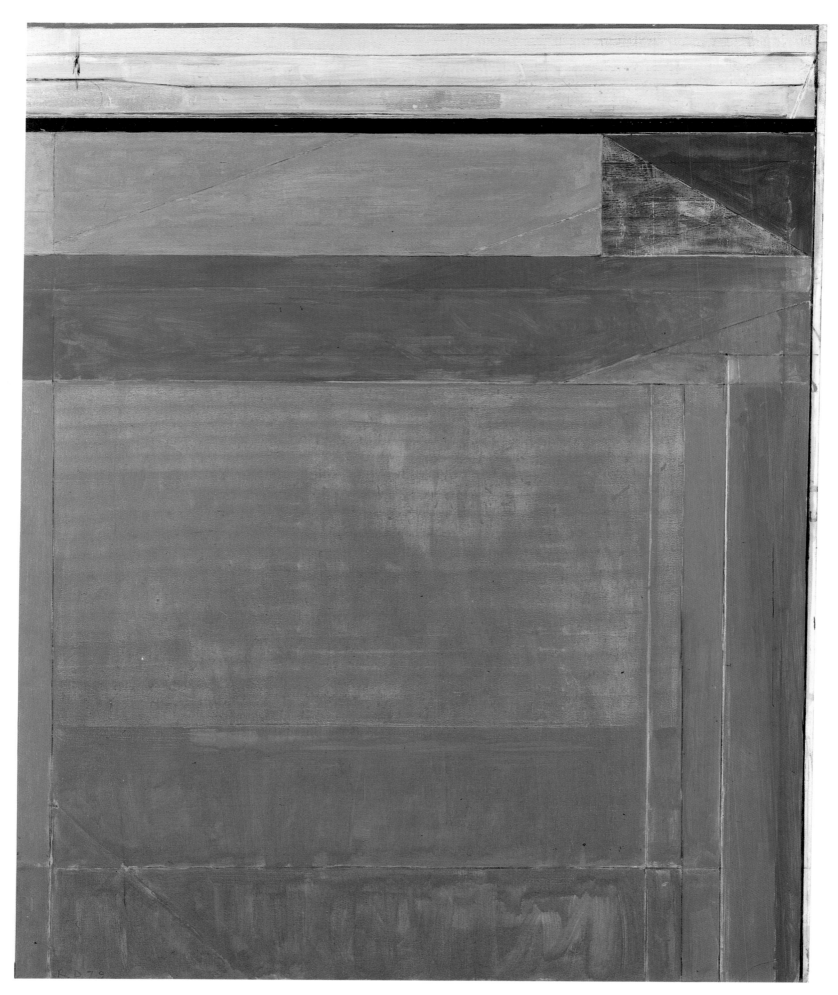

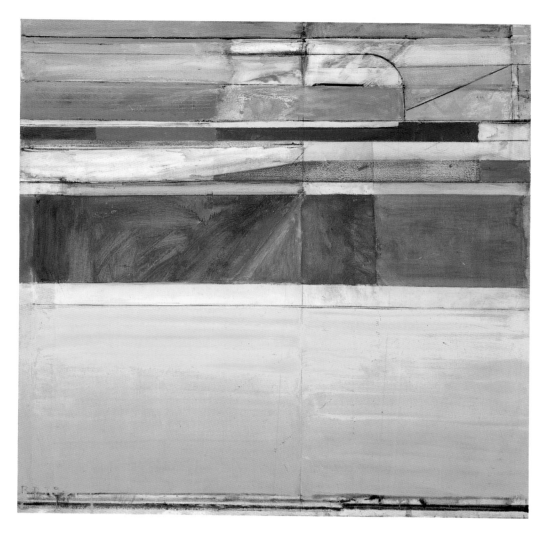

Opposite:
Ocean Park No. 115, 1979. Oil on canvas. 100 x 81 in.
Collection, The Museum of Modern Art, New York,
Mrs. Charles G. Stachelberg Fund

Left:
Ocean Park No. 117, 1979. Oil on canvas. 45 x 45 in.
Private collection

idea's expression, inviting the viewer to become an active participant in a complex visual-mental exercise. A wedge of red, edging off at one margin, offers an echo of color that justifies a smudge of blue, a bar of grayed yellow, and dramatizes the rose field.

Rather halting drawing in *Ocean Park No. 131*, 1985 (p. 242), is opposed with vigorous purposeful brushwork in the rectangular fields. Meanderings, blots, and directional corrections in *Ocean Park No. 140*, 1985 (p. 246), show the painter's process clearly. Unpredictable brushwork in one passage is startlingly opposed to swiftly brushed and defined areas of singing color. In *Ocean Park No. 139*, 1985 (p. 245), vertical bars at the left and right margins are vigorously brushed in as though they had been created by a different hand than the one painting the remainder of the canvas, only to be integrated into the totality of the work. The artist's personal need to avoid the expected, the merely handsome, is dramatized. On the other hand, he also works to avoid the willful embrace of the tough or the deliberately ugly by the tenderness of two crimson bars and the opaque blue field.

In November 1984, Diebenkorn authorized this writer, then Director of the Milwaukee Art Museum, to begin a monograph spanning his career as an artist.[99] The artist disapproved the idea of a biography and insisted that the scope of the project be restricted to his work as an artist. The Guggenheim Foundation provided assistance with the project,

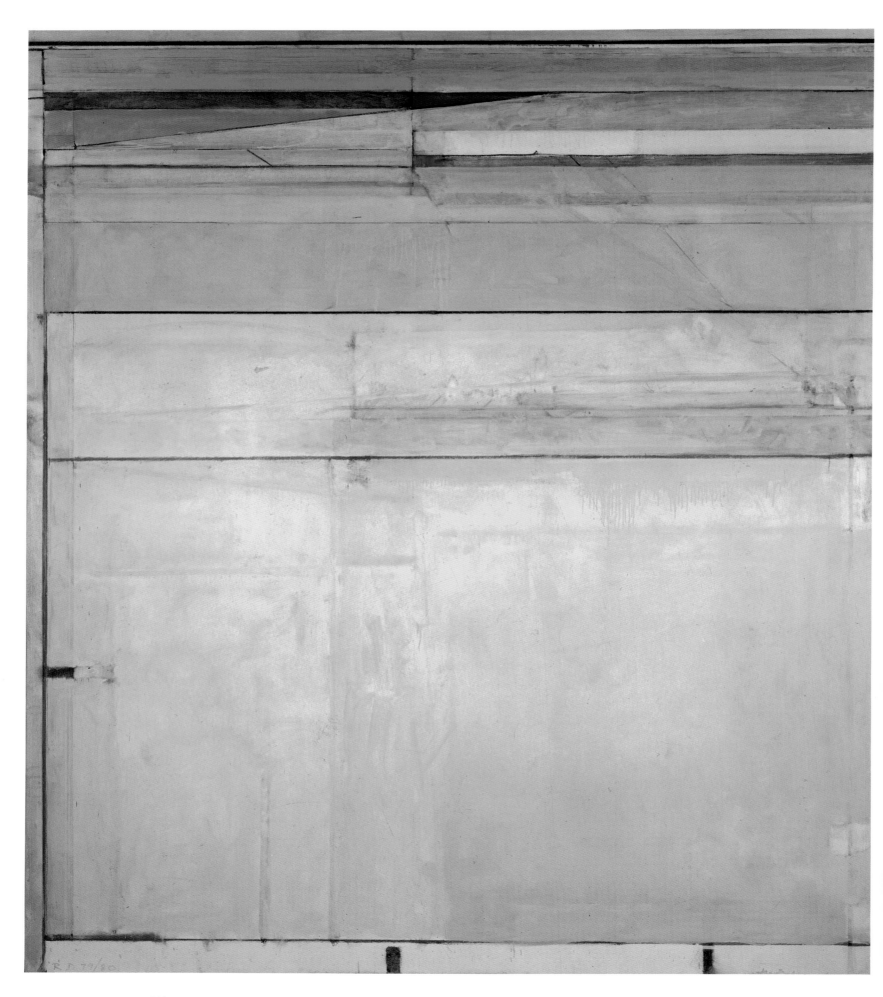

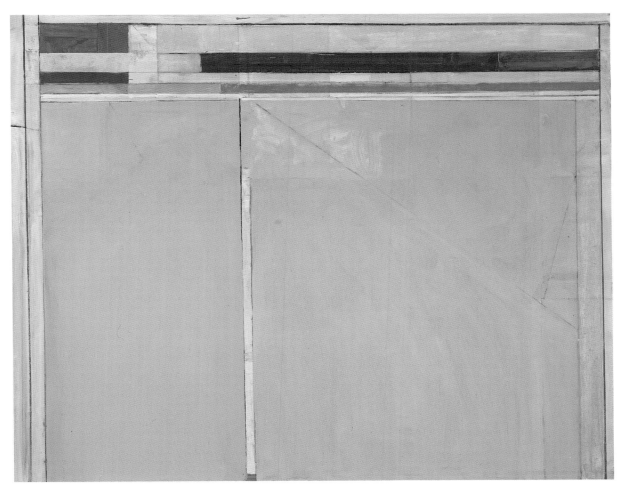

Opposite:
Ocean Park No. 118, 1979–80.
Oil on canvas. 93 x 81 in. Martin Z.
Margulies collection, Miami

Left:
Ocean Park No. 119, 1980. Oil on
canvas. 65 x 81 in. Richard and
Dorothy Sherwood collection,
Beverly Hills, California

Below:
Ocean Park No. 120, 1980.
Oil on canvas. 55 x 93 in.
Private collection

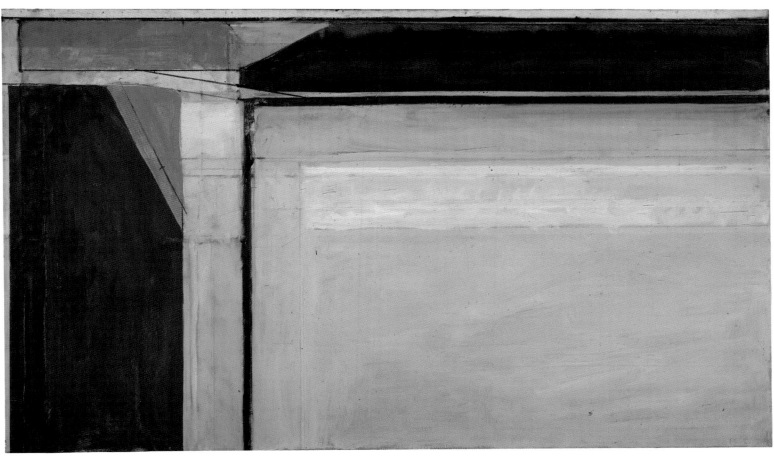

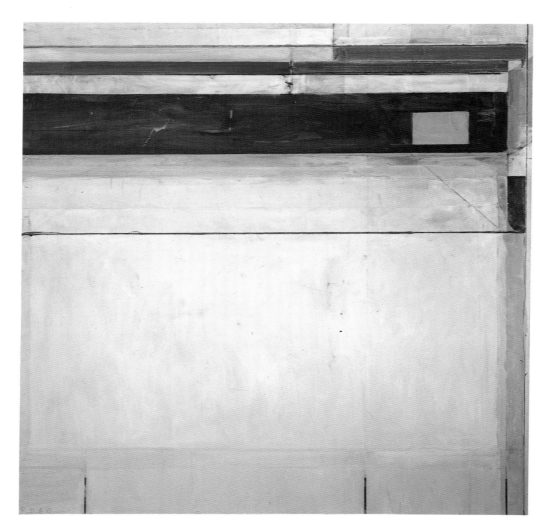

which entailed frequent visits to the artist's home and studio for interviews and continuing discussions of the emerging text. The artist and his wife devoted considerable time to each of four drafts and repeated revisions of the list of illustrations.[100]

In 1985 Diebenkorn became the "founding master" of the Master's Art Program of the Santa Fe Institute of Fine Arts, and he was a force in its continued success. He supported the Institute's artistic goals—helping to attract both Masters and students to the program. He gave a late etching, *High Green*, to the Institute in 1992, and established the Richard Diebenkorn Scholarship Fund, demonstrating his belief in the mission of offering opportunities for small groups of advanced students to work in-studio with internationally acclaimed professionals in brief but intensive two- to four-week sessions.

During much of 1985–87, Richard Newlin of Houston Fine Art Press was developing an anthology of color reproductions of the Ocean Park period works on paper, which Diebenkorn had approved. The book was published in 1987 and includes 140 reproductions of Ocean Park images on paper, from 1966 to 1987, in startling fidelity. Photographs were made by a number of photographers who had a record of providing transparencies to the artist's satisfaction. Newlin's equally high standards made it necessary, in some cases, to have work rephotographed, and no expense

Ocean Park No. 121, 1980. Oil on canvas. 78 x 78 in. Private collection

The artist with *Ocean Park No. 123*, 1980

Opposite:
Ocean Park No. 123, 1980. Oil on canvas. 93 x 81 in. California collector

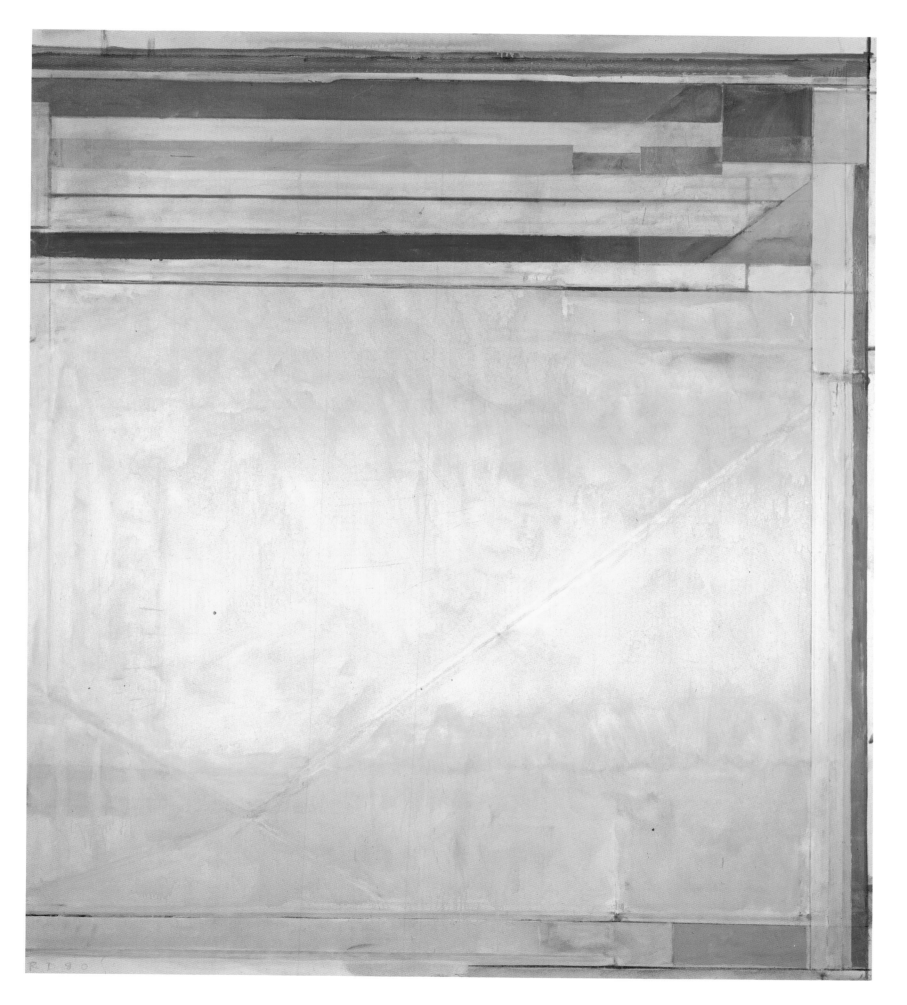

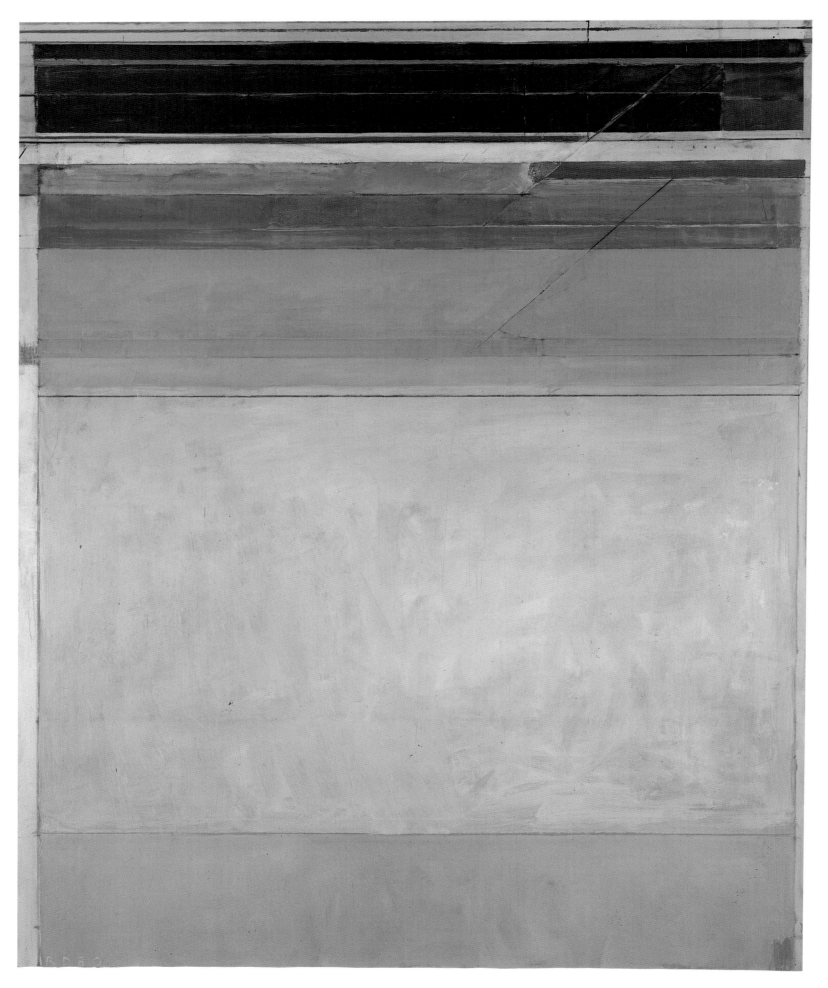

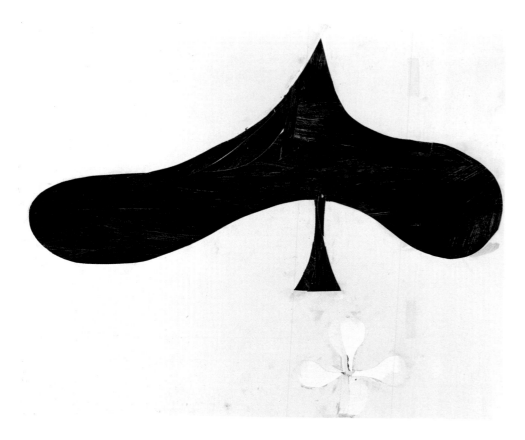

Opposite:
Ocean Park No. 125, 1980. Oil on canvas. 100 x 81 in. Collection, Whitney Museum of American Art, New York, Gift of an anonymous donor (by exchange), Charles Simon Purchase Fund, and purchased, Painting and Sculpture Committee

Left:
Untitled #1, 1980. Collage. 19 x 22 ½ in. Sally Sirkin Lewis collection, Los Angeles

Below:
Untitled #17, 1981. Gouache and crayon on paper. 25 x 26 in. Private collection

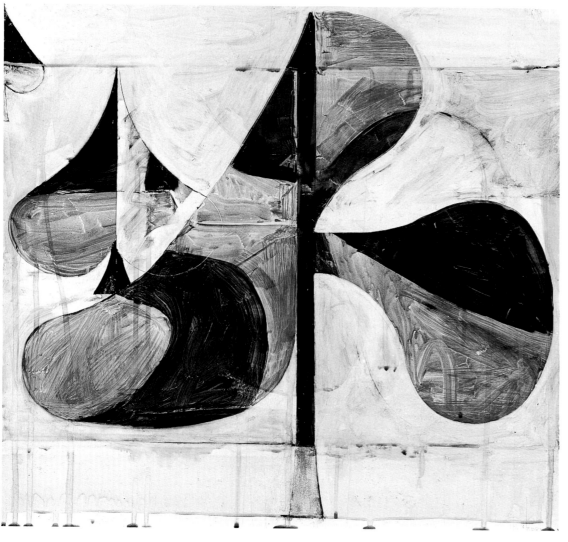

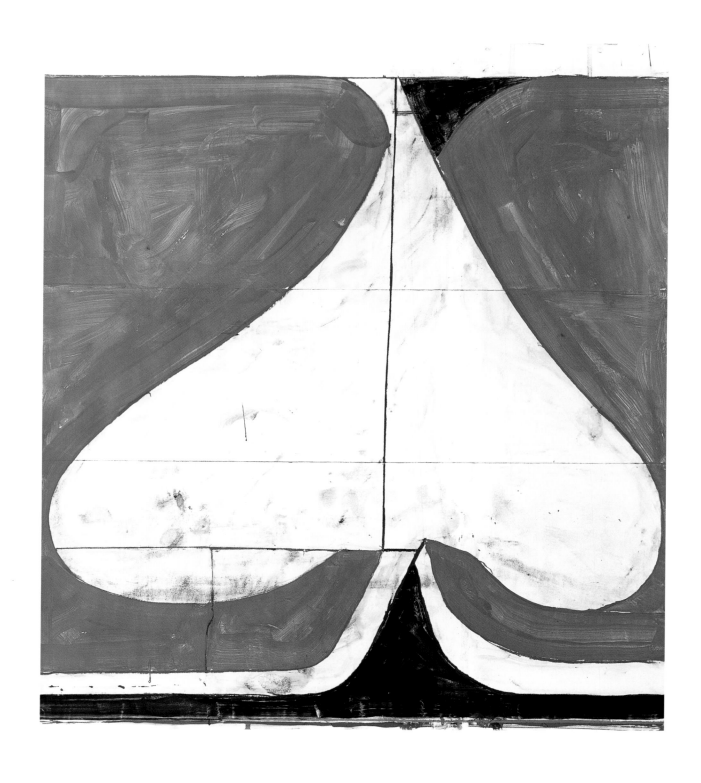

Untitled #14, 1981. Gouache and crayon on paper.
28 x 25 in. Private collection

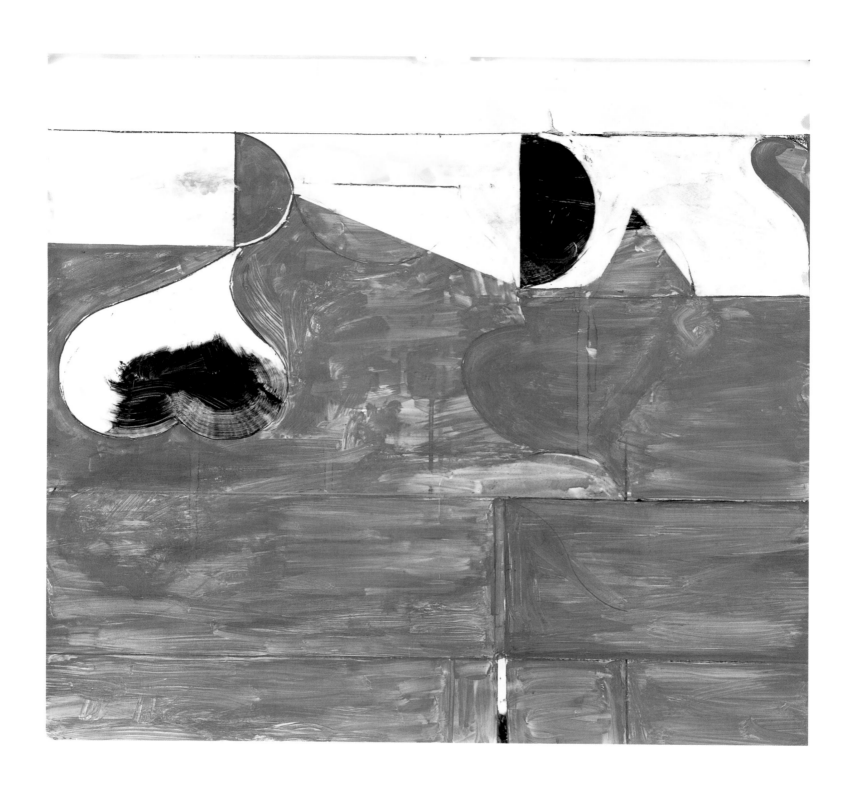

Untitled #33, 1981. Gouache and crayon on paper.
25 x 27 in. Lawrence Rubin collection, New York

was spared in press-proofing, which contributed significantly to the quality of the reproductive printing. The artist acknowledged the extraordinary attention to the color and balance of the original works. Mr. Newlin had become acquainted with Diebenkorn during his Artist-in-Residency at Stanford University in 1964–65. Since that time Newlin had become a collector and built a career in fine-arts publishing, which led him to imagine and produce this elegant book.[101]

By late 1987 Diebenkorn had become committed to a number of new and exciting projects, and he and Phyllis purchased a house near Healdsburg in the Alexander Valley of Northern California. The house was a simpler, Western incarnation of one of Edward Hopper's straightforward, spacious, Victorian-house portraits. The comfortable building was isolated on a spread of land overlooking the Alexander Valley's vineyards, northwest of Santa Rosa. The building's infrastructure required some work, and the barn needed rehabilitation to provide a skylighted studio. Subsequently the Diebenkorns added a separate, smaller structure with a guest bedroom, an office, and space for a systematic archive of professional records and art documents.

At the same time, the University of California, Los Angeles, announced its decision to award Diebenkorn the UCLA Medal, the University's highest accolade for exceptional achievement; a "Profile" on the artist was approved by the *New Yorker* magazine editors, to be written by Dan Hofstadter,[102] and a major examination of the artist's original works on paper throughout his forty-year career was being developed by John Elderfield for the Museum of Modern Art in New York , with a tour to three other U.S. museums.

At the 1986–87 UCLA Commencement, June 14, 1987, the Chancellor of the University, Charles E. Young, with the assistance of the Provost, conferred the UCLA Medal upon three persons: Ella Fitzgerald, jazz vocalist, and John W. Ryan, educator, and Diebenkorn.[103] Chancellor Young, the award's founder, described the painter:

Richard Diebenkorn is an American painter of exceptional talent who has captured and teamed the vibrancy of color with unique design and brought it to life on canvas. A recent article in *Art News* magazine accurately described him as being "among a handful of American artist to have achieved greatness."

The artistic excellence and inspirational style that characterize Mr. Diebenkorn's paintings are appreciated by art lovers worldwide. His works are represented in permanent collections across the nation. . . . For his exceptional achievements in the world of art, his commitment to excellence, and unsurpassed skill in creating paintings that have contributed to the integrity of American art, we proudly bestow upon Richard Diebenkorn the UCLA Medal.[104]

The major retrospective in drawing media opened on November 17, 1988, at the Museum of Modern Art. Titled "The Drawings of Richard Diebenkorn," the exhibition ran through January 10, 1989, and then

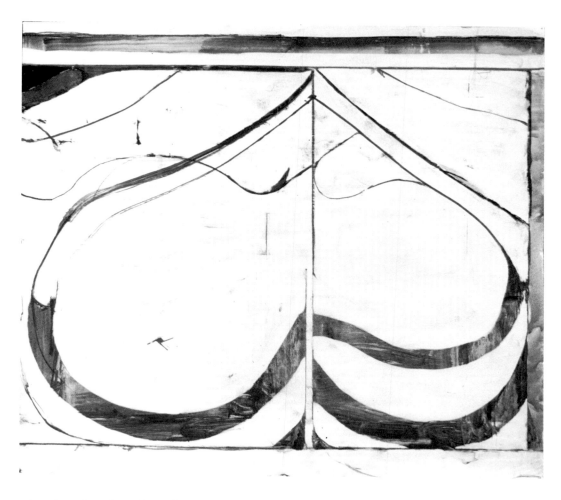

circulated to Los Angeles County Museum of Art, San Francisco Museum of Modern Art, and The Phillips Collection, Washington, D.C., where it closed in December 1989. "Drawings" was the most comprehensive and well selected exhibition in the artist's career to date, covering the abstract expressionist, figurative, and Ocean Park periods with even and dispassionate fairness. Scores of Diebenkorn's most satisfying and impressive drawings were included among 185 works.

While there were drawings in pencil, charcoal, and ink—the mediums most readily associated with this category—one must recollect Diebenkorn's quirky definition of *drawing*—any work on paper—which many artists and experts have adopted. Many of the most powerful and successful of these works might be described more accurately as paintings on paper, because they are executed primarily in a mixed-medium of any or all of the following—pencil, ink, charcoal, watercolor, gouache, acrylic, collage, and even oil paints. These papers tend to be intensely worked and fastidiously revised in a process indistinguishable from painting in their multiple layerings—excepting the choice of support. The spontaneity often associated with drawing exists in pentimenti allowed to shine through successive layers of transparent color that reveal their constructive revisions and corrections, and a number of the finished works wear the heavy skin of painting even when actualized on a paper support.

Despite the success and beauty of the exhibition, Jed Perl and Richard B. Woodward wrote reviews from the self-consciously protective insider

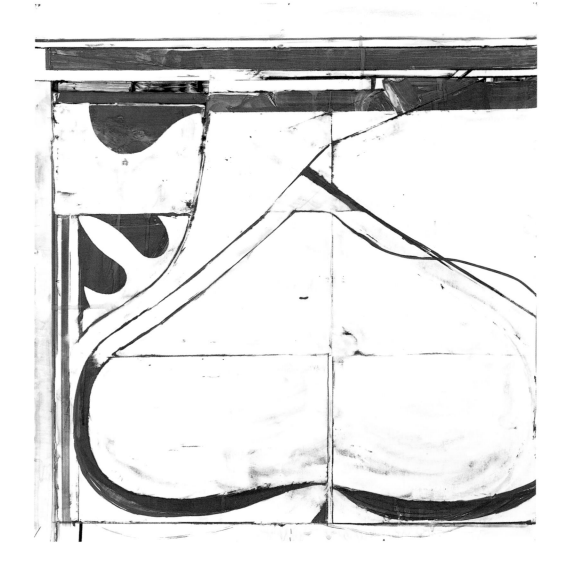

angle of New York provincialism which had dogged Diebenkorn throughout his career:

I suspect that for Diebenkorn—who is an art-world outsider by virtue of being a California artist—the outsider aspect of Matisse's Cubism holds a considerable appeal. By working out of Matisse's nature abstraction, Diebenkorn believes he can become a seminal but unorthodox abstractionist.

What are all those lines in the Ocean Park drawings? Where are they leading us? How much gray-blue fog can we take with no end in sight?[105]

Richard Diebenkorn's mentors, like his palimpsests of color, are visible just beneath the surface. One of the least original but most determined and independent artists at work today. Diebenkorn doesn't hide his admiration for Cézanne, Cubism, early Matisse and Mondrian, and late Kline and Rothko.... Elderfield discusses many of the artist's influences, although he says little about important contemporaries de Kooning . . . and Johns.

Untitled #46, 1981. Gouache and crayon on paper.
27½ x 25 in. Private collection

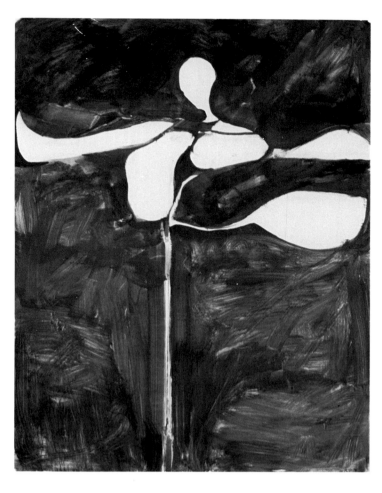

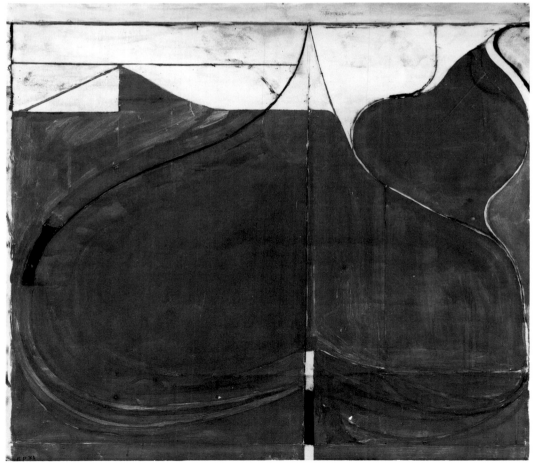

Untitled #51, 1981. Gouache on paper. 28 x 19 in.
Private collection

Untitled #52, 1981. Gouache and crayon on paper.
25 x 23 in. Martin Z. Margulies collection, Miami

In every phase one feels the plane of the canvas pulled back and forth by the layers of smudged lines and scumbled color—glowing opulent volumes cut up into figured-out ratios.

Diebenkorn is the ideal artist for The Museum of Modern Art. He gladly carries the burden of modernist painting and represents the best kind of academic, rigorous, methodical, staunch in his convictions. Nothing is tentative about his hand, but everything contains the drama of the incomplete. He doesn't want to destroy or reinvent the history of art; he doesn't flit. In today's climate he may look stuffy and mirthless, but he stands taller for never having been a prankster.[106]

Michael Kimmelman's examination of the show in the *New York Times* served to correct the insular art-world "outsider" charge and to recognize the artist's stature and achievement:

Quietly and steadily, befitting his work, Richard Diebenkorn has amassed the respect from peers and critics that few living artists attain. No one deserves it more or has sought it less aggressively than this painter. During a career spanning four decades Mr. Diebenkorn has transformed himself from a West Coast apostle of the New York School into a maker of figurative pictures and then back into an abstractionist—this time one whose gridded images, awash in soft cool colors, evoke strongly the landscape of Southern California where the artist lived until recently.

. . . despite these shifts of gear, Mr. Diebenkorn has been very much the same man, addressing similar problems and achieving solutions of increasing eloquence and certitude. Nowhere does this fact emerge more explicitly than through the drawings, which for the artist have been not merely preliminary to paintings but ends in themselves. Among the 180 objects making up this large and thoughtfully composed exhibition hang works exuding all the poise and polish and the vividness of color that typify the best of Mr. Diebenkorn's canvases.

If they lack the scale of the big paintings, they express an intimacy all their own. The drawings reveal, even more transparently than do the paintings, this artist's unusually painstaking method of constructing a composition—putting together the pieces like so many parts of a puzzle, shifting them around until finally arriving at something improbably gracefully balanced. Mr. Diebenkorn lets the alterations show so that the completed objects disclose the history of their own making. It is this confessional posture that separates the artist from someone like Piet Mondrian, with whose paintings his works have occasionally been compared. Mr. Diebenkorn frankly shows the fragility of his elegant designs; his is an art entirely without pretense and posturing.[107]

In 1982 Garner Tullis, the experimental printmaker and publisher, had invited Diebenkorn to a fresh encounter with monotype. They had

first met in 1966 through Nathan Oliveira, at the time of the Stanford University monotypes, and Tullis had since become a recognized printer and publisher of graphics with a workshop in San Francisco and later in Santa Barbara, California. Diebenkorn accepted Tullis's invitation five years later in 1987, and arranged to work in the Santa Barbara studio in April of 1988, saying at the time, "The paintings are getting so heavy . . . going nowhere. I want to do those prints we talked about."[108] In six days Diebenkorn developed twenty images from a variety of plates. Some are in progressive series, some not. Contrary to earlier bouts of monotype printing, when he was somewhat hesitant, Diebenkorn was ready to work. "He circled the plate like a bird of prey . . . closed in on it. Working with him was the highest highlight of my career as a printer. Every idea was pulled out of his experience. I was not a collaborator . . . [I] just provided him with a facility that served what he wanted to do."[109]

In November–December 1988, the Pamela Auchincloss Gallery, in New York City, presented the monotypes produced in the Tullis Workshop, with an accompanying catalogue which reproduced eighteen of the images in color. Ten works were sold, with the remainder reserved by the artist and not for sale. This was the first opportunity for Diebenkorn's monotypes to be seen in New York, and the reception was positive. The artist's lyricism and spontaneity were clearly recognized, and the example of his improvisational method of revision and clarification made plain.

In 1991, the artist was again honored, this time with the National Medal of Arts. On July 9, 1991, President George Bush held a ceremony for the recipients at the White House, followed by a luncheon for the guests and their families, members of the Cabinet, and Senator Claiborne Pell and Representative Sidney Yates. President Bush saluted the honorees in the East Room, "this afternoon we honor . . . a group of men and women whose creative efforts really do capture America's vigor and spirit . . . their passion and their genius and their courage add new dimension to our lives. They remind us of a truth expressed long ago by William Blake, who wrote: 'Nations are destroyed or flourish in proportion as their poetry, painting, and music.'"[110] The President continued: "In a world where people too often try to reduce life's imponderables to black and white entries on a spread sheet, our award winners provide color and depth and perspective. Teacher and painter, Richard Diebenkorn, does not blink from the challenge of expressing himself as he sees fit. In his studio or his classroom, he teaches the importance, the necessity of personal integrity."[111]

The Whitechapel Art Gallery, London, had been discussing its wish to originate a Diebenkorn retrospective, and a European tour, since 1985. In 1991, Catherine Lampert, Whitechapel director, and the artist agreed to a very selective representation, of between forty and fifty works, for an exhibition not exceeding a twelve-month period. Plans were developed for the exhibition to travel to the Fundacion Juan March, Madrid, and to the Frankfurter Kunstverein, for the convenience of some of the lenders. The final selection was both compact and definitive, within obvious limits. John Elderfield of the Museum of Modern Art, was enlisted to write an

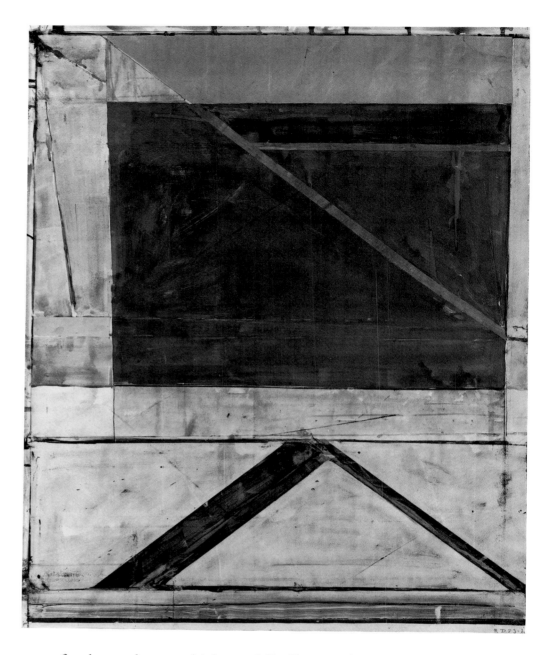

Untitled #7, 1983. Gouache, acrylic, crayon, and pasted paper on paper. 29 ¾ x 24 in. Mr. and Mrs. Richard Diebenkorn collection, Santa Monica, California

Opposite:
Untitled #12, 1983. Gouache, acrylic, and crayon on paper. 38 x 25 in. California collector

essay for the catalogue, which was fully illustrated in color.[112] Reviews of the London showing in *Apollo*, *Arts Review*, and *The Burlington Magazine* evidence the response:

> The retrospective of Diebenkorn's painting at the Whitechapel Art Gallery encapsulated for British audiences the curious, almost perverse trajectory of the artist's career from the late 1940s until recent times . . . at his most abstract he never loses hold of his material surroundings, and at his most overtly figurative, he is never far from abstraction.
>
> The finest of the Ocean Park paintings offer a dense engagement with painting and issues of perception, while remaining reserved and even hesitant in their pictorial means.
>
> Richard Diebenkorn has made some of the most subtle, intelligent and austerely beautiful paintings of the late 20th Century.[113]

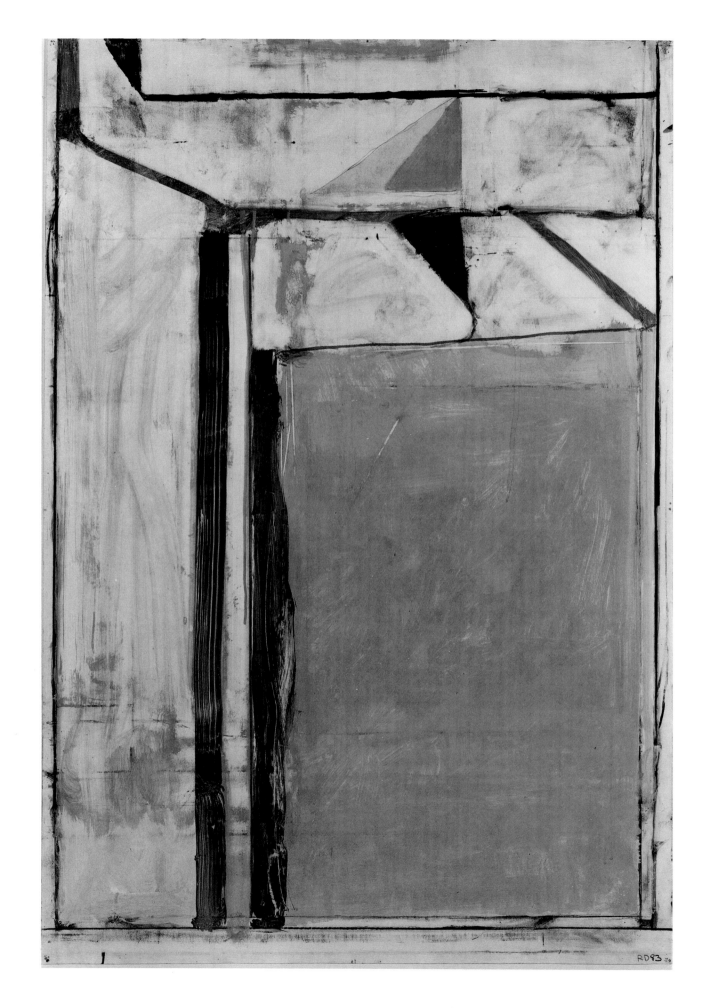

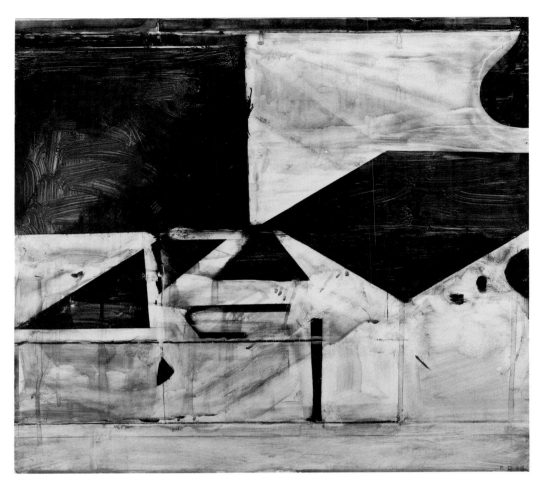

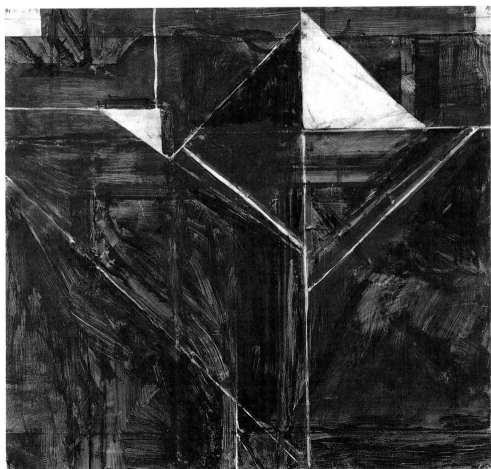

Untitled #24, 1983. Gouache, acrylic, and crayon
on paper. 25 x 27 in. Mr. and Mrs. Richard Grant
collection, Berkeley, California

Untitled #29, 1983. Gouache and crayon on paper.
25 x 25 in. California collector

232

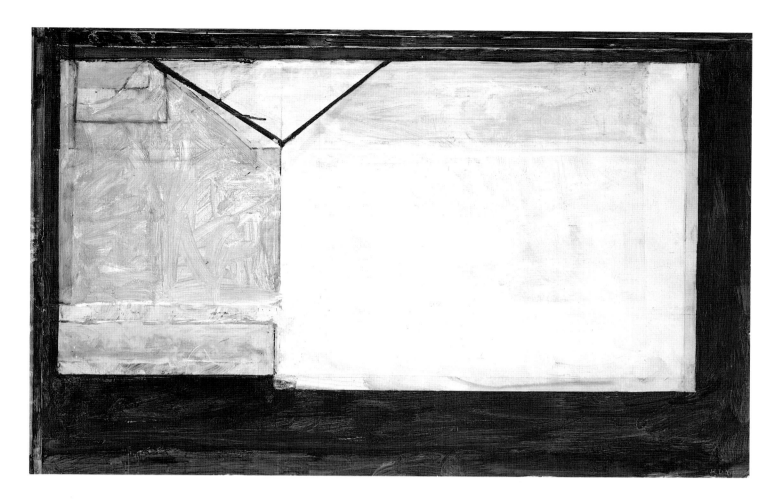

Diebenkorn does not so much scrutinize as stare, rather in the manner of someone whose mind is on other things. The figure is dissolved into a series of visual equivalents, of form and patterns. There is, it is true, tenderness about the work, a sense of the artist treading softly around his sitters privacy, but then Diebenkorn's art is itself essentially private. It is as though he were deliberately emptying out not only his mind but his eyes, trying to go beyond the act of looking to attain an indifferent, undifferentiating sight. The looking and the painting are both exciting to this meditative state.

It is this unseeing quality which makes the Ocean Park series seem such a natural development from the portraits. The Californian landscape is subsumed in, almost dissolved in the Californian light, the Californian mood. The result is art which is cool, leisurely and spacious without—miraculously without—ever becoming vacuous.[114]

The retrospective at Whitechapel while permitting a clearer appreciation of Diebenkorn's career, may conceivably dispel some of its mystique. Several of the informal abstractions of the 1940s and 1950s . . . are today chiefly interesting as period pieces . . . more notable now for *where* they were made than for any enduring individuality. Similarly the figurative work of the late 1950s and 1960s, robbed of the frisson evoked by its defiance of the period's abstractionist hegemony, can look merely worthy, even collegiate.

Untitled #37, 1984. Gouache, crayon, and pasted paper on paper. 25 x 38 ¾ in. Private collection

233

There is room for doubt, too, about Diebenkorn's very active, physical brushwork, announcing conscientious struggle as well as sensuous enjoyment in the medium. The roughed up surface can read primarily as an attempted compensation for an over-determined design which it cannot fundamentally influence.

Diebenkorn's handling in the '50s and '60s again survives, in refined form, into the elegant disarray of the Ocean Park pictures, where the question of its reality becomes more pressing. Pentimenti abound, drips are let stand, undercoats show through equivocal washes. Decisions are provisional. The structures are consciously rough or flawed diamonds.[115]

Contrary to their intent and agreements entered into between the artist, the Whitechapel, and the lenders to the European retrospective, to conclude the project within a year, two California museums pressed for the privilege of displaying the European show in the artist's home state. Richard Koshalek of the Museum of Contemporary Art, Los Angeles, felt it essential for his audience to view the European show, as did John R. Lane of the San Francisco Museum of Modern Art. The two directors eventually prevailed, and an exhibition was reconstituted with a percentage of original works selected for the tour, although significant works had been withdrawn at the close of the Frankfurt showing. Both California museums supplemented the remainder with paintings available in local public and private collections, reshaping the balance of curatorial judgment achieved by the Whitechapel-Elderfield team (with the artist's counsel and advice). The Whitechapel catalogue was used by both institutions, even though it could not interpret the omissions or new inclusions.

Diebenkorn had always been the beneficiary of a healthy constitution and was well equipped both physically and mentally for the demanding occupation of a painter. He enjoyed physical activity and particularly the exercise of painting, during most of his career. He suffered occasional bursitis in the right, painting shoulder, and there were periods in which he had to account to that shoulder and restrict his work to smaller scale compositions. He endured troubling back pains which required surgery in 1969. There were years when an exercise bar was ever present—usually hanging in one of his interior doorways—from which he would suspend himself for regular periods, to relieve back pain. But in late 1988 he suffered a heart aneurysm. Coronary surgery and an aortic valve replacement were prescribed. The surgery was carried out in January 1989 at the University of California, Berkeley. The procedure was not entirely successful, inasmuch as the transplanted valve leaked and the patient suffered an infection requiring drugs with debilitating side-effects. Conquering the infection took months. Recovery from the drug took still longer before he was able to endure corrective surgery at Stanford Memorial Hospital in September 1989. During the interim his doctors discovered that he had a spot of cancer on one lung, which required surgery. Both Diebenkorn and his wife had smoked cigarettes since college days, but had quietly given it up in the 1970s. The Stanford doctors believed that it would be possible to

accomplish both the corrective surgery and the removal of the lung tumor with a single anaesthesia. Ultimately the heart surgery proved more demanding than had been anticipated, and while the tumor was successfully excised, the lung did not reinflate. Consequently, Diebenkorn's physical stamina could not reestablish itself and he was often short of breath. He became unable to pursue his normally active physical life and was restricted in the vigorous professional activities his art required.

Following his second surgery, Diebenkorn would climb the gentle slope to the Healdsburg barn and mount the stairs to his studio only to find himself winded. He elected to deal with his limitation and suspended work on canvas to devote himself to works on paper until he regained strength. He took to working while seated, in the comfortable ground floor living room of the Healdsburg house. He did much good work, found strong new ideas, varied his color range, discovered new curvilinear shapes, continued his experiment with extended horizontal compositions, and occasionally drew on etching plates. At this time, Andrew Hoyem, publisher of Arion Press, San Francisco—which produced fine limited edition books with artist's prints—invited him to create a suite of prints to accompany a selection of poems by William Butler Yeats, introduced by Harvard's Helen Vendler. Despite his health problem, being an admirer of modern poetry, and particularly of Yeats, Diebenkorn accepted the challenge.

Diebenkorn reviewed Vendler's selections from Yeats's poetry, looking for a theme that would lend itself to his esthetic feelings. Yeats's late poem "The Apparitions" (1938) afforded him a visual link in the italicized refrain "Fifteen apparitions have I seen / The worst a coat upon a coat hanger." Five years earlier, following his mother's death, when sorting through her personal effects, the artist and his wife had come upon a rolled drawing from Diebenkorn's Marine service in Quantico—a precise rendering of his field uniform jacket on a coat hanger, limned in graphite on paper (p. 15). He had given it to his mother in 1943. The sheet had been stored in a drawer of his mother's chiffonier, never framed and rarely seen. Recovering the sheet seemed of consequence to him and he celebrated its return, while feeling sympathetic disappointment in his mother's lack of response to this memento of the war and his early artistic evolution, mixed with sorrow for her recent death. At the same time he recalled another poem by Yeats, long since committed to memory, in which the poet laments dying generations: "An aged man is but a paltry thing, / A tattered coat upon a stick. . . ."[116]

Diebenkorn had uncovered a theme as deeply embedded in his own human experience as it was in these selected poems from Yeats's life. The resultant images simultaneously refer to the artist's life, war service, his sensitivity to the passing years, and to the poet's lament. In the successive etching planes, Diebenkorn explored the jacket image, which became a hollow volume for an absent subject, a flattened, folded, cubistic rearrangement of a packed garment (p. 235), a suit bag zipped shut with unknown content, and a distressed and depleted garment bereft of protective capacities, ready for discard.[117]

In mature years Diebenkorn had never envisioned himself as an illustrator. He had a longstanding admiration for the unsentimental realistic

Coat III, 1990. Etching. 8 ½ x 6 ½ in.
Private collection

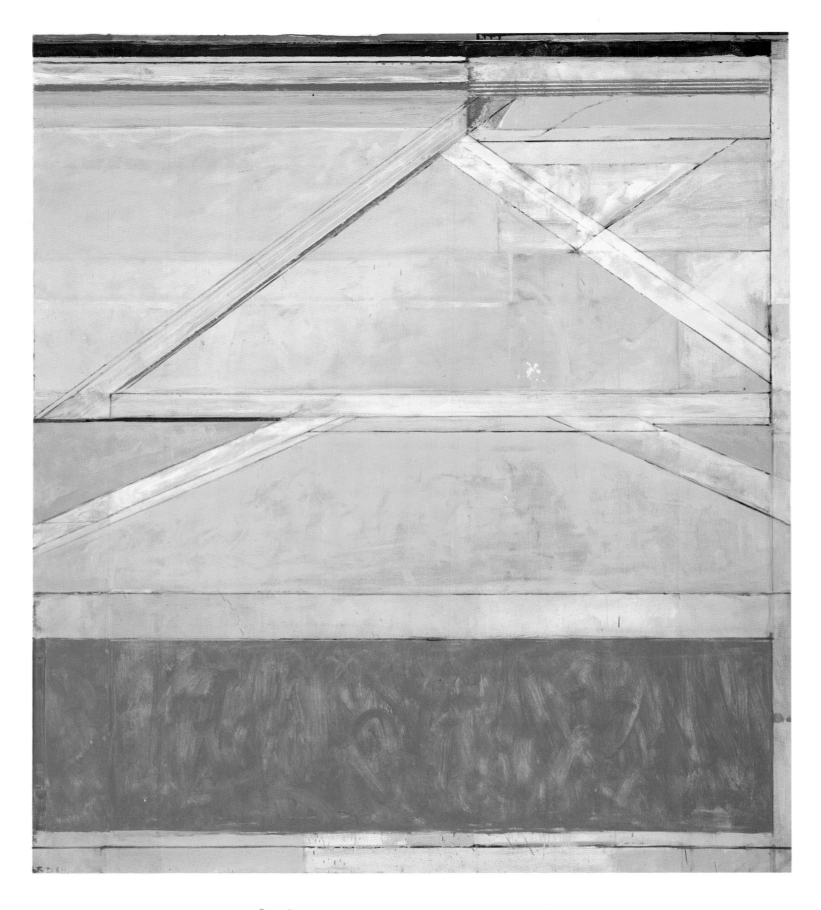

Ocean Park No. 126, 1984. Oil on canvas. 93 x 81 in.
Donald and Barbara Zucker collection, New York

Opposite:
Ocean Park No. 128, 1984. Oil on canvas. 93 x 81 in.
Lawrence Rubin collection, New York

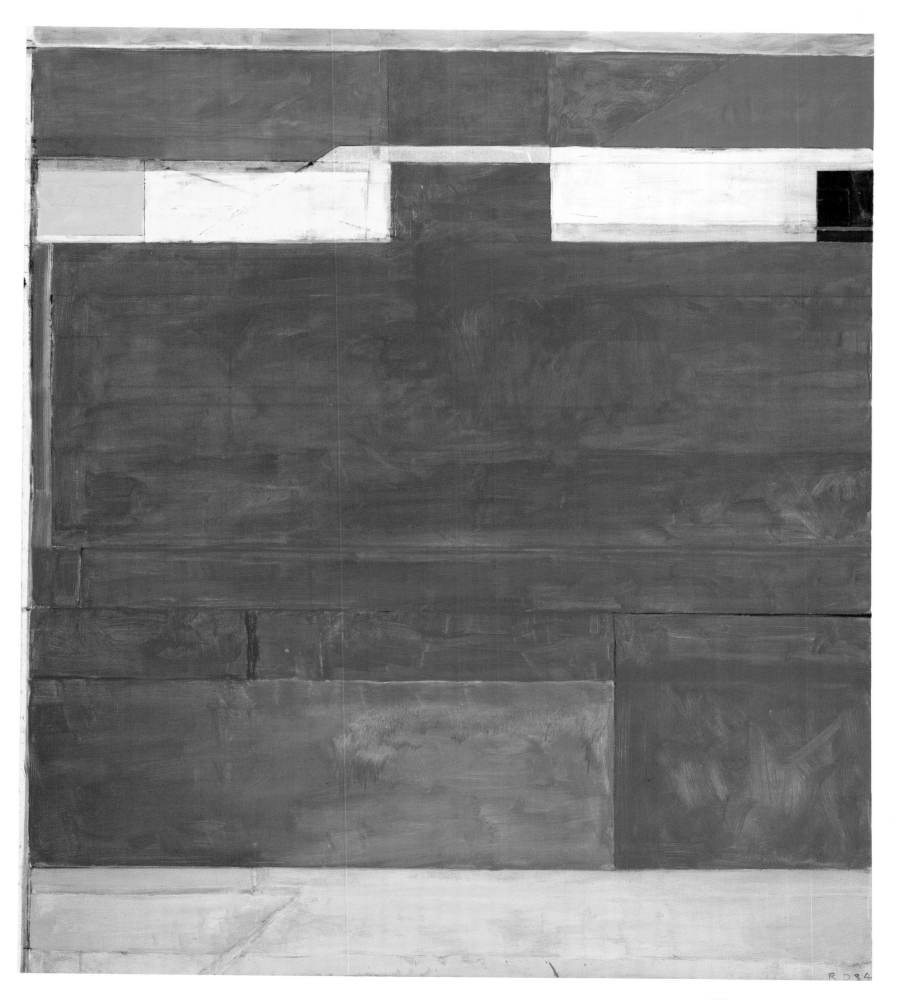

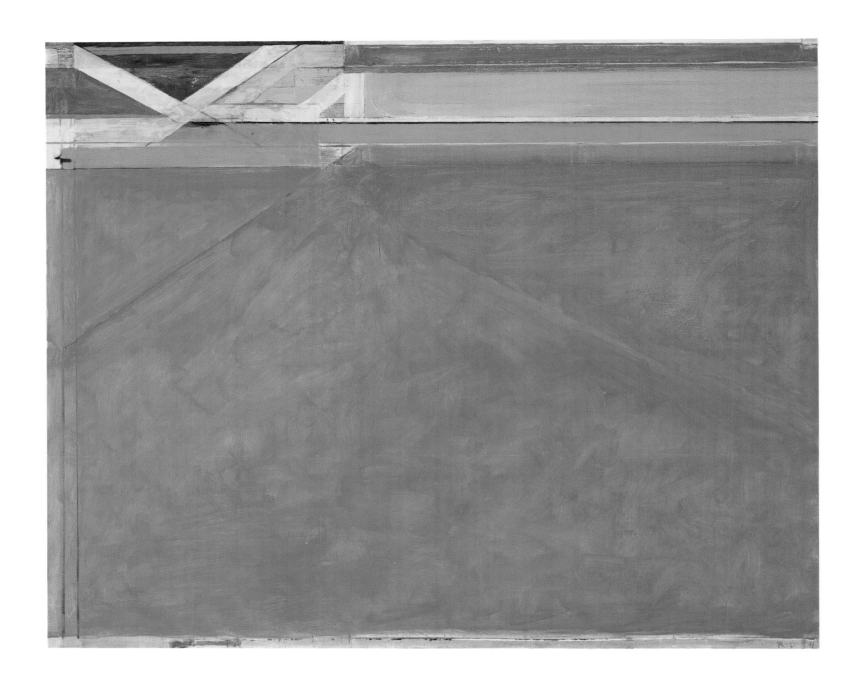

Ocean Park No. 129, 1984. Oil on canvas. 66 x 81 in.
Diane and Steven Jacobson collection

Opposite:
Ocean Park No. 130, 1985. Oil on canvas. 93 x 81 in.
Private collection

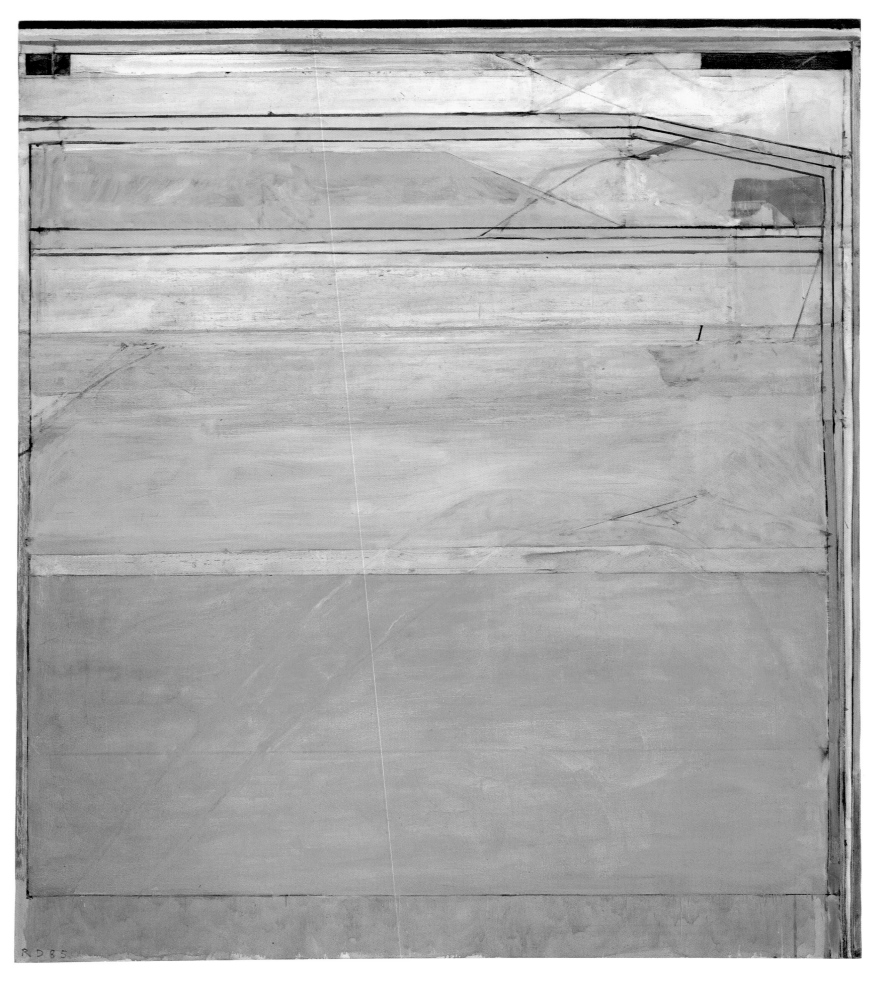

illustrators—N. C. Wyeth and Howard Pyle, but their realism was not his. He conceived a suite of parallel, multi-layered, and independent images consonant with but separate from Yeats's theme and mood, which could yet harmonize gracefully when gathered in the new volume. His contribution reflected his creative life from student of figuration to professional master of abstraction, his veneration of Yeats and his empathy with human vulnerability. Andrew Hoyem's idea of bringing together Yeats and Vendler, Yeats and Diebenkorn, resulted in an extraordinary conflation, arousing complementary and intergenerational readings of Yeats's work.

Working in the Healdsburg living room, with a drawing board to which his sheets were held by push pins, Diebenkorn would review earlier work and scrutinize recent pieces. *Untitled No. 12*, 1989–91 (p. 255), was at one point considered completed but was revised before it found its true final form. It is as remarkable an example of Ocean Park imagery as can be found, freshly imagined on paper. It presents a glowing golden field—nearly two-thirds of the surface—balanced by the upper third's complex series of neutral horizontal bars paced by a few strongly colored ones and a scattering of colored geometric shapes in purple, orange, and assorted gray-blues. It exudes a dazzling light and displays a boldness of workmanship that is admirable.

Untitled No. 10, 1991 (p. 256), is an even larger work on paper, measuring nearly forty inches in width. Developed in crayon, graphite, and acrylic with pasted papers, it relates to horizontal papers of 1986 (p. 229). It departs from the Ocean Park work creating a great flag of perhaps twenty extended horizontal bars, with greens, assorted blues, distinct reds, and browns, punctuated by grays, off-whites, blacks, near purples, and shards of yellow. The bars do not conform to their stacked places, but branch out, cross parallels, advance to separate planes. "I just wanted to cross myself up with some unfamiliar problems."[118] The facture is handmade, revisionary, with colors modulated from one end of a stripe to the other. Bars are fractured, interrupted by linear demarcations, corrections, and pentimenti. Like a cubist portrait or still life *Untitled No. 10* presents an endless guide to visual avenues for examination and delight.

Untitled, 1991 (p. 257), is an acrylic on paper, developed in dark blues and rhythmic patches of red, gray-white, and green. It is a wholly new Healdsburg image—an allover composition in which thinly painted layers of color develop, modify, and body forth darker hues and near violets in an inimitable creative effort. However, one might sense an echo of Matisse's late decorative paper cut-out compositions such as *Ivy in Flower* or *Parakeet and the Mermaid* (both of 1953). Even smaller works on paper such as this one can suggest a surprising scale, deep spaces, and alternative readings.

Untitled, 1992 (p. 259, left), composed of gouache and pasted paper, is a large, late work in the Ocean Park idiom. While there are vertical and horizontal lines and bars, the scaffold has all but disappeared. An inconsistent neutral ground is delimited by clear hand-formed red, black, and blue vertical markings. The black vertical on the inner left has been established and rethought more than once, finally becoming an interrupted element,

partly painted out, regained authoritatively in the upper center, and corrected and smudged toward the top. That black element works as a foil for the encompassing neutral ground, and for the central pink-rose rectangle bordered by a retiring mid-blue rectangle below, and an overhanging green lintel above. Pentimenti abound, in the encircling ground, in the pink and green fields and in the five parallel bars above the lintel. The artist's touch is knowing, direct, delicate but honest.

Untitled, 1992 (p. 259, right), is a tiny acrylic and gouache on paper, and relates closely to the 1991 *Untitled*, mentioned above. It is another uniquely Healdsburg image, emphasizing the formal interactions between curvilinear color forms in red, yellow, blue, green, and purple within a simplified architectural schema recalling Persian miniatures. The upper margin is dominated by a freely painted dark rectangle, penetrated by a meandering snakelike yellow form. Blue and purple elements embrace the dominant red form in the center, on the yellow ground, while a spadelike shape at the lower margin is graced with white, puddled green, and red stainings in the neutral ground that connect to and rhyme with neighboring forms. The artist clearly had found a new inspiration, a new avenue for development, which could prove as memorable and exciting as had those of Albuquerque, Urbana, Berkeley, and Ocean Park. His physical limitations were recognized, but his mind and hand were improvising with familiar ease.

Diebenkorn's health had continued to degenerate following his surgery for the aneurysm, and the corrective heart and lung surgery, in 1989. He was hospitalized several times. On Tuesday, March 30, 1993, the painter suffered respiratory arrest and died on the way to the hospital, at about 11:00 a.m. Obituaries appeared on the front pages of the *New York Times* and the *Los Angeles Times* on the following morning. Both papers traced his early, middle and late career with respect and the Los Angeles paper described him as "arguably the most historically and aesthetically important modernist painter to come out of California."[119]

An exhibition of the artist's works on paper had opened on March 10 of that year at the Fisher Gallery, University of Southern California, Los Angeles. The works were loaned from the Harry and Mary Margaret Anderson Collection in Atherton, California. The exhibition and its catalogue evolved from a seminar in museum studies led by Dr. Susan Larsen, Professor of Art History, working with a group of graduate students, followed by supervised study of the works in Atherton and at USC. Composed largely of etchings, drypoints, and aquatints, the show of seventy prints also included representative lithographs, wood block prints, and six unique works in acrylic, gouache, and oils. The catalogue documented and interpreted the selections through six essays, illustrations, and bibliography.[120]

The USC/Fisher Gallery project afforded Los Angeles an occasion to mourn the artist's passing and to celebrate his remarkable achievement. This was but the first of a series of memorials which included a concert by the Pacific Mozart Ensemble, directed by Richard Grant, with members of the Magnificat Baroque Orchestra at Saint Mark's Episcopal Church, Berkeley, in June 1993; "Richard Diebenkorn (1922–1993): Stanford

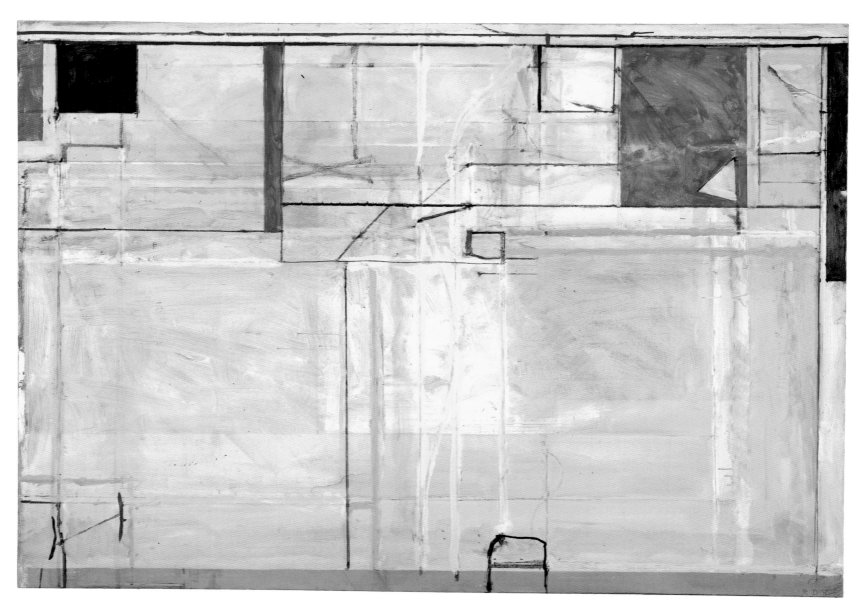

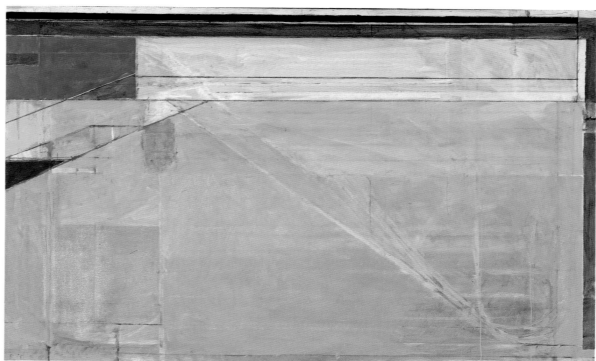

Ocean Park No. 131, 1985. Oil on canvas. 65¼ x 92 in. Lenore S. and Bernard A. Greenberg collection, Beverly Hills, California

Ocean Park No. 132, 1985. Oil on canvas. 48 x 78 in. California collector

242

Remembers," an exhibition with works gathered from collectors and friends in the Stanford community and presented at Stanford University Art Gallery, July–September 1993; and "A gathering of friends in memory of Richard Diebenkorn," in the Blumenthal Patio of the Metropolitan Museum of Art in New York City, in November 1993. William Luers, Executive of the Metropolitan at that time and a friend of the artist for thirty years, convened the proceedings which were opened and closed with the music of Franz Joseph Haydn's trio compositions. Invited speakers included Robert T. Buck, Gifford Phillips, John Russell, John Elderfield, and the painter's son, Christopher Diebenkorn—a cross section of friends who were coincidentally museum leaders, curators, collectors, critics, and family. The participants spoke of art and process briefly, but mostly of the man, using words such as "commitment," "private," "carefully chosen words," "moral dead-centeredness," "self-effacing," "inner directedness," "friend-ship," "integrity," and "love of life." Those speakers knew the man well.[121]

Diebenkorn had enjoyed a long and unusually rewarding relationship with The Phillips Collection, in Washington, D.C., and its leaders. He had found respite from wartime exercises in the museum with his wife, enjoyed profound esthetic encounters with important works in the collection by Bonnard, Braque, Cézanne, and Matisse, and taught himself how to look at modern paintings in its comfortable spaces. The Phillips Collection had purchased Diebenkorn's *Interior with View of Ocean*, 1957, in that year, and *Interior: Woman with Plant*, 1960, in 1961. It was also in 1961 that The Phillips Collection gave Diebenkorn a solo exhibition. Gifford Phillips, the founder's nephew made a gift of *Berkeley No. 1*, 1953, in 1977. The new special exhibition galleries of the Goh Annex opened with a traveling exhibition of Diebenkorn's works on paper from MoMA in 1989. Diebenkorn made a gift to the Phillips of a charcoal drawing, *Standing Nude*, 1966, in 1990. In 1991 the museum received *Berkeley No. 12*, 1955, as a gift from the estate

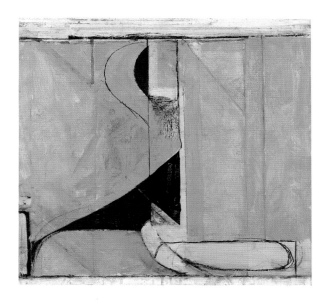

Ocean Park No. 135, 1985. Oil on canvas. 16¾ x 17½ in. Private collection

Portrait of the artist, 1982

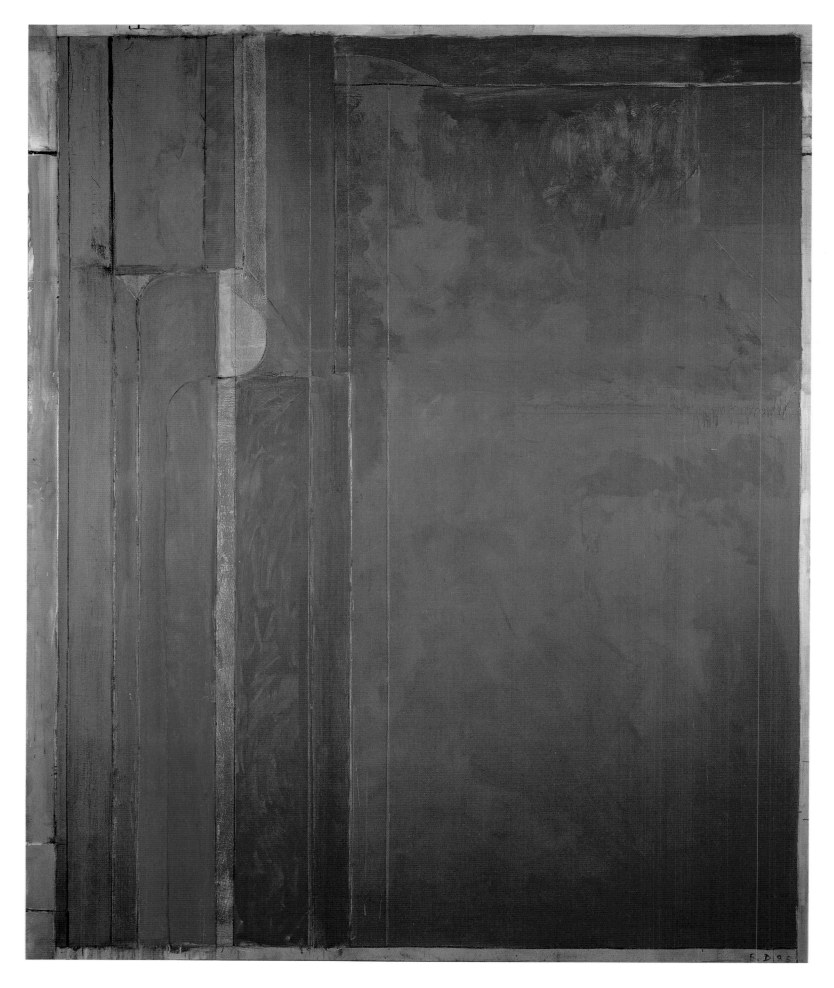

244

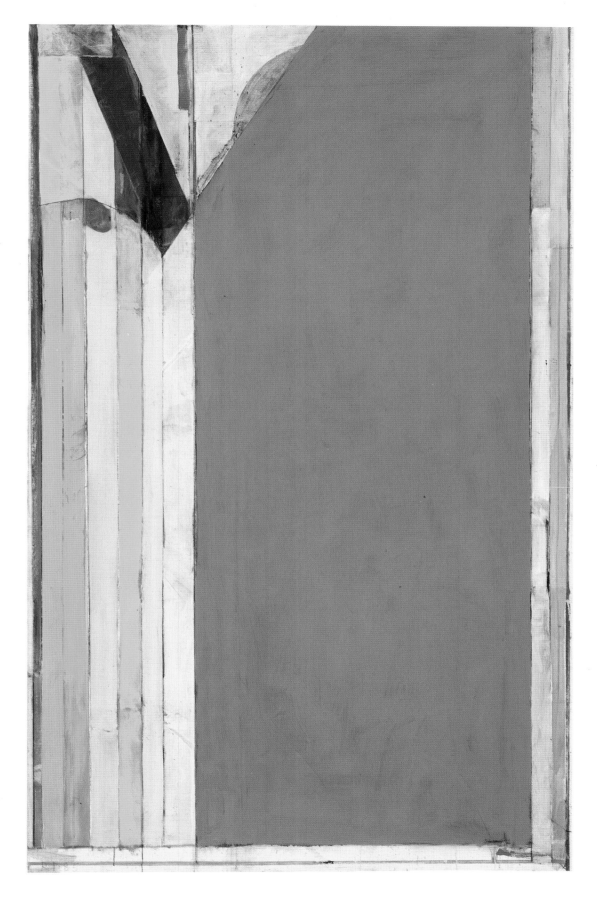

Opposite:
Ocean Park No. 137, 1985. Oil on canvas. 100 x 81 in.
Keith Barish collection, Los Angeles

Ocean Park No. 139, 1985. Oil on canvas. 93 x 58 in.
Private collection

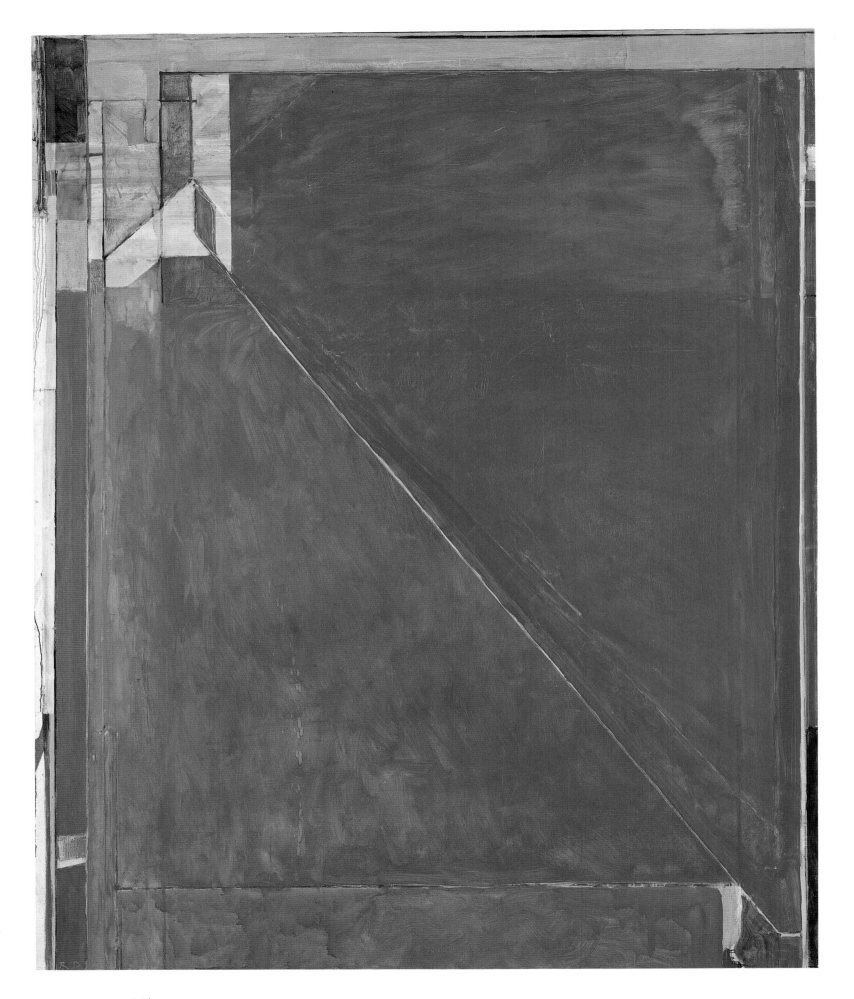

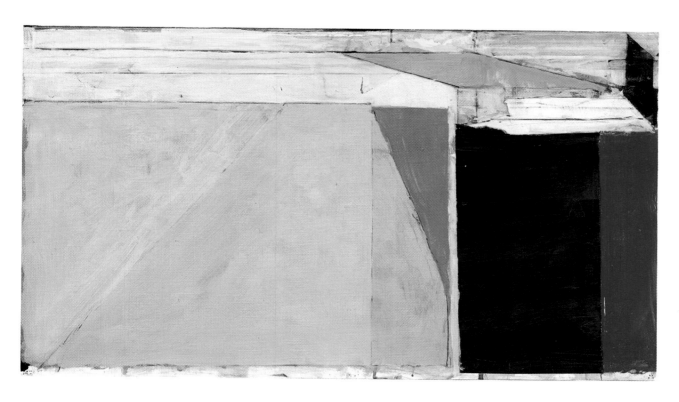

Opposite:
Ocean Park No. 140, 1985. Oil on canvas. 100 x 81 in.
Douglas S. Cramer collection, Los Angeles

Above:
Untitled, 1986. Acrylic, gouache. and crayon on
paper. 17 x 29 in. Courtesy, M. Knoedler & Co., Inc.,
New York

Untitled, 1986. Charcoal on paper. 18 x 37 in.
Courtesy, M. Knoedler & Co., Inc., New York

Untitled, 1986. Acrylic, gouache. and crayon on
paper. 25 x 44 in. Courtesy, M. Knoedler & Co., Inc.,
New York

of Mrs. Judith Miller. Prior to his death, Diebenkorn expressed the wish
to Phyllis that she give two works on paper to the Phillips—*Untitled
(Ocean Park Drawing)*, 1971, and *Untitled*, 1983 (p. 216), instructions that
she carried out within the year. The gift was celebrated at the Phillips in
March and April 1994.[122]

In 1975, Diebenkorn had contracted with Lawrence Rubin to be rep-
resented by M. Knoedler & Company in New York. Rubin became a close
friend. Six shows were presented at Knoedler between 1979 and 1991,
each accompanied by a fully illustrated color catalogue. In 1994 two
Diebenkorn shows were mounted at Knoedler—"Ocean Park Paintings
on Paper" in February, and "Small Format Oil on Canvas Figures, Still Lifes
and Landscapes" in November. When Rubin's plans to retire from Knoedler
became known—to live and deal in art from Zurich, Switzerland—there
was a managerial coup at M. Knoedler, and Rubin's careful plans for suc-
cession were jettisoned. Disturbed by what she believed to be an injustice
to Rubin, Phyllis Diebenkorn withdrew her husband's estate from the
gallery. When Galerie Lawrence Rubin, Zurich, opened in 1995, Mrs.
Diebenkorn committed a show of the artist's abstractions—to include
fifteen works on paper from the early periods (Sausalito, Albuquerque, and
Urbana), and eleven works from the Ocean Park series. Rubin produced
a full color catalogue, in keeping with his earlier practices.[123] The arrange-
ment provided continuity for a valued relationship and afforded the Estate
authoritative representation in Europe. Friends and advisors urged Phyllis
Diebenkorn to establish a parallel representation in New York City, and

many dealers expressed interest in assuming the role. Ultimately Phyllis chose, with Rubin's approval, Acquavella Contemporary Art, a veteran and well-regarded enterprise, which had shown continuous regard for Diebenkorn's work through the secondary market.

Acquavella Contemporary Art initiated "Richard Diebenkorn/ Figure Drawings"[124] in April–May 1996 to unusual critical success. The sixty drawings were selected from the period 1958–67 from the estate's reserves, and all were reproduced in a handsome black-and-white catalogue. It was surely the most masterful of the artist's figure drawing shows since the Stanford University exhibition and publication of 1965. An *Art News* critic wrote:

> There was nothing redundant about these 60 charcoal drawings, all but one of a single female model—fully dressed, half-dressed, or not at all—roughly of equal size (17 x 14 inches), and dating between 1960 and 1967. One wished there were more.
>
> Richard Diebenkorn found in his endless reworkings of the human figure a way to resolve problems—of composition, perspective, line and pattern—at a time when much of the art world was infatuated with abstraction. In these drawings we see Diebenkorn weighing his options. Quick scumbles stand for shadow or describe a blouse. Veils of ink wash throw the figure into deep space or delineate its flesh. A decisive sinuous line relaxes a limb or takes over to define completely figure, ground, and props....
>
> Diebenkorn was rigorous, methodical, and searching. He was aware that he was part of a great tradition; his figure drawings read like a litany of modernism. Cézanne appears in intricately related geometric spaces that pull the plane of the paper back and forth; Matisse, in the striped and oriental fabrics and in contours that articulate forms and then seem to color them; and Hopper, in the awkwardness of the models, who are often depicted in unflattering postures, with knees splayed. [125]

Peter Goulds, founder of L. A. Louver Gallery, secured Phyllis Diebenkorn's approval to present a second show of the artist's drawing from the model in Venice, California, in November 1996. The selection included thirty-four mainly individual nude female figures, standing, seated, or reclining on chairs, couches, or beds, from 1954 to 1967, and executed in the usual media and combinations: pencil, charcoal, ink, ballpoint pen, conte crayon, ink wash, and gouache on the artist's favorite shiny coated paper, and presented in uniform sizes. L. A. Louver's selection was somewhat less austere than the Acquavella selection—perhaps more experimental, with uncustomary poses taken by the models, broadly textured spreads of charcoal, seductive use of pattern, and the familiar display of ink wash.[126]

Diebenkorn had suspended drawing from the figure when he moved into his north-lighted Ocean Park studio in 1967 and found his way into the new Ocean Park work. He no longer required the discipline of figure

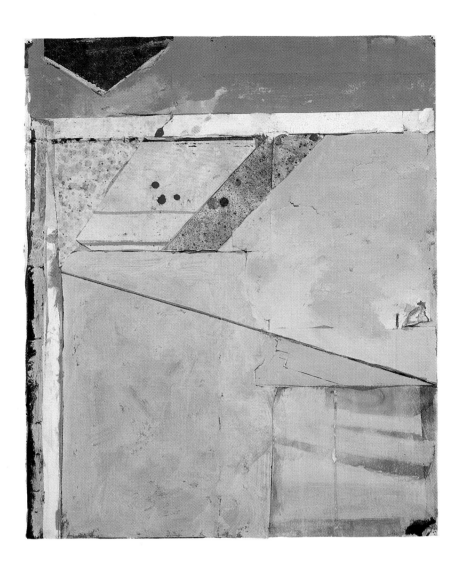

Untitled, 1986. Pasted paper and acrylic on paper. 24 x 19 in. Courtesy, M. Knoedler & Co., Inc., New York

drawing, and that visual dialogue between model and eye, mind and hand. While the Ocean Park canvases rank among the high achievements of late twentieth-century art, it has nonetheless been a loss to the visual arts for this leading draftsman to relinquish his long practice of seeing, learning from, and celebrating the human figure. Diebenkorn's drawings are, in effect, autobiographical exposures of his mind and sensibility at work. His memorable drawings in every period have made indelible impressions on the consciousness of his contemporaries. The hesitations, corrections, erasures, and emendations which the viewer traces constitute the expression of his self-education, his standard and credo of quality, and his commitment to the timeless claim of modern art from Cézanne through Matisse and Mondrian to himself.

For many years critics, artists, and curators in the West had expressed the need for a comparative study of the emergence of Abstract Expressionism in San Francisco after World War II with its more highly publicized counterpart in New York. The San Francisco Museum of Art had provided early recognition of new painters through first solo museum exhibitions for Arshile Gorky (1941), Clyfford Still (1943), Jackson Pollock (1945), and Mark Rothko, Hans Hofmann, and Robert Motherwell (all 1946). A West Coast freelance curator, Susan Landauer, took up the challenge to

Untitled, 1987. Oil and crayon on paper. 38 x 25 in.
Courtesy, M. Knoedler & Co., Inc., New York

write such a study, adding fine illustrations to produce *The San Francisco School of Abstract Expressionism*, published by the University of California Press in 1996. The book served as catalogue for an exhibition, which had been intended to make a broad national impact, but could not because the New York and Florida venues failed to fulfill their commitments. The exhibition was seen only at Laguna Art Museum, in southern California, and at the San Francisco Museum of Modern Art, thereby defeating the intended national impact, though the book remains.

Landauer established that in the years immediately following the war, "A sweeping transcontinental modernist [art] thrust," could be recognized, in which the major centers were New York and San Francisco.[127] Landauer emphasized the adventurous scheduling of the San Francisco Museum of Art's contemporary exhibition in contrast to that of the Museum of Modern Art, in the same period, and the excitement engendered by Douglas MacAgy's direction for the California School of Fine Arts through its faculty of artists, photographers, and filmmakers, including Park, Still, Spohn, Corbett, Diebenkorn, Rothko, and Smith. Landauer gives prominence to both Clyfford Still and Mark Rothko, but also features from among thirty artists—through full page photo-portraits and a profusion of color and black-and-white plates—four primary leaders of San Francisco abstract expressionism: Edward Corbett, Richard Diebenkorn, Hassel Smith, and Frank Lobdell, in that order.

She defined the national movement of abstract expressionism:

> ... the ideology of Abstract Expressionism embraced a globalist perspective that equated modernism with universal humanism. It was an essentially romantic movement committed to individual vision and intuitive, subjective expression. Like other romantic ideologies, it rejected mechanistic materialism in favor of spiritual values and viewed the world, not in terms of fixed absolutes, but as an inchoate process or flux. Art was seen as an experience of adventure, discovery, and evolving consciousness. Above all, the Abstract Expressionist ideology passionately rejected all constraints upon the spirit. The exaltation of freedom was expressed in the unbounded, expansive painting language, and in the reluctance to systematize meaning. Ambiguity of form and content can thus be read as metaphors for noncoercion and self-determination.

With this definition, Diebenkorn can be seen one of the truest expressions of the movement.

Landauer went on to establish the parallel development of the two groups:

> ... The majority of artists in San Francisco evolved individual styles by the late 1940s. Corbett's smoky mists, Stillman's spidery scaffolds, Smith's playful whiplash lines, and Lobdell's hulking forms had emerged by that time. This was not to say that the San Francisco painters were untouched by developments in New York. Still's contact with some of the artists represented by Art of This Century and

the Betty Parsons Gallery provided an important conduit of ideas between San Francisco and New York in the late 1940s. While teaching at the CSFA from 1946 to 1950, Still kept in close touch with Rothko and Newman, and it was through his urging that Rothko was employed as a guest instructor.... Moreover many San Francisco artists, including Diebenkorn, were avid readers of the New York magazines *View* and *Tiger's Eye*.... Rothko was as much a recipient as a transmitter of ideas during his San Francisco trips. Ad Reinhardt, who taught at the CSFA in the summer of 1950, made no appreciable impact in San Francisco, though his own work was inspired by the black monochromes of Corbett. [128]

Jane Livingston, an independent curator operating in the greater Washington, D.C. area, proposed a major Diebenkorn retrospective—"The Art of Richard Diebenkorn"—to be circulated in the later 1990s, with the support of the Morgan Bank, the Phillip Morris Companies, and the National Endowment for the Arts. Organized and funded over a period of four years, with its first viewing at the Whitney Museum of American Art in New York, October 1997, and subsequent venues at the Modern Art Museum of Fort Worth, Texas, The Phillips Collection, Washington, D.C., and finally to the San Francisco Museum of Modern Art in October 1998. A fully illustrated catalogue was produced, with essays by Livingston, Ruth E. Fine, and John Elderfield. [129] Composed of 172 works, drawn from 1949 to 1992, the show was clearly the best selected representation to date of the artist's retrospective exhibitions. Livingston made the point, as have many commentators, that Diebenkorn was "provincialized" and diminished by the New York critics as a "Californian" artist. While he held shows regularly in Los Angeles and San Francisco from the 1940s and early 1950s, he also did so in New York, from the mid-1950s onward. He also held solo shows in Chicago (1954), Boston (1957), Washington (1961, 1964), London (Waddington, 1964, 1967; Marlborough, 1973), Zurich (1974), and was included in international exhibitions in São Paulo (1955, 1961), Brussels (1958); Venice (1968, 1978), and the Carnegie Internationals of 1958, 1961, 1964, 1970, as well as the traditional Whitney, Corcoran, University of Illinois, and Art Institute of Chicago annuals and biennials. Nonetheless, he was habitually stigmatized—as a non-New Yorker—and judged to be lacking in appropriate seriousness and ambition.

Robert Hughes wrote of the 1997 show at the Whitney: "Foot for square foot, the current retrospective of Richard Diebenkorn's paintings at New York City's Whitney Museum of American Art offers more esthetic pleasure than any other show—at least of contemporary art—in town.... Nobody who cares about painting as an art ... could be indifferent to Diebenkorn's work or to the long, intense and fascinating dialogue with the modernist past it embodies." [130] Eric Gibson admired the selection, writing, "The traveling Richard Diebenkorn retrospective is more than a celebration of an artist. It is a celebration of painting itself, both as a vehicle of personal experience and as a discipline. It is also a highly unusual

exhibition, both perplexing and thought-provoking. . . . The normal summary of Diebenkorn's [career has been added to and] . . . another aspect of [his] artistic personality comes to the fore, that of psychological withdrawal and even melancholy . . . Matisse is tempered by the existential bleakness of Hopper. It is an odd yet strangely powerful slant. . . . Adding spice to Livingston's reading of Diebenkorn in this show is the fact that the artist's widow played an important role in the effort. What we have here then might be something close to the way Diebenkorn viewed himself."[131]

Mario Naves saw it most clearly:

Diebenkorn's *Ocean Park* paintings and related works on paper are among the artistic triumphs of the latter half of the century. . . . no one can doubt the power and aesthetic accomplishment of the "California artist" at his best. . . . Yet, because of its implied parochialism, the label is misleading. . . . Diebenkorn's achievement has been, one feels, only grudgingly acknowledged, particularly in New York. . . . The narrative of the exhibition, if we can call it that, shows that Diebenkorn was not, as some would have it, given to stylistic caprice . . . [his] shifts of emphasis throughout his career were always well-reasoned responses to the aesthetic logic of his art. Their culmination in the *Ocean Park* series while not preordained, is utterly natural. . . . This retrospective makes for a refreshing jolt of sanity—and it should be added, beauty—in an art world given to excess and faddishness.[132]

After two years with the Acquavella representation, Phyllis Diebenkorn withdrew the Diebenkorn Estate from the management of the 79th Street dealership. Having maintained in close touch with Lawrence Rubin, who had formed the intent to move from Zurich to Milan, while keeping in active contact with art commerce in the U.S., she expressed interest in Rubin's representing Diebenkorn in New York. Rubin soon secured an appropriate exhibition space, established a new organization with new partners, and in February 1999 the new entity opened at Fifth Avenue and 57th Street—Lawrence Rubin-Greenberg Van Doren Fine Art—with a Richard Diebenkorn exhibition. The exhibition focused on the Ocean Park period of 1969 to 1985, with eight canvases, one panel, and seven works on paper drawn from the artist's estate.[133] The estate had achieved a new stability with one principal international representative.

Robert Motherwell noted fifty years ago that, "Every intelligent painter carries the whole culture of modern painting in his head. It is his real subject, of which anything he paints is both an homage and a critique."[134] Diebenkorn could well be the model for such an intelligent painter, who devoted most of his life to learning about and understanding the tradition and culture of modern painting by traveling to see it, discussing it with fellow artists, keeping informed through books and catalogues, and practicing and criticizing his own art ruthlessly. He knew that being a painter required honesty, and he made every effort to face the challenges he found

Untitled No. 12, 1989–91. Crayon, graphite, and acrylic on paper. 38 x 25 in. Leslie Feely Fine Art, New York

Untitled No. 10, 1991. Crayon, graphite, acrylic, and pasted paper on paper. 22 x 39½ in. Mr. Christopher Diebenkorn collection

Untitled, 1991. Gouache on paper. 24 ½ x 19 in.
Private collection

in making original art out of his experience and his sense of the culture of painting. He no sooner found a successful entry into the development of a painting than he felt the need to vary it, or to avoid it, in order to maintain a freshness and integrity.

Tradition means literally to surrender knowledge, information, beliefs or customs to a later generation. Diebenkorn was driven to understand the historical and cultural lineage of modern painting, and he adopted one severe master after another. Hopper's work came to him through Mendelowitz at Stanford; Matisse through his visit to Sarah Stein's home and from The Phillips Collection; Cézanne through the teachings of Erle Loran and again the paintings in the Phillips. He drew upon Rothko from visits to see *Slow Swirl at the Edge of the Sea*, 1944, at the San Francisco Museum of Art, from conversations with the artist during summer session visits to San Francisco in the late 1940s, and from viewing Rothko's art and its reproductions over a lifetime. As Mark Tobey said, "Artists learn only from other artists and from art."

Diebenkorn's early regard for the work of Henri Matisse grew in depth with each year and with each new monograph and exhibition presenting unknown works from the artist's oeuvre. He recognized in himself Matisse's comment on his own school: "Needless to say, many of my students were disappointed to see that a master with a reputation for being revolutionary could have repeated the words of Courbet to them: '*I have simply wished to assert the reasoned and independent feeling of my own individuality within a total knowledge of tradition.*'" He also knew Matisse's thoughts on "art influence":

> I will repeat what I once said to Guillaume Apollinaire: For my part I have never avoided the influence of others. I would have considered it cowardice and lack of sincerity toward myself. I believe that the artist's personality affirms itself by the struggle he has survived. One would have to be very foolish not to notice the direction in which others work. I am amazed that some people can be so lacking in anxiety as to imagine that they have grasped the truth of their art on the first try. I have accepted influences but I think I have always known how to dominate them.[135]

Diebenkorn continued also to show keen interest in Cézanne's *Portrait Drawings*, well into the 1970s, and he voiced admiration of "Cézanne: The Late Work" shown at the Museum of Modern Art in 1977–78. He freely admitted feeling close to the work of Mark Rothko and said that he recognized himself in it. He was a sensitive artist who felt influences, but like Matisse, adjusted to them, made them his own, and thereby dominated them.

Diebenkorn never lost his deep regard for Edward Hopper's art and mood. He could later say, "Hopper was a little more rough-hewn and cruder than I once thought and his figures are as awkward as the devil. But of course their awkwardness is their strength." And he could add, "I would never consciously trade awkwardness for elegance."[136] But after his student days at Stanford University, there was never another Diebenkorn

Untitled, 1992. Gouache and pasted paper on paper.
39 x 16¼ in. Private collection

Untitled, 1992. Acrylic and gouache on paper.
7½ x 6¼ in. Private collection

work which might be directly associated with Hopper's influence.

There remain canvases which are frank homages to Matisse—*Recollections of a Visit to Leningrad*. So it has been with the influences of Cézanne, Rothko, and Mondrian. These are artists of enormous international importance and influence, but their impact on Diebenkorn was to make him rethink their work, understand its fundamentals, and adjust his practice to embrace it. His challenge was always to hold himself to their high level of achievement.

Diebenkorn said a number of times that being "moved" by a work of art means more than being impressed or temporarily affected by something; it meant that one was somehow changed in attitude or point of view, so that ever afterward one existed in a different condition than prior to having been "moved." Likewise, Diebenkorn demonstrated his unwillingness to rest on successful patterns through his relentless search for fresh color, new harmonies, and new beginnings, clearly manifested in each new group of canvases. He pushed, in turn, intense and saturated colors and pale and fragile ones, seeking his own surprise in their variability. He mastered a quality of allover light in his 1947–55 period, joining it to his unique color sense, which derived from his response to local light and his compulsion to adjust line, form and color to one another in seeking a unified composition. His particular light also derived from his custom of working in layers of thin paint, which allowed him needed freedom. The multiple layers of thin paint coalesced into an inimitable personal color technique. Throughout his career, in every period, figurative or non-figurative, in drawing, painting, or printmaking, he sought for an imagery and balance that was his own, but he also intended to preserve the artifice of image making, within the doctrine and practice which had come to him through his diligence in exploring even unwelcome aspects of the tradition which he guiltily accepted as the proper discipline of a serious artist.

Richard Diebenkorn shaped his oeuvre around showing us how he perceived the works of his chosen masters. He coaxed us into understanding how he looked at modern art, and he made his own dialogue with the process of painting the subject of his Ocean Park series, which John Russell rightly asserted was "one of the most majestic pictorial achievement of the second half of this century. . . ."[137] At the same time the artist was always concerned with a harmony and integration of surface, space, luminosity, and the illusion of depth. A man of considered judgment, Diebenkorn didn't talk to hear himself. He liked words and he kept an unabridged dictionary handy. He used his words carefully and seldom made pronouncements. When he did make a statement, it was logical, compressed, thoughtful, like his work. One day while we were sitting in his garden, he commented: "Part of painting is physical. Another part is intellectual. The most highly prized aspect is intuitive, when it is operative. The percentage changes with each painting. There should be a balance."[138]

The physical aspect of painting that Diebenkorn referred to may be the simplest component. The intellectual is more demanding for it has little to do with art historical priorities, but involves the personal discovery of opportunities for exploration and development. Diebenkorn came to the

art scene at an opportune moment. He had the intelligence, the eye, and the self-directedness that were necessary to sort through the contradictory information and impulses of the heady 1940s. He became a journeyman in the physical aspects of painting in a few years and worked to expand his understanding in each of his periods with some ease but always with determination and high seriousness. The intuitive, which is neither physical nor intellectual, is never mastered, nor can it be. It is unpredictable: it stays with an artist for a time but can readily vanish. Efforts to trap it or force it, only make it more elusive. Diebenkorn's grasp of improvisation, and his lifelong willingness to abandon successful strategies and to destroy those works he perceived as having become studied or formulaic kept him in touch with the intuitive and in the front ranks of professional artists for more than forty years. He had a firm hand on the physical and intellectual controls; meanwhile he prepared for new engagements with the intuitive. His creative process moved at its own maddening pace, and new values, proportions, colors, and harmonies originated in the working. In his absence, one finds his work more profound, more skillful without being slick, more meaningful, and more passionate than ever. One can be certain that Richard Diebenkorn's works will continue to be viewed as influential, serious, and highly accomplished by successive generations. Even now, when we encounter his works that are new to us, they continue to be unforeseeable and yet inevitable, startling and yet logical, surprising and already part of the tradition.

NOTES

1. Interview with Richard Diebenkorn, Santa Monica, California, May 4, 1976. Unattributed quotations are drawn from interviews conducted by the author with the artist between June 1964 and August 1983 in the San Francisco Bay area and in Washington D.C., Los Angeles, and other cities.

Richard Diebenkorn's father was Richard Clifford Diebenkorn, born Cincinnati, Ohio, 1893, died La Jolla, California, 1964. According to Clem Mullins, design department chief at the company where Richard's father had worked, the senior Diebenkorn was "'straight-arrow'— highly principled, reserved, never spoke personally or about his family. Strictly business."

The name Diebenkorn is derived from an archaic Swedish word meaning "grain stacked in the shape of a house." Diebenkorns may still be found in the Hamburg and Mecklenburg areas of Germany, where the family settled in the seventeenth century, having migrated from Sweden. Richard's paternal great-grandfather left Germany for the United States in the early 1860s.

Diebenkorn's maternal grandmother was Florence McCarthy Stephens, born Dublin, 1869, died Palo Alto, California, 1946. She was a short-story writer, poet, watercolorist, and radio book reviewer. When she was in her thirties, she returned to school to study law, passed the bar, and subsequently spent several years defending German-Americans whose civil rights had been violated during World War I. According to Diebenkron, she never lost a case.

2. *Ibid.*

3. Maurice Tuchman, "Diebenkorn's Early Years," in *Richard Diebenkorn: Paintings and Drawings, 1943–1980* (New York: Rizzoli International Publications/Albright-Knox Art Gallery, 1980), p. 5.

4. Richard Diebenkorn, quoted in Joseph Pulitzer, Jr., *Modern Painting, Drawing & Sculpture: Collected by Louise and Joseph Pulitzer, Jr.* Vol. 1 (Cambridge, Mass.: Fogg Art Museum, Harvard College, 1957), p. 31.

5. Tape-recorded interview with Richard Diebenkorn by Susan Larsen, Santa Monica,

California, May 1, 1985 (transcribed by the Archives of American Art, Smithsonian Institution, Southern California Research Center), p. 10 (first draft).

6. Larsen, p. 19.

7. Larsen, p. 10.

8. Interview with Richard Diebenkorn by the author, Santa Monica, California, May 6, 1976.

9. Larsen, pp. 18–19.

10. Larsen, p. 23.

11. Interview with Richard Diebenkorn by the author, Santa Monica, California, June 28, 1976.

12. Interview with Richard Diebenkorn by the author, Santa Monica, California, June 29, 1985.

13. *Ibid.*

14. Interview with Erle Loran by the author, Kensington, California, October 26, 1985.

15. *Ibid.*

16. See Herschel B. Chipp, *Theories of Modern Art: Source Book for Artists and Critics* (Berkeley, Calif.: University of California Press, 1969), p. 94.

17. Larsen, p. 44.

18. Larsen, pp. 52–53.

19. Interview with Richard Diebenkorn by the author, Santa Monica, California, May 1986.

20. Interview with Elmer Bischoff by the author, Berkeley, California, June 25, 1985.

21. Telephone conversation between Richard Diebenkorn and the author, May 1986.

22. Richard Diebenkorn, quoted in Tuchman, p. 7.

23. *Ibid.*

24. Interview with Richard Diebenkorn by the author, June 28, 1985.

25. *Ibid.*

26. *Ibid.*

27. *Ibid.*

28. *Ibid.*

29. Draft of handwritten letter (dated 11/3/73) and typescript of answers to the first three questions of a questionnaire submitted by Dan Tooker for a projected book on the postwar years at the CSFA.

30. Interview with Richard Diebenkorn by the author, Washington, D.C., summer 1964.

31. Interview with Frank Lobdell by the author, San Francisco, June 24, 1985.

32. Tuchman, p. 12.

33. Interview with Richard Diebenkorn by the author, Santa Monica, California, June 29, 1985.

34. Mark Rothko and Adolph Gottlieb, letter to Edward Alden Jewell, *New York Times*, June 13, 1943, excerpted in Jewell's column, sec. 2, p. 9. See also Dore Ashton, *On Rothko* (New York: Oxford University Press, 1983), pp. 76–78.

35. Interview with Richard Diebenkorn by the author, Santa Monica, California, June 29, 1985.

36. James Schevill, "Art: Richard Diebenkorn," *Frontier* 8, no. 3 (January 1957): 21–22.

37. Interview with Elmer Bischoff by the author, Berkeley, California, June 25, 1985.

38. Interview with Richard Diebenkorn by the author, Santa Monica, California, February 1986.

39. Larsen, p. 62.

40. Interview with Richard Diebenkorn by the author, Santa Monica, California, June 28, 1985.

41. Letter from Hassel Smith to the author, July 25, 1986.

42. Unsigned review, *San Francisco Chronicle*, March 12, 1950, n.p.

43. Richard Diebenkorn, quoted in Mark Lavatelli, "The Albuquerque Paintings of Richard Diebenkorn," dissertation, University of New Mexico, Albuquerque, 1979, p. 23.

44. Interview with Richard Diebenkorn by the author, Santa Monica, California, June 1985.

45. *Ibid.*

46. *Ibid.*

47. Interview with Enrique Montenegro by the author, Albuquerque, New Mexico, April 2, 1985.

48. Mark Lavatelli, "Richard Diebenkorn: The Albuquerque Years," *Artspace* 4, no. 3 (June 1980): 21.

49. Pulitzer, p. 31.

50. Interview with Richard Diebenkorn by the author, Santa Monica, California, May 1986.

51. Tuchman, p. 12.

52. Lavatelli, "The Albuquerque Paintings of Richard Diebenkorn," p. 23.

53. Richard Diebenkorn, quoted in "Diebenkorn, Lee Mullican, and Emerson Woelffer: A Discussion," *Artforum* 1 (April 1963): 24–29.

54. Karen Noell, *Docent Study Guide* (San Francisco: San Francisco Museum of Modern Art, 1983), n.p.

55. Pulitzer, p. 31.

56. Richard Diebenkorn, quoted in Paul Mills, *Contemporary Bay Area Figurative Painting* (Oakland, Calif.: Oakland Art Museum, 1957), p. 12.

57. Pulitzer, p. 31.

58. Larsen, pp. 102–03. In his May 1985 interviews with Susan Larsen, Diebenkorn recalled this new version of his initial return to figurative painting. Previously he had spoken of picking up a small canvas and painting "a messy still life," which he saw, by chance, before him in his studio. That version has been published.

59. Interview with Richard Diebenkorn by the author, Santa Monica, California, July 2, 1985.

60. Hershel B. Chipp, "Diebenkorn Paints a Picture," *Art News* 56, no. 3 (May 1957): 46.

61. Dore Ashton, "First One-Man Show at Poindexter Gallery," *Arts and Architecture* 73, no. 4 (April 1956): 11.

62. Richard Diebenkorn, in response to a questionnaire from Dan Tooker, April 3, 1973, in preparation for a book and filmstrip to be published by Harcourt, Brace, Jovanovich.

63. Richard Diebenkorn, quoted in Gail Scott, *New Paintings by Richard Diebenkorn* (Los Angeles: Los Angeles County Museum of Art, 1969), p. 6.

64. Mills, p. 12.

65. Interview with Richard Diebenkorn by the author, Santa Monica, California, July 1, 1985.

66. *Ibid.*

67. Mills, pp. 6, 22.

68. Interview with Richard Diebenkorn by the author, Santa Monica, California, July 2, 1985.

69. Hilton Kramer, "Pure and Impure Diebenkorn," *Arts* 38, no. 3 (December 1963): 46–53.

70. Interview with Richard Diebenkorn by the author, Santa Monica, California, May 11, 1976.

71. From miscellaneous studio notes before 1977 compiled by the artist and made available to the author.

72. *Ibid.*

73. Letter from Richard Diebenkorn to Frank Gettings, quoted in *Drawing Since 1974*, exhibition catalogue published by the Hirshhorn Museum and Sculpture Garden, Smithsonian Institution, Washington, D.C., September 17, 1984.

74. Jack D. Flam, *Matisse on Art,* (New York: Phaidon, 1973), p. 73.

75. Scott, p. 6.

76. *Ibid.*

77. John Canaday, "Richard Diebenkorn: Still Out of Step," *New York Times*, May 26, 1968, sec. 3, p. 37.

78. Gerald Nordland, *Richard Diebenkorn, The Ocean Park Series: Recent Work* (New York: Marlborough Gallery, 1971), p. 11.

79. John Elderfield, "Diebenkorn at Ocean Park," *Art International* 16 (February 20, 1972): 20.

80. Dore Ashton, "Richard Diebenkorn's Paintings," *Arts* 47 (December 1971–January 1972): 35–37.

81. *Ibid.*

82. From miscellaneous studio notes before 1977 compiled by the artist and made available to the author.

83. Henri Matisse, quoted in Flam, p. 73.

84. John Russell, *Richard Diebenkorn, The Ocean Park Series: Recent Work* (London: Marlborough Fine Art Ltd., 1973), n.p.

85. Nigel Gosling, "Review" *The Observer* (London), Oct. 4, 1964, p. 25.

86. See Lee Seldes, *The Legacy of Mark Rothko* (New York: Holt, Rinehart & Winston, 1978)

87. Kathan Brown, quoted in Mark Stevens, *Richard Diebenkorn: Etchings and Drypoints, 1949–1980* (Houston: Houston Fine Art Press, 1981), p. 26.

88. Telephone interview with Marcia Bartholme, a former printer at Crown Point Press, August 1989. See also Gerald Nordland, *Richard Diebenkorn / Graphics 1981–1988* (Billings, Montana: Yellowstone Art Center, 1989), pp. 25, 29, 30.

89. Gerald Nordland, *Richard Diebenkorn Monotypes* (Los Angeles: University of California Press, 1976), pp. 11–44.

90. *Ibid.*

91. The catalogue for this survey was Mark Stevens, *Richard Diebenkorn: Etchings and Drypoints 1949–1980* (Houston: Houston Fine Art Press, 1981).

92. Review published for opening of show in Buffalo, John Russell, "Diebenkorn's Stunning Achievement," *New York Times*, December 5, 1976, sec 2, p. 33.

93. Review published for opening of show in New York, Hilton Kramer, "Diebenkorn's Mastery," *New York Times*, June 12, 1977, sec. 3, p. 25.

94. Robert Hughes, "California in Eupeptic Color," *Time*, June 27, 1977, p. 58.

95. Thomas Albright, "Diebenkorn's 'Ocean Park'—A New World," *San Francisco Sunday Examiner & Chronicle*, November 20, 1977, p. 48.

96. Dore Ashton, *Diebenkorn / Small Paintings from Ocean Park*, with a preface by George Neubert (Lincoln: Sheldon Memorial Art Gallery, University of Nebraska, 1985).

97. Interview with Wayne Thiebaud by the author, Sacramento, California, August 1986.

98. Letter from Richard Diebenkorn to the author, November 14, 1985.

99. Diebenkorn had worked with the author on at least five occasions— Washington Gallery of Modern Art, 1964; Marlborough Fine Arts Gallery, 1971; San Francisco Museum of Art, 1972; University of California, Los Angeles, 1976; and Albright-Knox Art Gallery, 1976.

100. The book was reviewed by John Russell in "Richard Diebenkorn," *New York Times Book Review* of Christmas books, Dec. 6, 1987—

In California, one sees Diebenkorn everywhere—in the cut and color of the landscape, in the sky, in the symbiosis of indoors and outdoors, in traffic patterns, in the sandy, scuffed look of sidewalks near the ocean and in the body language of the people. Even the food, in the end has a look of his palette. It is now 20 years since he tackled these things directly, but they are still very much there, as distilled and refined essences, in the long series of apparently abstract "Ocean Park" paintings that have occupied him for much of that time. They are as much there, in fact, as they were in 1954, when he had already done some of the best paintings produced in this century since World War II and yet was thinking of driving a taxi for a living.

Gerald Nordland has the advantage that he has always been there, that he has had Mr. Diebenkorn's full and generous cooperation, and that his publisher has allowed him 300 illustrations (150 in color). One can imagine a tighter, brisker treatment, but Mr. Diebenkorn has never been someone who goes on the rampage when his work is in question, and the quiet conversational tone of the book may well be what he likes most.

101. *Richard Diebenkorn / Works on Paper*. Edited by Richard Newlin (Houston Fine Art Press, 1987).

102. Dan Hofstadter, the author of a number of other *New Yorker* profiles on artists met Diebenkorn in 1986 and later visited the Santa Monica house and the Ocean Park studio. Diebenkorn occasionally recalled incidents from his career in mildly contradictory fashions for different writers including this author, Larsen, and others. Diebenkorn had been reviewing my drafts of the first printing of this book for some months, and he had settled on that telling of his career, despite inevitable imprecisions which he stoically endured. Hofstadter was the first interviewer to benefit from the newly consolidated life story. His *New Yorker* piece reached the public in September 1987, shortly before the Rizzoli monograph. Hofstadter's profile was well received as an affectionate and respectful depiction of the highly regarded artist, and it was republished five years later by Knopf, in a slightly modified. Dan Hofstadter, "Profiles: Almost Free of the Mirror," *The New Yorker*, September 7, 1987, pp. 54–73. Reprinted in a slightly different form in *Temperaments / Artists Facing Their Work* (New York: Alfred A. Knopf, 1992).

103. Since the medal was initiated, in 1979, sixteen artists have been honored, including Laurence Olivier (1983), Isaac Bashevis Singer (1984), Toshiro Mifune (1986), Rufino Tamayo (1988), I. M. Pei (1990), Vaclav Havel (1992), James Earl Jones (1993), Carlos Fuentes (1993), Francis Ford Coppola (1994), Marvin Neal Simon (1996), Quincy Jones (1998), and Mario Vargas Llosa (1999).

104. The UCLA Medal was created to pay tribute to national and international leaders in government, education, science, industry, and arts and culture in 1979. Each year the medal is awarded at commencement or convocations. Medalist nominees are recommended by Deans and Vice Chancellors and are decided kupon by the Chancellor and his Executive Committee. The Chancellor's statement was provided by Special Events & Protocol Office, UCLA, February 22, 2000.

105. Jed Perl, *The New Criterion*, (March 1989): 45–48.

106. Richard B. Woodward. "Richard Diebenkorn—MoMA," *Art News*, (March 1989): 168.

107. Michael Kimmelman, "The Elegant, Playful Images of Diebenkorn," *New York Times*, November 18, 1988, sec. 3, pp. 1, 32.

108. Garner Tullis, conversation with the author, August 1989.

109. *Ibid.*

110. Transcript provided by Mindy Richman Garfinkel, National Medal of Arts Coordinator. The National Medal of Arts was established by Act of Congress, January 23, 1984, authorizing the President to award no more than 12 medals each year "to individuals or groups who in the President's judgment are deserving of special recognition by reason of their outstanding contributions to the excellence, growth, support, and availability of the arts in the U.S." The National Endowment for the Arts solicits nominations for the medal from various arts fields. Nominations are reviewed by the National Council on the Arts, and a list of the most highly qualified candidates is forwarded to the President for final consideration. Recipients included Maurice Abravanel, Roy Acuff, Petro Belluschi, J. Carter Brown, Charles "Honi" Coles, John O. Crosby, Richard Diebenkorn, R. Philip Hanes, Jr., Kitty Carlisle Hart, Pearl Primus, Isaac Stern, and the Texaco Corporation.

111. Federal Information Systems Corporation, A Federal News Service, July 9, 1991.

112. Catherine Lampert and John Elderfield, *Richard Diebenkorn* (London: Whitechapel Art Gallery, 1991).

113. Richard Kendall, "Painting Against the Grain: Richard Diebenkorn at Whitechapel Art Gallery," *Apollo* (December 1991): 429.

114. Charles Hall, "Richard Diebenkorn, Whitechapel," *Arts Review* (London) (November 1991): 582-83.

115. Merlin Ingle James, "London, Whitechapel: Richard Diebenkorn," in *The Burlington Magazine* (December 1991): 856-58.

116. W. B. Yeats, "Sailing to Byzantium," (1927), in *The Tower*. (New York: Macmillan Co., 1928).

117. *Poems by W. B. Yeats*. Selected and with an introduction by Helen Vendler; with six etchings by Richard Diebenkorn; 400 copies. (San Francisco: Arion Press, 1990).

118. Diebenkorn quoted in Michael Kimmelman, "A Life Outside," *New York Times Magazine*, September 12, 1992, p. 60.

119. William Wilson and Myrna Oliver, "Richard Diebenkorn, Renowned Painter, Dies." *Los Angeles Times*, March 31, 1993, pp. A1, A22.

120. Susan C. Larsen, et al., *Richard Diebenkorn: Works on Paper* (Los Angeles: Fisher Art Gallery, University of Southern California, 1993).

121. Invitations and programs provided by the Metropolitan Museum of Art. Transcript of remarks made available by John Elderfield, of the Museum of Modern Art, New York.

122. *The Phillips Collection News & Events*, March–April 1994. Cover reproduction in color of *Untitled*, 1983, plus a photo of *Untitled*, 1971, on p. 8 and a brief essay on pp. 8–9.

123. Gabriele Lutz, *Richard Diebenkorn: Abstraktionen* (Zurich: Galerie Lawrence Rubin, 1995).

124. *Richard Diebenkorn: Figure Drawings* (New York: Acquavella Contemporary Art, Inc., 1996).

125. Deidre Stein Greben, "Richard Diebenkorn/Acquavella." *Art News* 95, no. 6, (September 1996): 130.

126. *Richard Diebenkorn: Drawing from the Model 1954–1967* (Venice, Calif.: L.A. Louver Gallery, 1996).

127. Susan Landauer, *The San Francisco School of Abstract Expressionism* (Berkeley: University of California Press, 1996), p. 5.

128. *Ibid.*, p. 7.

129. Jane Livingston, Ruth E. Fine, and John Elderfield, *The Art of Richard Diebenkorn* (New York: Whitney Museum of American Art; Berkeley: University of California Press, 1997).

130. Robert Hughes, "God Is in the Vectors," *Time* 150, December 8, 1997, pp. 45–48.

131. Eric Gibson, "Reviews," *Art News* 96 (December 1997): 159.

132. Mario Naves, "Richard Diebenkorn at the Whitney," *The New Criterion*, (January 1998): 39–41.

133. *Richard Diebenkorn: Ocean Park Paintings* (New York: Lawrence Rubin-Greenberg Van Doren Fine Art, 1999).

134. Robert Motherwell, *The New York School* (Beverly Hills, Calif.: Frank Perls Gallery, 1951), n.p.

135. Henri Matisse, quoted in Flam, *Matisse on Art*, p. 55.

136. Richard Diebenkorn, quoted in Michael Kimmelman, "A Life Outside," *New York Times Magazine*, September 12, 1992, pp. 58–64.

137. John Russell, *New York Times*, December 5, 1976, sec. 2, p. 33.

138. Conversation between Richard Diebenkorn and the author, Santa Monica, California, June 1986.

EXHIBITIONS AND AWARDS

Exhibitions accompanied by an important catalogue are indicated with an asterisk.

SOLO EXHIBITIONS

1948
"Richard Diebenkorn," California Palace of the Legion of Honor, San Francisco

1951
Master's Degree exhibition, University Art Museum, University of New Mexico, Albuquerque

1952
"Richard Diebenkorn," Paul Kantor Gallery, Los Angeles

1954
"Richard Diebenkorn," Paul Kantor Gallery, Los Angeles

"Richard Diebenkorn," San Francisco Museum of Art, San Francisco

"Richard Diebenkorn," Allan Frumkin Gallery, Chicago

1956
"Richard Diebenkorn," Poindexter Gallery, New York

"Richard Diebenkorn," Oakland Art Museum, Oakland, California

1957
"Richard Diebenkorn," Swetzoff Gallery, Boston

1958
"Richard Diebenkorn," Poindexter Gallery, New York

1960
★"Recent Paintings by Richard Diebenkorn," California Palace of the Legion of Honor, San Francisco

★"Richard Diebenkorn," Pasadena Art Museum, Pasadena, California

1961
★"Richard Diebenkorn," The Phillips Collection, Washington, D.C.

"Richard Diebenkorn," Poindexter Gallery, New York

1962
"Richard Diebenkorn," National Institute of Arts and Letters, New York

1963
"Richard Diebenkorn: Paintings 1961–1963," M. H. de Young Memorial Museum, San Francisco

"Richard Diebenkorn," Poindexter Gallery, New York

1964–65
★"Richard Diebenkorn," retrospective exhibition, Washington Gallery of Modern Art, Washington, D.C. Traveled to Jewish Museum, New York; Pavilion Gallery, Newport Beach, California

★"Drawings by Richard Diebenkorn," Stanford University Art Gallery, Palo Alto, California

1965
★"Richard Diebenkorn," Waddington Galleries, London

"Recent Drawings by Richard Diebenkorn," Paul Kantor Gallery, Los Angeles

1966
"Drawings by Richard Diebenkorn," Poindexter Gallery, New York

1967
"Richard Diebenkorn," Stanford University Art Gallery, Palo Alto, California

"Richard Diebenkórn," Waddington Galleries, London

1968
"Richard Diebenkorn," Nelson Gallery-Atkins Museum, Kansas City, Missouri

"Richard Diebenkorn," Poindexter Gallery, New York

★"Richard Diebenkorn," Richmond Art Center, Richmond, Virginia

"Drawings by Richard Diebenkorn," Pennsylvania Academy of the Fine Arts, Philadelphia

1969
★"New Paintings by Richard Diebenkorn," Los Angeles County Museum of Art, Los Angeles

★"Richard Diebenkorn: Drawings," Poindexter Gallery, New York

1971
★"Richard Diebenkorn, The Ocean Park Series: Recent Work," Marlborough Gallery, New York

"Richard Diebenkorn," Irving Blum Gallery, Los Angeles
"Richard Diebenkorn," Poindexter Gallery, New York

"Richard Diebenkorn," Smith Andersen Gallery, Palo Alto, California

1972
★"Richard Diebenkorn Lithographs," Gerard John Hayes Gallery, Los Angeles

★"Richard Diebenkorn, Paintings from the Ocean Park Series," San Francisco Museum of Art, San Francisco

1973
"Richard Diebenkorn," Robert Mondavi Gallery, Oakville, California

★"Richard Diebenkorn, The Ocean Park Series: Recent Work," Marlborough Fine Art Ltd., London and Marlborough Galerie, A.G., Zurich, Switzerland

1974
★"Richard Diebenkorn: Drawings 1944–1973," Mary Porter Sesnon Gallery, University of California, Santa Cruz

1975
★"Early Abstract Works, 1948–1955," James Corcoran Gallery, Los Angeles. Traveled to John Berggruen Gallery, San Francisco

★"Richard Diebenkorn, The Ocean Park Series: Recent Work," Marlborough Gallery, New York

1976
★"Richard Diebenkorn: Monotypes," Frederick S. Wight Art Gallery, University of California, Los Angeles

★"Richard Diebenkorn: Paintings and Drawings 1943–1976," retrospective exhibition, Albright-Knox Art Gallery, Buffalo, New York. Traveled to Cincinnati Art Museum, Cincinnati; Corcoran Gallery of Art, Washington, D.C.; Whitney Museum of American Art, New York; Los Angeles County Museum of Art, Los Angeles; Oakland Museum, Oakland, California (catalogue revised in 1980: *Diebenkorn: Paintings and Drawings 1943–1980*)

1977
★"Richard Diebenkorn," M. Knoedler & Co., Inc., New York

1979
★"Richard Diebenkorn," M. Knoedler & Co., Inc., New York

1980
★"Richard Diebenkorn," M. Knoedler & Co., Inc., New York

1981
★"Richard Diebenkorn: MATRIX/BERKELEY 40," University Art Museum, Berkeley, California

★"Richard Diebenkorn: Etchings and Drypoints, 1949–1980," Minneapolis Institute of Arts, Minneapolis. Traveled to Nelson-Atkins Museum of Art, Kansas City, Missouri; Saint Louis Art Museum, St. Louis, Missouri; Baltimore Museum, Baltimore; Museum of Art, Carnegie Institute, Pittsburgh; Brooklyn Museum, New York; Flint Institute of Arts, Flint, Michigan; Springfield Art Museum, Springfield, Missouri; University of Iowa Museum of Art, Iowa City; Blaffer Gallery, University of Houston, Houston; Newport Harbor Art Museum, Newport Harbor, California; San Francisco Museum of Art, San Francisco

1982
★"Richard Diebenkorn," M. Knoedler & Co., Inc., New York

★"Diebenkorn Etchings," Crown Point Press, Oakland, California

"Richard Diebenkorn: Intaglio 1961–1980," Brooklyn Museum, New York

1983
"Richard Diebenkorn: Works on Paper," John Berggruen Gallery, San Francisco

★"Richard Diebenkorn: Paintings 1948–1983," San Francisco Museum of Modern Art, San Francisco

1984
★"Richard Diebenkorn: Recent Work," M. Knoedler & Co., Inc., New York

"Richard Diebenkorn: A Portfolio of 41 Etchings and Drypoints Published in 1965," L.A. Louver Gallery, Venice, California

"Richard Diebenkorn/Etchings: Process into Form," San Jose Institute of Contemporary Art, San Jose, California. Traveled to Milwaukee Art Museum, Milwaukee, Wisconsin

1985
★"Richard Diebenkorn: An Intimate View," Sheldon Memorial Art Gallery, University of Nebraska, Lincoln. Traveled to Brooklyn Museum, New York

"Richard Diebenkorn, Etchings and Drypoints," Patricia Heesy Gallery, New York

★"Richard Diebenkorn: Recent Work," M. Knoedler & Co., Inc., New York

1986
"Richard Diebenkorn: 1981–1986," Crown Point Press, New York

1987
"Richard Diebenkorn: Recent Work," M. Knoedler & Co., Inc., New York

1988
"The Drawings of Richard Diebenkorn," Museum of Modern Art, New York. Traveled to Los Angeles County Museum of Art, Los Angeles; San Francisco Museum of Modern Art, San Francisco; The Phillips Collection, Washington, D.C.

"Richard Diebenkorn: Monotypes," Pamela Auchincloss Gallery, New York

1989
"Richard Diebenkorn: Graphics 1981–1988," Yellowstone Art Center, Billings, Montana. Traveled to Modern Art Museum of Fort Worth, Fort Worth, Texas; Tacoma Art Museum, Tacoma, Washington; Arkansas Art Center, Little Rock

"Richard Diebenkorn," Hara Museum of Contemporary Art, Tokyo, Japan (organized with SFMoMA)

1990
"Richard Diebenkorn," The Whitechapel Art Gallery, London. Traveled to Fundacion Juan March, Madrid; Frankfurter Kunstverein, Frankfurt; and in a new form to Museum of Contemporary Art, Los Angeles; San Francisco Museum of Modern Art, San Francisco

1991
"Richard Diebenkorn: Monochrome/Almost Monochrome," Associated American Artists, New York

1992
"Richard Diebenkorn: Ocean Park Paintings," Gagosian Gallery, New York

"Richard Diebenkorn: A Survey 1963–1990." Graystone Gallery, San Francisco

1993
"Richard Diebenkorn: Works on Paper from the Harry W. and Mary Margaret Anderson Collection," Fisher Gallery, University of Southern California, Los Angeles

1994
"Blue Surround, Evolution of a Print," M. H. de Young Memorial Museum, The Fine Arts Museums of San Francisco

"Ocean Park Paintings on Paper Never Before Exhibited," M. Knoedler & Co., New York

"Small Format Oil on Canvas Figures, Still Lifes and Landscapes," M. Knoedler & Co., Inc., New York

1995
"Richard Diebenkorn: Abstraktionen," Galerie Lawrence Rubin, Zurich

"Richard Diebenkorn: 41 Etchings/Drypoints, 1965, and Selected Rare Prints from 1961–62," John Berggruen Gallery, San Francisco

"The Ocean Park Image, Paintings on Paper and Important Prints," John Berggruen Gallery, San Francisco

1996

"Richard Diebenkorn: Figure Drawings,"
Acquavella Contemporary Art, Inc.,
New York

"Richard Diebenkorn: Selected Works
from 1949–1991," John Berggruen Gallery,
San Francisco

"Richard Diebenkorn: Drawing from the
Model 1954–1967," L.A. Louver Gallery,
Venice, California

1997
★"The Art of Richard Diebenkorn," retro-
spective exhibition, Whitney Museum of
American Art, New York. Traveled to Modern
Art Museum of Fort Worth, Fort Worth,
Texas; The Phillips Collection, Washington,
D.C.; San Francisco Museum of Modern Art,
San Francisco

1999
★"Richard Diebenkorn 1922–1993: Ocean Park
Paintings," Lawrence Rubin-Greenberg
Van Doren Fine Art, New York

"Richard Diebenkorn: From Nature to
Abstraction," Campbell-Thiebaud Gallery,
San Francisco

2000
"Richard Diebenkorn: Representational
Drawings," Galleria Lawrence Rubin, Milan

SELECTED GROUP EXHIBITIONS

1946
"66th Annual Exhibition: Oil, Tempera, and
Sculpture," San Francisco Museum of Art,
San Francisco

1948
★"California Centennial Exhibition,"
Los Angeles County Museum of Art,
Los Angeles

★"67th Annual Exhibition: Oil, Tempera,
and Sculpture," San Francisco Museum of Art,
San Francisco

1949
Lucien Labaudt Gallery (with Hassel Smith),
San Francisco

1951
★"20th Century American Painting,"
Grand Rapids Art Museum, Grand Rapids,
Michigan

"Contemporary Paintings," Paul Kantor
Gallery, Los Angeles

1954
★"New Accessions USA," Colorado Springs
Fine Arts Center, Colorado Springs, Colorado

★"Younger American Painters," Solomon R.
Guggenheim Museum, New York. Traveled
to Los Angeles County Museum of Art,
Los Angeles

1955
★"Three Young Americans: Glasco,
McCullough, Diebenkorn," Allen Memorial
Art Museum, Oberlin College, Oberlin, Ohio

"24th Biennial," Corcoran Gallery of Art,
Washington, D.C.

★"Painters Under 35," Congress for Cultural
Freedom, Rome. Traveled to Musée National
d'Art Moderne, Paris; Palais des Beaux Arts,
Brussels

★"1955 Pittsburgh International Exhibition of
Contemporary Painting," Museum of Art,
Carnegie Institute, Pittsburgh

"Contemporary Arts," Poindexter Gallery,
New York

★"III Bienal International de São Paulo,"
Museu de Arte Moderna, São Paulo, Brazil

★"Contemporary American Painting and
Sculpture," University of Illinois, Champaign-
Urbana, Illinois

"1955 Annual Exhibition of Contemporary
American Painting," Whitney Museum of
American Art, New York

★"Vanguard 1955," Walker Art Center,
Minneapolis

1956
★"Pacific Coast Biennial," San Francisco
Museum of Art, San Francisco

1957
"LXII American Exhibition: Paintings,
Sculpture," Art Institute of Chicago, Chicago

"Objects in the New Landscape Demanding
of the Eye," Ferus Gallery, Los Angeles

★"Modern Painting, Drawing and Sculpture
Collected by Louise and Joseph Pulitzer," M.
Knoedler & Co., Inc., New York. Traveled to
Fogg Art Museum, Cambridge, Massachusetts

★"American Paintings 1945–1957,"
Minneapolis Institute of Arts, Minneapolis

★"Contemporary Bay Area Figurative
Painting," Oakland Museum, Oakland,
California. Traveled to Los Angeles County
Museum of Art, Los Angeles

"Richard Diebenkorn—Paintings; Kenneth
Armitage—Sculpture," Swetzoff Gallery,
Boston

"IV Bienal International de São Paulo,"
Museu de Arte Moderna, São Paulo, Brazil

1958
★"Seventeen Contemporary American Artists
and Eight Sculptors," Brussels Universal
and International Exhibition (World's Fair),
American Pavilion, Brussels. Traveled to United
States Information Service Library, London

★"1958 Pittsburgh Bicentennial International
Exhibition of Contemporary Painting
and Sculpture," Museum of Art, Carnegie
Institute, Pittsburgh

★"American Painting, 1958," Virginia
Museum of Fine Arts, Richmond

★"1958 Annual Exhibition of Contemporary
American Painting," Whitney Museum of
American Art, New York

1959
"First Annual Group Show," Dilexi Gallery,
Los Angeles

"Contemporary Art—Acquisitions 1957–58,"
Albright-Knox Art Gallery, Buffalo, New York

"26th Annual," Corcoran Gallery of Art,
Washington, D.C.

"Aspects of Representation in Contemporary
Art," William Rockhill Nelson Gallery (and
Atkins Museum), Kansas City, Missouri

★"New Directions in Painting," Florida State
University Gallery, Tallahassee, Florida.
Traveled to John and Mable Ringling Museum
of Art, Sarasota, Florida; Norton Gallery and
School of Art, West Palm Beach, Florida

★"New Imagery in American Painting,"
Indiana University Art Museum,
Bloomington, Indiana

★"New Images of Man," Museum of Modern
Art, New York

1960
"The Image Lost and Found," Institute of
Contemporary Art, Boston

"LXIII American Exhibition: Paintings,
Sculpture," Art Institute of Chicago, Chicago

★"25 Anni di Pittura Americana 1933–1958," Italy. Traveled

★"Moderne Amerikanische Malerei: 1930–1958," organized by the City Art Museum, St. Louis, Missouri, for the United States Information Agency. Traveled to Hessische Landesmuseum, Darmstadt, Germany; to Göteborg Konstmuseum, Göteborg, Sweden, as "Moderne Amerikanische Malerei: 1932–1958"

★"American Art, 1910–1960: Selections from the Collection of Mr. and Mrs. Roy R. Neuberger," M. Knoedler & Co., Inc., New York

"Oliver Andrews—Richard Diebenkorn—Bryan Wilson," Stanford University Art Gallery, Palo Alto, California

"Art across America," Munson-William-Proctor Institute, Utica, New York

"Landscapists," Poindexter Gallery, New York

"Elmer Bischoff, Richard Diebenkorn, David Park," Staempfli Gallery, New York

1961
★"The Figure in Contemporary American Painting," American Federation of the Arts, New York

"Third Winter Invitational Exhibition," California Palace of the Legion of Honor, San Francisco

★"1961 Pittsburgh International Exhibition of Contemporary Painting and Sculpture," Museum of Art, Carnegie Institute, Pittsburgh

"27th Annual," Corcoran Gallery of Art, Washington, D.C.

★"Two Hundred Years of American Painting 1755–1960," Santa Barbara Museum of Art, Santa Barbara, California

★"VI Bienal International de São Paulo," Museu de Arte Moderna, São Paulo, Brazil

★"Contemporary American Painting and Sculpture," Krannert Art Museum, University of Illinois, Champaign-Urbana

★"Main Currents of Contemporary American Painting," State University of Iowa, Iowa City

1962
★"The Artist's Environment: West Coast," Amon Carter Museum of Western Art, Fort Worth, Texas, in collaboration with University of California Art Galleries, Los Angeles, and Oakland Museum, Oakland, California. Traveled to all three institutions

★"Selections 1934–1961, American Artists from the Collection of Martha Jackson," Martha Jackson Galleries, New York

★"American Art since 1950," Seattle World's Fair, Fine Arts Pavilion, Seattle, Washington. Traveled to Rose Art Museum, Brandeis University, Waltham, Massachusetts; Institute of Contemporary Art, Boston

★"Fifty California Artists," organized by San Francisco Museum of Art, with the assistance of Los Angeles County Museum of Art, Los Angeles. Traveled to Whitney Museum of American Art, New York; Walker Art Center, Minneapolis; Albright-Knox Art Gallery, Buffalo, New York; Des Moines Art Center, Des Moines, Iowa

"Exhibitions of Contemporary Painting and Sculpture," National Institute of Arts and Letters, New York

"Exhibitions of Work by Newly Elected Members and Recipients of Honors and Awards," National Institute of Arts and Letters, New York

★"Lithographs from the Tamarind Workshop," University of California Art Galleries, Los Angeles

★"The Gifford and Joann Phillips Collection," University of California Art Galleries, Los Angeles

"Selection of East Coast and West Coast American Painting," Gimpel Fils, London

"Art U.S.A.: Now," Milwaukee Art Center, Milwaukee, Wisconsin. Traveled

"Vanguard American Painting," Embassy Building, London

1963
"LXVI American Exhibition: Paintings, Sculpture," Art Institute of Chicago, Chicago

"1963 Annual Exhibition of American Painting," Whitney Museum of American Art, New York

"American Painters from A to Z," American Cultural Center, Paris

"Drawings by Bischoff, Diebenkorn, Lobdell," California Palace of the Legion of Honor, San Francisco

"28th Biennial Exhibition 1963," Corcoran Gallery of Art, New York

1964
"75th Anniversary Alumni Exhibition," University Art Museum, University of New Mexico, Albuquerque

★"A Special Exhibition Celebrating the 50th Anniversary of the Association of College Unions," Fine Arts Gallery, Indiana University, Bloomington

"American Paintings on the Market Today II," Cincinnati Art Museum, Cincinnati, Ohio

"Six Americans," Arkansas Arts Center, Little Rock

★"Painting and Sculpture of a Decade," Tate Gallery, London. Organized by the Calouste Gulbenkian Foundation

★"American Drawings," Solomon R. Guggenheim Museum, New York

"The 1964 Pittsburgh International Exhibition of Contemporary Painting and Sculpture," Museum of Art, Carnegie Institute, Pittsburgh

"New Dimensions in Lithography," Fisher and Quinn Galleries, University of Southern California, Los Angeles

"83rd Annual Exhibition," San Francisco Museum of Art, San Francisco

★"Seven California Painters," Staempfli Gallery, New York

1965
★"Two American Painters, Abstract and Figurative: Sam Francis, Richard Diebenkorn," Scottish National Gallery of Modern Art, Edinburgh

"1965 Annual Exhibition of Contemporary American Painting," Whitney Museum of American Art, New York

"Selections from the Work of California Artists," Witte Memorial Museum, San Antonio, Texas

★"The San Francisco Collector," M. H. de Young Memorial Museum, San Francisco

1966
★"Drawings," University of Texas Art Museum, Austin, Texas

★"Art of the United States 1670–1960," Whitney Museum of American Art, New York

★"The Permanent Collection," Washington Gallery of Modern Art, Washington, D.C.

1967
★"20th Century American Painting," Grand Rapids Art Museum, Grand Rapids, Michigan

★"California Art Festival," Lytton Center of the Visual Arts, Los Angeles

"Documentation—Sculpture, Paintings, Drawings," Finch College Museum of Art, New York

"Exhibition of Work by Newly Elected Members and Recipients of Honors and Awards," National Institute of Arts and Letters, New York

"1967 Annual Exhibition of Contemporary American Painting," Whitney Museum of American Art, New York

★"American Paintings since 1900 from the Permanent Collection," North Carolina Museum of Art, Raleigh, North Carolina

★"A Point of View: Selected Paintings and Drawings from the Richard Brown Baker Collection," University Art Gallery, Oakland University, Rochester, Michigan

★"Drawings by Americans," Henry Art Gallery, University of Washington, Seattle

1968
★"Painting as Painting," University of Texas Art Museum, Austin

★"Late Fifties at the Ferus," Los Angeles County Museum of Art, Los Angeles

★"East Coast–West Coast Paintings," Museum of Art, University of Oklahoma, Norman, Oklahoma, and the Oklahoma Arts Center, Oklahoma City, Oklahoma. Traveled to Philbrook Art Center, Tulsa, Oklahoma

★"163rd Annual," Pennsylvania Academy of the Fine Arts, Philadelphia

★"Untitled, 1968," San Francisco Museum of Art, San Francisco

"Modern Art from Midwestern Collections," University of Kansas Museum, Lawrence

★"XXXIV Venice Biennale," (The Figurative Tradition in Recent American Art, American Pavilion), Venice. Traveled to National Collection of Fine Arts, Washington, D.C.; Sheldon Memorial Art Gallery, University of Nebraska, Lincoln

1969
★"West Coast 1945–1969," Pasadena Art Museum, Pasadena, California

★"Kompas VI—West Coast U.S.A.," Stedelijk van Abbemuseum, Eindhoven, the Netherlands

"1969 Annual Exhibition of Contemporary American Painting," Whitney Museum of American Art, New York

1970
★"A Century of California Painting 1870–1970," Crocker-Citizens National Bank, Los Angeles

★"L'Art Vivant aux États-Unis," Fondation Maeght, St.-Paul-de-Vence, France

★"Looking West," Joslyn Art Museum, Omaha, Nebraska

"Inner Spaces—Outer Limits," Compas Gallery, New York. Traveled to Vera G. and Arthur A. List Art Center, Kirkland College, Clinton, New York

★"1970 Pittsburgh International Exhibition of Contemporary Art," Museum of Art, Carnegie Institute, Pittsburgh

★"The New Vein: The Human Figure 1967–1970," Geneva. Traveled to Belgrade and Milan

★"Excellence: Art from the University Community," University Art Museum, University of California, Berkeley, California

★"Trends in Twentieth Century Art, A Loan Exhibition from the San Francisco Museum of Art," University of California Art Galleries, Santa Barbara, California

★"1970 National Drawing Exhibition," San Francisco Museum of Art, San Francisco

1971
★"Made in California," Grunwald Graphic Arts Foundation, Dickson Art Center, University of California, Los Angeles

★"11 Los Angeles Artists," The Arts Council of Great Britain, Hayward Gallery, London

★"Two Directions in American Painting," Purdue University, Lafayette, Indiana

"Stanford Collects," Stanford University Museum of Art, Palo Alto, California

★"A Decade in the West," Stanford University Museum of Art, Palo Alto, California. Traveled to Santa Barbara Museum of Art, Santa Barbara, California

★"Accessions 1970–71," University of Iowa Museum of Art, Iowa City

1972
★"LXX American Exhibition: Paintings, Sculpture," Art Institute of Chicago, Chicago

★"Abstract Painting in the '70s: A Selection," Museum of Fine Arts, Boston

"1972 Annual Exhibition of Contemporary American Painting," Whitney Museum of American Art, New York

★"Looking West," ACA Galleries, New York

★"Crown Point Press at the San Francisco Art Institute," San Francisco Art Institute, San Francisco

1973
"33rd Biennial of Contemporary American Painting," Corcoran Gallery of Art, Washington, D.C.

★"Twenty-Five Years of American Painting, 1948–1973," Des Moines Art Center, Des Moines, Iowa

"American Artists: An Invitational," Charles MacNider Museum, Mason City, Iowa

"Mixed Bag," University of Maryland Art Gallery, College Park

★"American Drawings 1963–1973," Whitney Museum of American Art, New York

★"The Private Collection of Martha Jackson," University of Maryland Art Gallery, College Park. Traveled to Finch College Museum of Art, New York; Albright-Knox Art Gallery, Buffalo, New York

"American Drawing 1970–1973," Yale University Art Gallery, New Haven, Connecticut

"A Sense of Place," Joslyn Art Museum, Omaha, Nebraska; Sheldon Memorial Art Gallery, University of Nebraska, Omaha

1974
★"New Accessions USA," Colorado Springs Fine Art Center, Colorado Springs, Colorado

★"Twentieth Century Art from Fort Worth/Dallas Collections," Fort Worth Art Museum, Fort Worth, Texas

★"Fifteen Abstract Artists," Santa Barbara Museum of Art, Santa Barbara, California

★"Contemporary American Painting and Sculpture 1974," Krannert Art Museum, University of Illinois, Champaign-Urbana

★"Twelve American Painters," Virginia Museum of Fine Arts, Richmond

1975
★"The Martha Jackson Collection at the Albright-Knox Art Gallery," Albright-Knox Art Gallery, Buffalo, New York

★"An Evolution of American Works," Brooks Memorial Art Gallery, Memphis, Tennessee

"34th Biennial of Contemporary American Painting," Corcoran Gallery of Art, Washington, D.C.

"California Landscape, A Metaview," Oakland Museum, Oakland, California

★"Young America," Pennsylvania Academy of the Fine Arts, Philadelphia

★"Figure and Field in America," University of Texas Art Gallery, Arlington

★"Richard Brown Baker Collects," Yale University Art Gallery, New Haven, Connecticut

★"Selections from the Martha Jackson Gallery Collection," University Art Gallery, State University of New York, Albany

1976
★"Acquisition Priorities: Aspects of Postwar Painting in America," Solomon R. Guggenheim Museum, New York

★"Heritage and Horizon: American Painting 1776–1976," organized by Toledo Museum of Art, Toledo, Ohio. Traveled to Albright-Knox Art Gallery, Buffalo, New York; Detroit Institute of Arts, Detroit; Toledo Museum of Art, Toledo, Ohio; Cleveland Museum of Art, Cleveland; John Berggruen Gallery, San Francisco

★"Three Generations of American Painting: Motherwell, Diebenkorn, Edlich," Gruenebaum Gallery, Ltd., New York

★"The Last Time I Saw Ferus," Newport Harbor Art Museum, Newport Harbor, California

★"LXXII American Exhibition: Paintings, Sculpture," Art Institute of Chicago, Chicago

Untitled group exhibition, Poindexter Gallery, New York

"Paintings from the Collection of Mr. and Mrs. Max Zurier," La Jolla Museum of Contemporary Art, La Jolla, California

1977
"American Paintings and Drawings," John Berggruen Gallery, San Francisco

★"Watercolors and Related Media by Contemporary Californians," Baxter Art Gallery, California Institute of Technology, Pasadena

"Vault Show I," University of Arizona Museum of Art, Tucson

1978
★"XXXVIII Venice Biennale" (From Nature to Art, from Art to Nature [Richard Diebenkorn], American Pavilion), Venice

"Drawing Explorations: 1930–1978," Janus Gallery, Venice, California

"Three Generations: Studies in Collage," Margo Leavin Gallery, Los Angeles

"Western Art," John Berggruen Gallery, San Francisco

"Fine Art Press," Walnut Creek Civic Arts Gallery, Walnut Creek, California

"American Paintings of the 1970s," Albright-Knox Art Gallery, Buffalo, New York. Traveled to Newport Harbor Art Museum, Newport Harbor, California; Oakland Museum, Oakland, California; Cincinnati Art Museum, Cincinnati, Ohio; Art Museum of South Texas, Corpus Christi; Krannert Art Museum, University of Illinois, Champaign-Urbana

1979
"Works of Paper," Rockland Art Center, West Nyack, New York

"Works on Paper," Knoedler Gallery, London

1980
"American Drawing in Black & White," Brooklyn Museum, New York

"Three by Four," Blum Helman Gallery, New York

1981
★"37th Biennial Exhibition of Contemporary American Painting," Corcoran Gallery of Art, Washington, D.C.

"California: The State of Landscape, 1977–1981," Santa Barbara Museum of Art, Santa Barbara, California

1982
★"A Private Vision: Contemporary Art from the Graham Gund Collection," Museum of Fine Arts, Boston

"Artists Choose Artists," Clara Diamant Sujo Gallery, New York

"Drawings by Painters," The Mandeville Art Gallery, University of California, San Diego (La Jolla), California. Traveled to Oakland Museum, Oakland, California

1983
"15th Annual Exhibition," National Academy of Design, New York

★"Changes," The Aldrich Museum of Contemporary Art, Ridgefield, Connecticut

★"The Painterly Figure," The Parrish Art Museum, Southampton, New York

★"Art for a Nuclear Weapons Freeze," coordinated by Barbara Krakow Gallery, Boston. Participating galleries: Margo Leavin Gallery, Los Angeles; Fuller-Goldeen Gallery, San Francisco; Munson Gallery, Santa Fe; Delahunty Gallery, Dallas; Greenberg Gallery, St. Louis; John C. Stoller & Co., Minneapolis; Richard Gray Gallery, Chicago; Barbara Krakow Gallery, Boston; Brooke Alexander, Inc., New York

★"The First Show: Painting and Sculpture from Eight Collections 1940–1980," Museum of Contemporary Art, Los Angeles

1984
"The Zurier Collection," John Berggruen Gallery, San Francisco

★"Drawing since 1974," Hirshhorn Museum and Sculpture Garden, Washington, D.C.

"1984 Official Olympic Posters," exhibited in private reception and viewing, General Motors Building, New York

"Prints: Frankenthaler, Diebenkorn, Ganzer, Ruscha & Fischl," Patricia Heesy Gallery, New York

★"The Figurative Mode: Bay Area Paintings, 1956–1966," Grey Art Gallery and Study Center, New York University, New York. Traveled to Newport Harbor Art Museum, Newport Harbor, California

★"The Skowhegan Celebration Exhibition," Hirschl & Adler Modern, and Hirschl & Adler Galleries, New York

★"Twentieth Century American Drawings, The Figure in Context," organized by the International Exhibitions Foundation, Washington, D.C. Traveled to Terra Museum of American Art, Evanston, Illinois; Arkansas Arts Center, Little Rock; Oklahoma Museum of Art, Oklahoma City; Toledo Museum of Art, Toledo, Ohio; Elvejhem Museum of Art, University of Wisconsin, Madison; National Academy of Design, New York

"Group Show," Solomon & Co., Fine Art, New York

"American and European Painting, Drawing, and Sculpture," L.A. Louver Gallery, Venice, California

"American Still Life, 1945–1983,"
Neuberger Museum, State University of
New York, Purchase

"Treasures from the Smithsonian Institution,"
Royal Scottish Museum, Edinburgh

★"Art of the States/Works from a Santa
Barbara Collection," Santa Barbara Museum
of Art, Santa Barbara, California

"Ten Los Angeles Artists, A Tribute,"
Jack Rutberg Fine Arts, Inc., Los Angeles

1985
"Recent Acquisitions," John Berggruen
Gallery, San Francisco

"On Paper," Greenberg Gallery, St. Louis,
Missouri

"Portfolio: Prints in Context," Barbara Krakow
Gallery, Boston

★"Sunshine and Shadow: Recent Painting
in Southern California," Fisher Gallery,
University of Southern California,
Los Angeles

"American/European, Painting and Sculpture,"
L.A. Louver Gallery, Venice, California

"Recent Acquisitions," Art Special Gallery,
Oakland Museum, Oakland, California

★"American Prints of the '80s," Waddington
Graphics, London

"Art in the San Francisco Bay Area,
1945–1980/A Major Exhibition,"
Oakland Museum, Oakland, California

★"Charcoal Drawings 1980–1985,"
Jamie C. Lee Gallery, Houston

★"Contrasts of Form: Geometric Abstract
Art 1910–1980," Museum of Modern Art,
New York

1986
★"Individuals: A Selected History of
Contemporary Art 1945–1986,"
Museum of Contemporary Art, Los Angeles

★"After Matisse," organized by Independent
Curators, Inc., New York. Traveled to Queens
Museum, Flushing, New York; Chrysler
Museum, Norfolk, Virginia; Portland Museum
of Art, Portland, Maine; Bass Museum of Art,
Miami Beach, Florida; The Phillips Collection,
Washington, D.C.; Dayton Art Institute,
Dayton, Ohio; Worcester Art Museum,
Worcester, Massachusetts

"New Prints," Patricia Heesy Gallery,
New York

1987
"Recent Prints: Richard Diebenkorn, Howard
Hodgkins, Robert Motherwell," Mary Ryan
Gallery, New York

1989
"Illustrious Alumni," Jonson Gallery,
University of New Mexico, Albuquerque

"Richard Diebenkorn—Jim Dine—Sam
Francis," Associated American Artists, New York

1990
"Bay Area Figurative Art, 1950–1963,"
San Francisco Museum of Modern Art,
San Francisco

1991
"A Selection: California Figurative Painters
from the '50s," Meredith Long & Company,
Houston

1995
"A Bay Area Connection: Works from the
Anderson Collection, 1954–1984," Triton
Museum of Art, Santa Clara, California

"XXV YEARS—The 25th Anniversary
Exhibition," John Berggruen Gallery,
San Francisco

1996
"The San Francisco School of Abstract
Expressionism," Laguna Art Museum,
Laguna Beach, California. Traveled to the
San Francisco Museum of Modern Art,
San Francisco

1997
"Important Bay Area Paintings 1954–1960,"
John Berggruen Gallery, San Francisco

"American Works 1945–1975," C & M Arts,
New York

AWARDS

Albert Bender Grant
Woodstock, New York
1946–47

Abraham Rosenberg Traveling Fellowship
for Advanced Study in Art
Berkeley, California
1954–55

National Institute of Arts and Letters, member
1967

Carol H. Beck Gold Medal,
Pennsylvania Academy of Fine Arts
1968

National Council on the Arts, member
1974–75

XXXVIII Venice Biennale,
selected to represent the United States
1978

Edward MacDowell Medal,
MacDowell Colony
Peterborough, New Hampshire
1978

Skowhegan Medal for Painting,
Skowhegan School of Art
Skowhegan, Maine
1979

American Academy of Design, member
1980

Honorary Doctorate of Fine Arts,
Occidental College, Los Angeles
1982

Honorary Doctorate,
University of New Mexico, Albuquerque
1985

American Academy of Arts and Letters,
member
1985

UCLA Medal,
University of California, Los Angeles
1987

National Medal of Art
Washington, D.C.
1991

BIBLIOGRAPHY

ARTICLES

Albright, Thomas. "Diebenkorn's 'Ocean Park'—A New World." *San Francisco Chronicle*, November 20, 1977: 48.

Alloway, Lawrence. "London Chronicle." *Art International* 2 (December 1958–January 1959): 33–36, 101.

———. "Abstract Artists." *Nation* (January 3, 1976): 29.

Andrews, Colman. "Six Artists. Six Views. One City." *TWA Ambassador* (July 1981): 44–45.

"Art Spectacle in Pittsburgh." *Life* (December 1, 1961): 126.

"Art USA: The Johnson Collection." *Arts* 39 (April 1965): 22–25.

Ashton, Dore. "Young Painters in Rome." *Arts Digest* (June 1955): 6.

———. "First One-Man Show at Poindexter Gallery." *Arts and Architecture* 73 (April 1956): 11.

———. "An Eastern View of the San Francisco School." *Evergreen Review* 1, no. 2 (1957): 148–59.

———. "Art: Rebel in the West." *New York Times*, February 25, 1958, p. 25.

———. "Flight into Reality at the Poindexter." *Arts and Architecture* 75 (May 1958): 29.

———. "Contemporary American Drawing." *Arts* 39 (April 1965): 28.

———. "Richard Diebenkorn's Paintings." *Arts* 46 (December 1971–January 1972): 35–37.

———. "Richard Diebenkorn." *Flash Art* (March/April 1981): 8–13.

Baker, Kenneth. "Ocean Park Series." *Christian Science Monitor* (January 14, 1970): 8.

———. "New York." *Artforum* 9 (May 1971): 74–75.

———. "Thiebaud, Diebenkorn in Tandem." *San Francisco Chronicle*, April 11, 1991.

———. "The Big Picture on Diebenkorn." *San Francisco Chronicle*, 1992.

———. "The Evolution of a Diebenkorn." *San Francisco Chronicle*, April 9, 1994, n.p.

———. "A Window on a World of Shape Color," *Smithsonian* (March 1998): 73–82.

Baker, Richard Brown. "Notes on the Formation of My Collection." *Art International* 5 (September 20, 1961): 40–47.

Brown, B. "Richard Diebenkorn." *Arts* 57 (February 1983): 46–47.

Butterfield, Jan. "Diebenkorn: A Painter's 'Pentimento.'" *United* [magazine of United Airlines] (June 1983): 108–18.

Campbell, Lawrence. "Exhibition at Poindexter Gallery." *Art News* 57 (March 1958): 13.

———. "Reviews & Previews: Richard Diebenkorn." *Art News* 64 (March 1965): 12.

———. "Reviews & Previews: Richard Diebenkorn." *Art News* 67 (summer 1968): 14.

Canaday, John. "Richard Diebenkorn: Still Out of Step." *New York Times*, May 26, 1968, sec. 3, p. 37.

———. "Diebenkorn Marries Skill to Feeling." *New York Times*, January 4, 1969, sec. 3, p. 23.

———. "Win, Lose or Draw at Chicago's All-American Show." *New York Times*, June 25, 1972.

Cecil, Sarah. "New Editions: Richard Diebenkorn." *Art News* 82 (April 1983): 87.

Chipp, Herschel B. "Art News from San Francisco, Pacific Coast Leaders." *Art News* 55 (September 1956): 18.

———. "Art News from San Francisco, Group-Show Winners." *Art News* 56 (February 1957): 20, 60.

———. "Diebenkorn Paints a Picture." *Art News* 56 (May 1957): 44–47.

———. "Retrospective Assembled by the Pasadena Art Museum." *Art News* 59 (February 1961): 54.

Coffelt, Beth. "The Arts: Doomsday in the Bright Sun." *San Francisco Sunday Examiner & Chronicle*, October 16, 1977, pp. 22–28.

Colt, Priscilla. "Remarks on the Figure and Lester Johnson." *Art International* 7 (January 1964): 64–67.

"Combination." *Paris Review* 26 (fall 1984): 18.

Conrad, Barnaby III. "Los Angeles: The New Mecca." *Horizon* (January/February 1987): 17–30.

Coplans, John. "Notes from San Francisco." *Art International* 7 (May 25, 1963): 73–74.

Davis, Douglas. "Gallery-Hopping in New York." *Newsweek* (December 27, 1971): 36.

Diebenkorn, Richard. "Ocean Park #24." *Art Now* (January 1970): n.p.

———. *David Park, 1911–1960*. Exhibition catalogue with a note by Diebenkorn. New York: Salander-O'Reilly Galleries, Inc., 1985.

Edgar, Natalie. "Reviews & Previews, Richard Diebenkorn." *Art News* 68 (November 1969): 14.

"Edging Away from Abstraction." *Time* (March 17, 1958): 64–65, 67.

Eitner, Lorenz. "Diebenkorn, A Living Artist's Example...." *Stanford Today* (summer 1964): 8–11.

———. "The Stanford Museum." *Stanford Magazine* (fall 1983): 51.

Elderfield, John. "Diebenkorn at Ocean Park." *Art International* 15 (February 20, 1972): 20–25.

———. "Exhibition at Poindexter Gallery." *Art News* 62 (December 1963): 54.

Fenton, Terry. "Exhibition at Poindexter Gallery." *Artforum* 8 (January 1970): 64–65.

"Fine Arts in the Market Place." *Life* (September 19, 1960): 13.

Forgey, Benjamin. "Three Different Diebenkorns." *Washington Star*, April 17, 1977, pp. 20–21.

Frankenstein, Alfred. "Diebenkorn Retrospective of Evolution, Enrichment and Specialization." *San Francisco Sunday Examiner & Chronicle*, November 14, 1977.

Fryberger, Betsy G. "Richard Diebenkorn." *Stanford Magazine* (summer 1987): cover, 24–31.

Gardner, Paul. "When Is a Painting Finished?" *Art News* (November 1985): 96–97.

Garver, Thomas H. "Exhibition at Los Angeles County Museum of Art." *Artforum* 8 (September 1969): 66.

Getlein, Frank. "Two Privacies." *New Republic* (December 5, 1964): 15–26.

Geisen, Sara. "Richard Diebenkorn: Before and Behind the Eye." *Arts* 49 (June 1975): 79–81.

Gibson, Eric. "Reviews." *Art News* (December 1997): 159.

Glueck, Grace. "Exhibition at Poindexter Gallery." *Art in America* 57 (September 1969): 66.

———. "Swirl of the Golden West [interview]." *New York Times*, June 10, 1977, sec. 3, p. 20.

Goldyne, Joseph R. "Observations on Richard Diebenkorn's Later Drawings." *Drawing* (March/April 1994): 124–27.

Gopnik, Adam. "The Art World: Diebenkorn Redux." *The New Yorker* (May 21, 1993): 97–100.

Gosling, Nigel. "A New Realist." *The Observer* (London), October 4, 1964, p. 25.

Greben, Deidre Stein. "Richard Diebenkorn: Acquavella." *Art News* (September 1996): 130.

Green, Lois Wagner. "Emphasizing Art." *Architectural Digest* (July 1982): 38–45.

Greenberg, Clement. "After Abstract Expressionism." *Art International* 6 (October 1962): 24–32.

Grisson, Sarah. "San Francisco." *Arts* 32 (May 1958): 20–21, 69.

Gruen, John. "Richard Diebenkorn, Radiant Vistas from Ocean Park." *Architectural Digest* (November 1986): 52–60.

———. "Richard Diebenkorn, The Idea Is to Get Everything Right." *Art News* 85 (November 1986): 80–87.

"Halfway House." *Time* (August 1, 1969): 50–51.

Hall, Charles. "Richard Diebenkorn: Whitechapel." *Arts Review* (London) (November 1991): 581–83.

Hazlitt, Gordon J. "An Incredibly Beautiful Quandary." *Art News* 75 (May 1976): 36–38.

———. "Problem Solving in Solitude." *Art News* 76 (January 1977): 76–79.

———. "Diebenkorn: The Painter's Painter." *Hughes Airwest Sundancer* (September 1977): 42–45.

Hinson, Tom E. "Recent Paintings by Richard Diebenkorn and Jack Tworkov." *Bulletin of the Cleveland Museum of Art* (February 1980): 31–40.

Hofstadter, Dan. "Profiles [Richard Diebenkorn]: Almost Free of the Mirror." *The New Yorker* (September 7, 1987): 54–73.

Hopkins, Budd. "Diebenkorn Reconsidered." *Artforum* 15 (March 1977): 37–41.

Hopps, Walter. "Current Concerns." *LAICA Journal* (February 1975): 54–57.

Hudson, Andrew. "The Painting as Object." *Canadian Art* (March/April 1965): 31.

Hughes, Robert. "California in Eupeptic Color." *Time* (June 27, 1977): 58.

———. "A Geometry Bathed in Light." *Time* (January 5, 1982): 46.

———. "God Is in the Vectors," *Time* (December 1997): 45–48.

"The Human Figure Returns in Separate Ways and Places." *Life* (June 8, 1962): 54–61.

Illustrious Alumni. Albuquerque: University of New Mexico Art Museum, 1989.

James, Merlin Ingle. "London, Whitechapel: Richard Diebenkorn." *The Burlington Magazine* (December 1991): 857–58.

Kaufman, Betty. "New Kind of Humanism." *Commonweal* (June 16, 1961): 310–11.

———. "Diebenkorn." *Commonweal* (May 5, 1965): 755–56.

Kendall, Richard. "Painting against the Grain: Richard Diebenkorn at Whitechapel Art Gallery." *Apollo* (December 1991): 429.

Kessler, C. S. "Los Angeles: The Seasonal Tide." *Arts* 35 (November 1960): 19.

Kessler, Julia Braun. "Treasure Island: Richard Diebenkorn's Love Affair with Santa Cruz Island." *Modern Maturity* (June–July 1991): 42–47.

Kimmelman, Michael. "Connections Amid Diversity in 2 London Retrospectives." *New York Times*, November 19, 1991, sec. 3 pp. 15–16.

———. "The Elegant, Playful Images of Diebenkorn." *New York Times*, November 18, 1988, sec. 3, pp. 1, 32.

———. "A Life Outside." *New York Times Magazine*, September 13, 1992, pp. 58–64.

———. "Richard Diebenkorn, Lyrical Painter, Dies at 71," *New York Times*, March 31, 1993, pp. 1, 19.

Knight, Christopher. "The Challenging Art of Reinvention." *Los Angeles Times*, April 1, 1993, pp. F1, F5.

Kramer, Hilton. "Month in Review: This Year's Whitney Annual." *Arts* 33 (December 1958): 46–49.

———. "Month in Review." *Arts* 34 (January 1960): 42.

———. "Latest Thing in Pittsburgh." *Arts* 36 (January 1962): 26.

———. "The Figures of Yektai." *Arts* 36 (September 1962): 38.

———. "Pure and Impure Diebenkorn." *Arts* 38 (December 1963): 46–53.

———. "Art Mailbag—Concerning the Diebenkorn Case." *New York Times*, June 12, 1966, sec. 3, p. 22.

———. "Diebenkorn's Mastery." *New York Times*, June 12, 1977, sec. 3, p. 25.

———. "Uptown: New Richard Diebenkorn Works." *New York Times*, January 15, 1982, sec. 3, pp. 1, 18.

Lanes, J. "Brief Treatise on Surplus Value; or, The Man Who Wasn't There." *Arts* 34 (November 1959): 30–31.

———. "Richard Diebenkorn, Cloudy Skies over Ocean Park." *Artforum* 10 (February 1972): 61–63.

Langsner, Jules. "Exhibition of Drawings and Paintings at the Paul Kantor Gallery." *Art News* 53 (May 1954): 47.

———. "Is There an American Print Revival? [Tamarind Workshop]." *Art News* 60 (January 1962): 35.

———. "Los Angeles Letter." *Art International* 6 (December 1962): 38–40.

Larsen, Susan C. "A Conversation with Richard Diebenkorn." *LAICA Journal* (July/August 1977): 24–30.

———. "Cultivated Canvases." *Artforum* (January 1986): 66–71.

Lavatelli, Mark. "Richard Diebenkorn: The Albuquerque Years." *Artspace* (June 1980): 20–25.

Leider, Philip. "California—After the Figure." *Art in America* 51 (October 1963): 73–83.

———. "Diebenkorn Drawings at Stanford." *Artforum* 2 (May 1964): 41–43.

Leonard, Susan S. *The Influence of Henri Matisse on the Art of Richard Diebekorn, Ellsworth Kelly, and Joan Mitchell.* M.A. Thesis for the School of the Art Institute of Chicago, 1990.

Lippard, Lucy. "New York Letter." *Art International* 8 (April 3, 1965): 51–52.

"Look of the West Inspires Art." *Life* (November 4, 1957): 65–69.

"Los Angeles, A New Center for Contemporary Art." *Connaissance des Arts* (November 1981).

Lynton, Norbert. "London Letter." *Art International* 4 (May 1962): 96–97.

MacAdam, Alfred. "Richard Diebenkorn: Rendering the Abstract Human." *Art News* (April 1998): 100.

Magloff, Joanna. "Art News from San Francisco [de Young Museum Exhibition]." *Art News* 62 (January 1964): 52.

Marmer, Nancy. "Richard Diebenkorn: Pacific Extensions." *Art in America* 66 (January 1978): 95–99.

Mills, Paul. "The New Museum's Policies Are Discussed by Curator Paul Mills." *Artforum* 3 (December 1964): 30.

———. "Richard Diebenkorn: Paintings Against The Tide." *Saturday Review* (November 1972): 55–59.

Monte, James. "Reviews: San Francisco, Winter Invitational." *Artforum* 2 (February 1963): 46, 48.

———. "Reviews: San Francisco." *Artforum* 2 (July 1963): 7–8.

———. "Richard Diebenkorn, de Young Museum." *Artforum* 2 (November 1963): 43.

Munro, Eleanor C. "Figures to the Fore." *Horizon* 2 (July 1960): 16–24.

Murphy, R. "Painting Should Have Flex." *Horizon* 21 (July 1978): 66–71.

Naves, Mario. "Richard Diebenkorn at the Whitney." *The New Criterion* (January 1998): 39–41.

Newman, Robert. "Exhibitions at Poindexter Gallery." *Arts* 42 (summer 1968): 60.

Nordland, Gerald. "6 x 5." *Frontier* 7 (October 1956): 23–24.

———. "Collecting in Los Angeles." *Artforum* 2 (summer 1964): 13, 16, 17.

———. "The Pasadena Art Museum." *Artforum* 2 (summer 1964): 25.

———. "Richard Diebenkorn: A Fifteen Year Retrospective Is Organized by the Washington Gallery of Modern Art." *Artforum* 3 (January 1965): 20–25.

———. "Gift of Diebenkorn Painting to the Stanford Museum." *Committee for Art at Stanford Newsletter* (winter 1969–70): 1–4.

O'Doherty, Brian. "Ethics of Adversity." *Newsweek* (November 30, 1964): 97.

"The Patron's Role." *Time* (September 7, 1962): 36, 43.

Perl, Jed. "Art: Autumn Alphabet." *The New Criterion* (March 1989): 45–48.

Peterson, Ivars. "Computing Art / Can a Computer Be Taught To Take a Painting's Measure?" *Science News* 129 (March 1, 1986): 138–40.

Peterson, Valerie. "Exhibition at Poindexter Gallery." *Art News* 59 (March 1961): 13.

———. "Exhibition at Poindexter Gallery." *Art News* 62 (December 1963): 54.

Plagens, Peter. "Los Angeles." *Artforum* (April 1971): 84.

———. "Richard Diebenkorn: Whitney Museum of American Art." *Artforum* (February 1998): 85.

———. "The Diebenkorn Debate." *San Francisco Sunday Examiner & Chronicle*, October 4, 1998, pp. 38–39.

———. Interview with Richard Diebenkorn. *Preuves* (October 1956): 43.

Ratcliff, Carter. "New York Letter." *Art International* (February/March 1976): 26, 40.

Raynor, Vivien. "In the Galleries: Richard Diebenkorn [retrospective at Jewish Museum]." *Arts* 39 (March 1965): 54.

———. "Diebenkorn Refines His Vision." *New York Times*, May 25, 1979, sec. 3, p. 24.

———. "Art: Painting on Paper by Richard Diebenkorn at Knoedler." *New York Times*, May 18, 1984, sec. 3, p. 18.

Relph, Ted. "To See with the Soul of the Eye." *Landscape* 23, no. 1 (1979): 32.

"Reviews: Richard Diebenkorn." *Artforum* 18 (September 1979): 78–79.

Rexroth, Kenneth. "Figurative Art Revival." *San Francisco Examiner*, September 15, 1963.

"Richard Diebenkorn." *Art Voices* (summer 1966): 41.

"Richard Diebenkorn." *America Illustrated* [published by U.S. Information Agency, distributed in U.S.S.R.] (February 1967): 60.

"Richard Diebenkorn." *Studio* (July–August 1974): 14.

Roditi, Edouard. "Border Art, California Meets the 'Real Thing.'" *Arts* 41 (March 1967): 50–51.

Rose, Barbara. "New York Letter." *Art International* 8 (April 1964): 52–56.

Russell, John. "The Radiance of Diebenkorn Paintings." *New York Times*, December 6, 1975, sec. 3, p. 25.

———. "Diebenkorn's Stunning Achievement." *New York Times*, December 5, 1976, sec. 3, p. 33.

———. "Richard Diebenkorn at Knoedler." *New York Times*, November 22, 1985, sec. 3, p. 24.

———. "Richard Diebenkorn." *New York Times Book Review*, December 6, 1987.

Sandler, Irving Herschel. "California Artist at the Staempfli." *Art News* 59 (December 1960): 15.

———. "New York Letter." *Art International* 4 (May 1961): 52–54.

Sawin, Martica. "In the Galleries: Richard Diebenkorn [Park, Bischoff, Diebenkorn at Staempfli]." *Arts* 35 (December 1960): 50.

Schevill, James. "Richard Diebenkorn." *Frontier* 8 (January 1957): 21–22.

Seckler, D. G. "Painting." *Art in America* 46 (winter 1958–59): 34.

Seldis, Henry J. "A Look at Diebenkorn, Past & Present." *Los Angeles Times Home Magazine*, August 7, 1977, pp. 18–19.

"The Singing Colors and Evocative Scenes of Richard Diebenkorn." *Ameryka* [published by U.S. Information Agency, distributed in Poland], no. 82 (1965): 44, 48.

Stevens, Mark. "Amazing Grace of Richard Diebenkorn." *Newsweek* (June 20, 1977): 83.

Temko, Allan. "The Flowering of San Francisco." *Horizon* 1 (January 1959): 13–15.

Tillim, Sidney. "In the Galleries, Brussels '58." *Arts* 33 (February 1959): 55.

———. "Month in Review." *Arts* 35 (February 1961): 48–52.

———. "Exhibition at the Poindexter Gallery." *Arts* 35 (April 1961): 48.

———. "Month in Review." *Arts* 37 (December 1962): 40.

———. "Realism and 'The Problem.'" *Arts* 37 (September 1963): 51–52.

———. "The Reception of Figurative Art: Notes on a General Misunderstanding." *Artforum* 7 (February 1969): 31–32.

———. "A Variety of Realisms." *Artforum* 7 (summer 1969): 45–46.

Tuchman, Maurice. "Richard Diebenkorn: The Early Years." *Art Journal* (spring 1977): 206–20.

Tyler, Parker. "Exhibition at Poindexter Gallery." *Art News* 55 (March 1956): 51.

Van Der Marck, Jan. "The Californians." *Art International* (May 1963): 28–31.

———. "The Venice Biennale: Can It Rise Again?" *Artforum* 17 (September 1978): 74–77.

Ventura, Anita. "Recent Figurative Paintings in Exhibition at Poindexter Gallery." *Arts* 32 (March 1958): 56.

———. "Prospect over the Bay." *Arts* 37 (May 1963): 20.

———. "San Francisco, the Aloof Community." *Arts* 39 (April 1965): 72–73.

Westfall, Stephen. "Richard Diebenkorn: A Reasoned Sensuality." *Art in America* (October 1998): 106–11.

Whittet, G. S. "Figurative Abstraction—or Abstracted Figuration?" *Studio International* (December 1964): 272–75.

Wight, Frederick. "The Phillips Collection—Diebenkorn, Woeffler, Mullican: A Discussion." *Artforum* 1 (April 1963): 23, 25–28.

Wilson, William (& Myrna Oliver). "Richard Diebenkorn, Renowned Painter Dies." *Los Angeles Times*, March 31, 1993, pp. A1, A22.

Wilson, William, "The Artist's Quest for the Impossible," *Los Angeles Times*, April 1, 1993, pp. F1, F5.

Wolf, Daniel, "Diebenkorn and the Cult of Originality," *The Threepenny Review* (Spring 1998): 23–24.

Woodward, Richard B. "Richard Diebenkorn: Museum of Modern Art." *Art News* (March 1989): 168.

GENERAL REFERENCE BOOKS

Albright, Thomas. *Art in the San Francisco Bay Area 1945–1980, An Illustrated History.* Berkeley, Calif.: University of California Press, 1984.

Albright-Knox Gallery, *Contemporary Art 1942–72: Collection of the Albright-Knox Gallery.* New York: Praeger Publishers, 1973.

Arnason, H. Harvard. *History of Modern Art: Painting, Sculpture, Architecture.* 3rd ed. New York: Harry N. Abrams, Inc., 1986.

Arthur, John. *Realist Drawings & Watercolors.* Boston: New York Graphic Society, 1980.

Feldman, Edmund Burke. *Varieties of Visual Experience.* New York: Harry N. Abrams, Inc., 1972.

Gatto, Joseph A. *Cities.* Worcester, Mass.: Davis Publications, Inc., 1977.

Geldzahler, Henry. *New York Painting and Sculpture: 1940–1970.* New York: E.P. Dutton & Co., 1969.

Henning, Edward B. *Fifty Years of Modern Art, 1916–1966.* Cleveland: The Cleveland Museum of Art, 1966.

Johnson, Ellen H. *Modern Art and the Object.* London: Thames & Hudson, 1976.

Lipman, Jean, ed. *The Collector in America.* New York: The Viking Press, 1961.

Lucie-Smith, Edward. *American Art Now.* New York: William Morrow & Co., 1985.

Mendelowitz, Daniel M. *A History of American Art.* New York: Holt, Rinehart, and Winston, 1970.

McChesney, Mary Fuller. *A Period of Exploration: San Francisco 1945–1950.* Oakland, Calif.: The Oakland Museum Art Department, 1973.

Motherwell, Robert, and Ad Reinhardt, eds. *Modern Artists in America.* New York: Wittenborn Schultz, Inc., 1952.

Paulson, Ronald. *Figure and Abstraction in Contemporary Painting.* New Brunswick, N.J.: Rutgers University Press, 1990.

Pellegrini, Aldo. *New Tendencies in Art.* New York: Crown Publishers, 1966.

Pulitzer, Joseph, Jr. *Modern Painting, Drawing and Sculpture: Collected by Louise and Joseph Pulitzer, Jr.*, Vol. 1. Cambridge, Mass.: Fogg Art Museum, Harvard College, 1957.

Richardson, E. P. *A Short History of Painting in America.* New York: Thomas Y. Crowell Co., 1963.

Rose, Barbara. *American Art Since 1960.* New York: Frederick A, Praeger, 1967.

Wilmerding, John, ed. *The Genius of American Painting.* London: Weidenfeld and Nicholson, 1973.

MONOGRAPHS

41 Etchings, Drypoints. Berkeley, Calif.: Crown Point Press, 1965.

Drawings by Richard Diebenkorn. Foreword by Lorenz Eitner. Palo Alto, Calif.: Stanford University Press, 1965.

Richard Diebenkorn Monotypes. Text by Gerald Nordland. Los Angeles: Frederick S. Wight Art Gallery, University of California, Los Angeles, 1976.

Richard Diebenkorn: Paintings and Drawings, 1943–1980. Essays by Robert T. Buck, Jr., and Linda L. Cathcart, Gerald Nordland, Maurice Tuchman. New York: Rizzoli International Publications/Albright-Knox Art Gallery, 1980.

Richard Diebenkorn: Etchings and Drypoints, 1949–1980. Foreword by Phyllis Plous. Text by Mark Stevens. Houston: Houston Fine Art Press, 1981.

Richard Diebenkorn: Small Paintings from Ocean Park. Preface by George Neubert. Essay by Dore Ashton. San Francisco: Hine Inc., and Houston: Houston Fine Art Press, 1985.

Richard Diebenkorn: Works on Paper. Essay by Richard Newlin. Houston: Houston Fine Art Press, 1987.

The Drawings of Richard Diebenkorn. Text by John Elderfield. New York: Museum of Modern Art, 1988.

Richard Diebenkorn: Graphics 1981–1988. Text by Gerald Nordland. Billings, Mont.: Yellowstone Art Center, 1989.

Richard Diebenkorn: Ocean Park. Essay by Jack Flam. New York: Gagosian Gallery, 1992.

The Art of Richard Diebenkorn. Essays by Jane Livingston, Ruth E. Fine, John Elderfield. New York: Whitney Museum of American Art, and Berkeley: University of California Press, 1997.

INDEX OF WORKS

ACKNOWLEDGMENTS

This is the first extended study of the work of Richard Diebenkorn.
I am grateful to the artist, Richard Diebenkorn, for taking precious time
from work for lengthy interviews through the course of eight separate
projects on which we collaborated. The artist died in 1993, and this new
and enlarged edition of the 1987 book has been brought into existence
with the assistance of helpful friends, fellow artists, curators, dealers
and photographers, who have provided information, documentary
evidence, and photographs. First, I am grateful to Phyllis Diebenkorn,
and her family—Christopher Diebenkorn, Gretchen Diebenkorn
Grant, and Richard M. Grant—for advice and assistance with added
reproductions and transparencies.

I want to repeat my thanks to the John Simon Guggenheim Memorial
Foundation for the grant of 1985–86, which gave me the freedom to
gather the work of earlier projects and spend still more time with the
artist at a crucial time in his life.

Many individuals connected with museums, galleries, and printshops
have been gracious in giving information and providing photographs.
I want to thank Marcia Bartholme, ex-printer for Crown Point Press,
San Francisco; John Berggruen of the John Berggruen Gallery, San
Francisco; Kathan Brown, founder of Crown Point Press, San Francisco;
Charles Campbell of Campbell-Thiebaud Gallery, San Francisco; John
Elderfield, Chief Curator at Large, The Museum of Modern Art, New
York; Leslie Feely of Leslie Feely Fine Art, New York; Hal Fondren of
Poindexter Gallery, New York; Mindy Richman Garfinkel, National
Medal of Arts Coordinator, Washington, D.C.; Peter Goulds, of L.A.
Louver Gallery, Venice, California; Andrew Hoyem of The Arion Press,
San Francisco; Jane Livingston, curator and friend; Richard Newlin,
Houston Fine Art Press; Nathan Oliviera, inspirer of the Stanford
monotypes (1975); George Page, Master Printer and facilitator of the
Los Angeles monotype series (1974); Lawrence Rubin, personal repre-
sentative of the artist's estate, Milan and New York; Garner Tullis, artist
and printer, who helped with Diebenkorn's last monotypes; and the
Special Events & Protocol Office, UCLA.

A number of longtime friends of the artist have favored me with
interviews, which have contributed to the preparation of the text.
I want to thank Elmer Bischoff, Berkeley; William Brice, Los Angeles;
Frank Lobdell, San Francisco; Erle Loran, Kensington, California;
Hassel Smith, Bath, England; and Wayne Thiebaud, Sacramento. I must
add the names of Mark Lavatelli, Irving, Texas; Enrique Montenegro,
Albuquerque, New Mexico; and Clem Mullins, San Francisco, for
helpful documents and interviews.

Finally, I dedicate this book to my wife, Paula Giannini.

Portrait of the artist, 1984

PHOTOGRAPH CREDITS

Jon Abbott: 220, 221, 222, 223, 224T, 227
David Allison: 59, 164B
Damian Andrus: 40B
courtesy, Arion Press: 244
courtesy, Art Institute of Chicago.
 All Rights Reserved: 168
courtesy, William Beadleston, Inc.,
 New York: 157
courtesy, John Berggruen Gallery,
 San Francisco: 90T, 132
Ben Blackwell: 45
Brenwasser: 85B
Rudolph Burkhardt: 116T, 120T
Carlo Catenazzi: 119
Geoffrey Clements: 116B
Ken Cohen: 216, 217, 218T
courtesy, Corcoran Gallery of Art,
 Washington, D.C.: 101
Crown Point Press: 189, 190L
Christopher Diebenkorn: 246
Phyllis Diebenkorn: 134, 190R
eeva-inkeri: 133
Lee Fatherree: 73, 99, 107, 125C
courtesy, Leslie Feely Fine Art: 245
Kurt E. Fishback: 208R
courtesy, Gemini G.E.L.: 188
Richard M. Grant: 140
Lewis Harrington: 154
Biff Henrich: 176
Leo Holub: 247
courtesy, Martha Jackson Gallery: 116T
Bruce C. Jones: 143, 198, 200, 201, 202, 205,
 206, 207B, 208T, 209, 210
courtesy, Knoedler Galleries: 158, 160, 162,
 211, 212, 213, 214, 215, 216, 217
courtesy, Los Angeles County Museum of Art,
 L.2337.64–32: 44
courtesy, Los Angeles County Museum of Art,
 L.2337.64–30: 64
Herbert Lotz: 33
Courtesy, L.A. Louver Gallery: 131TL
Rose Mandel: 92

courtesy, Marlborough Gallery: 135
courtesy, Pierre Matisse Gallery: 145
Edward Meneeley: 120B
Don Meyer: 81, 123
Ph. Migeat/Ch. Bahier: 144
Hans Namuth: 93, 225
Nienhuis/Walls: 150
Douglas Parker Studio: 2, 12, 14, 15, 21, 22, 26,
 29L, 30, 34, 39, 40T, 41, 49, 52, 53, 56, 60,
 68, 74, 76, 84 ,87T, 90B, 95, 96 ,97, 98TL,TR,
 103, 108, 112L, 113, 114, 122, 124TL,B,
 125B, 126, 127, 128, 129T, 130B, 130TR,
 136TR,B, 137, 139, 149, 164T, 192, 207T,
 224B, 228, 229, 230
courtesy, Poindexter Gallery: 120
courtesy, The Museum of Modern Art,
 New York: 131TR
Eric Pollitzer: 115
Bill Redic: 62
courtesy, Lawrence Rubin, Greenberg-
 Van Dorn: 131B
courtesy, Salander-O'Reilly Galleries,
 New York: 85T
Joe Samberg: 31, 70
Marina Schniz: 4
Schopplein Studio, San Francisco: 141
Ira Schrank, Sixth Street Studio,
 San Francisco: 247, 248
Steve Sloman: 132
Lee Stalsworth: 71, 118
George Stillman: 29R
Joseph Szaszfai: 91
Grant Taylor: 35, 36
Michael Tropea: 186
F. J. Thomas Photography: 67
Roland I. Unruh: 77